EVERYTHING SEEMED POSSIBLE:
ART IN THE 1970s

ᵀMINSTER

EVERYTHING SEEMED POSSIBLE:
ART IN THE 1970s

Richard Cork

Yale University Press
New Haven and London

To Adam,
with all my love

Designed by Ruth Applin and Beatrix McIntyre
Set in Bembo
Printed in China through World Print

Library of Congress Cataloging-in-publication data:
Cork, Richard.
 Everything seemed possible : art in the 1970s / Richard Cork.
 p. cm.
Includes index.
 ISBN 0-300-09508-2 (pbk. : alk. paper)
 1. Art, British − 20th century − Themes, motives. 2. Avant-garde (Aesthetics) − Great Britain − History − 20th century. 3. Art − Exhibitions. I. Title: Art in the 1970s. II. Title.
 N6768 .C673 2002
 709'.41'09047−dc21

 2002153136

Frontispiece: Photograph of Richard Cork, 1974

CONTENTS

All these articles were written for the *Evening Standard*, apart from 'The State of the Tate' (*Cambridge Review*), 'Extending the Tate' (*Art Monthly*), and three reviews published in *The Guardian*: 'Art from France', 'Film Poster Overkill' and 'A Spurious Simplicity'.

AUTHOR'S BIOGRAPHY

Richard Cork is an art critic, historian, broadcaster and exhibition organiser. He read art history at Cambridge, where he was awarded a Doctorate in 1978. He has been Art Critic of the London *Evening Standard*, Editor of *Studio International*, Art Critic of *The Listener* and Chief Art Critic of *The Times*. In 1989–90 he was the Slade Professor of Fine Art at Cambridge, and from 1992–5 the Henry Moore Senior Fellow at the Courtauld Institute. He then served as Chair of the Visual Arts Panel at the Arts Council of England until 1998. He was recently appointed a Syndic of the Fitzwilliam Museum, Cambridge, and a member of the Advisory Council for the Paul Mellon Centre.

A frequent broadcaster on radio and television, he has organised major contemporary and historical exhibitions at the Tate Gallery, the Royal Academy, the Hayward Gallery and elsewhere in Europe. His international exhibition on Art and the First World War, held in Berlin and London, won a National Art Collections Fund Award in 1995. His books include a two-volume study of Vorticism, awarded the John Llewelyn Rhys Prize in 1976; *Art Beyond the Gallery*, winner of the Banister Fletcher Award for the best art book in 1985; *David Bomberg*, 1987; *A Bitter Truth: Avant-garde Art and the Great War*, 1994; and *Jacob Epstein*, 1999. The present book is part of a four-volume collection of his critical writings on modern art, all published in 2003.

ACKNOWLEDGEMENTS

My principal thanks must go to Charles Wintour, a great editor who made me his art critic on the *Evening Standard* and never failed to provide encouragement, friendship, understanding and support. I must also thank the artists, galleries and museums who so kindly provided photographs of the work reproduced in this book.

I am grateful to Veronica Wadley, Editor of the *Evening Standard*, Alan Rusbridger, Editor of *The Guardian*, and Patricia Bickers, Editor of *Art Monthly*, for granting me permission to publish material that originally appeared in their publications.

At Yale, Ruth Applin and Beatrix McIntyre deserve an accolade for handling with such skill and patience all the complexities of publishing four books at once. My thanks also go, as ever, to my publisher John Nicoll. His enthusiasm for this project was invaluable, and I am fortunate indeed to benefit once again from his wisdom.

Each of these books is dedicated to one of my four children. Adam, Polly, Katy and Joe can never know how much they have sustained and delighted me, while my wife Vena has always given me a limitless amount of encouragement, friendship and love.

INTRODUCTION

When I began writing regular criticism at the end of the 1960s, it was still widely assumed in the West that most art took the form of painting, sculpture and graphic work. Few dissented from such a belief, even though it had been challenged in various far-reaching ways throughout the twentieth century. But the desire for radical redefinition was growing, and I was pitched into the middle of a period galvanised by restless innovation as soon as the *Evening Standard* made me its art critic. The year was 1969. And I realised, as a raw twenty-two year-old art history graduate, that the desire for renewal was transforming all our ideas and hopes.

Nothing seemed off-limits. Far from remaining satisfied with the old hierarchy of media, young artists were emerging with a host of heretical alternatives in mind. With accelerating resolve, I threw myself into supporting the whole notion of sloughing off arbitrary restrictions and claiming new freedoms. Its energy matched the vital moment in London before the First World War, when the Vorticist movement launched itself with such rebellious fire in the pages of *BLAST* magazine. During the early years of the 1970s, I was researching and writing a book about the Vorticists, who did so much to revolutionise modern British art and pioneer the spirit of innovation that still invigorates their successors today. They were the subject of my first *Evening Standard* article in November 1969, and the second enthusiastically declared that 'at the moment, a large number of serious artists are concerned with redefining the nature of art, seizing on new materials and new approaches in order to escape from all the old preconceptions about what art should be'.

It was exciting to encounter artists of my own generation employing any strategies they wished, including film, video, performance, raw documentation, photography, texts and many other alternatives, in the conviction that their work need no longer conform to the old hierarchy. The meaning of the word 'art' has always changed according to the requirements and aspirations of society, and the 1970s were in urgent need of a new openness that would enable artists to work on a

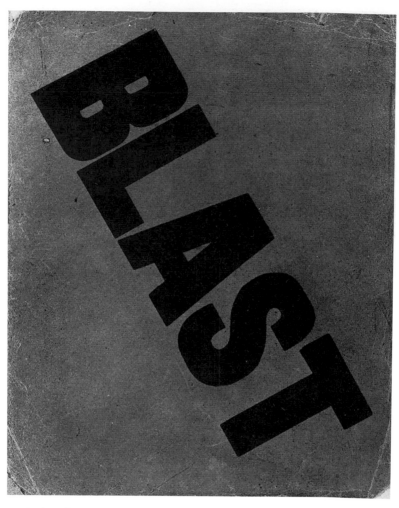

1. Cover of *BLAST*, ed. Wyndham Lewis, 1914

far broader front. At the beginning of the decade, I emphasised that 'the latest generation of artists is interested, not so much in the old idea of executing easel paintings or free-standing sculpture, as in exploring the idea of closing the gap between art and everyday life'. It could never, of course, be bridged altogether. But the old art – life divide was certainly narrowed by artists like the young Gilbert & George, who proposed with

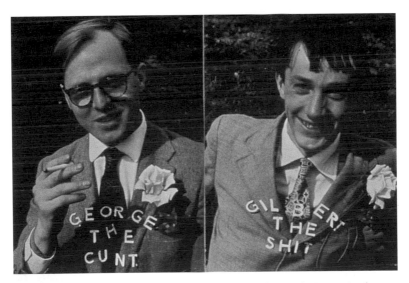

2. Gilbert & George, *Magazine Sculpture*, as published in *Studio International*, 1970

precocious assurance that everything they did together could be regarded as living sculpture. In their remarkable early work, they pushed a certain kind of enquiry as far as it could go, and did so with disarming humour. I remember receiving their postcards, letters and propositions on a regular basis through the post. Each one was very courteous, but the politeness contradicted the often outrageous daring of the notion behind it.

Plenty of projects were carried out beyond the conventional limits of the art world. Richard Long, a recent graduate of St Martin's School of Art where the spirit of dissent was at its strongest, decided that the entire natural world was now his working territory. With astonishing single-mindedness and flair, he turned his lonely walks across remote countryside into epic, mind-stretching art. His means were simple: words, maps, photographs and, above all, lines and circles made in the open air with the sticks and stones he found there. His fellow-student Bruce McLean, the irrepressible Glaswegian, mocked Henry Moore's *Fallen Warrior* by adopting a ridiculous pose in a soldier's helmet on a plinth near the edge of the River Thames. And Rose Finn-Kelcey, one of relatively few women artists to gain prominence during this male-dominated decade, produced dramatic flags. She flew one in 1971 from the top of the Radio Tower in Berlin,

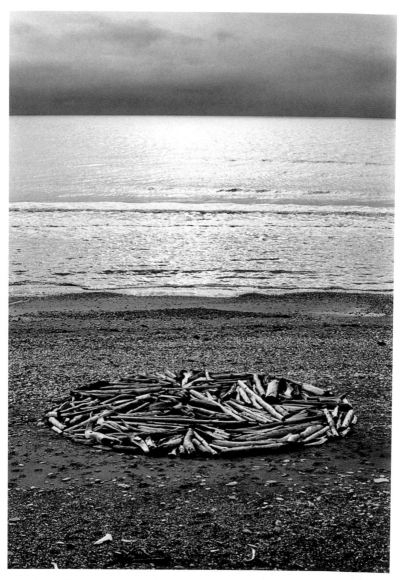

3. Richard Long, *Circle in Alaska*, 1977

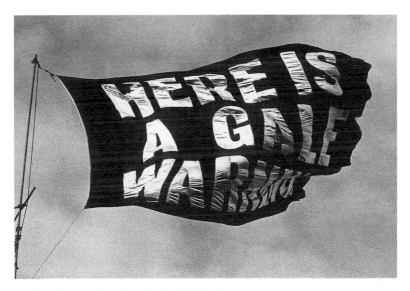

4. Rose Finn-Kelcey, *Here Is A Gale Warning*, 1970

bearing the ominous message 'Here Is A Gale Warning'. With hindsight, we can see how her words, combined with the billowing restlessness of the wind-buffeted flag, took on a larger, more symbolic significance. For a storm certainly blew through art during these turbulent years, and the changes left in its wake were at once profound and irreversible.

As an impatient young critic, I was fired by the feeling that art could fan out in a multitude of diverse directions. Everything suddenly seemed possible. Art, it appeared, might be anything that the artist wanted it to be. The overall priority lay in widening the range of possibilities that artists could explore, but a lot of established interests chose, quite inaccurately, to maintain that outright war had been declared on painting and sculpture. They also argued that the alternatives being developed by younger artists were nothing to do with 'real' art. Such reactions, if absurd, were on one level understandable enough: painters with a passionate commitment to their own medium felt threatened. On many occasions, I found myself accused of being an enemy of art for writing about new ways of working with the seriousness they deserved, organizing exhibitions like the Arts Council's *Beyond Painting and Sculpture* in 1974 and, later in the decade, editing *Studio International* magazine as a series of theme issues devoted to art's interaction with photography, avant-

5. Four covers of *Studio International*, 1975–6

garde film, video, performance, experimental music, architecture and alternative spaces. Over the years, I lost count of all the barbed retorts, accusations of blindness and enraged calls for my dismissal from the *Evening Standard* and *Studio* alike. The more apoplectic they grew, the less likely I was to pay them any attention. But the most disturbing criticism had nothing to do with rational argument. In the summer of 1973, I was puzzled to discover that one of my articles had been cut out and sent to me in an envelope postmarked Notting Hill. No abusive remarks were scrawled across it demanding my immediate committal to an asylum; no incensed reader declared his or her identity. I was about to drop it in the waste-bin when I noticed, with a shock quickly turning to disgust, that the back of the article had been smeared with shit. However much I would like to pretend that I was unaffected by this postal version of a Dirty Protest, the memory of the besmirched cutting has never gone away.

But this defensive intolerance made many younger artists behave just as aggressively in return. Amid the feuding over supposed territorial rights a rift grew between the generations, exaggerating their genuine grounds for dissent. The truth is that artists of widely varying ages were often united by shared priorities. Some senior artists were just as open-minded as their younger counterparts: Marcel Broodthaers (who lived around the corner from my house in London towards the end of his life), Joseph Beuys, Tadeusz Kantor, Ed Kienholz, John Latham, Mario Merz and Claes Oldenburg all, in their diverse ways, exemplified an attitude that refused to make a fetish out of any single medium. Indeed, they offered a refreshing corrective, and helped pave the way for new artists to move with supple, inventive resourcefulness among a range of alternatives. Kantor, in fact, was better known for his theatrical experiments than for his art work, while both Beuys and Latham devoted much of their energy to developing social roles for artists outside the gallery's boundaries.

Moreover, many of the young artists who were dismissed as perpetrators of 'anti-art' appear today to possess manifold and enriching links with the art of the past. The notion of working with the land has links with a primordial tradition, stretching back to prehistoric stone circles and hill drawings. Performance art had its roots in comparable ventures carried out by the Futurists, early Dada at the Cabaret Voltaire, and the Bauhaus. Artists who used a variety of other strategies as a means of social protest acknowledged their debt to the pioneering work of Otto Dix, George Grosz and John Heartfield. The cross-connections are inexhaustible, showing how senseless it is to lay down oppressive laws about what artists can and cannot do.

For some, the ancient notion of the *tabula rasa* had a potent appeal.

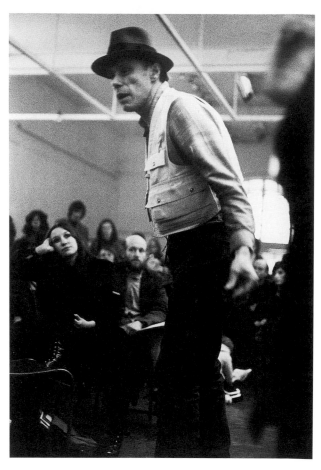

6. Joseph Beuys at the Whitechapel Art Gallery, London, 1972

With typical laconic wit, Keith Arnatt produced a text work in 1970 called *Is it possible for me to do nothing as my contribution to this exhibition?* Around the same time Bob Law applied the seductive idea of nothing to the surface of a colossal canvas, leaving its unprimed surface empty apart from a strong black line painted around the edges. He called one of these provocative assertions of blankness *Mr Paranoia*, and it certainly aroused hysterical fury at the time. After I wrote a positive review of Law's 1971 show at the Lisson Warehouse, enraged readers inundated me with

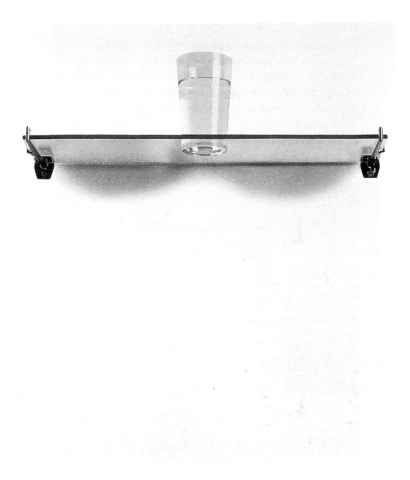

7. Michael Craig-Martin, *An Oak Tree*, 1973

protesting letters at the *Evening Standard*. But *Mr Paranoia* was as much a classic of the period as Michael Craig-Martin's *An Oak Tree*, consisting solely of a glass of water placed on a glass shelf. In his accompanying text, he argued with cool, ironic intelligence about his right to 'change a glass of water into a full-grown oak tree without altering the accidents of the glass of water.' Conceptual Art was the forbidding label most often bandied about during the early years of the decade, but the imaginative liberty claimed by Craig-Martin was exhilarating to contemplate.

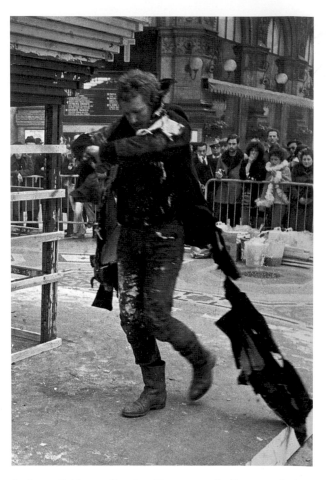

8. Stuart Brisley performing *Hommage to the Commune* during *Arte Inglese Oggi* exhibition, Milan, 1976

The 1970s, then, will surely be remembered as a time when the centuries-old dominance of painting and sculpture gave way at last to a general acknowledgement that 'art' could assume a far greater range of material identities. Alternatives posited by earlier movements and individuals, but never officially accepted as anything more than renegade offshoots with little effect on the main body of art, finally began to gain acceptance on their own terms. Major surveys of contemporary work started

giving artists who adopted radically new ways of working the same status as painters and sculptors. In 1976 I co-selected the British Council's large Milan exhibition *Arte Inglese Oggi 1960–76*. After much debate, it was divided into three sections: Painting, Sculpture and a new, all-purpose category called Alternative Developments, for which I wrote the catalogue essay. If plenty of artists and critics were still ready to deny these developments any right to coexist with more traditional media, it is still safe to say that the battle was won. The orthodoxy of art forms upheld in the West ever more rigidly since the Renaissance had now become subverted beyond recall – not in order to proclaim anything as preposterous or destructive as 'the death of painting', but to *extend* the options that artists can legitimately draw upon.

Far from posing a threat, this initiative greatly enlarged artists' potential freedom of manoeuvre. Now that the demystification of painting and sculpture had taken place, each could assume a scaled-down identity as one of many avenues artists were at liberty to explore. Those who claimed in the 1970s that I was opposed to orthodox media, almost as a matter of principle, will discover from this book how much I relished painters and sculptors of widely differing kinds, from Carl Andre, Dan Flavin, Sol LeWitt and Don Judd to Patrick Caulfield, Howard Hodgkin, Robert Mangold, Kenneth Martin and Robert Ryman. But I did not want easel painting, or indeed any other single working method, to predominate in future at the expense of all the others.

That is why this book stresses, through the range of activities it brings together, the increasingly open-ended character of art in the late twentieth century. Attempts will doubtless be made to reassert the innate superiority of a particular medium during the years ahead, just as painting's most outspoken supporters claimed that it had recovered a dominant role in the early 1980s. But a fruitful balance between the alternatives must be preserved and strengthened. Artists will never stop claiming fresh territory for themselves, and this process of incessant reinvention should be sustained in order to ensure art's continuing vitality.

Artists can thrive only if some people, at least, support their work. Throughout the 1970s I never stopped feeling that adventurous art led a beleaguered existence in Britain. I warmly approved of the Arts Council's Art Panel when its members decided to mount a large survey of emergent developments at the Hayward Gallery in 1972. But plenty of established interests were unhappy about the focus of *The New Art* show curated by Anne Seymour. Instead of recognising that her list of artists embraced some of the most stimulating members of the rising generation, the Arts Council advisors very nearly insisted that her

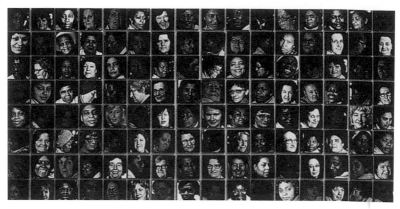

9. Margaret Harrison, Kay Fido Hunt and Mary Kelly, *Women and Work*, 1973–5 (detail)

selection be widened out into a far more catholic survey, thereby destroying the tough-minded emphasis that made it so worthwhile.

From the Tate Gallery downwards, too many institutions were slow to involve themselves in the full, momentous extent of the changes initiated by radical artists. Resistance to the new was endemic, and exacerbated at every turn by the Tate's own failure to bring its disastrously schizophrenic function to an end. While still at university I wrote a passionate attack on 'The State of the Tate' for *Cambridge Review* under Simon Schama's lively editorship, deploring the absurdity of cramming into one Victorian edifice the entire history of British painting as well as the whole international span of twentieth-century art. Calling for the creation of an entirely new museum for modern art on a central London site, I proposed that 'a nationwide lottery' could be instituted to fund the venture. But no such attempt was made, and the representation of modernism's achievements continued to be blighted by inadequate display in a building never intended to fulfil such an unlikely dual role.

It was a national disgrace, and the Tate's humiliating plight mirrored a general British unwillingness to greet innovative art with anything other than venom or hilarity. Few collectors bought such work, and artists had increasingly to rely on foreign sales to support themselves. Many failed to find buyers, and only just managed to survive. The marked austerity of their work reflects this disengagement from the market-place. Artists learned how to make a virtue of small budgets, often avoiding glamour in favour of a more documentary approach. It is evident in the gritty images and documents comprising *Women and Work*, a landmark feminist

exploration of the division of labour by Margaret Harrison, Kay Fido Hunt and Mary Kelly.

Young artists needed to be resilient, for few London dealers showed serious, sustained interest in supporting and exhibiting their work. The established West End galleries displayed scant desire to involve themselves in the most vital and audacious aspects of new art. Only outside the city's centre did several determined individuals create exhibition spaces where they were able to pursue remarkably radical and international programmes. Outstanding among them was the Lisson Gallery, where many leading artists from Europe and the US held their first UK solo shows during the 1970s. Although Nicholas Logsdail operated his modest-sized premises on a shoestring budget, he gradually built up a formidable reputation. I remember feeling surprised when American artists who showed there, like Carl Andre, Mel Bochner, Dan Flavin, Dan Graham, Robert Ryman and Sol LeWitt, told me that New York showed far less

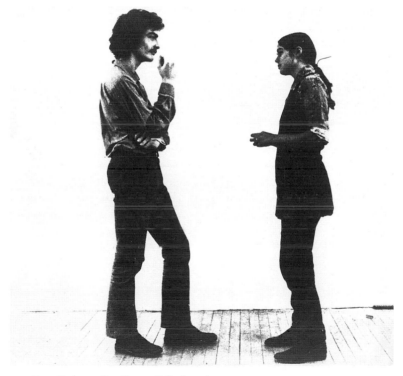

10. Dan Graham, *Past Future Split Attention*, 1972

11. Fly-poster in Kentish Town, London, for Lawrence Weiner's show at Jack Wendler Gallery, 1973

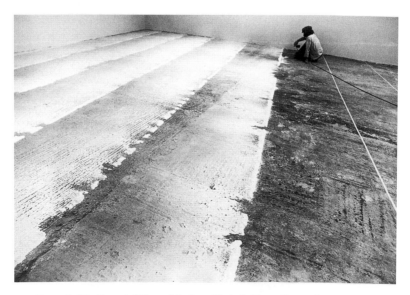

12. Barry Le Va, *Extended Vertex Meetings: Blocked; Blown Outwards*, at Old Burlington Street, London, 1971

interest in their work than the new galleries springing up across Europe. Manhattan was no longer the all-absorbing centre of the western art world, and London's alternative dealers played an increasingly potent part in ensuring that other cities, far removed from New York's territorial boundaries, welcomed experimental initiatives. Jack Wendler, an enlightened American who had settled in London with his wife Nell, showed an impressive array of artists in his gallery, including Daniel Buren, Douglas Huebler, Mario Merz and Lawrence Weiner. Memorable shows were also mounted by the ebullient Nigel Greenwood, Lucy Milton, Hester van Royen, Robert Self and Tony Stokes, who ensured that their premises in Chelsea, Covent Garden and Notting Hill became compelling places to visit. As early as 1971, Greenwood even managed, in collaboration with Anthony de Kerdrel, to invade the West End and enable Barry Le Va to make a spectacular floor-piece with blown white flour, transforming a monumental space in Old Burlington Street. And Felicity Samuel subsequently showed a whole range of American West Coast artists, including Larry Bell, at her elegant premises in nearby Savile Row.

Sometimes, the *Evening Standard* queried my determination to write at length on these exhibitions, and sceptical readers often sent in letters mocking my enthusiasms. One of them, reacting to an admiring review I had published on Richard Long's solo show in November 1974, wrily compared his work in the landscape with the activities of 'my cat — a wayward but very beautiful stray . . . if only Mr Cork could see her clawing the corner of the settee, with no conscious posing or striving after effect, he would have raptures.' The letter was published, alongside a drawing by an *Evening Standard* cartoonist showing me crouched wide-eyed on the floor exclaiming with aesthetic delight over the cat's paw movements. Although it made me laugh, I became aware after a while

13. Ken Taylor cartoon of Richard Cork in the *Evening Standard*, 27 November 1974

14. Nice Style in performance at Richard Cork's *Critic's Choice* exhibition, Tooth's Gallery, London, 1973

that certain members of the newspaper's editorial staff would have been quite happy to see my art column disappear entirely. Without the unwavering support of the liberal-minded Charles Wintour, who edited the *Evening Standard* with great incisiveness and flair, my presence in the paper might not have lasted long. But Charles, with remarkable openness, understood that I wanted to play a part in ensuring that young artists received the attention they deserved outside their own specialised world. Hence my delight when Tooth's Gallery, a prominent dealer in the heart of the West End, invited me to select a *Critic's Choice* exhibition in 1973. I was able to bring together a range of artists, among them Gilbert & George and Richard Long, who exemplified the spirit of exploration in new British work. The experience of seeing their work displayed in Tooth's august premises, just off Bond Street, was at once bizarre and exhilarating. It made me feel that innovative new art was at last penetrating the London establishment – especially when Nice Style, the 'world's first pose band', gave one of its début performances to a packed audience during the Tooth's exhibition on a memorable March evening.

Soon afterwards, having been asked to act as a buyer for the Arts Council collection, I decided to concentrate on purchasing work by adventurous young artists. The outcome, a 1974 exhibition called *Beyond Painting and Sculpture*, toured Britain and thereby exposed its

15. Poster for *Beyond Painting and Sculpture* exhibition, Arnolfini Gallery, Bristol, 1974, illustrating David Dye's *Mirror Film*, 1971

16. David Hall, *Interruption Piece* from *TV Interruptions (7 TV Pieces)*, 1971

challenging contents to audiences far beyond the metropolis. During the same period, a growing number of artists were fired by similar ambitions to make work outside the limits of the London gallery circuit. John Latham, who had earned notoriety by organising a ritual chewing of Clement Greenberg's book *Art and Culture*, founded with his wife Barbara the pioneering Artist Placement Group in order to explore the possibility of attaching artists to industrial firms, media organisations and government departments. Against the odds, APG managed to place artists in a remarkable variety of contexts, ranging from Barry Flanagan's stay at a plastics firm to Stuart Brisley's 'placement' with Hille. Freed from any binding obligation to make art objects, most APG artists did their best to flout all traditional expectations. As I pointed out in an article on APG in 1971, 'the real purpose of this unlikely marriage between art and industry [is] the nature of the relationship in itself, the adjustments which necessarily take place as a result of head-on contact.'

David Hall got through to a wider audience than most. His *7 TV Pieces*, a series of short, arresting films made during his 1971 'placement' with

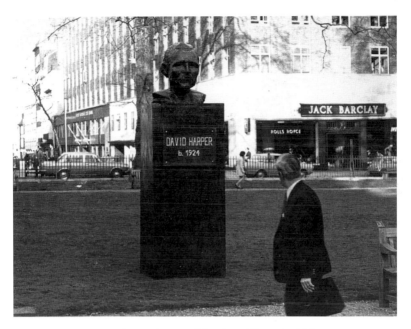

17. Braco Dimitrijević, *David Harper, The Casual Passer-by I Met at 1.10 pm*, London, 1972

Scottish Television, were screened as 'interruptions' between normal programmes during the Edinburgh Festival. Writing about them at the time, I described how 'they acted as admirably disruptive forces which shook viewers out of their stiffly controlled roles seated in front of a flickering box'. On the whole, though, television remained lamentably unwilling to let artists' film and video invade its channels. Other ways of working beyond the gallery had to be found, like Yoko Ono and John Lennon's ambitious decision to install the message 'WAR IS OVER! IF YOU WANT IT' in bold black capitals on city hoardings across the world.

Lacking the financial resources and global reach of Ono and Lennon, other artists settled for less expensive yet equally potent interventions. One April morning in 1972, I found myself gazing at an imposing bronze head on a tall marble plinth in Berkeley Square. It looked like a dignified memorial to a distinguished public figure, lodged at the heart of the West End. But the name picked out in gilded letters on the plaque beneath the head – David Harper – belonged to an unknown 48 year-old passer-by. Braco Dimitrijević, then still a student at St Martin's

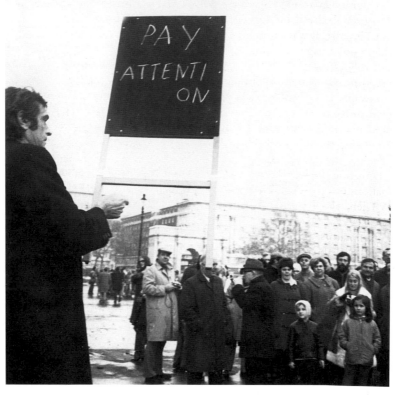

18. Marcel Broodthaers at Speakers' Corner, London, 1972

School of Art, had met him a couple of months before in a chance encounter on a London street, and decided to give the unsuspecting Harper this grand sculptural accolade. Permission to install and display the head in such a prominent location was only granted for two weeks. But it was long enough for Dimitrijević, with his strong undertow of democratic feeling for the chosen stranger, to make a succinct point about the role played by chance in the making of a reputation. He also made me think in a new way about the promotional methods employed by those wishing to publicise and aggrandise their heroes.

As it turned out, 1972 was a memorable year for art beyond the gallery. In February, Daniel Buren made a work for a billboard at 53 Shaftesbury Avenue. His utterly uncompromising series of 35 vertical stripes, each one pale purple and 8.7 centimetres wide, was juxtaposed on the same hoarding with a colossal Haig whisky advertisement. As Buren declared, his intervention was purged of 'all emotional or anecdotal import.' It was a tough, austere and ruthlessly abstract antidote to the clamorous images assailing anyone passing through the Piccadilly area, and the anonymity of Buren's stripes offered a salutary contrast to the brand-name commercialism so rampant elsewhere in the West End. Soon afterwards Jack Wendler, who was enterprising enough to sponsor the billboard project, backed Mario Merz when he applied the Fibonacci sequence to the everyday activities in two London pubs, one in Kentish Town and the other on Brixton Hill. The numbered, neon-lit sequences of photographs and video charted the flow of humanity in both places, articulating the links between the ancient numerical system and the fluctuations of quotidian life in modern London.

Then, towards the end of 1972, Marcel Broodthaers paid a visit to Speaker's Corner in Hyde Park. Coolly positioning himself among the noisy orators, he held up a series of messages written in chalk on a sandwich board above his head. A crowd quickly gathered, including one of those ample women who used to specialise in singing on the streets. They were clearly puzzled by Broodthaers' refusal to utter a syllable in competition with the other speech-makers operating nearby. When he held up the word 'Silence' on his board, the monumental singer started to warble *Silent Night*; and then, provoked by his muteness, she shouted: 'Have you got a tongue in your mouth?' Broodthaers kept his peace, because he wanted to play himself off against a context where verbal communication is expected from everyone who stands up on a platform. And he complicated his encounter with the Hyde Park crowd by brandishing written material in front of their expectant faces.

Despite the versatile ingenuity of such attempts to find a broader based audience for their work, artists in the 1970s were often obliged to endure vituperation from much of the press. It culminated in the extraordinary outburst of hysterical indignation when commentators suddenly discovered, four years after the event, that the Tate Gallery had purchased some lowly bricks from Carl Andre for a sum greatly in excess of the cost of the raw materials. With hindsight, we can now see that *Equivalent VIII* was a bargain compared with the prices Andre's work commands today. But in 1976 the scorn it provoked was boundless, and just about every dismissive verdict on the 120 firebricks was delivered by writers who had

19. Cover of the catalogue for *Sculpture Now: Dissolution or Redefinition?* curated by Richard Cork at the Royal College of Art, London, 1974

never seen the sculpture itself. As an admirer of Andre, I had written warmly about his work and included him in my international exhibition, *Sculpture Now: Dissolution or Redefinition?* at the Royal College of Art in 1974. So I found the venomous and often ruthless assault on *Equivalent VIII* particularly disturbing. The furore it elicited from every quarter, including a notorious *Daily Mirror* front page where the 'pile of bricks' was reproduced frontways, sideways and upside-down above the banner headline 'What A Load Of Rubbish', has never been forgotten. It was worthy of the days when *BLAST* found itself castigated by the *New York Times* as 'the *reductio ad absurdum* of mad modernity.'

The row continued throughout the year, augmented by snarling denunciations of the soiled nappy-liners in Mary Kelly's ICA show and an exhibition on the theme of prostitution by COUM, whose leading protagonists, Cosey Fanni Tutti and Genesis P-Orridge, became national *bêtes noires*. So did the performance group Ddart, three men who carried a pole on their heads during a circular walk through the English countryside. It was difficult to recall a period in recent history which had produced the flurry of scandalised attacks launched on contemporary art during that hysterical, jeering year. At one point in 1976, I found myself giving solemn evidence to a London Magistrates' Court in defence of Genesis P-Orridge, who had been accused of sending five indecent postcards in contravention of the 1953 Post Office Act. Despite everything that I, Ted Little of the ICA, Bridget Riley and William Burroughs tried to argue against the prosecution, the magistrates found Genesis guilty on all five charges.

20. Front page of the *Daily Mirror*, 16 February 1976

To make matters worse, the bodies responsible for supporting, purchasing and displaying the work that aroused such bitterness were conspicuously unready to justify themselves to the nation in fighting terms. The Tate's defence reiterated the weary argument about Time eventually revealing the true quality of controversial art: Sir Norman Reid, the gallery's director, cautiously maintained that 'for at least a hundred years

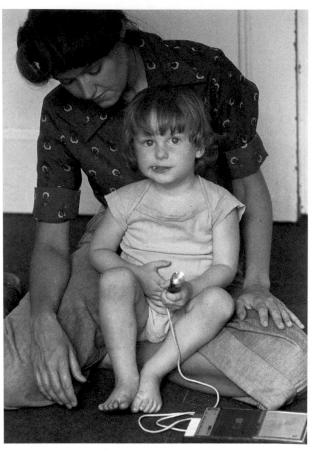

21. Mary Kelly and her two-year-old son in a recording session for *Post-Partum Document*, 1975. Photograph by Ray Barrie

every new form of art has been ridiculed and labelled a folly.' As for the national funding authorities, they ran scared from their responsibilities: Roy Shaw, the Arts Council's Secretary-General, shamefacedly admitted after visiting COUM's event at the ICA that 'it is my personal view that this is not the kind of thing which public money should be used for.' In both these cases, Britain's foremost museum of modern art and the government's official grant-giving body for the arts in general, there was a distinct note of embarrassment about the contemporary work they existed to foster.

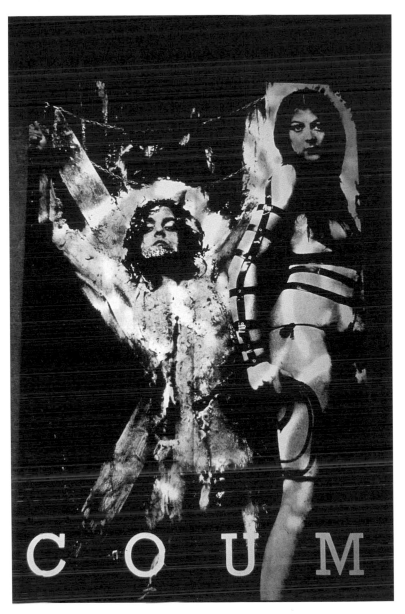

22. COUM Transmission, *Couming of Age*, 1974, Oval House, London

If Reid and Shaw had possessed the robust conviction which ought to be a prerequisite for anyone in their positions, they would have taken the sudden notoriety surrounding them as a welcome cue to defend and explain the abused objects under their aegis. The Tate, for instance, could instantly have mounted a special exhibition of its three Andre sculptures alongside its other holdings in Minimal art of the period, and thereby helped the thousands who visited the gallery in search of the notorious bricks to gain a fuller understanding of the motives behind these works. But the publication of the Tate's *Biennial Report*, which should likewise have been used as an ideal opportunity to discuss the bricks in a committed and informed manner, merely yielded the following pathetic statement from its Trustees: 'We believe that the Gallery also has an obligation to make it possible for the public to see and judge for themselves a selection of work which artists are producing in their own time.' One of the dictionary definitions of 'obligation' is 'burdensome task', and the Tate Trustees' words conveyed more than a hint of pained reluctance about a job they ought to have carried out with passionate conviction. Meanwhile the Arts Council set about forcing the beleaguered ICA's staff to cut back their multifarious programmes, and one of the most unfortunate victims was Barry Barker's bold directorship of the New Gallery where Mary Kelly's nappy-liners had aroused such a furore.

By the end of the year, I looked back on these unsavoury events with profound misgivings. 'How anyone responsible for showing modern art in London can continue to operate effectively, when the Tate and the Arts Council display such a chronic lack of confidence, is a matter for grave concern', I wrote. 'At a time when the need to disseminate contemporary work among the widest possible sector of the population is obviously more acute than ever before, when museums and other exhibiting institutions pay increasing lip-service to the role of "education", a widespread loss of confidence is cutting away at any initiatives which do try to find viable avenues out of the impasse. Now, over halfway through the 1970s, the prospects for a genuine interrelationship between new art and its putative audience seem alarmingly remote.' Nor did the climate improve in any dramatic way during the last three years of the decade. Soon after Charles Wintour left the *Evening Standard*, I resigned in 1977. Public hostility still soured the advent of exhibitions where 'difficult' art was displayed, although the uninformed questions raised by 'the bricks' affair were at last confronted when Nicholas Serota became Director of the Whitechapel Art Gallery and, with characteristic flair, mounted a superb exhibition of Carl Andre's work. During an interview I conducted with Andre at the show, he spoke very movingly about his attitude to the rumpus: 'I do not

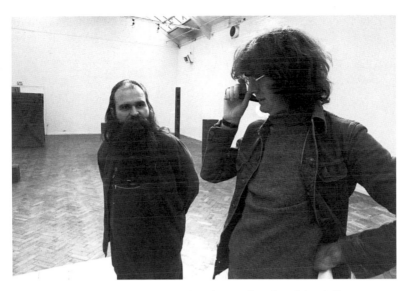

23. Richard Cork interviewing Carl Andre at Whitechapel Art Gallery, London, 1978

present my work as gesture, affront or offence. My work is meeting very deep, nearly unconscious needs within myself. Not ironically. It's not a hoax. I've staked my life on it. And I may have been fooled, but it would be myself who's doing the fooling with me. I'm not doing it with any intent of deceiving anyone else.'

More and more public seminars were organised, in the hope that open discussion might illuminate the contentious issues. They tried building on the extraordinary response to earlier debates, like the series called *4 Seminars* which Bill Furlong of *Audio Arts* magazine and the dealer Robert Self organised with me in 1975. Held at the handsome PMJ Self Gallery in Covent Garden, they attempted to provide 'an open platform on which artists, critics and administrators can discuss the multiple problems confronting contemporary art in Britain.' But despite the excellence of many speakers, and the organisers' hope that everyone present would 'direct the discussions into constructive areas that could lead to concrete proposals for the future', the debates themselves proved raucous and divisive. Far from providing 'intelligent public dialogue on recent art', they merely widened the fissures between different factions. Too many members of the large audiences had come simply to shout abusive comments at the speakers.

24. Announcement of Symposium on *Art Criticism and Art Today* at Art Net, London, 1976

It was an intensely disputatious time, and little could be gained from bringing bitterly opposed people together on the same platform. The following year, I acted as a panellist at Art Net in 'a symposium on the subject of art criticism and art today' with Wili Bongard, Alan Bowness, Germano Celant and Richard Hamilton. Left to ourselves, we might well have enjoyed a nourishing exchange of views. But the organisers of the event had given top billing to Clement Greenberg, who astonished us all by giving an extempore monologue on his recent visit to the Prado's Titians and the need for a return to life-class painting. Everyone felt baffled, and the event descended into incoherence. So when Andrew Brighton, Peter Fuller, John Tagg and I organised a weekend conference at the ICA in 1978, we attempted to devise a carefully planned series of sessions debating various aspects of 'The State of British Art.' With speakers ranging from Patrick Heron and David Hockney to Mary Kelly and Victor Burgin, the whole elaborate event could have degenerated into a battle between fiercely opposed participants. But it avoided excessive polarisation, exchanged anger for articulate argument and suggested that different factions could still meet in public to air their differences. The apoplectic mood of 1976 had given way to a rather more hopeful alternative, and I

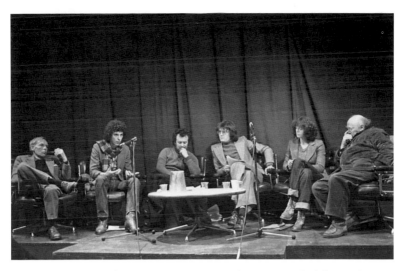

25. *The State of British Art* debate at ICA, London, 1978, with (left to right) Reg Butler, Victor Burgin, Terry Atkinson, Richard Cork, Lisa Tickner and Josef Herman

ended my chairmanship of the final session by suggesting that the conference could be seen as 'one small way of breaking down the isolation which at the moment prevents artists from reaching not just each other, but also – and more crucially – the rest of the world.'

In the debate's opening session, Mary Kelly made a particularly passionate point: 'That the work of individual women artists remains relatively unknown is not because, as I have often heard men say, there are no good women artists in this country, but because they are simply not getting the recognition they deserve.' Her remarks reflected the fact that, two years after the rage provoked by Kelly's pioneering exploration of motherhood at the ICA, interest in art made by women was beginning to stir at last. When I devoted an issue of *Studio International* to this theme in 1977, the time seemed right for such a publication. Seminars and debates on the subject abounded, survey exhibitions of women artists were regularly staged, and books had begun to examine the neglected aspects of their work, both historical and contemporary. As my editorial in *Studio* made clear, there were dangers involved in treating women artists as a separate category. Ideally, I wrote, 'women ought to take their place in the pages of art magazines as men's natural equals, not find themselves herded like

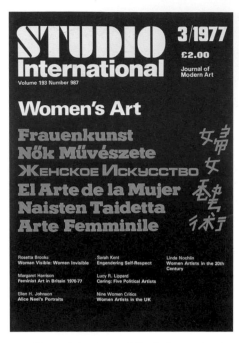

STUDIO 3/1977
£2.00
International
Journal of
Modern Art
Volume 193 Number 987

Women's Art

Frauenkunst
Nök Müvészete
ЖЕНСКОЕ ИСКУССТВО
El Arte de la Mujer
Naisten Taidetta
Arte Femminile

Rosetta Brooks Sarah Kent Linda Nochlin
Woman Visible: Women Invisible Engendering Self-Respect Women Artists in the 20th
 Century
Margaret Harrison Lucy R. Lippard
Feminist Art in Britain 1970-77 Caring: Five Political Artists

Ellen H. Johnson Nine Women Critics
Alice Neel's Portraits Women Artists in the UK

26. Women's Art issue of *Studio International*,
1977

cattle into a pen which implies that they are a contaminated species, best kept away from their robust masculine superiors.' However much I accepted the validity of such arguments, though, the need for an issue on women's art seemed to outweigh them. Too little discussion of the subject had then penetrated art magazines in Britain. Moreover, apart from committed feminist shows, women artists were still poorly represented in most major surveys of contemporary work. Of the thirty-two artists selected for the *Hayward Annual* in the very year when this issue of *Studio* was published, only one was a woman: Kim Lim. Curatorial committees were usually dominated by men, scarcely any important galleries had appointed women directors, and art schools were predominantly run by male, often intolerant members of staff.

In such a context, the notion of organising an issue on women's art seemed justified. All the articles were commissioned from women writers, in the belief that they had the best qualifications for understanding the problems concerned. The insight shown by Rosetta Brooks, Roselee Goldberg, Margaret Harrison, Catherine Lampert, Sarah Kent, Frances Spalding, Lisa Tickner, Caroline Tisdall and others proved that a new generation of articulate, incisive women critics had appeared in the UK. A historical perspective was provided by Linda Nochlin, who contributed to the catalogue of the major exhibition *Women Artists: 1550–1950* touring the US throughout that year. (I recall thinking what a shame it was that no comparable survey had been staged in Britain). But most of the issue was given over to contemporary art. Nine women critics were invited to write about women artists of their choice, including

27. Rita Donagh, *Aftermath*, 1975

Rita Donagh, Feministo, Yve Lomax, Kate Walker and Marie Yates. Lucy Lippard chose five American artists who each produced two-page spreads especially for the magazine: Mary Beth Edelson, Adrian Piper, Martha Rosler, Nancy Spero and May Stevens. Other contributors discussed broader questions, like the need to engender self-respect or the development of feminist art during the decade. There was no hint of complacency, and all the writers remained conscious of how much remained to be done. But throughout the issue, they shared a gratifying sense that many of the formidable barriers impeding women's fulfilment as artists were at last beginning to be dismantled. As Nochlin pointed out at the end of her article in *Studio*, the women's movement had 'brought

28. Kate Walker performance in conjunction with *Death of a Housewife* assemblage at Women's Free Arts Alliance, London, 1975

Torture today is essentially a
state activity. ...the preconditi
for torture make it almost the
exclusive province of the state.
Torture requires that the victim
be kept under the physical control
of the torturer.

29. Nancy Spero, *Torture of Women*, 1976 (detail)

TELL HER THAT I LOVE HER ALSO AND EQUALLY. TELL
HER THAT I WANT TO SEE HER, UP CLOSE. TELL
HER I'M NOT A POSSESSIVE CAT, NEVER DE-
MANDING, ALWAYS COOL, NEVER GET UPSET
UNTIL MY (OUR) FACE AND FREEDOM GET IN-
VOLVED. BUT MAKE HER UNDERSTAND THAT
I WANT TO HOLD HER (CHAINS AND ALL) AND
RUN MY TONGUE IN THAT LITTLE GAP BETWEEN
HER TWO FRONT TEETH.

GEORGE

AN IRRETRIEVABLE LOVE

ANGELA

30. May Stevens, *George Jackson and Big Daddy*, 1977 (detail)

into being a new history – a more valid, complex, expansive interpreta-
tion of the past – in art, as in every other realm of human experience.'

The breadth of the pioneering enquiry initiated by Nochlin and her
contemporaries was symptomatic of the decade at its best. Just as the
Vorticists had been keenly aware of international developments as invig-
orating as Cubism, Expressionism and Futurism, so young artists in the

1970s travelled a great deal and positioned themselves in relation to work produced across the world. They had a vital, wide-open outlook utterly opposed to any 'Little England' mentality. London gradually became a more international centre, welcoming and exhibiting like-minded artists from abroad including many of the individuals whose work is discussed in the following pages. The possibilities explored during this fertile time have been energetically revisited and developed since then. In particular, the international success of so many young artists in the 1990s owed a great debt to the spirit of audacious enquiry running right through this exceptionally stimulating period, when the coldness of the climate for new art failed to extinguish its resourcefulness, daring and verve.

NEW BLOOD

BRUCE MCLEAN
5 November 1971

Humour is one of the most potent weapons an artist can use in his fight to formulate a new standpoint in the teeth of established opposition. But it is also strangely neglected. For although laughter may be a ruthlessly effective medium with which to demolish an accepted consensus of opinion, it has always been regarded as the preserve of youth. Rembrandt, for instance, who began life as a robust enemy of the classical tradition, never followed up the subversive tone of his early *Rape of Ganymede*, where propriety is flouted by showing the screaming baby urinating as an eagle snatches him into the sky. And even Manet, the creator of perhaps the most wittily scandalous image of all in *Le Déjeuner sur L'Herbe*, later sobered up in his choice of subject-matter. Duchamp continued to cherish the power of satire throughout his life, producing at the age of seventy-seven a reproduction of the Mona Lisa without the famous moustache he had earlier drawn on her face, and inscribing it with one cheeky word: *rasée*! But even though Duchamp's influence permeates the best contemporary art more and more thoroughly, his wicked sense of humour has not inspired many successors. Art, it is still felt, should always reflect the seriousness of its practitioners' underlying intentions, and any attempt to inject it with wit must surely lead to damaging accusations of frivolity.

This is precisely the kind of criticism which Bruce McLean lays himself open to, and yet he rides it willingly and with puckish delight. For he realises that his ability to amuse is a very rare asset, and since his energies are all directed towards questioning the priorities of other contemporary artists, it becomes a tool that suits his purposes. A lot of his irreverence, aimed at the Caro school of sculpture, is the inevitable outcome of his early training at St Martin's School of Art. It will be fascinating, one day, to trace the different ways he and his fellow students there – Richard Long, Gilbert and George – reacted against the doctrines then prevailing in the School's sculpture department. Even now, several years later, McLean still becomes heated and vituperative when he remembers his experience there, imprisoned in what he felt to be a narrow dialogue which succeeded merely in replacing one set of sculptural conventions with another, equally rigid book of rules. Like his friends, he began to look for some activity outside the limited one prescribed by his teachers: something that did not automatically depend on the making of painted constructions. In one sense, his decision to escape from this

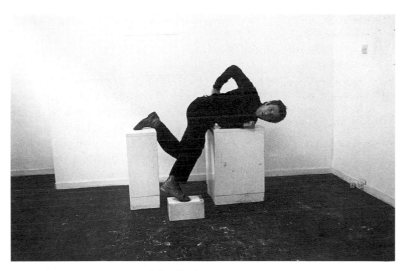

31. Bruce McLean, *Pose Work for Plinths*, 1971

tyranny carries on from where the Caro group left off when they defied the boundaries set up by the museum plinth. But in another, his leaning towards iconoclasm left the purely formal preoccupations of that group far behind.

One of the videotapes now to be seen in his current exhibition at Situation repeats an early piece evolved soon after the St Martin's period – a series of mocking poses which he assumes to poke fun at Moore's reclining figures. And this wildly entertaining performance would not have been recognised as a viable statement by the Caro cohorts. Straddled uncomfortably across three uneven plinths, McLean here exploits his natural talent for clowning to guy the lumbering weight of a Moore bronze. But it is not just a facile exercise in mud-flinging. By flexing his biceps like a bragging boxer, he manages at the same time to point out a vein of boorish pomposity in Moore which in fact constitutes a pertinent criticism of the older man's work. And by pushing the reclining attitudes into outright absurdity, so that his body finally ends up crawling in the most abject manner up the side of the plinths, McLean also highlights the tedious lengths to which Moore goes as he tries to ring the changes on a single, repetitive motif. A rich variety of meanings, therefore, inform this ostensibly simple and ingenuous piece, ensuring that McLean cannot be dismissed as a joker who never grew up. His restless temperament must

help here, preventing him from remaining satisfied with a superficial gesture that works on one level alone.

Symptomatic of this impatience is his approach to the present exhibition, which has been handled with total flexibility in order to let him experiment with a whole range of different ideas. Last week, he kicked off with plinths again, but this time there was a roomful of them and McLean himself did not participate. Instead, a page torn out of a glossy magazine was placed on each stand, thereby providing a concrete illustration of the exhibition's title: *Objects No Concepts*. It was a characteristically surreptitious reversal of the prevalent desire to oust art objects from the gallery environment, but McLean again aimed at commenting on another level, too. The pages all consisted of adverts for consumer products – domestic appliances in the main – and their come-hither captions were reprinted with ferocious glee as a list of exhibits pinned on the wall. So McLean was having it both ways, smiling at conceptual dogma even as he satirised the presentation of art as a commercial investment.

But all that disappeared with the advent of a new week, and for the last few days he has been working in the gallery, enacting a piece entitled *There's a Sculpture on My Shoulder*. Divided into two areas of activity, the exhibition now takes its cue from a rough series of lines drawn on the gallery wall, tracing the contour of McLean's shoulder as he crouches on the floor. This in itself refers ironically to the obsessions of artists like Ulrich Rückriem who involve their own physical capabilities in the making of a work. But the idea does not stop there. The names of all McLean's sculptural hates, including most of the St Martin's group, are inscribed over the lines to imply that their heritage has become an intolerably weighty burden, threatening to squash all the vitality out of him. Both points are deftly driven home; and so is the other piece in the exhibition, where McLean himself sits at a desk producing hundreds of worthless drawings, screwing them up and hurling them to the floor – only to be retrieved by a gallery director who carefully irons them out, one by one, and hangs them on the wall. The implied attitude towards the voracious supply-and-demand system is trenchantly dramatised and well worth expressing. But I felt dissatisfied with the activity, mainly because it seemed to exhaust my interest after one scrutiny. The potential danger of humour in art lies, of course, in this feeling that it is a stunt, hardly worth looking at more than once.

This failing is evaded in the videotapes and the Walter de Maria film, which hits out with magnificent verve and independence against the pettiness of contemporary artists as they stake out small slices of experimental territory for themselves and cling to them possessively. The combination

of McLean's own filmed performance and his raspingly militant sound-track creates a far richer experience, and prompts me to hope that he will use this particular medium again. For McLean is obviously talented enough to extend himself beyond these rather inbred comments on the present art context; and if the sentiment expressed in the last of his 1,000 sentences called *King for a Day* is anything to go by, he wants to do just that. 'Goodbye Sculpture, art pieces/things/works/stuff everything, Hallo life, piece,' it runs. And for once, I would be pleased if this turned out to be a straightfaced statement of intent.

GILBERT AND GEORGE

9 December 1971

It would not be hard to forgive anyone who imagined that the large photograph reproduced on this page was a simple, straightforward view of Gilbert and George posing in their studio. After all, what else could it be? An *Evening Standard* cameraman took the picture, so it cannot be claimed that the artists have produced the image themselves. And nothing is visible apart from two young men sitting beside a large win-dow in their front room. No artefacts are included, no tricks are played with perspective, light or a distorting lens to indicate that everything is not what it appears to be. And yet, despite all this evidence to the con-trary, the photograph does actually form an integral part of its sitters' joint attitude towards art and life.

Look at them a little more closely. Nobody asked Gilbert and George to have their hair cut in such a close-cropped, trimly brushed manner, to dress in white shirts, ties and identical suits which seem slightly too old and short for their own comfort, or to position themselves quite so fas-tidiously on either side of the picture-frame. Their strangely statuesque air is the result of a conscious, not to say self-conscious decision, just as the idea of placing themselves in subordination to the great expanse of glass behind came from them rather than a photographer's whim.

For Gilbert and George are the most idiosyncratic exponents of an international movement prompting more and more artists to regard their own bodies as a legitimate medium in their work. The notion may seem startling, even ridiculous, to those unacquainted with today's avant-garde; but it would be hard to think of anything less calculated to shock or affront

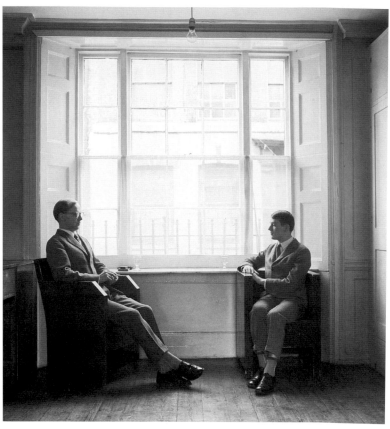

32. Gilbert and George, *Morning Light on Art For All*, 1972

than the mild-mannered activities of this inseparable pair. As the excessively polite aura of our photograph implies, they attach great importance to a peculiarly English set of characteristics: gentility, dreaminess, reserve and a weakness for whimsical nostalgia. All these elements are exploited in a prose-poem, called *A Day in the Life of George & Gilbert*, which they printed this autumn as a booklet – illustrated, incidentally, with a black-and-white version of the window photograph. This extract explains why:

> Being living sculptures is our life blood, our destiny, our romance, our disaster, our light and life. As day breaks over us, we rise into our vacuum and the cold morning light filters dustily through the window. We step into

the responsibility-suits of our art. We put on our shoes for the coming walk. Our limbs begin to stir and form actions of looseness, as though without gravity they bounce about for the new day. The head afloat on top levels on the horizon of our thought. Our hearts pound with fresh blood and emotion and again we find ourselves standing there all nerved up in body and mind. Often we will glide across the room, drawn by the window's void. Our eyes are glued to this frame of light. Our mind points ever to our decay. The big happening outside the window floods our vision like a passing film. It leaves us without impressions, giving up only silence and repetitive relaxation. Nothing can touch us or take us out of ourselves. It is a continuous sculpture. Our minds float off into time, visiting fragments of words heard, faces seen, feelings felt, faces loved.

The deliberately naïve tone of this passage supplies a precise verbal equivalent for the sober simplicity of the mood crystallised in our photograph, where the two 'living sculptures' are seen participating in their vision. But it is a naïvety which conceals the most deft kind of knowingness. Far from wallowing in a private dream, Gilbert and George avoid self-indulgence by retaining a sharp awareness of ends and means. Prose-poems and photographs are only a small part of a prolific wealth of experiments carried out since they were students together at St Martin's School of Art. Right from the start, they rejected all thought of making sculpture in the traditional sense and concentrated instead on conducting a wide-ranging enquiry into the best way of expanding their potential creative vocabulary. Like a couple of searching philosophers, they constantly asked themselves how sculptural theory could be extended until it started to collide with life. And the results, poised always on a perilous tightrope which threatened to snap and send them plunging down towards absurd preciosity, fanned out into a kaleidoscopic variety of ventures: eating sculpture, postal sculpture, television sculpture, meeting sculpture, musical sculpture, magazine sculpture and lecture sculpture.

One quality that united all these projects was a meticulous attention to context and presentation. Every experiment carried with it an exact format, like the parchment texture of the envelope – stamped with red sealing-wax – containing the first version of the window sculpture: a printed sheet with both a drawing and a written text describing the 'overwhelming purity life and peace' created by a fall of snow in the street outside their room. But the most elaborately staged and memorable of these semantic excursions is the musical sculpture, where Gilbert and George cover their faces with metallic paint and dance a mime to Flanagan and Allen's old song, 'Underneath the Arches'. Over the past two years, their

performance has become honed into a superbly polished non-stop ritual, riveting audiences with its bizarre amalgam of sentimentality and extreme physical rigour, and puzzling them with the strange props that accompany each different showing: a vaudeville combination of squeaking stick and rubber glove.

As if this heady catalogue was not enough to digest, Gilbert and George have also conducted forays into monumental painting and drawing – or what they like to call 'Descriptive Works'. Here, the use of photographs comes into its own on another level altogether, as the basis for enormous, surprisingly naturalistic reconstructions of the sculptors' response to the English countryside. But however much the traditionalist style of these pictures seems to contradict the consistently radical nature of the other experiments, the subject is still the same: Gilbert and George themselves, depicted in all their spruce formality among the lush vegetation of high summer landscapes. The contrast between the winsome, poetic humans and the hedonism of their surroundings gives them a further dimension – as almost puritanical figures, quietly contemplating the greenery around them. And in the most recent series of large charcoal drawings, extracts from *A Day in the Life of George & Gilbert* are incorporated, printed out below the design to emphasise the unity of all their ostensibly diverse activities.

So the kaleidoscope completes a full circle, returning to the point where we began with the photograph of the artists in their studio. For although they actually *make* very little in this sparsely furnished, well-scrubbed room – they hire a much larger working space whenever they want to paint or draw on a huge scale – this, in the end, is where Gilbert and George seem most appropriately at home. They call it 'Art for All', to emphasise the accessibility of their activities, and always include their address and telephone number on their postal invitations, limerick cards and broadsheets. With good reason, too. For if you fight your way through the markets of Spitalfields and knock on their door, you can expect to receive a very correct cup of tea in an environment that links up in an almost hallucinatory way with the character of their work. Here, in this small, bare room, life really does threaten to clash headlong with art; and only Gilbert and George could ever, conceivably, manage to push this unlikely conjunction so far.

KLAUS RINKE
20 January 1972

Any artist who turns away from traditional media and uses his body as an expressive tool instead ought, on the face of it, to end up denying his work its basic creative licence. Where painting and sculpture offer seemingly boundless opportunities to construct an imaginative world with its own, independent terms of reference, the human form should impose the most severe restrictions on art's ability to rise above the limitations of outward appearances. How, after all, could a vocabulary composed merely of corporeal elements ever hope to transcend earthbound fact and become unconstrained, metamorphosed or free? Deliberately choosing to cast off that wonderful sense of liberation and restrict yourself to the narrowly circumscribed boundaries imposed by bones, blood and flesh would appear to be the decision of a masochistic intelligence.

The case against employing the body is formidable enough, put forward in these terms; but does this argument actually bear any genuine relation to the way in which artists have always managed to discover an original vision? Infinity of choice has never in itself guaranteed merit: on the contrary, it has often led the best of talents into eclectic and formless chaos. Chardin thrived throughout his life on one, ostensibly myopic range of domestic subject-matter, just as Mondrian progressively erased from his pictures all suggestion of curvilinear, organic forms. Both men were in one sense behaving like self-denying puritans; and yet, in another sense, they were sufficiently great to realise that intensity can thrive on a deliberate policy of ruthless exclusion. So it is with the body, therefore, if the artist who uses it knows exactly how to turn its particular brand of confinement into fruitful emancipation. And knowledge of that kind does lie behind Klaus Rinke's exhibition at 29–30 Old Burlington Street, where no less than one hundred and twelve photographs of this young German's own head, arms and torso are assembled in one continuous parade around the room.

The effect, at first glance, is both monotonous and simple-minded: how can anyone really hope to sustain interest merely by ringing the changes on a basic, frontal pose? No deft tricks are played with the camera, no distortions – either spatial or perspectival – are injected to enliven this long progression of hieratic images. Rinke, his face unwaveringly solemn from one shot to the next, is left isolated to act out a series of gestures in surroundings as anonymous and bare as an automatic photo-booth. Not

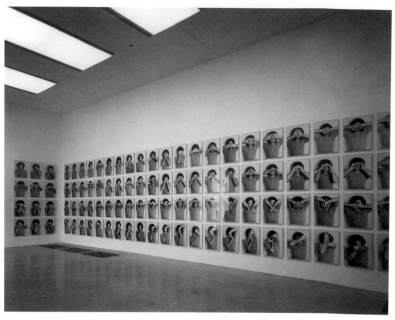

33. Klaus Rinke, *Mutations*, 1970

even the glare of a flashbulb adds drama to the proceedings: the lighting is flat, entirely subservient to the mime acted out by Rinke's limbs. And yet, precisely because no technical bravura is permitted to detract from the central activity of the artist himself, the pictures gain in expressive power. For there is a direct, beefy quality informing all these postures, and a self-consciously 'artistic' presentational gloss would only have weakened them, made them appear pretentious or narcissistic. As it is, Rinke is set free to make his superbly articulated movements impinge on the spectator's awareness of gestural messages.

Not that any overt symbolism is at work here – the attitudes have no literary meaning, and even when he clasps both hands together, the result does not specifically suggest supplication or prayer. Far from it: the poses are as purged of allegorical content as the purest arrangement of abstract shapes, and much of the pleasure to be gained from them springs out of Rinke's ability to turn his body into a strictly formal instrument. He makes this standpoint clear with the first three photographs in the series, which establish simple configurations with the clarity of a messenger

sending out semaphore signals. The left eye is covered with the left hand; its neighbour with the right hand; then both of them are covered up with both hands. But this extreme sobriety, set out with the grave deliberation of a language teacher explaining the first steps in a grammar lesson, is soon succeeded by other, far more complex alternatives. Most of them strike up active poses, pushed to the point of open aggression. Rinke closes his fists over his face in a burly clench, like a boxer, or else his hands stretch out in front of him as if to grab the spectator. He attacks his own body, twisting his arms into tortuous, convoluted, probably painful postures. He prods and pulls the skin on his face to accommodate a particularly knotty composition, and sometimes he approaches the emotional pitch of a Grünewald by making his fingers act as eyebrows, pushing up across the forehead into lines of tension and fear.

It would be a mistake, all the same, to overemphasise the Expressionist streak in these prints. They are decidedly Teutonic in their almost martial assemblage of bodily parts, to be sure; but the prevailing mood is calm, measured and essentially exploratory. Rinke likes to play around with the semantics of gesture: when a *fist* hides his face, it seems confident and defiant, but when a *hand* closes over it, the meaning approximates far more nearly to a kind of defensive hiding. And the whole exercise links up with his earlier work, which enquired into the potential of water as an expressive weapon. Just as he here uses the body as a testing-ground for various types of symmetry and asymmetry, simplicity and complexity, turning ordinary physical movement into a pictorial artefact, so he previously channelled water from its natural state into various types of compressed statement. Huge rhythmic arcs were described by throwing the contents of a bucket into the air with one great curving motion; bristling lines of energy were set up by forcing water through a high-pressure hose; and the spontaneous flow of a mountain spring was formalised by collecting it in metal canisters.

All these experiments interfered with or transformed a raw material, and so do Rinke's photographs: only this time, he chose his own anatomy as the subject rather than an external element. And even if some of the prints are merely variations on a theme which do not become potent inventions in their own right, the photographs as a whole are a triumph of disciplined resourcefulness. As I was beginning to decide that Rinke fundamentally wanted to let a process of depersonalization take over, forcing his body to become a collection of non-representational forms going through their combinations in a carefully cultivated void, I became aware of the intrinsic character of knuckles, thumbs, elbows and wrists. In other words, Rinke was refuting my abstract interpretation by transmitting his

own heightened understanding of each separate component's unique nature.

In one frame, he provides a reminder of how subtle and flexible the finger can be, converging his thumbs on his nostrils as a base, sliding his index fingers down the bridge of his nose from above, then locking his middle fingers up to form a delicate pyramidal apex at the top. And elsewhere, he produces the polar opposite of this digital house of cards by concentrating solely on brusque, swingeing sweeps of forearm: one shooting in horizontally over his face, the other rising up vertically like a massive column to rest underneath his chin. In either case, the essential quality of a human member is revealed with admirable force, and I came away from the exhibition wondering whether Bernard Berenson's old hobby-horse about life-enhancing 'tactile values' had been given a new meaning.

WILLIAM WEGMAN AND DAVID LAMELAS
11 February 1972

It has been clear for some time now that more and more artists are turning to the resources of film, as an alternative to physical objects on the one hand and written statements or photographs on the other. The appearance of video tapes was the practical catalyst here: their increasingly reasonable cost and amenability to transmission through ordinary television sets prompted a lot of people to explore their potential. Precisely how many was revealed at last year's *Prospect* exhibition in the Düsseldorf Kunsthalle, where more than one hundred programmes by seventy-five practitioners were shown over a ten-day period. The survey made clear that film appeals to artists because it helps to realise fundamentally conceptual activities in a fuller and more satisfying way. Instead of hanging on the wall as a cold, verbal explanation of a thought process, the work is given a visual embodiment which both explains it and makes it permanent. Art relying primarily on a one-off performance is thereby charted more comprehensively, and can be played over and over again; art which involves the maker's own physical capabilities or limitations becomes infinitely clearer; and art practised in isolated areas can be communicated directly, without the confusion and loss of intensity that a photographic record often causes.

34. William Wegman, *Stomach Song* from *Reel I*, 1970–2

Film has encouraged a young American called William Wegman, for instance, who is now exhibiting at Situation, to act out his quirky ideas with an almost theatrical immediacy. The photographs on show in the gallery have a sobriety which automatically places them at one remove: Wegman's deadpan wit is somehow dampened by such a static format. But his sequence of short video tapes affords far more immediate contact. Although they are uneven, often scrappy and could be improved by some hard-headed editing, the cumulative effect is remarkably unified. Often they include Wegman himself, making his navel a musical instrument by sucking it in and out to the accompaniment of some falsetto and bass humming. The sense of fun is gentle, wayward and inconsequential. Liquid is poured with the gentility of a formal tea-party into vessels which simply cannot contain them, and inanimate objects like dead fish or lamps are forced to assume human personae.

Wegman relies heavily on a deadpan, almost absurdist humour, and much of his hit-or-miss approach is due to the awkward fact that jokes sometimes misfire. The Situation selection contains its fair share of howlers. But there are palpable compensations. When Wegman's naked torso minces towards the screen, dressed in a draglike loincloth, the camera moves slowly up to reveal a remarkably ample pair of breasts. And the pay-off is hilarious as you realize that these superb appendages are nothing more than his elbows, bunched up so cleverly that even the nipples

35. David Lamelas, *Film Script*, 1971

are beguilingly simulated. Wegman's wit is domestic, and a dog called
Man Ray is treated as his equal. But occasionally he comes up with a
neatly executed idea which contains rather more complex meanings. In
one video, Wegman *crawls* backwards, projecting milk on to the floor
from his mouth and disappears, only to be replaced by the dog who *walks*
forward, lapping it all up again. It would be easy to dismiss these mildly
Surrealist excursions as merely frivolous, were it not for the undeniable
consistency of the outlook behind them. This individuality, as yet undis-
ciplined and often callow, could grow into a thoroughly subversive vision
when Wegman manages to tighten up his throwaway style.

If this trigger-happy approach contains more possibilities for future
development than it does convincing current achievements, another
artist exhibiting filmed work in London at present has already evolved a
highly organised means of presenting his ideas. David Lamelas, who has
previously conducted most of his activities from a base in Antwerp, is
showing a *Film Script* at Nigel Greenwood's Gallery which relies on a
positive battery of technical devices. While a projector runs through a
colour film of a girl walking in a park, driving a car to her flat, reading,
telephoning, moving around inside a room and finally going out into the
street again, three automatically operated slide-viewers snap through a
number of contrasting variations on the episode. The only noteworthy

incident in the whole story occurs when she knocks a glass off a table and breaks it: everything else is resolutely, not to say boringly unexceptional. But the slides, acting like an explosive Chorus, make up for this deliberate lack of drama by presenting a staccato and even contradictory alternative version of the truth.

Lamelas allows only one of the three slide shows to screen the complete number of sequences; the other two contain an incomplete number, and they also cut sequences out or change their order around. The result constitutes an attempt to analyse the conflicting ways in which we experience time as an everyday phenomenon. While the film presents a calm, externalised record of how the girl moves from one phase through to another, the slides approximate more closely to her own impulsive, fragmentary view of the occasion. They repeat a moment, an action or a fleeting facial expression, just as our own minds tend to mull over the motions of something we have done. They jump forward or back, mirroring the quixotic way in which we instinctively leap on to thoughts about the future while still remaining bound up in a previous mood. And they deny the smooth progression from event to event presented in the film, highlighting the juxtaposition of sudden transitions and tedious *longueurs* which any one period of the day inevitably carries with it.

They flashed mercilessly on and off throughout the duration of the film, seizing on arbitrary moments, elaborating on a movement, a glance or an urban view, contradicting their neighbours and then accompanying each other in presenting triple views of the same activity. They were disruptive, explanatory and mysterious by turn, but perhaps this description makes the project sound too exclamatory. Lamelas's own personality was, in fact, very much in the background, and he presented his work with the self-effacement that characterised his earlier photographic exploration of time in Antwerp and Brussels. Only the relentless pace of the slides as they clicked through their projectors and confounded the steady, measured pace of the film revealed the artist's temperament in action, controlling our responses to the point of outright bullying. That was all. The ensemble was conducted with great professionalism and rigour, but too much emotion was drained out of it. *Film Script* is an apt title: the piece seemed more like a blueprint than a fully realised experience. Unlike Wegman, who exposes his own personality without any reservations, Lamelas remains in the background manipulating his images. And it is, finally, this sense of reserve which makes *Film Script* a little too close to an academic exercise.

DAN GRAHAM
16 March 1972

One of the greatest weaknesses besetting younger artists today is the neat, almost glib way in which they direct their energies along one narrow line of enquiry. Obsessed by the need to establish a watertight identity for themselves, and determined not to be criticised as eclectic or undisciplined, they end up composing an exquisite series of variations on a sadly limited theme. Once intellectual respectability has been confirmed by a display of methodical consistency, with its own tidy boundaries and claims over territorial ownership, artists can settle down to roost on easily acquired reputations. Their myopic field of interest is recognised everywhere, and as long as they do nothing to contradict this instant personality, they are free to ring the changes on a single insight rather than pursue a genuinely creative evolution.

It is to the credit of Dan Graham, an American artist now exhibiting at the Lisson Warehouse, that he has always spurned such facile tactics. Indeed, his whole career has been marked by a refusal to present a flawless progression, right back to the time when he ran a gallery himself and tried his hand at art criticism. Although Graham's work is now widely known and admired, this is the first time he has mounted a one-man show: most of his experiments have been conducted in university surroundings, as if in tacit admission of their exploratory nature. And the Lisson exhibition bears out the wisdom of this approach, revealing the tenacity of a man who casts around tirelessly in order to hunt out new methods and approaches all the time.

His fundamental desire to concentrate on an art that defines itself and refers to nothing outside its own internal structure was made clear as early as 1966, when most of Graham's elders were still involved in the figurative excess of Pop Art. Even though the inquiry he then conducted into *Homes for America* contained elements of a Pop sensibility – the Californian housing developments he chose as his material are heavy with overtones of suburban materialism and tastelessness – it was basically concerned with the buildings' immunity from all aesthetic or human considerations. Architectural values were as far from the speculator's mind as the individual needs of the occupant when these faceless estates were constructed; and Graham delighted in photographing the façades of objects produced by a situation in which 'contingencies such as mass production technology and land use economics make the final decisions'.

The most powerful of these photographs contain shapes as minimal

and unrhetorical as Don Judd sculptures. But Graham was already more interested in the system lying behind the featureless appearance of these houses and, in a 1966 project called *Schema*, he managed to supply his own independent version. Just as the speculative builders had escaped from all external considerations, by determining in advance the exact amount and lengths of timber and multiplying them by the number of standardised houses to be built, so Graham hit on a work that depended solely on its intrinsic contents. A list of more than twenty constituents was drawn up, each one of which automatically belonged to the work as a whole: the number of adjectives in the list, the perimeter of the page where it would be printed, the weight of the paper and so on. These constituents only existed because their neighbours existed – no other reason lurked behind their presence together as a cluster of information. And Graham made sure that they alone defined their ultimate form by publishing *Schema* in various magazines, where it varied according to the particular character of the publication concerned.

A lesser artist would probably have rested on the laurels of this remarkably tough, pioneering formulation of art as an information system, but for Graham it was only a beginning. By 1969, he had moved on to a completely different medium, asking a group of people what the word 'like' meant to them and recording their replies on a tape. The answers, which varied from 'adore' to 'dig' or 'love a little', are now being played at the Lisson exhibition; and they show that any given group of people tends to construct its own internal structure of meanings, following directly on from the first person's attempt to reply. The tape also reveals that the participants model their answers on what they consider themselves to be like, and that the listener is as much involved in the quality of the speaker's voice as in the verbal meaning which the voice is conveying. The non-verbal sound and character of different intonations are therefore a vital part of the work's effect.

With each succeeding experiment, Graham revealed an impressive ability to restage his enquiry in a totally fresh way. At one stage, he used himself as the performing instrument in a work, repeating the word 'relax' into a microphone before a live audience while a previously recorded girl's voice declaimed the word 'lax' as an accompaniment. The focus of self-contained interest here lay in Graham's own shifting consciousness of his voice, the girl's and the audience's involvement with the breathing patterns set up by the recital as a whole. But in another project, he switched attention over to the visual effects of movement by rolling his body to the edges of a stage while directing a television camera connected to a monitor screen at the opposite end of the room. A

complex network of feedback relationships was thereby created, refer-
ring the machine back to itself, Graham to his task and the watching
audience to its bodies seated between the artist and the screen.

That project, however, was carried through two years ago. Now, in
January this year, an even more ambitious and sophisticated plan was put
forward, involving a dauntingly high level of articulateness on the part of
the performers. A woman focusing attention only on a television image
of herself has to verbalise her consciousness, while a man observing her
through the camera connected to the monitor screen focuses only out-
side himself and verbalises his perceptions as well. There will, inevitably,
be an overlap of consciousness because of the two performers' activities
and responses to one another. Each one's verbal impression, in turn, will
affect the other's perception, forcing an unusually accelerated sequence
of learning. This experiment is scheduled for performance at the Lisson
Warehouse tomorrow evening, and it will be fascinating to find out
whether any pair of people can actually manage to carry out Graham's
demanding programme satisfactorily. He himself tried to conduct an
enquiry into 'intention' last Friday, and after a successful start found that
the unexpected relationship between performer and audience brought
the venture to a premature end. This is the difficulty with Graham's art:

36. Dan Graham, *2 Consciousness Projections*, 1972

the further he moves into a subtle blend of improvisation, psychoanalysis and video images, the more unlikely a convincing enactment of his theories will become. But even though the works lay themselves wide open to embarrassment and failure, the extraordinary intellectual force of the mind behind them remains impressive. And Graham's implicit scorn for an art that relies on easy solutions or a minimum of risk becomes even more laudable when it is compared to the one-note facility practised by so many of his contemporaries.

DOUGLAS HUEBLER AND W. KNOEBEL
6 April 1972

For the sake of all those young artists in London who are trying to arouse some glimmer of interest in new work, and watching the queues stretching through Bloomsbury for a chance to see the contents of an Egyptian tomb sealed more than 3,000 years ago, tear yourself away from the Tutankhamun show at the British Museum for a moment. Visit Jack Wendler's new gallery at 164 North Gower Street. For Douglas Huebler, an American pioneer of the so-called conceptual movement, is holding his first English one-man exhibition there; and it proves him to be so adept at playing off a simple visual image against a verbal statement that the combination of the two takes on admirably subtle dimensions.

Much of his work has been concerned with drawings of lines or dots, which he forces to undergo any number of resourceful sea-changes by describing them in a myriad different ways. Viewed in isolation, a black dot on the page remains banal and devoid of interest, but once Huebler explains that it represents – for instance – the end point of a line positioned at an angle of ninety degrees to the paper, we realise how infinitely ambiguous it can become. All of a sudden, his unprepossessing marks seem capable of taking on a hundred possible identities: the written descriptions printed beneath the images do not allow them to rest content with the prosaic character they would automatically assume on their own. And although Huebler works out their permutations with the precision of a scientist, he uses the imaginative audacity of an artist as his fundamental impulse.

This daring is well to the fore in a 1970 project he sent in to *Studio International* magazine, where one black dot was positioned alone on a

37. Invitation card to Douglas Huebler's show at Jack Wendler Gallery, London, 1972

large white page and the statement beneath explained that 'the point represented above, exactly at the instant that it is perceived, begins to expand, at the speed of light, for the entire time that these words are being read, but returns to its original essence instantly after the last word has been read'. Huebler delights in defying the meagre visual evidence that confronts us, thereby affirming his ability to invest perceptual poverty with conceptual richness. And he does it again in the series of *Variable Pieces* on show at the Wendler Gallery, each of which consists of a contact sheet of photographs, one enlargement from the sheet and a verbal description.

Even though the large photographs all seem to depict similar views of people walking in a New York street, the written titles force us to view them differently: as 'people looking at the artist', 'people who might be pleased to be the subject of art', or 'people who look alike'. One of the pieces even succeeds in evoking a tragic mood, for Huebler declares that the photograph contains 'at least one person who may become a victim'. And once we have absorbed that suggestion, the figures in the picture immediately appear vulnerable, wholly lacking in the confident bearing of the people depicted in the other, virtually identical, photographs.

Just as Huebler achieves complexity by restricting himself to severely limited visible material, so the German artist W. Knoebel confines himself to minimal shapes in order to gain a maximum freedom of effect. His

videotape *Projektion X* is also being screened at the Wendler Gallery, and it exposes the stark geometrical heraldry of an X to endless change by projecting it in the form of a light beam on to the shapes of a nocturnal cityscape. The X goes through a whole spectrum of alternative distortions as a vehicle carrying the projector drives through the streets, making the beam flatten out on the side of a building for one second before disappearing into the glare of street lamps a moment later.

The cumulative effect is beautiful, mysterious and puzzling by turn, even if the inordinate length of the tape does tend to dissipate attention and lead to monotony. Whereas Huebler makes a single, unwavering image become the medium for a surprisingly versatile range of ideas, Knoebel turns the stern architecture of his X into a rippling, dissolving, fluid phantom as it is moulded by the unpredictable kaleidoscope of lights and façades encountered during a drive through the night.

MEL BOCHNER
13 April 1972

The term 'conceptual art' may be no more misleading than many of the other labels coined in the past to describe the concerns shared by a group or a movement. But just as the word 'cubism' utterly travesties the pictorial discoveries it purports to encompass, so the notion of an art which remains wholly conceptual is almost ridiculous. It suggests on the one hand that artists, up until now, have brainlessly refused to employ mental energy in their work, and on the other hand that today's conceptualists are wrapped in a cocoon of pure intelligence. Both implications are, of course, wildly misplaced: what really amounts to a shift of emphasis has been distorted through the use of an easy catch-phrase into a dogmatic exaggeration. So-called conceptualism is more accurately seen as an attempt to demonstrate that 'the "history of art" and the "history of painting and sculpture" were never the same, merely coincident at some points'. And one of the most rewarding ways to find out how this ambition works in practice is to study the development of Mel Bochner, the young American artist who formulated that statement.

Bochner, whose first English one-man show is now being held at the Lisson Warehouse, did actually start off in 1965 by trying to deny his art any material form apart from a series of notations. Groups of numbers

were set down on paper according to simple programmed rules, thereby setting themselves up as 'drawings' which had not been affected by the artist's prejudices about taste or his habitual manner of perceiving things. But although the number drawings did manage to eliminate his unwanted sensibilities in favour of a completely self-contained, abstract system, they still seemed unsatisfactory. Their exclusively mental area of operation came a little too close to the limitations which a truly 'conceptual' art would presumably saddle itself with, and Bochner wanted to avoid such a confined approach.

At the same time, he also remained determined to escape from the prevalent need to equate a work of art with the construction of an object. And so he decided to use the idea of systems in a wider sense, adhering only to procedures that carried with them some clear evidence of the artist's creative interference. 'I do not make art. I do art,' he wrote, succinctly summarizing the way in which he set out to express himself through the ordering of methods rather than the creation of artefacts. And in a piece called *Plant*, he clarified this ambition by placing a potted plant in front of a numbered grid traced on a wall. Neither the grid nor the plant owed their existence to Bochner's own activity as an artist; but he did manage to highlight the amount of change which the plant underwent through growth and death by measuring its ever-shifting shadow on the grid. In other words, he succeeded in arranging a situation, and the very act of arrangement charted a subtle middle course between either making physical objects or setting up intellectual patterns.

This course has been faithfully maintained in the Lisson Warehouse show, which concentrates on one major piece in each room. Upstairs, Bochner decided to react to the specific character of the space he had been given, and reject the use of any preconceived ideas. Instead, he responded in a flexible way to the challenge of a wall, a window and a floor, covering each of their surfaces with strips of paper tape that measured the span of his outstretched arms. The actual length of the tapes was, therefore, dictated to him like any other system by the fixed proportions of his body. And the simple sequence of numbers which he then proceeded to mark down along the tapes followed a similarly fixed order. Once again, Bochner's artistic initiative lay only in arranging these constituents: he could decree where exactly the tapes were placed on the surfaces, and how the numerical sequences would articulate the direction taken by the tapes. Even these decisions were derived from the dimensions of a room he had incorporated into the work without demur.

But the result is that the spectator becomes aware of an alert, sensitive imagination at work within all three spaces, even though so much of the

38. Mel Bochner, *Theory of Sculpture: # 6*, 1972

actual visual evidence does not arise directly from Bochner's own built-in sensibility. The paths taken by the tapes as they divide the wall up into two decentralised squares, tighten themselves into a cross on the floor and then slice through the centre of the window all seem to affirm the spatial organization at Bochner's disposal. And our appreciation of these paths is enhanced by the numerical progression, which encourages our eyes to follow the tapes on a precisely conducted journey. The art therefore appears to be rooted in the particular conditions imposed upon it by the room, and the experience Bochner offers us bears out another statement he has made: 'I do not believe that art is understood through intellectual operations, but rather that we intercept the outline of a certain manner of treating (being in) the world.'

Upstairs at the Lisson, the 'world' centres on the demands of three localised surfaces; but downstairs, it ceases to depend on the appearance of the gallery altogether. For Bochner has here set down a number of chalk stones in groups which all multiply up to twelve: a self-contained procedure entirely independent of any external consideration. At first glance, it would appear that he has agreed to place himself in subservience to the natural form these stones possessed when he found them on a beach near Brighton. But it soon becomes obvious that the

material he has employed is entirely arbitrary. The lucidity of the stones' various groupings within the order which simple mathematics provides is what really matters.

For Bochner has again set in motion two systems that operate outside his control – the various multiplications possible within the number twelve, and the accidental size of found objects – in order to explore the beauty of their conjunction. And within the apparently childlike structure he has arranged, a surprising wealth of relationships offer themselves for exploration: the tension between the six large groups, between the outer circles and the circles within, between the circles and the stones, and between the stones themselves. All are dependent upon the mathematical scheme that brought them into being, certainly, and Bochner stresses the sobriety of that scheme by calling the piece *Theory of Sculpture: 6*. But the cerebral dryness which such a title suggests is completely counteracted by the wonder of the piece itself, a wonder that helps to explain why Bochner approves of Wittgenstein's declaration: 'I have to discover the world, to measure things.'

DAVID DYE AND ALAN CHARLTON
4 May 1972

I hope film buffs, and all those who claim that cinema is a far more viable creative medium for the twentieth century than art, have been visiting David Dye's one-man show at the ICA. Not because it proves that art is still on top: such squabbling is basically irrelevant, and ignores the simple premise that every medium depends for its vitality upon the abilities of individual practitioners. No, Dye's admirably precise and cogent work is worth examining because it represents one way in which an artist's mind can conduct an inquiry into the nature and potential of film.

He even organised the exhibition like a seminar, guiding people from one item through to the next with the same care that has obviously been lavished on the procedural thought behind them all. The most self-explanatory piece was, for instance, left running the whole time, as if in admission of its role as a useful key to Dye's overall concerns. Two projectors, placed some distance apart in opposite directions, both showed a film consisting of texts which asked the spectator to watch the celluloid itself, as it ran out of each projector in a continuous loop along the wall

behind and back into the projector again. The loops therefore occupied the wall-space in between the two projectors, and the texts directed attention to a sequence of numbers placed on the wall at strategic intervals to mark the progress of the loop in its journey around a complete circuit. Every part of this didactic structure referred, then, to every other part, demonstrating the mechanics of film with great clarity. It made you aware of the whole process rather than the end-product image on a screen, and exposed the all-important element of time as well.

If this exercise sounds a little too neat and self-evident, let me emphasise that it gained in force by being set down among a large and versatile series of other experiments. Some consisted solely of projected films in a more conventional sense, one of which recorded on a double screen the progress of two projectors as they were moved over each other around a circle drawn on the floor. Once again, the result anatomised, step by step, the actuality of Dye's idea as he realised it; and the fact that it was impossible to divorce the idea from its physical execution made it all the more satisfying.

It was not, however, the most beautiful of the straightforwardly projected films. Dye exploits wit and mystery as well as clarity, and another split-screen work made two separate films of a foot walking in different directions look like one image of a pair of feet walking the same way, both hilariously out of stride with each other. A further irony, not admittedly obvious from the film itself, lay in the location: Dye decided to base it on the idea of walking towards, and away from, the ICA itself – thereby summing up his ambivalent feelings about the business of exhibiting in a gallery. The piece asserted a quizzical sense of humour, as pungent as his earlier contribution to the May 1971 issue of *Studio International* magazine; and this impulse was memorably extended in another film that started off with a mirror image of the artist himself behind the camera. Gradually, this static picture began to be disrupted by the appearance of a hand, rubbing away the substance which created the mirror from the sheet of glass. As the reflection of the artist was destroyed, so the hand became a head and revealed the identity of the rubber: the two images, openly at war with one another, underwent a sea-change that analysed the nature both of illusionism and of time. Dye realised the project in purely film terms, showing how an artist can draw upon the resources of a different medium in order to display more graphically the character of his own interests.

And these interests ranged widely, enjoying outright playfulness in the piece where Dye held sheets of paper as screens in front of a reversed film showing his hand writing a signature. The result was that the hand actually

39. David Dye projecting his work *Screen* at ICA, London, 1972

writes his signature *off* the empty sheets, which Dye then distributed among his audience like an old-style maestro giving away autographed works. And he physically involved himself in the performance of other works, too. The most impressive required Dye to hold a projector running a film of a photograph of himself, which grew steadily larger as the camera moved up to it. The tension in this performance lay in the fact that Dye had to keep the constantly expanding image of the photograph on the film contained inside a rectangle drawn on the gallery wall; and the only way to do this required him to walk, with his projector, towards the wall. The same forward motion which had, therefore, caused the photograph to become larger on the film now became the means whereby Dye was able to make the self-same photograph shrink down inside the rectangle.

An elegant demonstration of paradox through the resources of film was thus achieved, and it proved the artist's ability to operate with intelligence and ingenuity within a field which experimental film-makers doubtless consider to be outside the range of art. This was the excitement of Dye's exhibition: the realization it offered that the boundaries between the two media of expression need not be tightly sealed off, that both sides can converge and yet succeed in defining their different priorities with exactitude.

40. Invitation card to Alan Charlton's exhibition at Nigel Greenwood, London, 1973

Alan Charlton, by contrast, who is now exhibiting in Nigel Greenwood's gallery at 41 Sloane Gardens, still adheres very confidently to the act of painting a picture. Five canvases of monumental proportions bear witness to his belief in the supremacy of that tradition, and also to the high seriousness of his aims. At first sight, these sober, undemonstrative expanses of grey paint, interrupted only by isolated slots which have been cut through the picture-surface to reveal the wall behind, look like slabs of minimal sculpture translated into pictorial terms. But a more prolonged inspection shows that there is no real sense of borrowed sculptural mass or volume at all. The slots, most of which extend horizontally across the paintings, do not focus our apprehension on the pictures as physical objects by reminding us of depth or the space between wall and canvas occupied by each exhibit. They act rather as intervals, visual pauses that help to define the precise impact of each painting; and so they operate within the same area of reference as the brushmarks surrounding them.

In other words, there is no sense of interruption or contradiction, although the idea of cutting back through the picture plane might imply such an effect. Even the painting hanging in the corridor, cut all the way round so that one canvas is separated from the border containing it, carries

no suggestion of interference. Charlton rules out that possibility by presenting calm, monolithic presences, entirely removed from any hint of drama or gestural display.

Nigel Greenwood sensibly plans to change the selection after a few days and show some more of Charlton's work, so that a more complete idea of his achievement can be formulated. I look forward to this second instalment with interest because the pictures command respect; but I suspect that he needs more time before a fully convincing synthesis between his ambition and its embodiment is attained.

DENNIS OPPENHEIM AND JOHN DAVIES
14 July 1972

It would be easy enough to miss one of the most satisfying and moving exhibitions on view in London this week. Only one modest sign positioned at the entrance to the Tate Gallery informs the visitor that Dennis Oppenheim is displaying a slide and sound work downstairs in the Lecture Theatre, and the Tate's many alternative attractions could easily ensure that it remains overlooked. But anyone who makes a point of going there should not be disappointed, for Oppenheim – a young American well-known for his Land Art activities – has devised a simple yet superbly executed project for his first one-man show in this country.

The colour transparencies that follow each other in a gently dissolving succession on the screen seem, at the outset, to contain fantastically complex images. Elongated shafts of light are thrown across the screen's surface, traversing what seem like vast distances and containing a whole range of different textures, blurred objects and ambiguously shifting shadows. Surrounded by an impenetrable darkness, they could represent the incandescent slipstream of a spaceship or a giant laser-beam cutting through the night sky, so other-worldly is the aura created by their luminosity.

In reality, however, they emanate from a very earthbound carbon arc searchlight, set up to throw a cylinder of whiteness 2,000 feet along the ground. Oppenheim himself stands in the path of this intense blaze, blocking its projection and thereby casting a pair of parallel shadows in front of him. Bending half-way towards the ground, the artist then produces a strange shape which he has likened to a tuning-fork; and finally, by crouching lower down still, he makes this fork shrink into a much

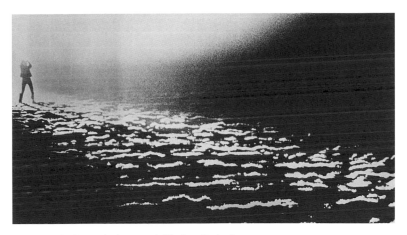

41. Dennis Oppenheim, *2000' Shadow Projection*, 1972

shorter spear. All these silhouettes are captured in the photographs shown on the Lecture Theatre screen, and as one slide fades into the next, so a powerful feeling of isolation – bordering on desolation – is conveyed.

Caught in the raking glare, Oppenheim forces his body to become the instrument whereby long black lines form themselves into a network of attenuated melancholy, and this elegiac mood is reinforced by the haunting sound of a horn he blew during his enactment of the piece. The low note provides a potent aural equivalent both to the image as a whole and the drawn-out shadows running through it. Oppenheim has stated that the project was conceived in memory of his father, and he has communicated his grief with an eloquence that arises from the most matter-of-fact and methodical of means. Precisely because no overt emotionalism has been allowed to enter the work, it succeeds in evoking a poetry akin to the spectacle of a lonely lighthouse throwing its beam through miles of empty blackness. The Tate, and the Situation Gallery which co-operated with them, are to be congratulated on presenting such a memorable work by an artist who would not normally be accorded an exhibition at Millbank. May there be many more of them.

A comparable sense of sadness also pervades the Whitechapel Art Gallery's large upper room, where a young sculptor called John Davies has assembled sixteen life-size figures in his first London show. They are all sober, quietly understated presences, even though the symbolism they contain is full of menace and foreboding: plaintive old men, dressed in ordinary dark suits and hidden behind sinister masks, crawl abjectly

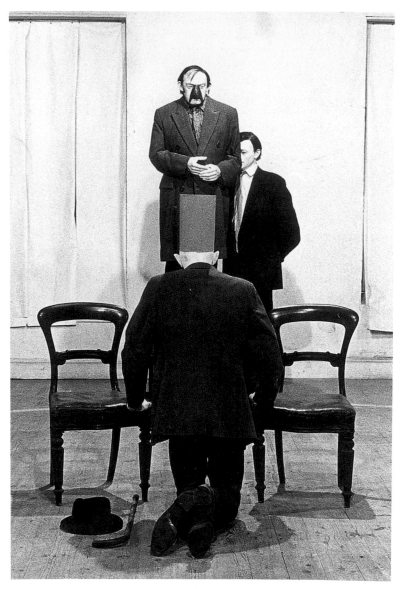

42. John Davies installation at Whitechapel Art Gallery, London, 1972

around a chalk circle drawn on the floor while another man, wearing a dunce's cap and a funny nose, kneels mutely before two chairs. Nothing actually happens throughout the room; but as you walk past these inexplicably forlorn replicas of humanity, their very inhibition and lack of demonstrative action become more affecting than a thousand Grand Guignol spectaculars. The whole gallery is heavy with stifled emotion and a despairing absurdity which seems closest of all to the world of Samuel Beckett.

Davies exploits the uncanny sensation that life-size effigies often convey, even inside a waxworks museum: they appear almost to be real people, and I could have sworn that the *Man with Closed Eyes* was actually about to look up and speak to me. It was easy to respond to these beguiling dummies, and yet far less simple to evaluate them as the work of a sculptor. For apart from the real clothes, the wigs and the theatrical props, the actual modelling of the bodies was conspicuous by its mundanity. Sensitive, yes, and disciplined, too: but just as Davies transmits positive emotion by freezing his figures into negative passivity, so he relies on an absence of bravura in the construction of his limbs and facial features in order to assert their sculptural presence.

The conspicuous weakness of the drawings displayed in the Whitechapel suggests that Davies would not be able to achieve that kind of sculptural quality anyway; and I suspect that much of his precocious individuality arises from an exact understanding of his own limitations. This kind of art can easily deteriorate into empty theatricality, and the very completeness of Davies' success makes me wonder whether he can develop any further. But for the moment, at least, his exhibition stands as a remarkable *tour de force* which lingers in the memory.

KEITH MILOW AND BILL WOODROW
10 August 1972

Although I never expect to attend the death of painting as a viable medium for the artist, it is becoming increasingly apparent that an enormous amount of the best contemporary art has left the easel picture far behind. A whole range of alternatives, many taking conceptual rather than visual considerations as their starting-point, have established their claim to our

closest attention. And it has grown correspondingly more difficult for any young artist with pictorial ambitions to make his work as adventurous as the experiments conducted by more unorthodox contemporaries.

Keith Milow, a twenty-six-year-old who is now holding a one-man show in Nigel Greenwood's gallery, has always been acutely conscious of this dilemma. As the contents of his exhibition reveal, the challenge of creating a rectangular image to hang on the wall lies at the centre of his concerns; and yet he can only justify such an interest by rejecting most of the devices which painters employed in the past. Not that Milow disowns all connections with senior generations: he has never made any secret either of his admiration for men like Richard Hamilton and Richard Smith, or of the influence they exerted on him. But his involvement with such painters is superseded by an even greater regard for sculpture, and this preference is symptomatic of the way he tackles the challenge of picture-making in 1972.

Straightforward painting is avoided in favour of a wider, more flexible and functional obsession with materials. Several years ago, Milow's regard for Pop allowed his figurative content – mostly based on photographs of architecture – to remain relatively clear. The forms of the buildings were immediately legible, obscured only by sudden interruptions of abstract activity or a superimposed grid of glazed colour. But now, the original motif is far more ambiguous and remote, progressively refined and fil-tered through a whole series of intricate strategies. When paint is used at all, it is applied with a plasterer's tool and combed into serrated patterns until an almost sculptural surface has been arrived at. More often than not, pigment is abandoned altogether, so that the structure of the picture and its subject can be stressed more forcefully. Resin and glass fibre are deployed as the main media, in order to enhance the physical actuality of the image as well as lending it a transparency which prevents the work from becoming too bulky. Sometimes the picture hangs down – like an Oriental scroll – as one thin photographic sheet; while elsewhere plastic frames or glittering varnishes cover the entire surface, to exploit the pos-sibilities of reflected light or even confront the spectator with a subdued mirror of himself and his surroundings.

The results, as this catalogue of diverse ploys might suggest, are vari-ous and immensely resourceful. But they do not seem too disparate: Milow's sensibility, always distinctive, is now more individual than ever before, and it serves to unify the whole exhibition. He possesses an Englishness which links up with the cool restraint and fastidious ele-gance of Ben Nicholson; and alongside this understated poise is a love of sweet colour and seductive flourish unmistakably his own. It can, indeed,

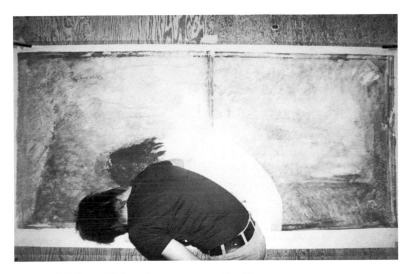

43. Keith Milow, *Work in Progress*, 1972–3 (detail)

become ingratiating and unnecessarily flattering to the eye. Milow's ability to soothe and charm easily teeters over into soft-centred deliquescence, just as his emphatic belief in structure sometimes looks heavy-handed. His greatest enemy, I believe, is a natural facility which on occasion looks merely artful, and yet his analytical detachment will surely prevent this weakness from ever gaining the upper hand. He is intelligent and inventive enough to build on his achievement over a long period, constructing perhaps a convincing, if delicate, balance between the disciplines of painting and the newer, more cerebral preoccupations of his radical contemporaries.

But a large question-mark does still hang over his future direction, one which makes me wonder how he will resolve his own realization that 'I'm between two stools: I'm not totally visual in that I don't make pieces which necessarily go all out to delight the spectator. On the other hand I'm not totally reliant on idea and form the way the more conceptual among us are.' Milow understands the problems very clearly, and the quality of his work so far leads me to hope that this seeming incongruity will yield an impressive harvest in the future.

Over at the Whitechapel Art Gallery an even younger artist, Bill Woodrow, is also showing work combining traditional elements with media which escape from tradition entirely. Only this time, the underlying

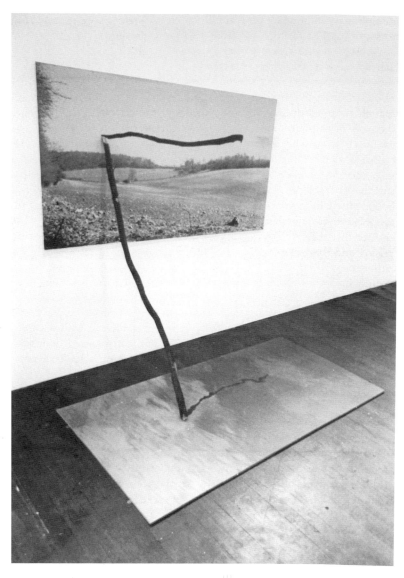

44. Bill Woodrow, *Untitled E46*, 1971

discipline is sculpture alone, and some of its conventions are used as a foil to set off against devices that have nothing to do with a tangible object at all. At least one of the pieces does have a substantial presence in the gallery – it employs a real branch to join up a photograph on the wall, showing a branch hovering in the air above a landscape, with another photograph on the floor showing a branch's reflection in a river. The real branch, propped diagonally between one picture and the other, touches the ends of its photographic equivalents and thereby implies some logical link between the two pictures.

But, of course, there is none. The tension of the work lies precisely in the expectations Woodrow has aroused through the reality of the branch, and the mysterious unreality of its image in the photographs. It should be an unwieldy conjunction, and yet Woodrow's understanding of the interplay between sculptural object and photographic counterparts ensures that the risk pays dividends. The other two works are less surprising and therefore less potent; but if at the moment his work seems rather too narrow and obvious, Woodrow could hardly be expected to furnish himself with a fully mature and independent voice at such an early stage in his development.

THE NEW ART
17 August 1972

Perhaps the most serious of all accusations levelled against art critics as a breed is that they lack a sense of commitment. And the complaint carries a lot of weight, too: for however competently a critic describes or analyses the work he encounters, his writings will only begin to transcend reportage if they spring from coherent – and indeed passionate – convictions about the broad direction in which art should ideally be moving. Such a firm, central belief need not turn him into a blinkered partisan who merely delivers judgements based on glib preconceptions, either. True commitment can only arise from a direct response to the challenging experiences which worthwhile artists provide, after all; and if the capacity to respond was missing, there would be no desire to support one area of contemporary art more fervently than its host of rivals.

For myself, at any rate, I can see little point in the whole business of regular criticism unless it is accompanied by a shaping view of what really

counts in the work on display around me. And I am delighted to find that the superb new exhibition of *The New Art*, opening today at the Hayward Gallery, gives me a chance to come right out in the open and disillusion anyone who thinks I operate from a pedestal of lofty detachment. This show, compiled with exemplary courage, intelligence and care by Anne Seymour, contains most of the young artists I admire in England today. Although her brief from the Arts Council implied a survey at once broader and more catholic than the one assembled, she rode over formidable opposition and insisted on the prime importance of a unified standpoint. The result, containing only fourteen separate contributions from the artists invited, represents a tiny and very one-sided fraction of the work at present being produced in this country. But to those who believe, as I do, that this segment constitutes the kernel of all the finest avant-garde art created here over the past few years, Anne Seymour's decision is a triumph. For the very first time, London is able to see the full range of radical developments that still remain sadly undiscussed outside the enclosed world of specialist magazines.

The exhibition is bound to attract heated controversy, particularly from visitors who expect to find at least a token section adhering to the old tradition of painting and sculpture. Only one of the participants, Keith Milow, subscribes in any way to the supremacy of these media, and he stands out as an almost uncomfortable exception among artists who share a common wish to move beyond hallowed categories into activities involving a wide spectrum of alternative materials. Even Milow robs his refined, deliquescent pictures of their status as unchangeable images by subjecting them to a blaze of sodium light. It dampens his work down until, deprived of their seductive and sometimes ingratiating orchestrations, they are reduced to an overall grey tonality. Milow's need to detach himself from the idea of straightforward painting is thereby made plain, and he plans to dramatise his ambivalent attitude still further by setting off a flashbulb every half-hour, irradiating the room for a split second and restoring his pictures to their original colour.

Lovers of convention who find themselves frustrated by these strategies may well derive comfort from the vast parchment drawings which Gilbert & George have draped across two walls of the Hayward's first gallery. Executed with beguiling virtuosity, these smoked charcoal evocations of the artists walking through a cascade of burgeoning foliage seem superficially to stand within an archaic representational idom. But the irreverent captions written underneath each strip, celebrating outdated catchphrases like 'terribly naughty', indicate an outlook infinitely more removed from tradition than Milow. Gilbert & George only adopt

45. Keith Arnatt, *Trouser-Word Piece*, 1972 (detail), shown in *The New Art*

a descriptive style here because 'we wouldn't even know how to draw another way'; and these beautiful wall-hangings are simply one part of a multiplicity of other devices they employ to present their quizzical relationship with art itself.

It is this mood of sustained questioning, expressed in its most gentle and burlesque form by Gilbert & George, which pervades the entire show. At first, there would appear to be little connection between their drawings and Richard Long's slowly expanding concentric rings of pebbles occupying the whole of the floor-space nearby. But these great circles, gradually revealing themselves as you walk up the ramp towards their room, are likewise the product of a stance utterly removed from all accepted stylistic conventions. Long's involvement with landscape – its picturesque associations, its history, structure and primal forms – expresses

more than anything else his isolationism. The pebbles have been selected with an eye for their sensuous appeal, certainly, yet they are also a gaunt affirmation of his removal from all other contemporary sculptural traditions. And their detachment here from the rural context treated with such delicate understanding in his photographic pieces – and in the sensitive juxtapositions of natural scenery displayed upstairs by Hamish Fulton – serves to emphasise Long's uncompromising refusal to enter into a dialogue with the Formalism he must have encountered as a St Martin's student.

Space does not permit me to discuss the rest of the exhibition with the depth it so richly deserves. David Dye, using a battery of projectors, throws a polyphony of ever-shifting images around the letters of his name and confounds expectations with immense precision, wit and economy. Gerald Newman sets up a fluid, flexible environment, in which the cool purism of his light pieces is played off against the more exclamatory impact of his noise structures, until the one bleeds in with the other to create an ambience of lyricism toughened with harsh, sudden shocks. Michael Craig-Martin deploys ordinary objects, mirrors and a video screen to concoct capricious and yet consistent exchanges between the functions of things and people; and John Hilliard deftly explores other kinds of visual transformations through the time-sequences and mechanics of photography.

The most rigorous and demanding sections, finally, are devoted to linguistic approaches: Victor Burgin's fantastically complex but limpid memory-structures; John Stezaker's tortuous perorations on the status of art works; and Art-Language's roomful of filing cabinets, containing an intricate cross-referential battery of writing based on the premise that relentless examination of art theory and criticism can itself 'come up for the count' as art. Such concerns impinge directly on my own function, and I am glad to extend to Art-Language – as to the rest of this heartening show – my most avid respect.

THE BERLIN SCENE AND NIELE TORONI
9 November 1972

Berlin: the name immediately evokes an art of anxiety, unrest and aggression. It is the city of Expressionism and Dada which we think of first, a turbulent society reflected above all in the savage drawings of George Grosz or John Heartfield's anti-Fascist polemics. And the post-war division into East and West sectors, coupled with the tension that the Berlin Wall engendered, would lead us to expect the same edgy feelings in any survey of the city's artistic activity today. Such expectations are, however, confounded by the exhibition of *The Berlin Scene 1972* at Gallery House, 50 Prince's Gate. Internationalism now holds sway – partly as a reaction against what the participants feel was a provincial attempt in the 1950s to revive the Expressionist brilliance of the early twentieth century, and partly because Germany as a whole has recently become a focal centre for artists all over the world. Düsseldorf was instrumental in this opening-up process, and still remains a far more vital cynosure than Berlin. But the Gallery House show does prove that this fragmented city has largely succeeded in laying the ghost of a past which at one stage threatened to turn its contemporary art into a retrospective and inward-looking affair.

Only a hint of the old familiar *angst* lingers on, and only in paintings that constitute the weakest part of the exhibition. Johannes Grützke is represented by some coarsely handled pictures of agonised, gesticulating men in anonymous suits, twisting their faces into caricatures of a Grünewald grimace. The style – a rough and ready brand of allegorical realism – petered out in the 1930s, and the sole justification for Grützke's inclusion here lies in his doom-laden references to Berlin's political situation. But these saving comments are absent from Markus Lüpertz's crude railroad paintings and Bernd Kolberling's watery landscapes, which look like a pathetic attempt to do for Germany what Hodler did for Switzerland. Their presence here erodes confidence in the selection of the show, a joint effort marshalled by Berlin dealer René Block, and points to its essentially arbitrary nature.

How strange, for instance, to choose artists like the Japanese-born New Yorker Arakawa and the English Peter Sedgley, neither of whom has any connection with Berlin apart from the fact that they are both on visiting scholarships there this year. I presume their inclusion is supposed to stress the city's cosmopolitan outlook, but it would have been far more sensible to send over some lesser-known German artists instead. I

46. K P Brehmer, *Skyline Variable Version*, 1970–2

noticed, too, that many of the other contributors are in fact middle-aged, established figures: strangers to English eyes, perhaps, but nevertheless safe and predictable. Any show claiming to record the Berlin Scene in its totality should surely encompass the younger generation as well, thereby injecting vitality into a very diverse and inconclusive exhibition.

There are some signs of a specifically Berlin awareness, of course. K P Brehmer has sent over some graphs of the city's 'skyline' which are actually computed from the amount of carbon monoxide and sulphur dioxide present in the air over a three-day period. The results, which could be called pollutionscapes, are terrifying as well as neatly devised:

the poison rises up in great monolithic tower blocks, all the more disturbing for being so methodically presented. (Brehmer tried to implement the same project in London, by the way, but found that the information about the air's contents so freely available in Berlin was impossible to obtain over here.) This, conceivably, is the new way in which the traditional Expressionism of Berlin art is now being communicated. In place of outright cries of pain, cool rationalism intervenes – Germanic passion fed through the structural devices of international radicalism. There are some fairly unpleasant images of violence, perversion and hysteria in Gerhard Rühm's photomontages, but they are put across in a deadpan manner. Even when an artist such as Stephan Wewerka does recall the days of Grosz and Heartfield in his architectural satires – one picture shows a photograph of an old church incarcerated like a prisoner inside the contours of a power station – the mood is whimsical rather than abrasive.

So where does the spirit of Berlin art lie? In the playful wit of Tomas Schmit's tongue-in-cheek drawings, the streamlined elegance of Piotr Kowalski's hand-held neon tubes, or the eclectic variety of Wolf Kahlen's *Reversible Process* films? There is no central direction or sense of identity about this survey, no real demonstration of René Block's claim that these artists all 'feel a great responsibility towards the actual situation of their city'. In terms of a community endeavour, maybe this statement holds true; but in terms of art, their escape from provincialism has also brought with it a loss of that definable character which would fully justify the decision to concentrate on work drawn exclusively from a single European city.

It is, in a different way, hard for us to grasp the undeniable political implications of Niele Toroni's exhibition at the Jack Wendler Gallery, 164 North Gower Street. Four paintings are on view here, each executed on strips of ordinary oil cloth with an identical number 50 brush, and each consisting of paint marks applied 30 centimetres away from one another in standard colours: dull blue, orange and green. The pictures are numbered like catalogue entries in a museum-style show, and yet these digits refer only to the number of brushstrokes in each painting. They look like unique objects, but their dimensions are completely arbitrary and they could equally well have been executed by anybody. And Toroni, who actually encourages members of the public to paint them, has not varied this one rigid format over the past six years, as if in reaction against the whole idea of a creative progression.

He flouts everything, supplying an artist's statement in pamphlet form called *Art/Critique* which turns out to contain only the familiar piece of

47. Niele Toroni, *Rosso o Nero*, 1975

oilcloth with a single green brushstroke planted carefully in the middle. He hangs these pictures in the one London gallery that has never shown paintings at all and, like his French colleague Daniel Buren, often prefers to display his work as ordinary hoardings on the shabbiest of street corners. So many devices are at work to strip the act of picture-making of every pretension, every quality which usually encourages us to value and appreciate the sensibility of the painter. And yet, for all this wilful negation, the paintings themselves do still possess a curiously tasteful beauty. It is as if Toroni wanted to achieve this result by perversely refusing to comply with all the ploys an artist normally relies upon. And here, I suppose, the political implications come in, even though his work contains no overt signs of protest or dissent. For these paintings are truly democratic: art reduced to a common denominator, so that it is forced to rely on its basic dignity as a mark-making process. I responded to the idea, but I would hate to see Toroni devoting the next six years of his life to the endless repetition of such a narrow and fanatical gesture.

RICHARD LONG

1 February 1973

Richard Long has always called himself a sculptor. But his determination to leave the studio, move into the land and make his work out of the natural elements he finds there would seem above all to rebel against sculpture as most people know it. Or so I thought when I wrote about his last London exhibition at the Whitechapel just over a year ago, and concluded that he had mounted a frontal attack on so many aspects of our sculptural tradition. Now, however, Long's new show at the Lisson Gallery appears to me to contain no hint of controversy or dissent: his activities are as simple and direct as those anonymous prehistoric men who, like him, carved their ideas and emotions into the chalk hillsides of the English countryside. The sense of isolation and privacy is still strong, certainly; yet the overriding feel of his work is gentle rather than militant, and only implies a rejection of other sculptors' conventions by quietly pursuing its single-minded aims.

In contrast with many other land artists, who are tempted by the sheer scale of the territory to indulge in overblown gestures and an almost boorish disregard for their chosen locations, Long takes his cue from the possibilities inherent in his site. As sensitive as a hunter to the spoor left behind by his animal prey, he never blunders into a landscape and imposes preconceived ideas regardless of their setting. On a recent trip to South America, he camped near a huge stone gateway erected by the Incas on a dramatic hilltop overlooking a panoramic expanse of water; but he was not tempted to vie with that spectacle and erect an alternative colossus. He simply took a photograph of the existing structure, cropped it half-way down to emphasise the way in which the Incas also managed to preserve the natural character of the stones they used, and then joined it to another photograph of an angular shape which he formed out of ash from the camp-fire. The juxtaposition of these two images, ostensibly so different in their intentions, is thereby left to impinge on the viewer. And quietly, without any prodding on Long's part, they become linked through their shared understanding of what the place itself demands. He does not even presume to disrupt the landscape with materials of his own: they arise out of the given situation as surely as the stepped pattern assumed by the scorch marks of the ash.

More often than not, Long's sculpture is rooted to such a self-effacing degree in the scene he selects that it seems as much a part of nature as the strata of a rocky outcrop or the meandering path pursued

by a stream. A photograph of a stone circle lying in front of a mountain range hardly appears to have been arranged by him at all: it looks entirely inevitable, reflecting Long's realization that all he needed to do was reveal an existing form by extracting some stones from the middle of the ring. Any suggestion of artifice is therefore dispelled, and along with it all trace of the sculptor as a maker of assertive, breast-beating declarations of personal power and authority.

Long's art stands at the very opposite pole from those who seek to impress with bulk, solidity and monumental excess. He makes most other sculpture look melodramatic or clumsily overweight, even though his involvement with the romance of walks, journeys and 'sacred places' could easily lead a less disciplined temperament to lose his way in clouds of mystical rhetoric. The romanticism is there all right, allied to a feeling for communion between man and the earth which connects immediately with a time-honoured English love of travel, exploration, even discovery. And yet there are no pioneering heroics attached to Long's wanderings. The prevailing mood tempers imaginative insight with the understatement of an artist who knows precisely how little is needed to convey the full immensity of his response.

There could easily be something simple-minded, precious or inadequate about his decision to walk across one line of a mysterious tracery of indentations left in the Peruvian desert generations ago by a forgotten tribe. But the result, photographed from a viewpoint which shows it as one soft stroke of white whispering its way across the ground until it tapers into a range of hills behind, combines certitude and poetry to a rare degree. Treading, subtracting, disclosing, sifting, trailing, supplementing, pointing, touching, laying, imparting: these are a few of the strategies which Long, more than anyone else I know of, has added to the language of sculpture. He pares his intervention down to a limpid essence that threatens to become feebly passive and low-key, but manages instead to convey an epic intensity.

Even when he leaves the landscape altogether and installs a floor-piece in a gallery, the understanding of scale, shape and particular materials is carried over intact from the rural to the urban environment. The tightly organised sequence of rectilinear relationships charted with pebbles on the Lisson's white floorboards represents a pattern at once inspired by Long's South American experiences and aroused by the space he was presented with here. The walls above it are bare, and yet the whole character of the room is made subservient to the lines charted below, so different in feeling to the gaunt cross of pine needles travelling out to infinity at the Whitechapel or the rounded fulfilment of the concentric rings

48. Richard Long, *Walking a Line in Peru*, 1972

which expanded and humanised the Hayward Gallery's space last autumn.

These installation pieces have an advantage over the photographs in that they are more clearly related to the sculptural tradition as we know it. The outdoor pieces only exist, so far as we are concerned, in the one camera angle and the one black-and-white or colour reproduction Long gives us in his photograph. Whereas the indoor pieces are self-sufficient, and do not need to rely on a visual record which inevitably creates a confusion both about the status of the photograph and the status of the actual sculpture in the landscape itself. What happens, however, to the Lisson's pebble installation once it is purchased by a collector and placed in a totally different setting? Its precise intentions would inevitably be distorted in some way, however careful Long is about who buys his work and where it finishes up. That such questions do not rankle as much as they should, or impede our enjoyment of the work, is a tribute to Long's quality. But I hope that eventually he will go some way towards clarifying them, because every instinct tells me that here is a man set fair to become one of the finest artists England has ever produced.

DANIEL BUREN

29 March 1973

When an artist agrees to hold an exhibition in a gallery, he is automatically submitting to a whole series of conventions which have a powerful effect on the way his work is seen. He is complying, for a start, with the idea that the proper place for art is a specialist gallery, visited only by people who make it their business to keep up with current artistic developments. No one else, he can be sure, will encounter his work there; and he can be equally certain that the reputation of the gallery itself further restricts his potential public. For most dealers concentrate on a particular *kind* of art, and they do not normally expect to attract anyone uninterested in this area. Indeed, the image built up around the gallery by its previous shows is bound to colour the reaction of those who do come, leading them to expect something which may have nothing whatever in common with the artist's intentions. Above all, the decision to hold a gallery exhibition in the first place means that the artist is falling in with the system society has evolved for consuming its art. Even if he wants to attack or change art's traditional role, the gallery situation ensures that he is conforming with the accepted method of expressing such a protest.

Most artists choose to ignore these inescapable facts, either because they are happy about the overtones of a gallery setting or because they cannot devise a better means of communicating with their public. But at least one artist – the Frenchman Daniel Buren – has concentrated over the past few years on tackling this very issue; and his exhibition at the Jack Wendler Gallery forces everyone else to think about it as well. It is, admittedly, surprising to find Buren displaying his work inside a dealer's premises at all: the last time he showed with Wendler, his painting was pasted on a huge billboard in Shaftesbury Avenue, and much of his previous work has been installed in similar street locations throughout Europe and America. But his willingness now to move inside a gallery does not mean he has abandoned his attempts to engineer a head-on confrontation with the cultural restrictions which usually control the presentation of art. Rather does he make us conscious of them by reading a terse, concise statement on a videotape recording.

The main gallery room is empty apart from a television set relaying the tape of Buren reading his text, and he stresses right from the beginning that 'this tape is not a work of art'. In other words, the exhibition itself comes later, and can only be seen once the visitor has been told exactly what Buren thinks of the gallery set-up. His tape reminds us of

49. Daniel Buren video at Jack Wendler Gallery, London, 1973

the invitation we received through the post from Wendler, and declares that 'you have been conditioned both by receiving this announcement and bringing yourself here to see an exhibition of paintings'. He then speculates on the varied reasons we may have had for coming along: 'Social, professional, sceptical, critical, aggressive, curious, hostile . . . you could be here by mistake, with a friend, by force, because of your boredom, because of your interest to be seen, maybe to see an exhibition of art.' Whatever the motive, Buren affirms that our response will be influenced by the reputation which preceding exhibitions have given the gallery, and points out that 'the next exhibition will be partly framed by this one. All exhibitions have the same frame, and this frame is not neutral.'

But although he understands this situation, Buren is under no illusion about the possibility of freeing himself from it. 'To pretend to escape from these limits is to reinforce the prevalent ideology which expects diversion from the artist,' he declares. 'Art is not free, the artist does not express himself freely (he cannot).' For however much the artist may believe himself to be free, he is still helplessly contained inside the special niche society has

given him; and Buren reveals his own deep political commitment when he goes on to assert that 'freedom in art is the luxury-privilege of a repressive society. Art, whatever it may be, is exclusively political.' Buren offers no way out of the system for the artist who wishes to rid himself of this constraint: society will have to change before that ever happens. But he can at least make the position absolutely clear and explain where his sympathies lie, so that anyone who wishes to see his work knows exactly what beliefs brought it into being. Hence Buren's insistence that 'this particular exhibition for which you have especially come will be visible and only visible if you express the desire to see it', armed with the knowledge which the taped statement has given.

The video message ends on this note, inviting anybody who really wants to pursue Buren's work further to ask Jack Wendler to produce the paintings. He does so on request, unfolding a number of linen sheets woven with bold vertical stripes. The sheets range from a relatively small size, which can easily be held by both hands, to an enormously long banner that unfurls itself almost to the entire stretch of Wendler's premises. And the colours vary, too, spanning dark grey on the one hand and bright yellow on the other. But the width of each stripe, and the spaces between them, never change: they are deliberately standardised, devoid of any internal meaning, and they flout all those qualities of sensibility and handwriting which society expects and values in painting. We recoil from such a brutal, materialist challenge to our notion of the artistic ideal; and then realise that it links up with Buren's determination to question the premises on which the whole idea of exhibiting rests. The video statement and the paintings thereby come together, presenting us with a lucid and unsettling autopsy on everything we normally take for granted in our sampling of art exhibitions and the galleries which house them.

BRACO DIMITRIJEVIĆ, DAVID TREMLETT AND RICHARD WENTWORTH
7 June 1973

It has often occurred to me, when thinking about the art of the past, that I only know what history *allows* me to know. I am, of course, free to judge relative merits within that recognised corpus of work, and it is fascinating to watch different artists or periods rising and falling in interest

as the years go by. But what about the others, the people who have dropped completely from sight and are no longer remembered, let alone discussed? Were they all beneath our interest, and how can we leave them to languish in neglect without examining them ourselves? Awkward questions indeed, to which there are no simple answers. For while there is a great deal of truth in the assumption that the art still valued and studied now would never have been singled out unless it was important in its own time, we are often notoriously bad at telling what will turn out to be the most enduring elements in the art created around us. The whole system is very fallible, and nowadays depends as never before on an elaborate promotional network as well. How can I get to know about a contemporary artist without seeing him in an exhibition, hearing of him through a friend or stumbling across him almost by accident? A pretty unsystematic way of sifting through anything, particularly in view of the thousands upon thousands of artists in England alone whose work I will never even have a chance of seeing.

These are some of the unsettling issues which the young Yugoslavian artist Braco Dimitrijević has tackled over the past few years. He has actively questioned this historical process of selection by choosing random passers-by in the street, elevating them to the status of fame by blowing up their photographs like politicians or pop stars on street hoardings and the façades of public buildings, commemorating them on written plaques outside houses ('John Foster Lived Here') and erecting monumental busts in their honour. The idea works very well, in that it forces us to consider the role that chance plays in the making of a reputation, and simultaneously employs the methods used by those who wish to publicise their heroes. There is also a democratic undertow of feeling for the chosen stranger, since Dimitrijević seems to be implying that any human being ought basically to deserve such an accolade at some stage in his life. All this takes place on location, of course, and no 'art product' exists beyond a simple photographic and verbal record of each project. Dimitrijević is quite happy about that – he maintains that the 'visual characteristics of the means I employ in the realization of this programme are quite unimportant' – and believes that his freedom from the art object actually helps him to break out of the strait-jacket which history imposes on us.

I sympathise with his aims, and enjoy hearing about the way he carries out his concepts; but I remain sceptical about his ability to change our attitudes towards the past. The conceptual movement to which he belongs is itself becoming part of an art-historical canon already, with its heroes, key exhibitions and significant dates. In other words, the assumptions on which his work rests have been absorbed into the very system

50. Braco Dimitrijević, *Casual Passer-by I Met at 6.24 pm, Düsseldorf*, 1972

he seeks to question; and Dimitrijević merely furthers the irony by showing documentation of his projects in a gallery exhibition like the one on view at Situation, in Horseshoe Yard off Brook Street. There, divorced from the public context which Dimitrijević knows how to use best, his lists of random names, stories, documentation and other assorted pieces seem rather thin and casually assembled. They came alive when Dimitrijević explained them to me – I particularly liked his idea of asking Lord Weymouth, who has covered the stately walls of Longleat with his own murals, to paint a wall in Dimitrijević's own, far humbler studio, thereby reversing the traditional relationship between an artist and his aristocratic patron. But if concepts are to be exhibited like art objects in a gallery, they really ought to be put together so well that no explanations are needed. Dimitrijević may argue that these records are not that important, yet their presence in a gallery suggests that they should be more self-sufficient than they turn out to be.

I have doubts of a similar kind about David Tremlett's show at Nigel Greenwood's, 41 Sloane Gardens. When I first reviewed his work at a Grabowski Gallery exhibition in 1969, Tremlett displayed an understanding of and sensitivity to materials like steel and brick which was impressive. Gradually, however, his involvement in a more conceptual area led him to abandon objects altogether and move towards experiments in a much wider, and less tangible, field of activity. Noises, travel, dance and film claimed his attention as he searched, somewhat erratically, for an alternative to the straightforward production of sculptural objects; and his latest work has moved much closer to the pastoral world of a Land sculptor like Richard Long.

Where his earlier sculpture was tough and unashamedly messy, now it is gentle, neat and wry: the Greenwood show consists of twelve pictures, each containing six thin, vertical photographs of the Cornish landscape captioned underneath with the name of the location. They are divided up according to the prefix of the name, and Tremlett clearly savours their often quirky and poetic ring – Trewhiddle, Pendruffle, St Veep and Polgooth. He is attracted to the history and folklore of his native county, but does not share Hamish Fulton's love of picturesque scenery or Richard Long's response to a particular setting.

The photographs are haphazardly shot and sometimes poorly exposed. They possess little intrinsic interest beyond their cumulative effect, which is reminiscent of short, sharp glimpses of the countryside seen on a train journey. This idea was made more specific at Tremlett's recent exhibition at the Françoise Lambert Gallery, where the pictures were actually arranged like a curving railway track across the wall. But

nothing as definite as that seems to have inspired the Greenwood show, and I was left with a sense of lightweight detachment, as if an inordinate amount of time and journeying had been expended on a very slight idea.

A word, finally, about a worthwhile exhibition by Richard Wentworth at the Greenwich Theatre Art Gallery. Officially called 'Drawings', his best pieces are really more concerned with the whole physical apparatus which makes up a picture hanging on a wall. Wentworth acts like a pictorial archaeologist, snapping off his frame to reveal the material from which it is made, breaking the glass to expose the paper beneath, peeling back the paper to reveal the chipboard below that and even burrowing through to the plaster of the wall itself. The subject of these works is therefore their structure, and Wentworth never allows you to forget the physical constituents which are normally hidden from view when a drawing is finished and placed in a gallery. He is an honest, sometimes witty artist who executes his ideas with craftsmanlike precision: the pictures may be split, sliced and torn, but they are still very well carpentered. I look forward to seeing more of his work.

MICHAEL CRAIG-MARTIN
21 June 1973

There are times, in art galleries as in life outside, when you become more aware of your own behaviour than the exhibition you are supposed to be visiting. Maybe the work on view is boring; maybe you are feeling too self-absorbed to take in anything else; maybe the atmosphere, or the other people in the room, disrupt concentration and make you conscious only of your slightest movement, attitude, expression. The glass in front of a picture grows into an insuperable barrier, throwing back an image of your face as it tries vainly to concentrate on the art behind the glass. The poses and gestures of fellow spectators seem so curious that they force you to think about your own body, the way it shifts, shuffles and then freezes into an unnatural stance. Whatever the reason, you treat yourself as the exhibit; and the harder you try to break out of this introspective prison, the more you end up studying your own efforts to do so.

I was reminded of these uncomfortable sensations by a visit to Michael Craig-Martin's new show at the Rowan Gallery. But the vital difference here is that they were brought on by the artist, not in spite of

51. Installation view of Michael Craig-Martin exhibition at Rowan Gallery, London, 1973

him. Several groups of small, thin, identical mirrors framed by black taped borders confront you, each one accompanied by a handwritten caption which comments on the reflection seen in the glass. The modest size of the mirrors – hardly as large as the glass you might use to shave in every morning – rules out any feeling that you are being forced into a rigorous examination of your responses. And the captions, scribbled so casually beneath the mirrors, are gently inquisitive rather than brutally searching. But the fact remains that Craig-Martin has provided nothing else to fall back on: if you look at the work, you look at yourself, and there is no alternative available anywhere.

However harmless the situation may appear, therefore, it carries a large, paradoxical sting in its tail. For a complete absorption in the exhibition would inevitably lead to an almost narcissistic analysis of your most private thoughts. Craig-Martin encourages this process by placing all his captions in the first person, and makes it easy for us to join in this confessional game by starting off with statements as unobjectionable as they are impossible to refute. One piece, for instance, begins with the self-evident caption 'I am looking at myself'; but this factual remark is

immediately followed by 'I am thinking about looking at myself', a rather more disconcerting activity which then becomes openly questioning with 'How do I see myself?' and 'How do others see me?' With every new caption, Craig-Martin anticipates your reaction to the previous one. By the time I reached 'I am feeling insecure', I was surprised to find that my reflection threw back a face of supreme, even stubborn self-confidence; but this determination to resist the caption's train of thought was thrown off-balance by the next one, which read: 'I am thinking about feeling self-confident.' *Touché*.

Not that Craig-Martin strives for an experience in any way revelatory or profound. He deliberately discourages such a mood by couching the captions in simple, conversational language; and sometimes, as in the group which alternates a confident statement like 'I recognise myself' with a single question-mark, the structure seems too glib to sustain prolonged interest. He would probably be the first to agree that his work only pursues small objectives, and when he titles one of his works *Kid's Stuff* he is admitting that the limited range of a children's story appeals to him far more than the sweeping ambitions of a complex novel.

But the most encouraging aspect of this exhibition is that Craig-Martin no longer relies on the elaborate devices which used to give his work an uneasy element of trickery. When he used mirrors in his Tate Gallery show last year, the results were undeniably ingenious: the spectator entered an empty booth only to discover that the mirror within reflected the image of another person, standing in a separate cubicle some distance away. The basic aim was the same as the one in the present Rowan exhibition – to take the normal function of an object or an implement and then confound it in some way – but the end product tended in the past to become over-reliant on cleverness. Ingenuity, too, often appeared to be an end in itself, and Craig-Martin's realization of this danger lies directly behind his decision to use mirrors here in a completely straightforward way.

I think it pays off: the captions draw attention all the time to the mirror's unique ability to serve up a direct reflection of appearances, and no other devices obscure this one central activity. As if to stress his new simplicity, Craig-Martin prefaces the show with an untitled group of five mirrors without any verbal accompaniment. They remind us that a normal reflection is all that can be expected of the exhibition ahead, and it is a necessary reminder – the main danger in the work on display here is that the visitor will not bother to look in the glass after a while, and flout Craig-Martin's intentions by reading the captions alone. I sometimes found myself doing precisely that (the mirrors are hung too low to

enable someone of my height to see his face without bending down a little). But on the whole, the basic layout of the show cuts through the possibility of misusing its contents: they are squarely and honestly presented, and their lack of showmanship stops the spectator in his tracks, leaving him alone with his most inward-looking thoughts.

AD DEKKERS AND MICHAEL ASHER
13 September 1973

One of the most valuable services a commercial dealer can provide in London is to introduce us to an established foreign artist whose work, for reasons no one should be complacent about, has never been seen here at all. The gallery performs, if you like, the role of a conscience-pricker; and when it is as small as Lucy Milton's at 125 Notting Hill Gate, it offers still more damning proof that worthwhile shows do not necessarily need formidable financial backing.

This time she has imported Ad Dekkers, a Dutch sculptor in his early thirties whom Holland regards as one of her best younger artists. I say 'sculptor', because Dekkers has never strayed beyond the procedures and materials which can be said to belong to sculpture. But the recent work displayed at Lucy Milton's disregards physical bulk and concentrates on line and proportion. There is no sign in this group of impeccably white reliefs that he is at all concerned with materials. Modest in size, painted and polished to a uniform smoothness which makes them act as neutral backgrounds, these slightly projecting blocks are meant as little more than carriers for Dekkers' linear structures

The lines are all incised, it is true, and their grooves often dig down to the more irregular texture of the chipboard beneath the finely honed paint. They are, moreover, deep enough to be affected by light shifts during the day, so that they vary from strong, forthright marks to discreet whispers. Dekkers welcomes this kind of accidental transformation, and it does succeed in humanizing the reliefs, preventing them from becoming too rigid or coldly cerebral in appearance. But line is his prime interest here: he wants it to stand both as a spatial divider in a relief's surface plane and as the definer of a more sculptural mass growing out of this plane. That is why the relief as such plays a self-effacing part, performing the function of a blank wall on which line can register its double aims

52. Ad Dekkers, *Square and Circle in transition, delimitation relief,*
1971

to the greatest effect. And the most impressive exhibits *suggest* a process
of change rather than actually *stating* it – one relief in particular, called
Beginning of the Equal Division of a Double Square, is interrupted only by
a small nick travelling up from the bottom centre edge; and yet it acti-
vates our imaginations far more than other, fully elaborated works.

Where Dekkers fails, it is because he appears too dogmatic and factu-
al about his most recurrent motif – the transition from a circle to a
square – leaving us to do little apart from admire how completely he has
worked out his mathematical programme. Where he succeeds, this transi-
tion is experienced as an organic process, interlocking two different geo-
metrical elements so that our understanding of their mutual relationship
is enhanced. I would like to see a lot more of this placid, essentially ration-
al sculptor, who gives every indication of knowing exactly what he wants
to achieve and carries it out with unwavering consistency.

Michael Asher, now showing at the Lisson Gallery, is another artist
familiar in America and his home city of Los Angeles but almost
unknown over here. Part of the reason may be that he has up until now

tended to avoid the international gallery circuit, with all its attendant pressures; but part also can be ascribed to the unassuming character of his work. A typical example, published by *Studio International* back in October 1970, is his environmental project at the Pomona College Art Gallery, where he turned the space at his disposal into two triangular rooms. The smaller of them opened out through an entrance on to the street, thereby allowing light (both natural and artificial) and sounds to alter perception of the space in the same kind of way that Dekkers permits. But very little of this external interference penetrated the inner room, because a narrow passageway between the two chambers effectively blocked it off.

Judging from photographs, the experience of walking through this space – its plain, bare walls emphasizing nothing except overall proportions – must have been akin to the cool, bleached refinement of the environments installed at the Tate Gallery a few years ago by three other Los Angeles artists, Irwin, Bell and Wheeler. And there may well be a peculiarly native Californian outlook which links Asher with them. But compared with him, they all appear positively outspoken and declamatory, extroverts who are not afraid to reach out for their audiences and seduce them with bravura set-pieces.

Asher is obviously quieter and more minimal than that. His piece in the Lisson Gallery's basement room is so reticent, in fact, that it can easily pass unnoticed by anyone unfamiliar with his work. I must confess to defeat myself: having looked round the room as carefully as possible, I had to ask the gallery owners to show me where the art was! The answer, it transpired, lay in the point at which the walls of the room touched the

53. Michael Asher installation at Lisson Gallery, London, 1973

floor. All the way round, a thin but palpable incision had been made in the base of the walls, so that they appeared slightly detached from the floor. It would sound inviting if I said that the walls thereby seemed to float or hover above the floor, but the effect was not as dramatic as that. Rather did it dislodge, in a hair's-breadth and not at all irrevocable way, the function of the walls, implying that their presence need not prevent us from imagining the floor extending beyond into the space outside the room.

Asher presumably wanted to enlarge our awareness by the most fractional means, just as one of the aims of his Pomona College project was to provide the visitor with a method of registering changes in light, sound and dimension without too much interference from the artist. In the case of the Lisson room, I would have welcomed a little more interference: it was altogether too slight to sustain more than my passing attention. But I also suspect that Asher may be one of those artists who yield more each time you see another of his works, and I would welcome the chance to explore them further.

ART–LANGUAGE AND JOHN STEZAKER
1 November 1973

It is several years now since artists first began to propose that their work could justifiably consist of writings about the language of art rather than objects exhibited in a gallery context. But the hostility they originally encountered from those who claimed that their work was mere theory, and nothing to do with the real, manly business of producing a proper work of art, has if anything intensified over the intervening period. On a crude level, the sceptics feel that the artist's prime function has always been to make, not to write; and on an equally crude but perhaps more insuperable level, the sight of sheet after typed sheet of closely argued thought hanging on a gallery wall alienates their sympathy. They are, after all, attracted to art in the first place because of its visual properties, and many people simply do not understand or relate to the alternative attractions of verbal debate.

Art-Language, the group which pioneered written dissertation in England, concisely rebutted such misgivings in the first issue of their journal, where they pointed out that 'there has never been any question' of their early works 'coming up for the count as members of the class "paint-

ing" and the class "sculpture"', insisting at the same time that 'there is some question' of them 'coming up for the count as members of the class "art work"'. And it is on these terms alone that they ought to be judged, as men who want 'to maintain that an art form can evolve by taking as a point of initial inquiry the language-use of the art society'. Then, in 1969, they explained exactly how they saw themselves in a direct line of descent from Cubism's use of a technique like collage – which seemed a sacrilegious device to use in a painting when it was first introduced – and from Duchamp's extension of that principle in his ready-made 'sculptures'. They considered it entirely logical to take this inquiry one stage further still. Instead of placing an ordinary found object in a gallery and calling it art, they exhibited pieces of printed paper which bypassed references to an object altogether and concentrated on written exposition.

Illegitimate? Many opponents seem to think so; but if you ask them why, it usually turns out that they either do not understand the terms Art-Language employ in their writings, or else fail to recognise the historical logic and need for such a development. I do recognise that need, and see no reason why they should not be treated with the seriousness they deserve. But I can also appreciate that the vocabulary they use, drawing on an interdisciplinary mixture of philosophy, science, mathematics and psychology, creates formidable barriers. And so the unfair suspicion grows that Art-Language has constructed some monstrously esoteric and in-grown ideology, whereas the truth is that the group is engaged in a notably open-ended process of enquiry which would be rendered nonsensical if any ideological preconceptions limited its functioning.

So much is clear from its current exhibition at the Lisson Gallery, where the group's activity is presented with a new and helpful directness in the form of a microfilm survey of the past twelve months' work. Unlike the printed red posters upstairs, displaying Art-Language's thoughts on 'discourse' in the form of a set theory, the microfilm machine in the basement makes available all the raw material they have produced recently. Strictly speaking, the microfilm section is not part of the exhibition proper. It will stay there more or less indefinitely, on tap for anyone who wants to consult it: a sensible acknowledgement of the fact that the sheer volume of their work takes a long time to absorb, that lengthy texts pinned on gallery walls are exhausting to study, and that each individual necessarily takes what he wants from the varied body of Art-Language's works rather than swallowing the entire corpus whole.

But more importantly, the honesty with which Art-Language have here disclosed even their most private and doubt-filled conversations means that their communal approach is now more accessible than ever

54. Art-Language, *Index 04*, 1973–4 (detail)

before. It is made apparent that they no longer choose to exhibit in art galleries in order to claim the status of artists for themselves: 'That has always been a pseudo-issue – an issue one can't progress with anyway,' one of them asserts. The true reason for this show is rather to be found in the flexibility of the art-gallery context – its ability to accept the kind of interdisciplinary methods Art-Language use without bawling them out of court for their lack of professional purism. The group even criticise their own 'research-paper style', confessing that although they don't 'typically borrow style to conceal lack of understanding', they have 'occasionally employed stylishness (and this includes stylish opacity) to avoid undue exposure of idiosyncracy'. Hence the choice of a microfilm presentation, which moves away from both the convoluted, baroque vocabulary and the seemingly definite tone of earlier works.

What it does not fully eradicate, however, is the feeling that Art-Language's debates may only ever appeal to other artists, and remain forever enclosed within that specialist field. The prospect does not worry them at all; but where John Stezaker, the other most impressive theoretical artist in England, differs from them is in his insistence on moving away from their post-Duchampian line of development and returning to a square-one position. Starting with a vacuum rather than an inheritance from Duchamp's ready-mades, he wants to move beyond an art for art's sake situation and construct an ideal, Platonic working principle which affirms the conviction that 'theory and practice should together form

one, and should remain undivided. For every theory is also a kind of speculative practice, and is no more and no less true than active practice.'

This quotation from Paracelsus prefaces the book Stezaker has just written to accompany *Mundus*, a machine now on show at Nigel Greenwood's gallery. And *Mundus* itself offers a means of combining the apprehension and attainment of this ideal through the sequences of a participatory game. Armed with two buttons to light up the various stages of the game as they are reached, the player can either pursue a subjective path which holds the end in view, or follow an objective path that concentrates on the meaning involved. And the final lighted panel, signifying the desired synthesis, joins both paths together to emphasise that a resolution cannot be reached without bearing both alternatives in mind. *Mundus* therefore offers a practical way forward, out of the purely theoretical region which Stezaker formerly felt was leading his work into a cul-de-sac. Bounded by the four sectors of Action, Custom, Learning and Law into which each of his panels is divided, we can experience the framework of his argument in a vivid, concrete way, testing our reasoning step by considered step.

In this sense, *Mundus* is to be welcomed as warmly as Art-Language's microfilms, and both devices should go some way at least towards clearing away the fog of misunderstanding that still bedevils the discussion of such work in this country.

55. Invitation card to John Stezaker exhibition at Nigel Greenwood, London, 1973

JUDY CLARK
20 December 1973

Judy Clark, a twenty-four-year-old Slade graduate whose first show is now at Garage in Earlham Street, relies more on the implications of the particles she uses than on the way she presents her findings in a gallery context.

I have chosen both words, findings and particles, with deliberate care, because the whole exhibition consists of minutiae from a human body gathered together, sifted, categorised and preserved like specimens in a research laboratory for our examination. The methodology is scientific, and so on the whole is the serial presentation of each sample. But the motive behind it is more akin to the intuitive processes of art, in that Clark has no medical case to establish with her collections of finger nails, hair, used bandages and other examples of normally private detritus. Rather does she want to call attention to the margins of our everyday lives, thereby asking us to accept these unloved and isolated emissions as revelations of a larger natural order, not embarrassments to be hidden away in dustbins.

An ecological purpose – 'we consume but never exhume, the cycle is always incomplete' – is married to a more poetic intention – 'the waste material left from some vital ritual retains the generated magic of the event'. And the crude sensationalism which could be produced by deciding to exhibit menstrual bloodstains on glass slides is avoided in the detached, factual nature of the enquiry.

At worst, her work does not rise above the simpleminded level of assembling finds from domestic archaeological digs; at best, the versatility of presentation, combining diagrams of the implements employed with phials, polythene bags or cotton-wool pads displaying the specimens, overcomes this danger and results in an organised and complex artefact like the *Catalogue of Skin*, which unites line drawings of the selected body sections with twenty-eight frames of skin imprints in an absorbing whole. It is a promising and in some cases revelatory debut, which manages to teach us in a totally unforced and disciplined way that 'the more intense the event, the more dangerous its issue'. My only doubt centres on the apparent maturity of the work: it is all so neatly resolved and efficiently communicated that there seems no room left for future development, while glibness and facility are both ever-present dangers.

56. Judy Clark, *Small Wounds*, 1973

CONRAD ATKINSON
25 April 1974

How far can an artist ever hope to effect political change within his own society? Is he bound always to remain a purveyor of aesthetic experiences alone, operating at a refined remove from the desperate injustices of everyday reality, or could he break through that barrier to become an agent of direct protest and reform? Above all, how does he reconcile his inevitable desire to produce worthwhile art with the equally pressing need to turn himself into a polemical fist, hitting out with force rather than subtlety? Are those two ambitions *ever* finally compatible?

These are the questions raised by Conrad Atkinson's exhibition called *Work* at the ICA, and there is no doubt how he resolves them in his own mind. He almost tells you in his handout for the show, where two comments on his work are quoted one after the other. The first,

from a hostile review by Tim Hilton in *Studio International*, deplores 'Atkinson's manifest inability to produce a political work of art'. And the second, a shop steward's comment on Atkinson's previous exhibition called *Strike at Brannan*'s, declares that it 'was a very good thing to have happened. One of the departments at Brannan's London factory has become one hundred per cent unionised after seeing the exhibition about the strike.'

So we know fairly and squarely where Atkinson stands: any qualms about the artistic excellence of his work pale, in his view, before the incontestable improvement brought to the lives of the workers concerned. But it is not as simple as that, of course. Atkinson has chosen to remain an artist rather than a social worker, a demonstrator or a politician. His arena is still that of the one-man show, situated within a gallery context, and so he presumably feels his best contribution can be made by retaining the title of artist in order to push it as far as possible towards an activist role. The result is that most of the traditional expressive resources of art have been exchanged for a raw, deliberately unsophisticated approach which presents photographs, documents and slides like exhibits in a court-room prosecution.

The main burden of the argument rests in a series of small square cards running round all four walls of the room, each one bearing a printed statement. Atkinson states his theme very clearly on the first of these: 'Wealth is considerably more unequally distributed in Britain than in the United States – despite all its millionaires and billionaires.' And the rest of the cards develop this factual overture, contrasting top people's salaries of well over £1,000 a week with the £20 mark of the lower-paid; juxtaposing one newspaper report of a Hyde Park Gardens flat selling for £350,000 with another report about twelve thousand homeless London families; and following a story of an old woman, found dead on Christmas Eve after choking to death on cardboard, with a second story describing how one English aristocrat sends his chauffeur on four-hundred-mile road trips from his stately home simply to buy some special bacon in London.

The catalogue of inequality, of excessive luxury and excessive hardship, is compiled in devastating detail, only occasionally becoming questionable in its editing of the facts. (Perhaps there was some good legal reason why the millionaire's daughter was given two years' suspended sentence for stealing her parents' jewellery, while the millworker's son received six years for handling the goods?). And above this row of cards, Atkinson drives the same message home in different ways, displaying a continuous run of miserably low pay-slips for a farm worker, a shop

57. Conrad Atkinson installing *Work, Wages and Prices* at ICA, London, 1974

assistant, a railway maintenance man and a student nurse, a long strip of contact prints showing workers in factory situations and, right at the top, a reel of ticker-tape from the Stock Exchange charting share fluctuations minute by hectic minute.

Various kinds of evidence, then, verbal and visual, real documentation and factual digests, statistics and photographic impressions, are laid out in an unending stream around the room. They are further supplemented by three screens relaying colour slides of graffiti, street posters, people performing manual jobs and mass demonstrations. 'No Rent is Fair Rent' is glimpsed, scrawled across a slum façade; workers are shown spraying cars with masks tied tightly over their mouths; and a Save The Children poster is seen side by side with an advertisement for the Ideal Home exhibition, both on the same hoarding. The image of a society festering with the wrong priorities, and cracking as visibly as the stucco on a derelict terraced house, is projected over and over again. Atkinson shades in the detailed features of capitalism's unacceptable face, and it is not a pretty sight.

There is nothing here for an art critic to wax eloquent about, no subtle transformations of pictorial meaning, formal pyrotechnics or even the impassioned brilliance of a committed documentary. Only a steady, remorseless piling-up of data takes place, and it is precisely this dogged refusal to skirt around the issue which becomes, in the end, effective. We

all know about the glaring inequalities Atkinson exposes, and my first reaction – as always with his work – was one of impatience. Since the information I was being offered contained nothing new, and did not happen to be marshalled in any very original or sophisticated way, the exhibition seemed disappointingly clumsy and naïve. I came to a similar conclusion over Atkinson's *Strike* show two years ago, and decided that it was 'hamfisted' compared with a hard-hitting television documentary or a newspaper probe. But such a reaction and such comparisons are ultimately wrong-headed. Atkinson is not offering a savagely clever denunciation: he is setting up a forum for debate, offering the visitor a chance to participate with contributions or objections over a period of weeks, and providing at the same time a background to the ICA's own programme of films and lectures on the subject of Alienation. Moreover, he is consciously adopting a 'hamfisted' stance in order to drive home a fundamental truth all too easy to forget or dismiss in our daily lives. Simply because the issues he raises are so obvious and apparent, we normally grow immune to their presence.

Atkinson's determination to concentrate on these apparent banalities and not be deflected by secondary considerations, either of form or content, therefore finishes up as a source of strength. He does not allow us to forget, to be sidetracked by aesthetics or dazzling reportage. Instead, he nags and unsettles the conscience by presenting the inescapable flaws in our society as the first and only real priority, undiluted by artistic diversions. This is not to suggest that Atkinson has forgotten he is an artist. On the contrary, he is using the exhibition format to maximum effect, and his calculated disregard for the niceties we expect from an artist finally becomes an aesthetic programme in its own right. Only thus, he seems to be arguing, can the rival demands of art and politics settle into a fruitful relationship.

FIVE DUTCH ARTISTS
29 August 1974

There is a lot of truth in the claim that the increasing ease of communication between art communities throughout the world is constantly eroding national boundaries. Increasing opportunities for travel, greater access to information through magazines or exhibitions and the growth

of a global village have all helped to throw into doubt the notion that an English, French, German or American kind of art still exists. I have never believed, however, in the feasibility of a wholly international art form. Local identities cannot be eradicated or dismissed so quickly: they are strong forces, and their differences often provide a vigorous individuality which we would be unwise to sneer at. The ideal, surely, is for every country to pit its own native character against the international context, so that the twin dangers of insularity on the one hand and anonymity on the other are both avoided. Any artist who has taken care not to be parochial in outlook should not need to worry about the national flavour of his work: he should cherish that flavour, and seek to make as much capital out of it as he can.

All the same, I wonder how many artists share this attitude towards their origins. Although the Serpentine Gallery is now presenting an exhibition called *Five Dutch Artists*, for instance, there is a distinct unwillingness to entertain any suggestion that the work on show could only have come from Holland. Indeed, William Feaver insists in his catalogue introduction that it is not 'an exercise in spotting national trends and characteristics', and that 'nationality these days knows no frontiers to speak of'. Hence, presumably, his decision to choose 'individuals who have something to say in a variety of languages' rather than attempting to survey 'The Dutch Scene as We See It'. And hence, too, the rather haphazard effect of the exhibition, which is at such pains to forget about birthrights and concentrate on personalities that it almost makes the whole notion of a Dutch contingent seem superfluous.

There is not even a hint of a shared idea, let alone adherence to a particular contemporary movement. Ranging in age from forty-two to twenty-nine, and including two artists who work in London rather than Holland, the show is catholic and deliberately diverse in its effect. Where Jules de Goede appears to focus exclusively on the possibilities offered by painted and incised canvases, Douwe Jan Bakker displays 236 *Pronounceables* – small wooden objects which are supposed to be held in the mouth by a thin peg, thereby enabling the holder to 'pronounce' a visual system. And while Cornelius Rogge uses wood, chrome, perspex, cloth, iron and plastic to make his enigmatic constructions, J. Floris van den Broecke exhibits a selection of methodical form-clusters called *Dirid*, made out of self-adhesive colour tape on paper.

In other words, they all operate from entirely different premises. De Goede reaffirms a more or less orthodox belief in paintings, albeit one that plays coloured surfaces and linear geometry off against deep cuts which at times are as sharp as a knife but at others swell out into rounded funnels

58. Douwe Jan Bakker, *Pronounceables: Random Object Series Nr. 2/9 Ear*, 1973

running behind the canvas. Bakker dispenses with the painting/sculpture tradition altogether, and evolves instead a long series of unclassifiable forms which tend to take a ready-made shape and push it through a number of permutations that would not appear in the language a human mouth normally pronounces. Van den Broecke is interested in serial development, too, but the results are far nearer to orthodox abstract art than Bakker. And Rogge's curious monuments, which enclose incommunicative chrome walls or suspended sacks in elaborate showcases and build window-frames around views consisting merely of Magritte-like wooden slats, are clearly affiliated with sculptural tradition.

All four artists do share, however, an uneasy relationship with conventional forms of art activity, and this attitude is summed up most succinctly by their companion, Reindert Wepko van de Wint. He gives himself the nickname 'Jochum and Rudi, the Painters', to dramatise the schizophrenia he feels within himself: one half an old-fashioned artist in love with painting for its own sake, the other a more rational and calculating 'semi-constructivist' who demands an intellectual and analytic

approach to his art. It is a defensive stance, adopted by someone whose loyalties lie with painting even as he stresses that the old idea of developing a personal style is no longer enough. As Cor Blok points out in an article accompanying the catalogue, van de Wint wants to investigate methods of image- making, and the large acrylic paintings he displays here are mostly concerned with the pictorial convention of the seascape. They are sensitive, unremarkable demonstrations of the seeing habits which persuade us that an abstract treatment of light and dark hues actually represents a seascape, if the artist wants it to.

Rash as it may be to generalise about national characteristics, there *is* a definable Dutch tang to the exhibition and there ought ideally to have been a more vigorous attempt to define it. Neatness, method, order, clarity and the avoidance of emotional extremes: all these qualities, which cannot be applied either to Rembrandt or Van Gogh but nevertheless permeate twentieth-century Dutch art through Mondrian and De Stijl, can be found here. The work on view is thoroughly respectable, much of it is well-made and the exhibition as a whole seems balanced and pleasing. But it also has the defects of these virtues. There is little sense of adventure, of artists who have found a new way forward rather than embroidering on the achievements of the recent past. If *Five Dutch Artists* has solid merits, it shows disappointingly little sign of harnessing them to a thirst for exploration and renewal. I would like to think that another, more comprehensive survey of radical Dutch art could be staged over here to prove me wrong.

NICE STYLE
17 October 1974

Ever since the *Spectator's* 'Consumer's Guide to Critics' described me as 'posing as an art critic in the London *Evening Standard*, but really just an enterprising journalist who found himself with the assignment', I have often amused myself by wondering how anyone would go about acquiring such a persona. Should the archetypal art critic sport a fastidiously waxed goatee beard, a set of flashing, vicious teeth and a limp aesthetic wrist? Or ought he to be hairy and forgetful, a shabby clown forever scribbling incomprehensible notes on the back of cigarette pack ets and running into doorways when an artist he has slated walks by?

The possibilities are infinite, and not to be taken too seriously. But there is still a very real sense in which everyone, whatever his profession or job of work, tailors himself and his life-style to fit how he feels he is expected to look and behave. We live in a society so conscious of the importance of an image, so geared by the power of advertising and instant myth-making to the creation of fabricated personalities, that it is virtually impossible to find anybody immune from artifice in presenting himself to the outside world. In this context, where careless dress or behaviour is often the biggest pose of all, it would be strange if an activity as self-regarding as art was not covered in the most virulent rash which this form of stylistic contagion can assume. No other human activity (apart, of course, from the fashion industry, where the whole business of image-building is shot through with a saving irony) has become so dependent on the ability to construct a readily identifiable surface personality.

It is to the credit of Nice Style, the four men who make up 'the world's first pose band', that they have realised how much comic capital can be made out of the acute attention art pays to the cultivation of flawless identities. In their series of evening performances every Tuesday, Thursday and Saturday at Garage in Earlham Street, they perform an extraordinary hour-long dramatization of the rigid, laughable way in which art – and by extension, life as well – is dominated by the need to fabricate its own individual façade. Their platform is an arena so festooned with ropes, poles, ladders and equipment hanging from the ceiling that it looks more like a gymnasium than an ordinary stage. Only the presence of three full-length mirrors, arranged in a neat rank along one side, suggests that the athletes who use it might be tainted with narcissism and more interested in the aesthetics of physical exercise than in its body-building potential.

Sure enough, when the lights go out and the fourth member of Nice Style starts to issue his director-like instructions from the front row of the audience, the remaining trio appear dressed to kill in dinner-jackets, black ties and neatly brushed hair. Within seconds, as the three doors opposite the mirrors swing open and slam shut in swift, noisy attempts to honour the instructor's insistence that entering a room should be stylish above all else, we are catapulted into a frantic obsession with the mechanics of behaviour. Constantly exhorted by their director to reach out towards sweeter and sharper poses, adopted with increasingly ludicrous amounts of stylish *élan*, the performers twist, contort and stretch their limbs into caricatures of gestural elegance. Elbows, heels, cuffs, necks, fingers, knees, every facet of the anatomy is ordered to adopt attitudes which cross the clarity of mime with the robust exaggeration of the music-hall.

One of the most infectious aspects of the band's antics lies in its capac-

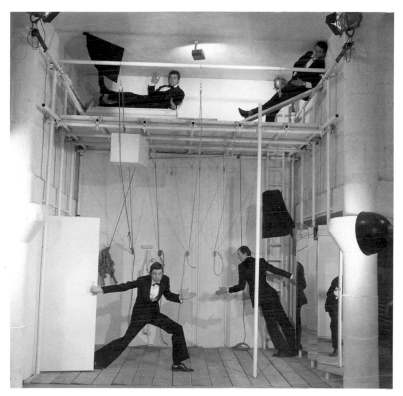

59. Nice Style, *High Up on a Baroque Palazzo*, at Garage, 1974

ity to produce a routine which is well-rehearsed but not complacent. They turn up planks from the floor-boards, suspend themselves from harnesses, drape arms and legs around an airborne plinth or strut in front of the mirrors with tremendous zest. Anything less than this total expenditure of energy, often so knockabout and headlong that it ends up splitting clothes and dousing the band in sweat, would look half-hearted and misfire. But as it is, these automated lounge-lizards sweep us along towards the grand climax, when the instructor announces that their posing is now good enough to be exposed 'high up on a baroque palazzo' (the title of the performance). And so, one by one, they limber up like sprinters before a race and then mount the ladder leading to an absurdly low eyrie above, where they are obliged to crouch and bend into the most distorted of all their postures.

The implication is that it signifies an exhibition gallery, towards which the twitching and leaping down below has been aimed in preparation, and on this level Nice Style is a satire on the way an artist devotes himself to the ultimate goal of a superbly posed one-man show. Such an allegory would be fully in agreement with the work Bruce McLean carried out before he became a member of the Pose Band: the one consistent inspiration behind the thousand pieces he collected together as *King for a Day* was a subversive desire to poke fun at every convention in art, either old hat or avant-garde, he could think of. But McLean announced his premature retirement as an artist after *King for a Day* was given a brief retrospective at the Tate Gallery; and however much Nice Style can be seen as a logical development of his earlier ideas, it does want to widen out from this ingrown commentary on art towards a statement about life in general. The band's last performance was held at the Hanover Grand rather than an art gallery for precisely that reason, and so its decision to stage the present offering in Garage may seem inconsistent.

The finale of *High Up on a Baroque Palazzo*, which consists of the trio's fatuous and yet style-bound efforts to hoist themselves up into a sofa-cum-indoor swimming-pool with the aid of a fork-lift truck, shifts the show on to the wider social plane of affluent living. But I found it more satisfying and pertinent as a satire on art alone: the sofa episode appeared to be tacked on, and nothing like as funny as the previous section where the idea of living sculpture cultivating its formal sophistication, before it is allowed to go on public view, is given great comic force. Art as a production line for the assembling of pointlessly polished products, destined to be displayed in a cultural ghetto like the palazzo, has rarely been more mercilessly mocked.

Remarkably well performed by men without any theatrical training, and probably more effective because it is self-taught, Nice Style's latest show proves that they are evolving and improving all the time. And if I urge that people interested in the future of theatre must go and see it before 2nd November, I am even more anxious that everyone who imagines that art itself cannot thrive outside the media of painting and sculpture should test their prejudices at Garage as well. They may not like it, but they cannot fail to be impressed by the band's determination, energy and flair.

ART AND POLITICS IN GERMANY
7 November 1974

In 1938, while some of his work was circulating Germany in a *Degenerate Art* exhibition organised by the Nazis to denounce the supposed insanity and ugliness of modern art, Max Beckmann gave a lecture on his painting at the New Burlington Galleries. The occasion was a large survey of work by the German artists who were being vilified in their own country, and its London sponsors had assembled the show as a gesture of support for this persecuted and in many cases exiled group. On the face of it, therefore, Beckmann had a good opportunity to hit back at the Nazi oppression in his lecture, but he did not even mention it. Instead, he began his talk by stressing that 'I have never had anything to do with politics', and even took it for granted 'that there are two separate worlds – that of the spirit and that of political reality: they may impinge on each other from time to time, but they are essentially different'.

By implication, Beckmann was upholding the belief that art's imaginative range becomes limited if it is tied down to a polemical involvement with politics, and the selection of his paintings now on view at Marlborough Fine Art explains why. For although a deep and abiding sense of horror runs through his work, proving how affected he always was by man's apparently limitless capacity for evil, the pictures express this revulsion through allegory, dream-images and the creation of a private world which refers only obliquely to real events. The tenets of Beckmann's relationship with the Fascist forces, which first of all dismissed him from his teaching post at Frankfurt, then confiscated over five hundred of his works from German museums and finally drove him away from his native land are therefore reaffirmed in this exhibition, thirty-six years after he spelled them out in his lecture. As he grew older, Beckmann made sure that his paintings grew increasingly committed to the exploration of symbol and myth rather than direct comment: there is no hint of apology in his lecture's admission that 'painting is a difficult job and demands every ounce of one's being, and as a result I have no doubt been blind to many things in the practical and political world'.

Such sentiments would, however, be anathema to the artists from today's Germany who have mounted, as if in defiant challenge of Beckmann's attitude, a crusading plea for total political involvement at the ICA. It is called *Art into Society: Society into Art*, and if they had been branded as degenerates by Hitler during the thirties, they would have

considered it their duty to fight the Nazi threat with every means at their disposal. Indeed, Christos M. Joachimides condemns the stance adopted by artists like Beckmann when he writes in his catalogue introduction that the idea 'of the artist as "child-like", "inspired", a "genius", remote from practical matters, requiring assistance, protection and a helping hand, has the objective function of perpetuating the "bohemian" ideology of the nineteenth century'.

So totally have the participants in the ICA show renounced this role that most of them operate outside the consumer-oriented gallery system typified by Marlborough Fine Art. Klaus Staeck works wholly through the medium of protest posters, designed to look like professional advertisements so that they can take their place on street hoardings and subvert this selling context to put forward images of protest. Albrecht D likewise disseminates his polemics with cheaply produced leaflets and postcards which are equally useless from the art market's point of view, and Dieter Hacker has actually turned his own studio into a public gallery, where he holds exhibitions and publishes newspapers and booklets devoted to giving art a meaningful place in the lives of ordinary people.

Joseph Beuys goes one stage further than that by proposing a Utopian ideal of total integration, where the construction of society itself would be the work of art and every member of the public enabled to realise his or her spiritual being in terms of art on the broadest of all possible fronts. Such an aim requires a lot of preliminary ground-clearing before it even begins to look remotely feasible, whereas K P Brehmer approaches political commitment from the standpoint of an individualist who still produces work for the bourgeois collector and is unsure about the degree to which he can join in a collective endeavour. Hans Haacke, living in New York rather than his native country, is far cooler and more analytic in his approach, and only views his socio-political investigations into the structure of museums as part of a general interest in systems theory as a whole.

His standpoint therefore contrasts sharply with the more agitational tactics employed by Staeck or Hacker, and it is to the credit of this exhibition that each artist is permitted to register the precise terms of his own involvement with political activities. Because their work is presented as a variety of avenues rather than a communal movement, the survey is also able to embrace Gustav Metzger, who is ambivalent about his own identity as an artist and is devoted to changing both the structure of the art world and society in general. He is not even represented in the exhibition, except by name, and in the catalogue proposes that all artists go on strike for three years in order to bring about the collapse of the present art system.

60. Klaus Staeck, *For Wider Streets Vote Conservative*, 1974

Why, then, have these dissenters agreed to display their work in a gallery context at all, albeit a non-commercial institution like the ICA? They defend their decision by arguing that it would be superficial to fly over to England and start political work inside a country they know very little about. And from that point of view the ICA survey is more honest, since it sets out simply to present possible models for future action on the street corner or the shop floor. It is undeniable, too, that an activist ideal would ensure that all those artists who are inevitably never going

to produce memorable or lasting works of art might as well make themselves useful by furthering a political cause they believe in. Modern art is desperately divorced from the mass of society at the moment, and one way of bridging that gap is to view art work as a polemical weapon capable of engendering social change.

But it is only one way, and I would defend the right of any artist to claim, with Beckmann, that art and political action should remain entirely separate activities. The worst aspect of politics as a whole is its tendency to think in slogans and simplistic, hectoring dogma. Every artist has the right to decide that he or she wishes to claim the advantages of working in other ways. By doing so, they do not become socially irresponsible or bourgeois decadent: art is imaginative communication before it is anything else, and Beckmann's work is not any the less moving or forceful because it eschews polemical issues. Anyone who claims otherwise is acting as a repressive rather than a liberating agent, and it would be a pity if the vigour and conviction to be found at the ICA ended up disputing the ability of other artists to enrich society without manning the barricades.

TIM HEAD
16 January 1975

When photography first announced its extraordinary, almost magical ability to produce not only an illusion but also a replica of reality, artists quite understandably felt threatened by the revelation. Some of them reacted by trying to make their paintings even more accurate and lifelike than the most clear-eyed daguerreotype; some by using the new visual information which photographs provided in order to convey the snapshot sensation of a caught moment; and others by deciding that the camera's increasing sophistication set them free to explore pictorial areas outside the range of photography altogether. Few artists, it is safe to say, remained untouched by the power of the aperture, but fewer still dreamed of openly employing the unique expressive means offered by photography in their work. Even Degas, who was more willing than any other nineteenth-century painter to learn from the camera in a supple and imaginative way, stopped short of acknowledging it as a medium worth pursuing for its own sake. Art was one thing, photography quite

another, and it is only in relatively recent times that the two rivals have become reconciled to the idea of working together.

But although the use of photography in art today is a commonplace, an artist like Tim Head – who relies on the beguiling illusionism of the camera in everything he attempts – remains a rarity. Instead of complying with the contemporary tendency to treat the photograph as a quick and reliable tool, adept at conveying or documenting the artist's work with neutral efficiency, Head makes the camera's simulation of appearances into a central issue. And his installation at the Rowan Gallery, where three of the huge white walls are treated as screens upon which equally sizeable colour slides are projected, relies to a great extent on photography's capacity to persuade us that its images represent reality itself.

Even so, he does not hide the mechanics behind such a deceptive environment. The first thing to greet the visitor descending into the gallery is a carousel on a stand, throwing its beam down the room towards the end wall. And this blunt declaration of the means as well as the end runs through the entire space, ensuring at every point that all the projectors are placed well within view, virtually on a par with the illusions they create. Head has given them equality of status because he wants the spectator to sort out how the installation has been set up: only thus can the reasons why it takes this particular form be established. Put another way, nobody can enjoy or appreciate Head's work without trying to grasp its organization, and he ensures that we are involved in his environment whether we want to or not. Our own bodies are constantly getting in between the projected beam and the picture on the wall, so that their silhouettes often block out a large section of the illusion. We are sometimes obliged to confront the naked glare of a beam, which jolts us out of the illusion created by that beam. And the real mirrors leaning against the walls also play an alienating role, catching us out with reflections of ourselves staring at the room as we walk round it.

This is not to suggest that Head makes the task of discovering precisely what he has done at all easy. Each of the three walls is treated as a platform for his perplexing interplay between photographs of what these walls used to look like, with a series of props placed near or against them, and what the walls look like now, with those same props rearranged in a different order. Apart from the mirrors, which have become a signature in Head's work, his *mise-en-scène* is made up of deliberately mundane objects. A broom, some simple wooden chairs, a ladder and a bucket are deployed, implying that the room has been stripped for cleaning and redecorating. Nor is that a fanciful notion: it can be seen as a metaphor

61. Tim Head, *Displacements*, at Rowan Gallery, London, 1975 (detail)

for Head's desire to perform a similar cleansing operation on our perceptual grasp of his environment.

The operation is carried out in a different way on each wall. On the left, two different slides showing the same ensemble of clock, mirror and broom are projected next to each other, bouncing their photographic version of the truth off against the actual props themselves. Taken as a whole, these three separate readings blend together to produce something akin to a Cubist multiple survey of one motif; and as if this was not dense enough, the reflections contained in each of the mirrors also make us aware of objects to be found in the rest of the room.

All the while, Head is referring us to the total environment rather than an isolated section of it, and one of the mirrors shows a ladder and bucket which can be found on the end wall. The props here are juxtaposed with one enormous slide, showing them placed in radically different positions, so that there is a fine tension between the dramatic shadows cast by the ladder in the photograph and its actual position close up against the wall, casting almost no shadow at all. This time, a generous segment of floor is shown in the photograph on the wall, with the result that the bucket is stated in three varying ways: as a real object in front of the wall, as a shadow on the wall, and as a photographic version floating oddly in space some distance up the wall. Perhaps most disorienting of

all is the chair shown on the left of the slide, because the actual chair only becomes visible when you walk right up to the wall and find it hiding round a corner.

But Head does not allow us to rest content once we have sorted out these conundrums. For the real chair is itself placed next to a mirror, which in turn appears as part of the large photograph projected on to the third wall. And here the survey of the room is brought full circle, since most of this wall is occupied by a slide of the first wall we came to. Head therefore throws us back from one area to another, putting into practice the Futurists' determination to place the spectator at the centre of their paintings. It is deftly engineered, and full of elegant little touches like the ambiguous shadow of a photographer's lamp which appears in the slide on the third wall but cannot be found in reality.

Head calls his installation *Displacements*, a title that summarises the uneasiness we feel as our eyes and brains attempt to distinguish between the photograph and reality, time past and time present, simulated space and actual space. The whole exercise looks disarmingly simple if you block off the projected beams for a moment, and discover just how banal his objects appear without the slides to back them up. Unblock them again, however, and you at once appreciate the ease with which the photograph can create an illusion more convincing than its real equivalent. That Head appears happy to exploit such illusionism to the utmost is a sign of how far artists are now prepared to enjoy the resources of photography, rather than regarding it as a danger or a servile device.

ART AND ARCHITECTURE
27 February 1975

The erosion of the clearly defined boundaries which used to separate art from other disciplines like film, poetry, performance, photography, music and philosophy has not until recently affected architecture at all. Designing buildings and planning the environment are activities in many ways related to sculpture and large-scale mural painting, of course, and many architects have in the past worked closely with artists they admired. The two media even came together in some of the most radical twentieth-century art movements: Sant'Elia's contribution to Futurism is now seen as one of its most remarkable achievements, and

De Stijl fostered an intimate, harmonious relationship between architects and painters who shared common objectives. But despite the symbolic meaning of the Bauhaus as a structure which paralleled the visual and plastic principles taught within its walls, art and architecture have never really recovered the mutual understanding they shared during the Renaissance and Baroque periods.

Indeed, it could be claimed that the ever-increasing pressures which capitalism exerts over the production of buildings, making architects more and more the servants of a rapacious socio-economic system rather than free creative agents in any sense of the word, have severed whatever bonds once existed between architectural practice and art. No serious artist with any pretensions to self-respect could possibly identify with the appalling travesty of a profession now obliged to erect commercial boxes for developers, who care a lot about cost-effectiveness and very little about the quality of our surroundings. Most worthwhile art has been at pains to fight against its commodity aspect during the last decade, and the spectacle of an architecture almost wholly dominated by the demands of soulless entrepreneurs could not be further removed from the idealism of artists determined not just to become pawns in an investment game.

This dismal stalemate now looks as if it might soon be broken. One distinct portent is provided by a stimulating exhibition called *A Space: A Thousand Words* at the Royal College of Art, where twenty-eight artists and architects have been invited to contribute a visual record and a verbal commentary of no more than one thousand words illustrating their various attitudes towards space. The entries, each one framed and hung in a unified format which draws no distinction between work from either discipline, represent a salutary coming-together on the part of these two separate media. And it quickly becomes apparent that, as Bernard Tschumi points out in his catalogue preface, architectural concepts have always been realised 'by the writings and drawings of space rather than by their built translations'.

Not only were many of the most memorable architectural achievements from the past simply drawn and described, and never put into three-dimensional form: our respect for a large proportion of the buildings which were in fact erected is also based entirely on plans, views and texts documenting structures long-since demolished or remodelled. Moreover, the reputations of several important architects, the visionary Boullée perhaps foremost among them, are based on designs either too revolutionary or too personal to be accepted as practical propositions at the time. They, like a depressingly large number of young architects

62. Dan Graham, *Homes for America*, 1966–7

today, had little hope of realizing their projects outside theoretical exposition or drawing; and some of the most influential models in European architecture, like Mackintosh's plans for the House of a Connoisseur in 1901, never got beyond the drawing-board stage.

A growing number of architects are now accepting this state of affairs. And instead of compromising themselves, by working up through a commercial office until they are eventually allowed to erect more standardised examples of urban brutality, their energy is channelled wholeheartedly into an exploration of spatial concepts which do not depend on the act of building. A contradiction in terms, and a denial of the classic

modernist dictum about architecture as a means of producing 'machines for living'? Not necessarily: the principles governing any architectural work are fully established in diagram form, after all, and there is no suggestion in the Royal College exhibition that building should not take place if the unlikely opportunity arises. Rather do the architects contributing to this show wish, in an undogmatic way which rules out the possibility that they are part of an avant-garde 'group', to avoid viewing physical realization of their schemes as some kind of crowning fulfilment. They can disseminate their ideas quite happily without having to build, and this survey is itself one method of doing so.

The connections between Bernard Tschumi's declaration that 'ultimately, the words of architecture become the work of architecture', and contemporary art's development of a more conceptual approach to its work, are therefore apparent. At the Royal College this area of common ground is mapped out, and it is as yet broad enough to encompass a diversity of individual approaches. No coherent exhibition devoted exclusively to art could now include practitioners as widely differing as Daniel Buren, John Stezaker, Bill Beckley and Dan Graham, but here they manage to fit into a context which has nothing to do with specific sorts of art practice and everything to do with cross-fertilization. An atmosphere of generalised learning, within which architects can benefit from artists and vice versa, is thereby established; and if I would guess that architects probably have more to gain from such a meeting than artists, this is only a reflection of how very insulated architecture has become from the open-minded absorption of alternative means of expression so widespread in art today. Braco Dimitrijević's statement that 'the aesthetic and visual characteristic of the means I employ to realise this programme are unimportant' is, for instance, unexceptional in contemporary art theory. But the idea of a non-functional exploration of space in no way attached to a particular visual style is still highly controversial in architectural terms, and it will be fascinating to see how far it can be developed without challenging the fundamental premises on which architecture is supposed to rest.

For the moment, it is already possible to notice how Ugo la Pietra's decision to concentrate not on erecting 'physical structures' in the city but on 'the possibility of a creative attitude in relation to behavioural and mental areas' links up with the current preoccupations of many artists. Just as there is a comparison to be made between Daniel Buren's attempt to combat the architecture of the Guggenheim Museum with his vertical stripe painting, and Gaetano Pesce's extraordinary plan to 'restore' a Neapolitan villa by gutting its interior and constructing a huge staircase

down to a suite of new rooms deep in the ground below. Buren the artist (who actually carried out his scheme, only to have it censored by the museum) and Pesce the architect (who was not in the end backed by the villa's owner) formulated their ideas for very divergent reasons. But the strategies employed to implement Buren's political motives and Pesce's romantic impulses are not so far apart, and they are presented in this exhibition through the same combination of words and images.

Speaking for myself, I would not applaud any interaction between art and architecture which ended up blurring the distinctions separating the two activities to an anarchic degree. It is healthy to have an exchange of views and a greater awareness of what other media are doing in any culture, but it is equally vital to retain a sharp awareness of how particular activities differ from each other as well. So long as both these priorities are kept in mind, however, the preliminary shaking of hands to be witnessed in this exhibition is a welcome sign that architects and artists do not want their damaging estrangement to continue any longer.

JOHN HILLIARD
10 April 1975

Five black and white photographs, all mounted in frames of an identical size and hung as a cruciform pattern on the wall, confront the visitor who walks into John Hilliard's exhibition at the Lisson Gallery. They look harmless and peaceful enough. At the top of the group, a girl is shown quietly fishing in front of a bridge. On the right, a lilo and an inflatable ball float on water. On the left, some shirts dangle from branches over a stream. And in the bottom picture, an empty drinking flask lies on the edge of a river bank, its stopper alongside. Four pastoral scenes, all positioned around an even more tranquil view of a pool placed in the middle. Viewed singly, they amount to an unexceptional portrayal of some pleasant rural locations.

But Hilliard's composite arrangement makes sure that this mood soon gives way to a feeling of unease, as we discover that each photograph is inextricably linked with its neighbours. The section of pool shown in the central frame also forms a part of the other pictures surrounding it. They take this neutral view and extend it upwards, downwards and sideways, changing its meaning in every case. Once this connection has been

established, it enables us to see just how much an innocuous image of nature at her most straightforward is open to total manipulation. And the process of change in itself creates an awareness of overtones which were not originally suspected. The girl beside the distant bridge transforms the water into an urban river, a lifeline for someone who wants to escape from the city into solitude and relaxation. The empty lilo, containing a book still open at the place where its reader suddenly left it, hints at an accidental drowning. The hanging shirts suggest that their owners have just washed them in the stream because it is an extremely isolated setting, and there is no other method of cleaning clothes. The empty flask implies that a thirsty traveller has abandoned it after realising that the water is hopelessly polluted.

Such inferences might sound forced and over-dramatic stated like this, but in Hilliard's photographs thay all grow out of a mundane context which is discreet rather than laboured. The disquieting aspect of the work lies in its calm, methodical demonstration of how a harmless picture recorded by the camera can be twisted and even contradicted by a shrewd editing intelligence. The stretch of water becomes a passive vehicle for whatever strategies are inflicted upon it, and Hilliard's canny cropping testifies to the ease with which a photograph's supposedly factual authority often conceals the most extravagant fictional distortion. It is all analysed and held up for inspection here: the group of pictures could only have been assembled from one complex photograph full of situations carefully devised beforehand. But in advertising or journalism, where Hilliard finds many of his structural starting-points, similar manipulations are never explained. They are employed all the time to heighten a selected version of so-called reality, and sometimes – as in the case of James Jarché's vivid shot of a policeman chasing a naked gaggle of boys through Hyde Park – the whole incident is 'laid on' by a cameraman prepared to pay for a staged and simulated slice of life.

Hilliard, by contrast, lays out and explains the ambiguous falsehood inherent in any photographic documentation, and by doing so promotes a keen awareness of how we habitually interpret a given collection of signs and symbols. Once the central pool picture has been identified as the controlling image in the group, it becomes a visual conscience which insists that every seeming set of codes we accept in a photograph is open to flagrant abuse. Not that Hilliard takes this abuse as the pretext for an outright polemic. He articulates his disturbing situations with clinical dispassion, using a content so loaded with implications about the way society absorbs pictorial information that he does not need to present it emotionally. Instead, the whole exhibition is conceived as a controlled

63. John Hilliard, *Cause of Death?* 1974

series of four distinct variations on the theme of editorial manipulation, and each variation charts that theme through its own internal order.

Although they differ considerably in structure, none of them resorts to any overt bombastic devices. Just as the pool group restricts itself to the exploration of an unremarkable everyday scene, so the other exhibits concentrate on equally natural locations. Hilliard has called a book reproducing three of these works *Elemental Conditioning*, and the title indicates his preference for subjects that look as untouched as possible by the artist's intervention. Unlike several earlier pieces, which relied on people performing in often theatrical tableaux, these new works dispense with artifice and settle for simple, apparently unarranged raw material. In *Black Depths*, for example, the four dark squares grouped together in the

left-hand frame are widened out in the other frame to disclose a starlit sky, sea growths in a pool, the heart of a fire and a cave-like bed of rocks. In other words, all four rely on pre-existing phenomena, and their clear reference to the four elements of fire, earth, air and water is matched by their directional leanings towards the north, south, east and west.

Needless to say, *Black Depths* counteracts this feeling of natural inevitability with its decision to isolate the four squares on the left. Their minimal, compact strength reminds us that Hilliard still brings the sensibility of his sculptural training to bear on these photographic works: each block or segment of a picture is treated as a unit of form as well as a conveyor of visual facts. But where an orthodox sculptor might feel free to dispose such units according to his private expressive impulses, Hilliard's forms are subservient all the time to the elucidation of a lesson in signreading. He is more like a teacher than a maker of subjective art, and in the two most concentrated works on view at the Lisson Gallery form and content meet very succinctly.

One deals with stones, the other with an apparent patch of mist; and both condense Hilliard's didactic intentions into four self-contained images. Brief captions accompany the pictures to explain how their upper, lower and sideways extensions reveal totally different aspects of the substance he is investigating. The stones thereby become a wall, a ring round a fire, a path across a stream and a piled-up shelter, while the 'mist' changes from steam to fog, cloud to smoke. In every case the direction of the form–unit is dictated by the kind of element Hilliard uses. And the one section common to all four photographs is more subtly deployed than elsewhere, because it is not singled out on its own as a tactical key with which to crack the code operating in each piece. This succeeds particularly well in the steam/fog/cloud/smoke group, where Hilliard's intervention is reduced to an absolute minimum and the metamorphoses seem utterly true to the material in every instance. They possess an in-built organic symmetry as well as a schematic one, and their gentle revelation of the photograph's capacity to undergo sea-changes in meaning is permeated with a poetic appreciation of the many shifting faces nature can assume.

BOYD WEBB AND OTHER DÉBUTS
24 July 1975

This is the time of year when, if you are lucky, it might be possible to find in the London galleries young artists who are worth discovering and remembering. The college diploma shows have by now been held, producing a number of possibilities for dealers observant and energetic enough to give a promising graduate a first showing. And besides, the onset of mid-summer means that some galleries at least are prepared to mount group exhibitions of unknown names rather than rely on more predictable work by established reputations. Three such artists can be found at the moment in the new PMJ Self Gallery, Earlham Street, which has gone out of its way during the short period it has been open to air young and relatively unexposed talents. The current trio all use photographs as their medium, and to that extent they share some common ground. But the uses to which they put the camera vary enormously, demonstrating how flexible the seeming uniformity of the photograph can be.

Boyd Webb, who has actually been seen in London once before as part of a show of New Zealand artists working in this country, started out dealing with subject-matter from his homeland. But he approached it in a way that revealed a close knowledge of the international vanguard. Although his decision to photograph the various stages of a sheep-shearing session in sepia tints seemed, superficially, to be the act of an innocent country lad, it really sprang from a sophisticated understanding of how other modern artists have studied similar rituals in the same stage-by-stage manner. Absorbed in his superbly practised task, the shearer drove his razor through the wool like a sculptor shaping his raw material, and Webb emphasised this analogy by presenting the whole operation as a series of decisive moments which gradually transformed the animal's whole identity. But it was the reality itself, not Webb's treatment, which held the attention; and he fed far more of his own personality into another piece that took an old Maori legend about Lake Wakatipu and deflated it with affectionate wit. The knees of a 'fearsome monster' called Te Tipua are supposed to have formed the mountains around this lake, and its mysteriously rising water levels are attributed to his deep subterranean breathing. Webb therefore placed some photographs of the lake above some shots of upturned knees in a bath – arranged so exactly that the human limbs paralleled the actual mountains – and raised the bath water by blowing some bellows in and out.

It was an ingenious concept, and at the PMJ Self show Webb now uses colour photography combined with printed texts beneath to illustrate his own series of contemporary fables. They are wry and deadpan, produced with immaculate precision and displayed very formally in mounted frames. This correctness is, however, employed as a foil against which Webb plays off his strange and almost anarchic sense of humour. One typical story explains, in a matter-of-fact way, how a man manages to grow a lichen inside his mouth in order to make himself eligible for a disability pension. This enables him to indulge his passion for betting, and the text explains that 'nutrients essential for this lichen's survival are filtered from the humid fug of despair, jubilation and nervous effluvium peculiar to betting shops'. A telling piece of social observation is thereby produced from an otherwise macabre fantasy, and the documentary style of a first photograph, showing the man entering a betting shop, gives way to repugnant comedy in a second picture, where his mouth is being prised open to reveal a bed of brown, tobacco-like substance covering his tongue. The effect is both light-hearted and disturbing, a dual quality shared by all Webb's exhibits; and if he can manage to avoid becoming merely fanciful in the future, he might well develop the fable idea into an effective vehicle for commenting on the insane logic of our times.

Michael Peel, who has arranged three long, horizontal rows of photographs across the top, middle and bottom of the end wall, could not be more different in his approach. This time, the pictures are black-and-white, unframed and taken with no obvious concern about the attractiveness of the end result. They are there more as a comprehensive record of the gallery's interior, and most of them are taken up with the circular bulk of the tall, white columns which punctuate the space in this converted Covent Garden warehouse. Peel calls the piece *View-finder Installation: Column Location*, which is precisely what it tries to articulate. In almost every case the ceiling capital, middle and base of one or more of the pillars are taken as the starting-point for a methodical tour around the gallery. And the assembled photographs do promote a greater awareness of the architectural environment in which they hang. Whether this awareness amounts to anything more than a patient catalogue is open to doubt: I found that the wealth of visual information did not, in the end, justify itself in terms of the insights it offered. And Peel fails to make clear why exactly the central row of photographs contains one less image than either of the other two.

If Peel restricts himself to documenting the material on hand in his immediate surroundings, Richard Johnson goes to the opposite extreme

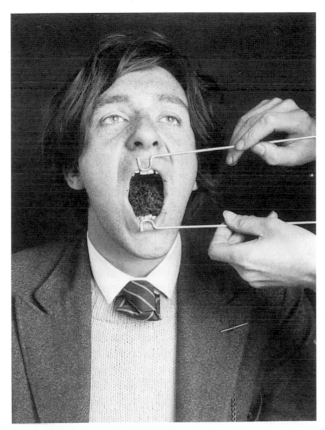

Through skilful husbandry the lichen Sponsio Grovesiaceae has adapted successfully to the inclement environment of the human throat. Nutrients essential for this lichen's survival are filtered from the humid fug of despair, jubilation and nervous human effluvium peculiar to betting shops.

64. Boyd Webb, *Herbert Groves*, 1973 (detail)

and displays photographs of a videotape which records an event taking place in a remote stretch of countryside. Twelve small, slightly sepia images, followed by six larger monochrome details, focus on the activities of a girl in a rocky landscape. She crouches, gets to her feet and moves from one area to another, apparently engaged in moving some stones or

other objects to a different location. But it is not made at all clear, even in the blown-up pictures that close on the girl's movements and omit most of her environment, what is taking place. Presumably Johnson does not want us to know: his previous involvement with the Strider dance group would suggest that he intends to concentrate on the gesturing of limbs for its own sake. And this emphasis on almost abstract pose is further reinforced by the blurring effect from the video screen, which runs across the photographs and guarantees that the precise meaning of the girl's actions becomes indistinct. In that sense, Johnson seems to be searching for a means of transferring his interest in dance to a more static medium, and the bewildering variety of ideas noted in his 'journal', also available to read in the gallery, suggests that he has yet to find a satisfactory form of alternative communication.

But it is through exhibitions like these that a young artist can get the chance to decide how best to develop. They should be staged far more frequently than they are at the moment.

THE ITALIAN AVANT–GARDE AND PALLADIO
28 August 1975

There would seem, on the face of it, little point in drawing comparisons between the Andrea Palladio exhibition at the Hayward Gallery and the survey of Contemporary Italian Artists at PMJ Self in Earlham Street. The Palladio show is a massive and definitive event, examining the life and times of a sixteenth-century Italian architect who exerted enormous influence in this country. Whereas the Self offering is a modest introduction to the work of twelve artists scarcely seen in England before, selected by Angelo Bozzolla in the hope that it may pave the way for a long-overdue major exhibition of recent Italian art in London. The pamphlet accompanying this show makes only a brief attempt to place it within a larger perspective, and is often enigmatic: Pierpaolo Calzolari, for instance, is restricted to the statement that 'as for explanatory notes, I am sorry, but it is not my habit to accompany my work with texts'. The Palladio survey, by contrast, is armed with a long and scholarly text from the Renaissance historian Howard Burns, who makes every effort to explore the social, cultural and economic conditions which enabled this prolific architect to realise so many of his projects.

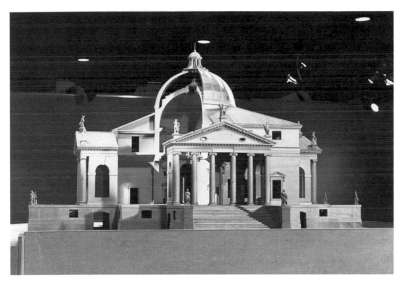

65. Installation at the Palladio exhibition, Hayward Gallery, London, 1975

Nor do the differences stop there. Palladio, dependent throughout his career on commissions from patrons who wanted each of their palaces, churches and above all villas to serve a specific function, knew exactly what role he was supposed to play in northern Italian society. He may sometimes have complained that 'often it is necessary for the architect to fit in with the views of the people who are spending, rather than with what one should observe.' But he was at least sure of his overall context, studying Vitruvius and Roman architecture in the confident belief that he could thereby anchor his work in the fundamental principles of design and apply them to the requirements of his own age. As if in response to his enviable sense of certainty, the Hayward exhibition supplies not only large photographs of Palladio's major buildings, but fleshes them out with spectacular wooden models, an absorbing sequence of colour slides, many original drawings, and paintings, sculpture, furniture, applied art and books which go a long way towards recreating the framework in which he operated.

No such singleness of purpose buttresses the contemporary Italians' contributions, however. Although the inclusion of middle-aged artists like Giuseppe Chiari and Mario Merz emphasises a linking of interests between the generations, none of the participants displays any faith in

66. Jannis Kounellis, *Parrot*, 1967

the ability of past art to provide them with the sustenance Palladio drew from classical antiquity. Architecture is, of course, a far more utilitarian discipline than art, which could not be expected to aim at satisfying the practical needs Palladio always had to bear in mind. But there is still a stark divide separating Renaissance notions of art activity from the complete contextual vacuum which the Italian avant-garde inhabits, a *laissez-faire* situation dominated by the single rule that there are no rules at all. If Jannis Kounellis can bring a live parrot into the gallery and position it against a painted sky, Sandro Chia feels able to exhibit a real grey top hat with photographs, tucked neatly into the hat-band, of a baby staring upside-down through its legs. And if Bagnoli appears to thwart any prospect of communication by supplying one small sheet of closely written brown paper, full of almost indecipherable jottings, diagrams and

equations, Chiari makes his ironic message only too plain by broadcasting the message 'ART IS EASY, ART IS FASHION' in huge capitals handwritten on paper hung well above the visitor's normal line of vision. Nearby Vettor Pisani continues Chiari's use of art to comment on art by exhibiting two identically proportioned glass palettes, one clear and the other a mirror, while Maria Teresa Corvino provides a more factual alternative to Pisani's interest in the artist as narcissus with a stage by-stage photographic documentation of colours being mixed on a plate to prepare for painting.

The prevailing mood is therefore wry and alienated, far removed from any straightforward belief either in the art object or in the function art itself might fulfil. Even the obvious attractions of the multi-coloured parrot, whose natural beauty is brought into a head-on confrontation with the man-made painting hung behind it, carries a sting in its tail: a notice beside it warns that 'This Bird will Bite'. And Merz's Igloo structure, rooted like all his work in Fibonacci's organic numerical system, disperses comforting thoughts about an underlying harmony and order with its jagged edges of broken glass. But the igloo is not an aggressive image. It shares with its neighbours a disdain for the artist as craftsman, and employs the most mundane materials to emphasise its detachment from the formalist tradition.

The most apparently conventional exhibit here is Bozzolla's series of drawings, seventy-two sheets arranged in blocks of nine and each containing six little sketches with the same typewritten text describing 'a universe of imprecise dimensions, of which the centre is everywhere and the circumference in no place'. With their echoes of Cézanne, Goya and even an arch-romantic like Victor Hugo, these tiny, rapid notations of landscape imagery are filled with shifting, baleful atmosphere, hints of blasted trees and figures dwarfed by their surroundings. They do not, however, represent a positive desire to place themselves within a particular tradition of draughtsmanship. Bozzolla's nervous handling is more like a common denominator, evolved in order to express himself with the minimum amount of elaboration and technical fuss. Man and the elements are all caught up in one continuous chain of light and shadow, lacking in focus and any hierarchy of values.

Palladio possessed a very clear understanding of the hierarchy as he and his society saw it. The Hayward show is aptly subtitled *The Portico and The Farmyard*, thereby summarizing the way in which sixteenth-century Italy used the language of classicism to articulate a carefully graduated order of priorities. The portico was reserved for the grand entrance to the main section of the villa, which extended with superbly organised

logic through to the outlying wings containing the farm buildings. The hard economic necessity of agricultural labour took its subservient and yet dignified place within a scheme of living, which came to a climax in the temple reserved for the landowner and his family; and Palladio's graceful, rational method of integrating the one with the other reflects a social balance long since destroyed. His present-day successors cannot share the assumptions he took for granted, and these two exhibitions between them dramatise the total fragmentation which Palladian unity has been forced to undergo.

STEVE WILLATS
16 October 1975

An absorbing show called *Meta Filter*, organised by Steve Willats at The Gallery, succeeds in proposing a new and positive way of redirecting art towards a more direct engagement with society. The title of the exhibition refers to a large computerised machine which takes up most of the gallery's space and invites two people to sit down, one at either side and invisible from each other, in order to respond to a series of problems posed by the machine. *Meta Filter's* subtitle is *A State of Agreement*, which neatly summarises the overall aim of the project: to invite its operators to compare each other's solutions to the problems presented by the machine and then, if these answers differ, to work through a number of alternatives until a consensus has been reached. Right at the outset, then, it is important to realise that *Meta Filter* does not base itself on the conventional idea of a test or quiz, to which there is one definitive, award-winning set of replies. The whole point of the exercise lies in the interaction between its operators, as they come to terms with the challenge of finding a solution which accommodates both of the attitudes they hold. And since the problems all take the form of photographs showing people relating either to themselves, to groups, or to permutations of the two, the entire programme revolves around how we all behave towards each other in easily recognizable, everyday situations.

 To begin with, the operators both press their 'start' buttons and look at the identical photograph they find on the screen in front of them. They then find the same picture in the Problem Book lying on their desks, and attempt to answer the question printed beside this picture. The

67. Steve Willats, *Meta Filter* installation at The Gallery, London, 1975

first photograph, for instance, shows a girl sitting alone in an empty room, and the operators have to decide whether she seems apprehensive, relaxed, angry, forlorn, etc. The word they eventually choose has to be selected from a thesaurus of nearly one thousand numbered words displayed beside the screen; and the operators feed their choice into the machine by punching out the word's number on their keyboards. This number is duly registered on each operator's display board, so that they can see at a glance how greatly they differ in their answers. The procedure is then repeated, with both sides attempting to find new words which come closer to an area of agreement, until they finally settle for a solution which satisfies the two players.

Six attempts are permitted, and since most people reach an agreement within this limit, they are then presented with a new photograph on the screen and the whole process begins again. After twelve photographs have been debated, the programme ends and the operators hand over the twelve forms they have also filled in with details of their choices. These forms are pinned on the wall, on top of the forms submitted by previous participants, so that comparisons can be made. Each session usually lasts about two hours, but if the operators fail to agree on any of the photographs, they remain stationary within the system and are required to

sort out their differences with a new problem drawn from the same kind of group behaviour. Players who fail to see eye to eye could, therefore, take several hours to complete the exercise.

If all this sounds impossibly complicated, let me hasten to add that the system becomes easy to handle after only one trial run. And the fascination of pitting your own interpretation of the photographs against your partner's makes the time pass very quickly. I happened to sit down to *Meta Filter* opposite my wife, and so we tended to agree on each of the twelve sections without too much agonizing. (This doesn't reflect on the harmony of our relationship: it just means that married people are usually adept at compromise and share a certain number of attitudes before they even begin the test.) It would therefore have been more stimulating to go through *Meta Filter* with a total stranger, preferably someone with a different social background who could vigorously contest all your responses and oblige you to take into account a way of thinking you might never have encountered before.

That, after all, is the fundamental point behind Willats's reasons for devising the work, which took two years to assemble with the help of an electronic engineer. Accepting the fact that our society is riddled with an enormous number of diverse groups, all interpreting the world in sharply differentiated ways, *Meta Filter* sets out to provide people with a flexible and not at all authoritarian method of finding some common ground, where their separate viewpoints can meet and learn from each other. There is no single set of correct responses to Willats's tests: that would negate the whole web of cross-references which *Meta Filter* sets up as a model of the social pluralism in the Western world. Hence the deliberately neutral character of the photographs Willats supplies, inviting us to feed our various codes of behaviour into situations which can be read in a number of different and even flatly opposed ways. (Asked to interpret how a group of girls in one of the photographs might be reacting to the suggestion that they go for a walk, I thought they were 'resenting' it, whereas my wife insisted that they found it 'invigorating'.)

It could well be objected that all the hardware, the detailed problems and the lists of words provided by *Meta Filter* are unnecessary, that the same results could be achieved simply by getting people to sit together in a group and exchange views. But the fact remains that Willats has created a carefully structured situation which facilitates a far more intensive exchange than would otherwise be possible. And *Meta Filter*, to be installed in a series of shops around the country after it leaves The Gallery, is calculated to attract members of the public who would not otherwise dream of entering into group discussion of this kind. There,

situated in the high street or a busy shopping precinct, it will grasp the attention of people utterly uninterested in the kind of contemporary art which remains so divorced from society at large.

CHARLIE HOOKER: THE PLIGHT OF THE NEW
31 December 1975

On the last Saturday before Christmas, a small audience assembled at the PMJ Self Gallery in Earlham Street for a performance of Charlie Hooker's *Six Sound Pieces*. It was in many ways an impressive event. During the course of an hour or so, a group of performers carried out a series of well-organised exercises which involved walking, clapping, beating on wood blocks or drums, and hammering out notes on the keyboards of four pianos. Some detailed programme notes enabled the audience to grasp the structure of each piece before it began, and thereby to enjoy Hooker's method of taking a simple rhythmic idea, then multiplying, varying and overlaying it with related alternatives so that complex patterns of sound and movement were produced. The pleasure was to be found in the clarity both of construction and execution: Hooker made sure that the initial starting-point was never lost sight of, however dense the eventual polyphony became. Every successive stage in the permutations he evolved was made aggressively explicit, sometimes to the point of downright crudity. For Hooker was prepared to sacrifice subtle nuances if it meant that his muscular, driving exposition could be enhanced.

It was an honest and inventive evening, devised by a young artist not long out of college who already has an uncompromising confidence in his ability to explore an area still very much neglected in this country. Hooker occupies a place half-way between the experimental music of a composer like Steve Reich, and the 'conceptual' strategies of an artist like Sol LeWitt, who shares a similar fascination with setting out a programmatic idea and seeing how it takes on a new, non-verbal identity when translated into line or sculptural form. Whether or not Hooker's involvement with sound will finally lead him outside the territory of visual art altogether, he certainly deserves support from writers and galleries who believe that much valuable contemporary art is being developed beyond the categorial boundaries of painting and sculpture.

68. Charlie Hooker, *Six Sound Pieces*, 1975

But what hope has he got of finding further venues for his perform-
ances, dealers or patrons who will back him, audiences prepared to turn
out for him and sit on a warehouse floor on a foggy December evening?
This, it seems to me, is the one question most worth asking at the end
of 1975, a year which has witnessed a steadily worsening decline in the
prospects for a vigorous contemporary art scene in England. Wherever
you look, the situation seems even grimmer than it did twelve months
ago, when I complained in this column about the desperate lack of inter-
est in – and support for – living artists both in London and elsewhere.
Hooker's work cannot be sold, and dealers altruistic enough to give him
a showing therefore have no chance of recouping either their running
costs or the hiring fees for his equipment. But even if he did offer a
saleable product, there is absolutely no tradition in this country of col-
lecting experimental art, and the few people who did once make some
attempt to buy have now been discouraged by a world-wide slump in
the contemporary market.

The appalling dearth of private English patronage, which itself pro-
vides one of the main reasons why there are so few galleries here to back
young (and not-so-young) artists, is symptomatic of a general lack of
concern for modern art. While sales at the Royal Academy's summer
show continue to boom, reflecting an undiminished appetite for the

familiar, the hackneyed and the safe formula, attendances at every gallery which attempts to back more experimental art have reached a new nadir during the past year. It would not matter if people actively disliked the exhibitions they saw, as long as they were actually visited, discussed or acknowledged in some way. But not to be seen at all is the most depressing fate that can befall any artist, and the results of this wholesale neglect are bound to be damaging.

Lucy Milton, who managed to run a lively and committed gallery at Notting Hill devoted to new systematic and constructive art, was forced to close at the end of September after four years of resourceful effort. And at least one prominent contemporary gallery, Nigel Greenwood, prolonged the run of a single show by Ger van Elk throughout the autumn season to ensure that some of the people who ought to have bothered to see it actually did so. In other words, the small corpus of dealers devoted to the modern artists most in need of exposure are being affected by the widespread deterioration of interest evident throughout the entire support structure of the English art community.

Simply because London remains the only city in this country with anything approaching a network of galleries devoted to contemporary activity, an inordinate amount of responsibility for this state of affairs rests with the two bodies at the head of the capital's structure: the Tate and the Arts Council. I have argued before now that the Tate's efficacy as a Museum of Modern Art is thoroughly castrated by its impossible dual role, and the need for a separating-out of these two functions is now more urgent than ever. Only by leaving the present Tate building to concentrate on the historic British collection, and by moving into new premises with its own expanded staff and financial resources, can the Tate ever hope to fulfil its obligations to show living artists comprehensively, and also pursue an exhibition programme no longer hamstrung by events like the forthcoming Constable survey. I gather that a new policy directed towards smaller, more regular shows of work-in-progress will shortly replace the present leaden emphasis on mammoth retrospectives, and that the opening of the new extension will enable the Tate to put much of its notoriously hidden holdings on permanent view. But this amounts to nothing more than another stop-gap measure, and the sooner the Millbank muddle is sorted out rationally, the nearer we will be to having a major museum devoted unequivocally to the dissemination and elucidation of art now.

The same applies to the Arts Council's programme at the Hayward Gallery, which at the moment echoes the Tate's preoccupation with hallowed figures like Constable and Paul Nash: after the Burne-Jones show

ends on Sunday, a centenary survey of Jean-François Millet runs until March, to be followed by an enormous four-month exhibition on The Arts of Islam and then, to delight art historians even further, the history of the American Indian. Where, you may well ask, is the contemporary art which the Hayward was supposed to display when the Arts Council first took the building over? The answer is to be found in a hybrid series of group shows held upstairs and entitled *New Work*, which mix together a haphazard brew of disparate artists (present participants range from Bryan Kneale to Gerald Newman, neither of whom quite knows what he is doing in the other's company). Whatever the good intentions behind this idea, I am afraid it looks like a half-hearted attempt to appease all those who quite rightly claim that the Hayward has abandoned any serious commitment to modern art. Until the Arts Council reverses its priorities, and decides that the Hayward should be given over exclusively to staging large-scale surveys of the influential artists who have *never* been given a proper airing in this country – the list grows longer and more shameful all the time – England might just as well abandon its feeble pretensions to being informed about current developments long since absorbed in Europe and America.

It could, I suppose, be claimed that big institutions will always lag behind, and that supposedly livelier bodies like the ICA, the Whitechapel, the Serpentine, the newly opened AIR gallery in Shaftesbury Avenue or a partisan co-operative such as Artists For Democracy in Whitfield Street should be relied on to provide the real initiative. Valuable work is indeed being done in this area, particularly by Barry Barker's two-roomed upstairs gallery at the ICA, but none of them has the space or the money to mount the kind of major shows we so desperately need to see. Without such shows, ignorance and parochial standards thrive, limiting the horizons of everything which happens within the non-institutional sector. It is symptomatic of our blinkered deficiencies, for instance, that London has no biennale, no regular international round-up of the new art being produced – largely unknown to us and almost wholly unseen – by the world outside this self-absorbed island of ours.

In order to ensure that young artists like Charlie Hooker evolve properly, we ought to expose them to the full range of present-day activities. For without such exposure, their work suffers, their potential audience grows smaller month by month, and England as a whole has every excuse to relapse into its time-honoured habit of shutting its eyes and pretending that modern art does not exist. I believe we are now, at the beginning of 1976, in grave danger of doing just that.

VICTOR BURGIN
12 February 1976

The illustration reproduced in my column this week could easily be mistaken for an advertisement. It will no doubt be seen in this way by many readers leafing quickly through today's *Evening Standard*, because the devices it relies on are similar to the ones which any sophisticated agency with a product to sell would employ. Rhetoric, at the same time subtle and unerring, is the name of the game behind both the photographs and the captions it contains. A persuasive combination of word and image, which invites you to enter into the dream advertisers are always feeding into your

Reflect Contradiction

Thinking of a change?
The change that changes everything
Two words — class consciousness
You'll never be the same again
Not just a different you, a radically different you

69. Victor Burgin, *Reflect/Contradiction*, 1975

conscious – and more particularly your subconscious – mind whenever you come across one of the many outlets they use within the media.

I do not know, at the time of writing these words, what kind of advertisement will be placed on this page, nor what it will be attempting to promote. But I can be fairly confident that it has a lot in common with the illustration I have chosen to accompany my review, since Victor Burgin, the artist whose exhibition at the ICA New Gallery I want to discuss, has deliberately raided the techniques of advertising in all his recent work. Indeed, the piece shown here is hardly distinguishable from those produced on behalf of the secretarial agencies which provide the *Evening Standard* with a substantial part of its revenue. Without such revenue, this newspaper would not be able to continue in its present form, I would not be able to earn a living as a critic, and artists like Burgin would not be able to see their work reviewed in the popular press at all. An obvious statement for me to make? Yes and no: the power and presence of advertising in a capitalist society is sufficiently apparent for everyone to be aware of it, and yet it is so deeply embedded in our way of life that we hardly ever pause to think about either its weapons or its implications.

Burgin, in common with a growing number of young English artists, has however become increasingly preoccupied with the language system developed by advertisers. He realises, like the Pop Art movement over a decade ago, that this language system is rich and pervasive enough to offer an absorbing fund of source material for any artist aiming at a direct, organic relationship between his work and the fabric of society today. But he also realises, unlike Pop Art with its gleeful acceptance of advertising's most glamorous attractions, that this same language system offers an extraordinarily concentrated reflection of the ideology which dominates Western civilization. Burgin, a socialist who sees no reason to divorce his political convictions from his art – and furthermore believes that any artist attempting to make apolitical work is labouring under a delusion – therefore appropriates the codes of advertising in order to expose the full ramifications of the priorities they uphold.

I share Burgin's socialist beliefs and, perhaps more importantly, his concomitant unwillingness to see art used as a propagandist tool. It is an admirable ambition to deflect modern art from its chronic and dangerously limiting habit of dissociating itself from the 'impure' realities of everyday life and producing an ingrown dialogue addressed only to a charmed circle of avant-garde specialists. But it is equally admirable to spurn the crude, slogan-ridden simplifications adopted by too many left-wing activists, who try to redress the injustice they oppose with aggressive bombast and populist clichés.

Instead of shaking a hot-headed and ineffectual fist at his targets, there-
fore, Burgin's exhibition offers a coolly ironic dissection of the ideologi-
cal tactics which capitalism employs. We all know that advertising is, in
the main, dedicated to fostering a spirit of rampant materialism, go-get-
ting acquisitiveness and all the other urges which stand in such stark con-
trast to the egalitarian ideal of universal love and compassionate respon-
sibility. Merely to rail at these ills is to run the danger of boring an already
wary and disillusioned public who know, instinctively, that the issues
involved can no longer be presented in simplistic, black-and-white terms.
Although many self-styled 'revolutionaries' will fail to find satisfaction in
Burgin's work, the course he has adopted is fully justified: to study the
workings of admass with rigorous analytical precision, so that the works
he produces can reveal the codings of the culture under investigation.

Burgin himself is the first to admit his profound debt to semiology,
which was defined by its founding father, Ferdinand de Saussure, as 'a sci-
ence that studies the life of signs within society'. The earliest work on
view in the exhibition, *Lei Feng*, announces this debt in a very overt way
by combining an advertisement image and a Maoist fable with long
stretches of semiological theory. When *Lei Feng* was first shown, in 1974,
it marked a turning-point in Burgin's development and I was impressed
with the possibilities it opened up. The central confrontation between
the Harvey's Bristol Cream sherry ad, where some well-heeled bour-
geois parents are toasting their daughter's success as a cover model for
Vogue, and the rigidly Communist Chinese moral about the social
virtues of dying in a mining disaster, was well pointed. The theoretical
text alongside it was welcome then, because it helped to explain
what Burgin's strategies were. But now, in comparison with newer works
displayed in the adjacent room, that text seems laboured, unnecessarily
explicit, and full of indigestible semiological jargon. It weighs down the
succinct exposing of ideologies, which grows more and more devastat-
ing as you follow the work through each of its nine separate panels, and
threatens to reduce it to a rather pedantic exercise. Above all, it ignores
the cardinal rule of the sign-system it seeks to unmask: most good adver-
tisements never present their audience with too much verbal informa-
tion. Their impact is instantaneous, their message easy to absorb.

That is why *Hussonnet*, the most substantial of the recent works in the
show, constitutes such a marked improvement on *Lei Feng*. For the the-
oretical discourse has disappeared, the photographic image assumes a
more appropriate place in the centre of each of the seven posters which
make up the whole work, and the captions − printed above and below
the picture − are both simple and direct. *Hussonnet* looks, then, like a

series of advertisements: its absorption within the codes it wants to lay bare is as total as that. Taken together, the posters would not appear out of place at a trade fair, papering the walls of a stand belonging either to a sink manufacturer or the Metropolitan Water Board. For the repeated image shows a luxury bathroom, replete with expensive tiles and potted plants, where the place of honour is occupied by a lavish curved sink full of water reflecting an attractive model's face. She seems almost to be lying under water, the beckoning and siren-like focus of a highly stylised composition which any surrealist artist would be proud of. But it is in fact an actual advertising image, transplanted wholesale from its original magazine context and thereby showing how much professional skill is lavished on such an image by agencies which are, after all, full of experts trained in art colleges.

The irony of a society that finds its artists employment as top-flight commercial manipulators is fully driven home, albeit in the most discreet and subliminal way imaginable (just as the best advertisements do). And Burgin proceeds to compound his exposure by juxtaposing the upper text, full of an obsessive emphasis on endless rinsing and cleanliness, with a lower text culled from Flaubert's novel *Sentimental Education*. The title of the work, *Hussonnet*, is taken from one of the characters in this book, who early on explains that 'he worked for the fashion papers, and designed advertisements for *Industrial Art*'. But aside from that, Burgin's quotations are sarcastic descriptions of the 1848 Revolution, so that he is able to confront a cleansing phrase like 'Now. Science confirms what you always knew', with the Flaubertian comment that 'Heroes don't smell very nice!' The whole work is replete with cleverly engineered humour – a tactic ignored by most militant propagandists – and the climax in the seventh poster is superb: 'You're clinically clean!' is opposed to 'a prostitute was posing as a statue of liberty'. *Touché*.

I will leave the work illustrated here to speak for itself, apart from saying that its choice of images (the left-hand girl slouched in static close-up, the right-hand girl striding even further to the right in full-length liberated flight) is as carefully judged as the purring captions. Its presence in this newspaper is more than apposite, and exhorts us all to cast a far more wary and critical look at the advertisements we take so much for granted. But Burgin should ponder on its presence here as well, because the work he is so fruitfully pursuing cries out to be placed beyond the galleries, and in among the source material he studies with such intelligence and cunning.

COUNTDOWN TO A MILANESE OPENING
4 March 1976

The most comprehensive exhibition of contemporary English art ever held opened last week at the Palazzo Reale in Milan. Organised jointly by the British Council and the Commune of Milan, and selected by a committee of which I was a member, it sets out to chart the major developments in English art from 1960 to the present day. This is how the week's events built up to the official opening last Friday.

Tuesday: Immediately after our arrival in Milan, all cosy thoughts of a pro-English week were dispelled by news of vociferous demonstrations by sacked workers from British Leyland's Innocenti plant. Victor Burgin, one of the artists in the exhibition, had apparently walked up out of the subway in the central cathedral square to be greeted by a cloud of tear gas from a nearby clash between demonstrators and police. While a performance in the same square by Roland Miller and Shirley Cameron was punctuated with angry questions from Innocenti's former employees, asking why the British government had spent so much money on an art show when they should have been saving car workers' jobs in Italy.

By midday, however, the situation had eased. Coum, an English performance group consisting in this instance of a woman (Cosey Fanni Tutti) and a man (Genesis P-Orridge), set up a scaffolding structure in the middle of the magnificent Galleria Vittorio Emmanuele arcade. Even before they began their performance, an enormous crowd had gathered in this, the heart of Milan's public city life. And while the two performers executed their restrained and remarkably balletic dialogue with each other, Cosey for the most part swimming through a 'bath' of polystyrene granules while Genesis moved through the scaffolding above her, the onlookers were all silent with awed concentration. Afterwards, a knot of admirers gathered round Coum's café table to congratulate them, and I could not help wondering whether a comparable crowd in London would ever have responded with such appreciation and seriousness.

I spent the rest of the day in the Palazzo Reale, on the whole impressed by the way the Italians had divided up this labyrinthine building – larger than the Royal Academy's exhibition spaces – into almost fifty separate exhibition areas. The initial decision taken by the selection committee, to restrict the number of artists so that each one could be represented by a body of work amounting in most cases to a solo show, paid off. There is nothing more confusing, or indeed depressing, than a rag-bag group exhibition where hundreds of artists each show

70. Coum performing in Milan during *Arte Inglese Oggi* exhibition, 1976

one work, giving only the barest notion of the individual participant's ideas and evolution. With a fraction of that number on view at the Palazzo, a clear view was provided of each artist's particular frames of reference, even though they differed strongly about how they should be represented. John Latham, for example, held a wide-ranging mini-retrospective, whereas Barry Flanagan insisted on displaying a single monumental work, made nine years ago.

But no survey, especially when conceived on this scale, is without its attendant share of problems. Art & Language, understandably unhappy about the cramped section they ended up with, decided to stick their largest poster works on the walls of the courtyard outside the exhibition proper. In this instance, the move also coincided with their ambivalent feelings about appearing in a personality-oriented show like this one. Gilbert & George, on the other hand, who felt happy about the handsome gallery they were given, were forced to hang their room with a series of empty frames before the photographs that eventually went inside them could be disentangled from a hold-up at the customs. Bob Law's problem was different again: his very minimal black-and-white

paintings, which needed above all a bare, uninterrupted space, were cruelly interfered with by several heavily moulded wooden doors.

Wednesday: The catalogue arrived. Selling at 10,000 lire, it is an incredibly expensive production even by Italian standards, but a quick look was enough to prove that the publishers – Electa – have justified that cost with their high printing standards. Every artist has been given six pages in which to reproduce essays, statements and photographs of his or her work, so that an impressive amount of information is offered. However, the curious decision to divide the catalogue into two volumes, thereby segregating painting and sculpture from activities which cannot be defined within those categories, was unfortunate. It exacerbated divisions in an exhibition dedicated, at the outset, to bringing together as many different ways of working as exist in England today.

Avant-garde film, for instance, which has never been included in an art exhibition of this size before, is positioned here right in the middle of the Palazzo's rooms. But by siphoning film off into the second volume of the catalogue, and only giving each film-maker two pages as opposed to the artists' more extensive coverage, the old barriers are still upheld. Several of the performance artists likewise told me that, although they were given every opportunity to do their work *outside* the Palazzo, they felt disappointed about not being placed within the exhibition area as well. The implication being that performance art was accepted as an entertaining side-show, but did not qualify for inclusion among the 'real' artists.

R. B. Kitaj, one of the most senior painters in this survey, would not agree with the attempt to embrace the full range of current activities within English art. 'Italians, here is a short lecture: treat this exhibition with caution,' he declares in a militant catalogue statement. 'Degas wrote of Parisian art life: "There is too much going on," and now the demands of internationalist fashion have corrupted our art life so that a nation must be represented abroad by reflecting every aspect of modernist fragmentation . . . a new academy, a new establishment disguised as an avant-garde.' After this preliminary blast-off, Kitaj then goes on lament the absence of various artists from the exhibition, and to infer that it should have concentrated on figurative painting rather than the multiplicity of media and working methods represented at the Palazzo.

While I wholeheartedly agree with Kitaj's concluding hope that 'our art may be brought back from the trivial margins of society into the social heartland', I do not agree with his complaint about fragmentation. If this exhibition set out to do anything, it was to present a coherent and comprehensive picture of the extreme diversity of English art today. A survey of figurative artists might well be valuable, but it hardly fits the

brief we set out to supply. Indeed, the exhibition as it stands can be faulted for not being wider still, embracing the video art which has emerged from this country in recent years, and artists who are trying to define a new social function for themselves through their work. But then, no one would want to swamp the exhibition with an indigestible amount of material, and any anthologizing show of this kind is by definition prone to the dangers of invidious exclusion.

Thursday: The Italians love official speeches. Today we were treated to a glut of them, accompanied by translations, first at the City Hall and then in the evening at the Private View. Sir Norman Reid, the Tate's Director, who appeared yesterday to have almost lost his voice (too much of Carl Andre's brick-dust flying around Millbank, perhaps?) recovered sufficiently to speak on the platform. And the Milanese turned out in their thousands, far more than any modern exhibition in London could reasonably expect, to prove that Italians have an enthusiasm for contemporary art which compares very favourably with the Anglo-Saxons' traditional mistrust of an artist who does not conform with their preconceptions about what art should be. Is the exhibition an exercise in nationalist tub-thumping? I suppose so, but it also gives a lot of worthwhile English artists the chance to communicate with a wide European public, and hopefully to establish links which will serve them in good stead throughout the rest of their careers. If this happens – and I think the exhibition does its best to facilitate that kind of contact – the whole gargantuan enterprise will have been justified.

DANIEL BUREN AND TONY BEVAN
11 March 1976

In view of the intense scrutiny which dealers' galleries have undergone over the past few years, it is surprising how many artists still use them as the principal outlet for displaying work. During a period when the evils of the art market have been attacked again and again, when artists have experimented with a hundred alternative methods of locating their activities outside all existing gallery structures, and when categories like video or performance have been developed to open up new ways of presenting art outside the convention of hanging objects on walls, the dealer system has held firm. Indeed, it has recently come to be regarded more

and more as a womb, regrettable but necessary, for artists who know no other way of making a living and accept the fact that whatever they do must eventually be cast in a form capable of being shown within a gallery context. Documentation of projects originally carried out elsewhere are brought back into the fold of the one-man show; events initially conceived in order to reach a broader community audience are restaged inside the gallery as well; and artists whose work cries out to be disseminated in less narrow ways end up appreciating the chance provided by dealers to contact the specialist exhibition-visiting public.

In one respect, Daniel Buren's show at the Lisson Gallery reflects such a tendency. When this French artist first 'exhibited' in London early in 1972, he used the services of a dealer – Jack Wendler – only to sponsor the hiring of a large billboard in Shaftesbury Avenue. There he pasted up a series of pale purple vertical stripes, just as he had previously placed the same stripes on sandwich boards, tube posters and other comparable settings elsewhere in Europe. Then, a year later, Buren decided to move inside Wendler's gallery the next time he made his work available in London. But only with the proviso that each visitor had to see a videotape, on which Buren explained how the gallery conditions the way art is consumed, before Wendler was allowed to produce the stripe paintings themselves.

Now, three years later still, these tactics have been dispensed with altogether. Apart from a row of violet stripes running along the gallery's street-front on the right of the entrance, Buren's work is firmly contained within the Lisson's own space, and no intermediary warning or statement interferes with our response to how this space has been handled. It is as if he has at last consented to accept that a gallery is the one most efficient and appropriate method of broadcasting his work, and that there is no point in fighting the orthodox system of exhibiting any longer.

But the experience offered within the gallery is by no means as simple as that. Once inside the door, it quickly becomes clear that the row of violet stripes starts on the left-hand wall, travels round the first room, out into the stairwell beyond, round the corner to extend along the side of the dealer's office backing on to the first room, and then returns via the rest of the stairwell to travel across the remaining walls of the room. In other words, the given architectural space dictates the form that Buren's work assumes: the gallery floor is used a base for the stripes, which extend more than a foot up the wall all the way round. And when these same stripes are obliged to move on to a higher floor in the adjoining room, they are cut down so as to remain at the same overall level as the stripes in the first room. An identical system is also adopted in the basement floor below, which likewise consists of two rooms on different

levels. The only difference being that brown stripes are employed there in a continuous row without a beginning or an end – whereas their violet equivalents upstairs carry on out through the street door and are brought to a halt by the drainpipe on the outer wall of the gallery.

By restricting himself to this one unvarying format – each stripe is 8.7 cm wide, a size which has not changed since he first started working in this way some nine years ago – Buren deliberately offers a banal visual experience. And the basic height of these stripes is determined merely by the size of the paper he purchases to print them on. We are therefore invited to concentrate on how Buren has reacted to the architecture placed at his disposal by the gallery, because all the usual qualities we expect to look for in painting (brushwork, combinations of colours, drawing, tonal subtlety, variations in scale from picture to picture) are wholly absent.

So what does he leave us with, once the initial impact of the iridescent violet and the more muted brown has been registered? An exercise in ruthless Gallic logic, which insists that all art is inescapably framed by the environment it is placed in. The entire show is directed towards an ideological demonstration of the theme of containment, by an artist who never wants us to forget that however seemingly 'neutral' a gallery may appear – with its virgin white walls and its desire not to distract attention

71. Daniel Buren, *On two levels with two colours*, installation at Lisson Gallery, London, 1976 (detail)

from the work on view – it is in reality a powerful device which imposes a particular set of values on whatever it exhibits. Buren's increasing wish to concentrate on gallery locations is not, therefore, the result of accepting them as an inevitable compromise. He actually wants to ram home the reality of that compromise, to prompt the realization that art is always profoundly affected by the social, political and economic character of the context that produces it. Nothing on display at the Lisson will change the situation Buren is dramatizing, and in that sense his sights are set disappointingly low. But his clear-eyed apprehension of a dialectic too many artists ignore at their peril is well worth attending to, all the same.

Although I doubt very much whether Tony Bevan shares Buren's ideological persuasions, there is a related determination to make the visitor acutely aware of the space and viewing conditions employed by artists in his exhibition at the PMJ Self Gallery. Unlike Buren, Bevan is prepared to alter the architecture he has been given, even to the extent of dividing one room more or less in half with an enormous partition. But the main burden of his work rests in carefully controlled speculation, through the medium of words alone, about our possible reactions to the space he creates and then discusses. I say 'more or less in half' because the partition does not allow us to see the area of the gallery it blocks off. Instead, a small mirror set into this partition is used as a screen for a carousel projector, which beams a series of conversational comments about the possible identity of the hidden space. They range from the purely factual – 'This Was Once One Room' – to statements about the height of the ceiling or the contents of the room which we, standing on the other side, are in no position to verify. With a deft humour that shows how alive he is to the idea of playing a game with his audience, Bevan uses a verbal medium to construct in our imaginations precisely realised pictures of the environment he manipulates.

Unlike a thoroughgoing conceptual artist like Robert Barry, who also employs slide-projected statements to discuss the attributes of a given subject, Bevan oscillates between the reality of the gallery and his own comments on it. The relationship is less precisely regulated in another slide piece, this time comparing the viewpoint in one section of a room to the viewpoint in another section, because there is no partition to force us to stand where he would like us to stand. But the exhibition, which also includes a specially constructed corner where a book is hanging with statements about the space both outside and inside, suggests that this young artist has already defined a personal territory for himself which could pay dividends in the future.

HANS HAACKE
15 April 1976

When we look at a picture hanging in a museum or gallery, it is no good pretending that we are free to enjoy it without concerning ourselves with the network of factors controlling our responses. The picture in question has only been made available in this privileged setting because of powerful social forces, which have decided that it passes the test imposed by contemporary 'taste', deserves to be singled out at the expense of most other work produced during the same period, and accords with a view of art history usually too schematic to faithfully reflect the full complexity of the culture it is supposed to survey. However much we may like to think that 'beauty' somehow rises above all these machinations, and in the end makes them irrelevant, the question of *whose* 'beauty' remains to be answered. For the fact is that we have been trained to look at art by the value-system upheld in the Western world alone, and anyone who refuses to consider the effects of this manipulation can hardly arrive at a realistic understanding of the picture he wants to appreciate.

One of the principal merits of Hans Haacke's exhibition at the Lisson Gallery is that he makes it impossible to ignore these issues. He pushes them into the foreground right from the start, by placing on the first wall not simply a coloured reproduction of Seurat's celebrated small version of the painting called *Les Poseuses*, but a photograph which includes the ornate gilt frame surrounding it as well. The heavily encrusted magnificence of this frame, so redolent of the way our civilization views its favoured art as treasure with enormous speculative potential, states Haacke's theme in purely visual terms.

But that in itself is not enough. Although the presence of the frame in this otherwise conventional reproduction prompts an awareness of how pictures are served up like precious jewels with prices on their heads, Haacke wants to spell out the full ramifications involved. And he does so through verbal investigation, following Seurat's painting with a series of fourteen printed panels which provide a detailed history of its provenance from 1888 to the present day. In each panel, a personality predominates: first the artist himself, and then the long succession of owners through whose hands *Les Poseuses* has passed. Haacke's approach to this cast-list is strictly factual, and he provides a sober biographical summary of the personalities involved. But as we scan his careful accumulation of data, a far from clinical parable emerges of the extent to which

72. Hans Haacke, *Seurat's 'Les Poseuses' (small version)*, 1888–1975 (detail)

one modestly proportioned canvas is transformed by the priorities of the society it is obliged to travel through and be affected by.

The entry on Seurat reveals a man dedicated to his work, sympathetic to anarchist Communism and protected by family support from the hardship which would otherwise have accompanied his inability to sell the majority of his pictures. Jules Christophe, *Les Poseuses*'s first owner, was probably given the painting by Seurat, whose anarchist leanings he shared and whose work he championed in print. By 1909, however, this affectionate and innocent relationship between *Les Poseuses* and a man supremely capable of loving it as art, rather than as an object of prestige or investment, was over. The picture was purchased by the Bernheim-Jeune brothers, successful dealers in French avant-garde art who boasted a family mansion with eighty Renoirs in its grand salon, a country château, several large automobiles and a dirigible balloon. Such men were eminently capable of making a resounding profit out of their

acquisition, and within a year they sold it for four thousand francs to Alphonse Kann, a wealthy connoisseur and amateur dealer who advised even more well-heeled friends on their collections.

From then on, the transformation of *Les Poseuses* from an obscure painting cherished only by a few into an eminently marketable pawn takes place with great speed. The New York collector John Quinn buys it in 1922 for $5,500; and his descendant sells it in 1936 for $40,000 to the collector Henry P. McIlhenny through an intermediary, Mrs Cornelius Sullivan, who received a ten per cent commission. The same Mrs Sullivan, Haacke informs us, was a co-founder of the Museum of Modern Art in New York, and so a clear link is at this stage established between the financial escalation of a 'masterpiece' and the museum structure which ultimately certifies the importance of works like *Les Poseuses* and presents them for our public consumption. In *Les Poseuses's* case, the link was fortified in 1970, when the painting was sold for over one million dollars at Christie's to Artemis – a private art-investment company – and placed on anonymous loan to the Bavarian State Museum in Munich. Haacke gives a blow-by-blow account of Artemis's directors, including the banker Baron Léon Lambert and the industrialist Walter Bareiss, who is chairman of the Bavarian State Museum's Gallery Association. And the final panel gives a run-down on Heinz Berggruen, the leading Parisian art dealer who acquired *Les Poseuses* in 1971 for an unknown amount stated by Artemis's annual report to constitute an 'impressive profit' for them. In 1974 Berggruen himself became an Artemis director.

All this information requires, of course, a good deal of concentrated reading, and it could be said that Haacke's work is more easily assimilable in book form. But the whole structure of these panels, framed and hung like a row of pictures around the gallery's walls, itself adds up to a telling comment on the tissue of motives behind the ultimate accolade bestowed on items such as *Les Poseuses* by the museums that house them. Haacke's exhibition is therefore very much a visual offering, despite its almost exclusive reliance on the printed word, and it delivers a devastatingly lucid demonstration of the need to take the social metamorphosis of an art work into account.

These panels also afford an object lesson to museum officials, who have a responsibility to reveal the way their holdings change in identity during the passage from artist's studio to hallowed institutional resting-place. Haacke's strategy could be seen as a model in this respect, once and for all laying the ghost of museum display which tries its hardest to imply that art is somehow impervious to the accretions of value and status it gathers through social use. The presence of his Seurat piece in a gallery

like the Tate would demolish, at a stroke, the formalist approach to exhibiting, and replace it with a more comprehensive attitude which takes into account the ideological implications of the way we handle art.

THE EMERGENCE OF BRITISH VIDEO ART
3 June 1976

Now that the Tate Gallery has at last decided to present its first video show, it might well be imagined that British video art is receiving vigorous support from the institutions which have neglected this new medium in the past. But we should remain wary of false optimism. For one thing, the London region committee of the Association of Video Workers has just sent an urgent telegram to the Minister for the Arts, deploring the fact that neither the BFI production board nor the Arts Council's Community Arts committee – the two main potential sources of patronage for video work – has provided it with any funds this year. The telegram asks for a supplementary allocation for video in the next fiscal year, and warns that 'if funds are not forthcoming shortly, independent video work will virtually cease to exist, and many ongoing projects will not be able to meet their commitments to the public'.

Moreover, the Tate's current exhibition, well organised as it has been by Simon Wilson with the technical assistance of Cliff Evans, is an oddly limited affair. Rather than representing a firm commitment to video art by the main body of the Tate's staff, who could easily have staged it as a major event in one or more of the principal galleries, it has only been allowed in through the good offices of the Education Department and granted the status of a side-show, politely but firmly removed from the space normally occupied by important exhibitions. The upshot is that a show which cries out for – and fully deserves – a maximum amount of public participation has been tucked away downstairs in the Lecture Room, which can only be reached after a long trail through the entire length of the Historic British collection. As a result its audience is sadly restricted to those prepared to make a special effort, while the majority of visitors streaming only through the upstairs rooms is denied the excitement of a chance encounter.

Such a denial is particularly ironic in view of video art's relationship with television, a communications system available to everyone in his or

her living-room at the flick of a switch. Precisely because television has become so familiar a part of our daily consciousness, the video artist's use of the same medium should in theory be accessible to a large public – even to people unversed in the language of painting and sculpture. In reality, however, the British television authorities have so far refused to extend a genuine welcome to video art, thereby cutting it off from an audience far vaster than any dreamed of by an artist exhibiting in a gallery. And a museum like the Tate, which ought to be compensating for television's misdeeds by providing video art with the kind of adequately financed, full-scale exposure it so desperately needs, is also falling short of its proper responsibilities. Hiring equipment for the multi-monitor installations to be seen in the present show is very expensive – one reason why no private galleries in this country support video work. I hope, therefore, that the Tate will see this exhibition as a preliminary step towards a regular involvement with video, both in terms of extensive group surveys on an international level and of including individual works in its permanent collection.

Not that mammoth congregations of video art should ever be encouraged. Last year's huge mixed show at the Serpentine Gallery was counterproductive in this respect, not only because it offered a surfeit but also because it failed adequately to define the several different areas of video art activity. This is where the current offering scores so strongly: concentrating on eight British artists who have been paired off and each given a one-week run, it gathers together work which deals with video as a primary medium rather than as a secondary means of documentation alone. Each participant displays an acute awareness of, and curiosity about, the mechanics of video – especially in terms of singling out what video's own unique properties and characteristics consist of.

During the first week, Tamara Krikorian assembled a cluster of eight monitors, placed on tall plinths and arranged in two ascending ranks, all of which relayed the same recording of clouds floating slowly across the screen. Their forms gradually disintegrated over an extended period of time, affording an experience so lacking in strong visual incident that the dominating, sculptural presence of the monitors themselves was asserted. Normally, television is at such pains to hold the viewer's attention with a frenetic bombardment of sound and action that this pervasive framing device is overlooked. But here it became inescapably apparent, and the complete absence of sound also encouraged the viewer to examine how the monitor contains and artificially controls our perception of the seemingly 'natural' phenomena drifting within its boundaries.

Krikorian relied on slow stealth and a perhaps unreasonable amount of sympathetic patience from her audience; whereas Brian Hoey's *Videvent*,

73. Tamara Krikorian, *Disintegrating Forms*, installation at Tate Gallery, London, 1976

installed in the next-door room, presented a row of five monitors all dedicated to throwing the observers' images back at themselves. The initial surprise created by finding your real-time reflection on the screen – one middle-aged lady near me reacted with horror and immediately began to straighten her hat and readjust her hair, as if she had been exposed to the disapproving gaze of millions – was compounded by a recorded playback device. This simultaneously offered a time-delay record of your recent actions, an unsettling form of alienation which intensified the viewer's self-consciousness. Moreover, the ghostly record of time past became progressively more ethereal as its fidelity dissolved, creating electronic abstractions that sprawled, amoeba-like, across the screens.

As well as constituting an ingenious demonstration of the perceptual mechanics which television's beguiling illusionism always hides, *Videvent* succeeded in providing an instantly enjoyable participatory game, especially for the children I saw crowding eagerly in front of it. And this ability to engage and involve the attention of the spectator over a lengthy period was also shown by the other four contributions. Stuart Marshall constructed a viewing platform which required the spectator to mount two steps only to find the eight monitors ranged in a channel below feet-level. The disorienting sensation of finding the normal horizontal viewing situation

74. David Hall, *Vidicon Inscriptions (The Installation)*, 1975

replaced by a vertiginous vertical alternative was enormously effective. And the pre-recorded tape of quickly cut shots showing waterfalls and more gently flowing streams added to the observer's awareness of the perceptual act: they constantly changed direction, obliging you to step over the monitors to the other side of the platform, turn your head round, and even crouch down to scrutinise the often ambiguous images more keenly.

In other words, Marshall disrupted the conventionally passive relationship between viewer and television monitor. Our readiness to bask in illusionism was thwarted, and our intensive physical manœuvrings destroyed any hope of slumping back in a state of motionless thrall. Apart from Krikorian's deliberately contemplative installation, in fact, all the artists demanded an active, questioning response to the monitor. David Hall's *Vidicon Inscriptions* used a polaroid shutter to register the real-time movements of the viewer and then, at intervals, the shutter was released for an instant, burning the images on to the camera's vidicon signal plate. Unlike Hoey's *Videvent*, the result combined a record of the passage of time with the fixed trace of that continuum, and the viewer gradually turns into a hunter, creating and then watching the progressive recession of his own tracks through space.

Hall's piece relies on a strongly lit confrontation with a single monitor, whereas Steve Partridge's absorbing installation employed eight monitors

and eight cameras, positioned around the spectator in order to involve him in an eight-minute cycle. Using a specially devised automatic video switcher, programmed to switch our reflected image from camera to camera and dissolve, wipe and fade it all in real time, Partridge assailed us with a multi-angled analysis of our own positions in the room. The effect was at once hypnotic and unnerving, as we swung round from monitor to monitor, trying to keep pace with spatial and temporal changes also signalled by the audible control pulses of the programme tape.

The number of permutations Partridge can make with this system are almost limitless, and could be used to create a terrifying, aggressive experience. Outside in the corridor, by contrast, Roger Barnard set up a single camera which taped the movement of people walking through, and then played it back on a monitor where the viewer could also find a real-time image of his actions. A gentle opposition is set up between past and present, where the forms of people no longer in the corridor blend eerily with those who are. Like his fellow-exhibitors, Barnard thereby managed to provoke a heightened consciousness of what is involved in being both the observer and the observed, manipulated by the faithful yet endlessly deceptive video screen.

'ENVIRONMENT' AT THE VENICE BIENNALE
22 July 1976

It was an appropriate and an ironic decision to devote the 1976 Venice Biennale to the theme of the 'Physical Environment'. Appropriate because Venice constitutes in itself the most seductive ambience to be found anywhere in Europe; and ironic because there is scarcely an acknowledgement, among the mass of exhibitions competing for the visitor's attention this year, of Venice's equally prominent status as a probable environmental tragedy. No less than thirty countries filled the national pavilions in the Giardini di Castello, a mercifully shaded stretch of parkland which still provides the Biennale with its focal arena. Yet none thought it worth calling attention to the fact that the city paying host to them faces the prospect of irreversible decay.

This Nero-like unwillingness to focus on such a self-evident example of the environment at risk is, moreover, paralleled by a general inability to respond to the Biennale's set theme in a direct way. The great advantage of

a thematic structure is that it encourages countries, who would otherwise simply send along their current contenders for international avant-garde stardom, to adopt a more intelligent and imaginative approach. But themes must be reasonably specific in their definition if they are to have any hope of ensuring that so many diverse participants really do respond to the context prescribed. And 'Physical Environment', a vague enough designation to begin with, became still more blurred when it was subsequently decided – at one of those endless committee meetings of which large multi-national surveys are so fond – to modify it to 'Environment, Participation and Cultural Structures'. This classic bureaucratic title could only have been concocted in an effort to accommodate a tangle of conflicting demands from countries who resisted the whole concept of an imposed theme, and the Biennale suffers as a consequence.

There are, certainly, several ancillary shows held elsewhere in Venice which deal with the environment in a literal way, and survey subjects like the influence of the pioneering German Werkbund, Italian architecture during the Fascist regime, and twenty-five contemporary architects' contributions to what are termed 'the suburb and the historic centre'. This readiness to embrace an interdisciplinary mix of arts activities, which also extend to graphic design, glass and Man Ray's photography in additional exhibitions, should be welcomed: if mammoth cultural beanfeasts like the Biennale have any real justification, it is in the opportunity they afford to stress that no single branch of art ever exists in isolation from its counterparts.

But so far as the Giardini section is concerned, the ostensible theme is rapidly obscured by a rash of irrelevant side-issues. At worst, some pavilions have chosen blithely to ignore it altogether: in an astonishing display of arrogance, the Americans decided that 'an exhibition properly investigating this significant theme would require a much longer period of time for preparation than was available'. Without explaining why such prolonged gestation would have been necessary, they proceeded to tackle the absurdly grandiose alternative task of providing 'a critical overview of the contemporary American scene'. And three critics duly came up with a diffuse offering which pushes fifteen artists into pigeonholes labelled Field Painting, Perceptual Fields, Objecthood, Narrative Art and – to satisfy a desperate search for novelty – Cultural Irony. The outcome, predictably, is a mish-mash of assorted individuals, none of whom is given the chance to display a proper body of work.

The same accusation could not be levelled at the pavilions organised by Venezuela, Greece, Columbia and Denmark, each of which gives its artists more than ample room to reveal their unremarkable abilities. But

here again the environment has been admitted only in the loose sense that sculpture occupies space (Eduardo Ramirez Villamizar's banal abstract constructions are sometimes placed on hilltops), or that painting can depict figures spinning in an anti-gravitational void (Alirio Rodriguez, claims the catalogue, attempts to place man 'outside the earthly orbit'.) These flagrant abuses of the Biennale brief serve only to prove how many nations are determined to press ahead with the promotion of their favourite cultural exports, irrespective of any pertinence to the event they have been invited to help define. The trouble with the term 'environment', however, is that it can be twisted to suit almost every purpose conceivable: Czechoslovakia, for instance, uses it as a pretext to show off stage sets by Svoboda and Ladislav Vychodil, while Austria has included Reimo Wukounig's anaemic drawings of emaciated and sometimes whipped boys' bodies because he 'pinpoints what is injurious in an environment which takes its toll on the weakest among us – man between childhood and youth'.

Other pavilions do tackle the set theme directly. Holland plunges into a documentary exposition of urban design problems, advocating a maximum amount of participation by the individual citizen as opposed to autocratic architectural blueprints. Somewhat defensively, the organiser declares that 'we would not deny the work of art its independent existence, but we do insist on our right to view it in a social context'. Admirable aims indeed, and yet there is no indication among the plethora of blown-up cityscape photographs and projected slides that art as such has any social role at all in the building process. In this respect, a white concrete sculpture called *A Physical Environment for Jerusalem, the City of Peace*, which the Israeli artist Dani Karavan erected beside the main Giardini avenue, offered a corrective. My two-year-old son insisted on returning to play among its intricate series of geometrical surfaces again and again, thereby demonstrating that artists are fully capable of making environments which children can accept with instinctive pleasure.

The two most memorable national contributions, however, were installed inside their respective pavilions. Joseph Beuys, who occupied the main room of the German building and insisted that it be left in its unrestored, peeling state of neglect, made a monument called *Tram Stop* which referred to memories of a place in his home town of Kleve. Dominated by a tall, totem-like column supporting a haunted face of a man, and surrounded by a group of tribal seats, this desolate space also contained a long stretch of tram-track set into the floor, a heap of waste and a circular hole bored through to the lagoon far below, out of which dangled a bent iron rod. Primitive and machine-age images here combined to produce a

75. Joseph Beuys, *Tram Stop*, German
Pavilion, Venice Biennale, 1976

melancholy memorial totally attuned to its specific location and inca-
pable of removal to another site. It made me realise how few artists or
organisers had adopted the same approach, and risen to the spirit of the
occasion by actually studying their given space and responding to it.

Another exception was Richard Long, who was given the entire
British pavilion and laid out a triple-track spiral of stones collected from
nearby Verona throughout the four rooms. Unlike his previous indoor
pieces, which sometimes looked too divorced from the landscape setting
that inspired much of his strongest work, this spiral could not be under-
stood simply by studying it from a distance. The only way to experience
it was to walk beside and – when the doorways were reached – within
it, which meant that Long obliged the spectator to participate in the kind
of measured journey he so often undertakes himself through the coun-
tryside. In other words, he provided a direct physical equivalent to the
travelling which is at the centre of his art and normally relayed in doc-

umented form alone, through photographs or annotated maps of otherwise inaccessible locations. This Biennale installation therefore takes a significant step towards integrating Long's own private activity with a three-dimensional recreation that involves his audience in a comparable experience.

The undoubted climax of the Biennale, a survey called 'Ambient-Art' organised by the Italian critic Germano Celant, shared this approach to a specific space. The first half reconstructed a series of room-based projects undertaken by artists like Balla, Kandinsky, Mondrian, Lissitsky and Fontana during the twentieth century. And this excellent history of an accelerating interest in thorough-going environmental art was supplemented by a sequence of thirteen spaces allotted to contemporary artists whose principal interests lie in the same area. The rooms by Doug Wheeler and Michael Asher, who might have been expected to produce outstanding contributions, were unfortunately not ready at the time of the Biennale opening. But their absence was amply compensated for by Dan Graham's large space, completely mirrored on one wall and divided in half by a sheet of glass, which provoked an extraordinary two-way interaction of intimacy and distance between the people standing in each section.

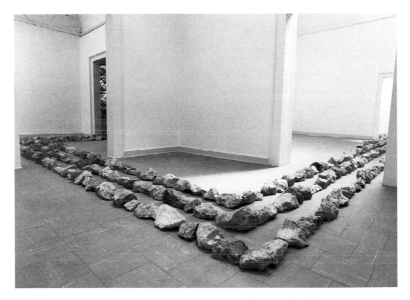

76. Richard Long installation at the British Pavilion, Venice Biennale, 1976

Sol LeWitt's space enabled him to devise a massive extension of the wall-drawing principle he has been investigating over the past decade, and outside the main exhibition building Maria Nordman constructed a white polygonal room which could only be entered by one visitor at a time. This restriction, the cause of uncomfortably long queues outside the door, turned out to be entirely justified. Lit by one narrow slit which cast a huge rectangle of light across the centre of an otherwise penumbral and disembodied space, her soft and mysterious environment demanded that each visitor be left alone to discover the room in private. It offered a contemplative affirmation of the theme which so much of the Biennale wilfully flouted.

SIMON READ

26 August 1976

When young artists hold their first one-person shows within the gallery system, the obvious benefits are always countered by other, less welcome considerations. On the positive side there is the chance – not given to many members of their generation – to present a quantity of work in surroundings that enable the public to focus on it in isolation, uncontaminated by the often jarring alternatives found on every side at a mixed exhibition. There is the prestige conferred by the act of being singled out, which carries with it the status of the more well-known artists supported by the gallery. And there is the purely professional attraction of gaining the opening line for that list of shows most successful artists insist on printing *ad nauseam* in every catalogue throughout their careers.

But set against these advantages, which also include the opportunity of a mention in the review columns and a possible entrée into major international surveys of new art, are drawbacks that can seriously compromise the work in question. If this initial showing is favourably received, the temptation to regurgitate and bolster a prematurely defined image becomes almost irresistible. Dealers may encourage such a process, in the knowledge that sales of a recognizable market product should ensue. Critics may place the work in a context which, although flattering at first, easily assumes the character of a strait-jacket inimical to full growth. And the possibilities opened up by the gallery convention, with its formidable history of older artists' response to the rules of the exhibition game, may

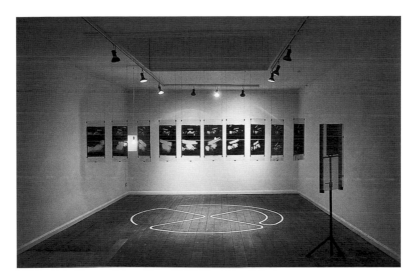

77. Simon Read, *Twelve Stern Presences*, 1976

ultimately have a narrowing effect on work that could otherwise have developed different options outside galleries altogether. Although it seems churlish to stress these dangers, therefore, no one should ignore them in the first flush of an exhibition début.

Simon Read, who has only recently left art college, is provided at Acme in Covent Garden with spaces more extensive than those offered by virtually any other London gallery willing to show young artists. The two rooms allow him to display not only a large seminal piece called *Twelve Stern Presences*, which gives the exhibition its name, but also three equally imposing works that apply the same basic technical procedure pioneered by this piece in different ways. There are, in addition, other items lining the walls, including a work-in-progress which is being built up day by day, and so the question arises: has all this space encouraged Read to indulge in overkill? In view of the unusual working method he has devised, the answer must be no. Each piece painstakingly incorporates the clues needed to grasp this technique, and yet its very unfamiliarity requires as many demonstrations as Read here provides.

Fundamentally, he relies on photography to carry out his intentions. But instead of using an ordinary camera, with its innate tendency to make the viewer forget about the mechanism involved and concentrate on the replica of reality it produces, Read has gone back to the old camera

obscura and replaced the lens with a slit. In *Twelve Stern Presences*, this slit proceeds in a series of permutations from a tiny diagonal cross to a big upright cross; and the photographs, all based on an identical view of Read's studio, show exactly how the slits affect the scene they record. In each of the twelve shots, strange abstract configurations caused by the slit hover in the studio, intermingling with its existing walls and pillars and registering as solid objects in their own right. They are reminiscent of the environmental sculptures which Russian artists like Lissitsky pioneered over fifty years ago, and yet the resemblance is misleading. For Read is concerned not with making his own invented forms as a substitute for reality, but with finding a way of honouring existing reality by presenting it in a new dimension. The frankness with which his exhibits explain how he arrived at that dimension is vitally important, because only by revealing the full workings of the process employed can he account for the transformation reality has undergone.

The photographic image in *Twelve Stern Presences* is, therefore, shown as only one element in the structure of the camera itself, which has in every case been flattened out between two sheets of glass and suspended from thin wires attached to the ceiling. Hanging one behind another in a long row stretching down the centre of the downstairs gallery, and allowing the slits to be lit from behind and thus remain visible, these glass frames look like X-ray samples assembled in a hospital to examine every facet of a patient's body. The analogy is appropriate, to the extent that Read is rigorously scientific in his procedural discipline. But the spatial progression of *Twelve Stern Presences* also acknowledges the fact that he is dealing with a given space rather than a given body; and the other three works all explore different ways of recreating that space in exhibition terms. One of them turns the slit into the shape of a famous maze pattern on the floor of Chartres Cathedral, and presents a complex group of no less than thirty-five frames hanging in a cruciform around the complete central frame. Every aspect of the maze is thereby examined and held up for inspection, with a zeal for the comprehensive working-through of a procedure that recalls Sol LeWitt's insistence on revealing all possible serial permutations.

It is, perhaps, too complex for its own good: the information presented becomes oppressive, and threatens to swamp the delicate apprehension of an existing space at which Read is aiming. After all, the main purpose throughout this show is to strike a sensitive balance between honouring the facts of a motif and making sense of those facts through a mechanical recording system – or, in the words of Read's explanatory statement, to use a camera 'as a means of inviting the outside inside'.

Upstairs, this invitation becomes more lucid once again, with the aid of fewer photographs, white diagrams of the configurations painted on the floor, and the camera-slit itself displayed separately. Moving through the exhibition provides a satisfying record of Read's own progression from one method to the next, and it is possible to understand why each subsequent refinement was attempted in order to improve on its predecessor. To that extent, it offers ample proof of an exceptionally intelligent and fertile artist working out his problems in public – a spectacle infinitely preferable to the show which hides those problems away and presents a flawless, edited façade devoid of any painful hint of struggle.

I only hope that Read does not fall into the trap of thinking that his invention is (to return to my medical comparison) a cure-all. Novel media can become an intoxicating substitute for grappling with the hard task of evolving a genuinely 'novel' interpretation of the reality an artist elects to deal with, and this show is already stamping Read with an instant, camera-inventor identity. He fully deserves to have such an extensive exhibition, but will its capacity to impress persuade him that he need look no further for his ideal working strategy? And will its thoughtful response to the gallery at his disposal mean that he now thinks too much in terms of the next exhibition? I respect Read's work enough to want him to ask these and all the other difficult questions which crowd in on an early entry to the gallery arena. For at the moment, his very ability to come up with an impressive mechanical formula is bland enough to deflect him from the difficult but crucial task of placing that formula at the service of more profound and searching meanings than the ones he has so far disclosed.

MARY KELLY AND DAVID DYE

14 October 1976

Two absorbing one-person shows in London now, one by a woman and the other by a man, try to analyse and provoke an enlarged awareness of the way society erects formidable structures around our everyday behaviour. Mary Kelly, at the ICA New Gallery, takes her own relationship with her baby as a very specific example of the general rule that infant care is still regarded as a female preserve. And David Dye, at the Robert Self

Gallery, takes narrative film as an equally convincing example of how we are all manipulated by the illusionistic codes employed in mainstream cinema. Both artists are at pains to dismantle the conventions they have chosen to deal with, and hold them up for detailed inspection so that the mechanisms involved are exposed in action. But whereas Kelly concentrates on a series of autobiographical case-histories, in order to demonstrate that both baby and mother are caught up in a reciprocal process of personality formation, Dye takes himself out of the arena and focuses on the audience's response to the conditioning devices which film uses.

The five works in Dye's show all tackle this crucial question of response in different ways. The walls of the main gallery space are hung with a series of monochrome photomontage panels, often in conjunction with mirrors and verbal captions. Perhaps the most explicit piece employs all three of these techniques in an attempt to recreate the ambience of a cinema. A trio of small white boxes jut out into space, and on the front of the first one all we can read are the words 'You are alert. Your mind is full of ideas. You think for yourself.' It is only by craning round behind this optimistic façade that we discover the mirrored interior of the cinema box, where a period photograph of an audience awestruck by the film they are watching is accompanied by a far more sinister caption: 'You are feeling drowsy. Your mind is going blank. You will let me do your thinking for you.' The other two boxes progressively peel away the fronts, with their injunctions to 'fight against conditioning', and allow this conditioning to become more visible. Cut-outs of the audience's bedazzled eyes float passively around the mirrors, near captions which end up by announcing that 'After this transfusion you depart feeling self-possessed, though I possess you'. The Big Brother power of film is thereby seen to be triumphing over any hopes the audience may have had about retaining an independent stance.

I have described the effect of this particular piece in some detail because it does spell out the main burden of Dye's concerns with great clarity. But it achieves this directness at the expense of subtlety. Dye's earlier works, most of which employed either projected film or stills reconstructing the successive stages of a film, were characterised by an ingenious and often witty inversion of normal film procedure. He exploited surprise and ambiguity, invariably leaving the precise meaning of his tactics quite open. Now, by contrast, he has reinforced his move away from the internal mechanics of film, and towards our mode of responding to those mechanics, by adopting a far more didactic use of message. The other works in the principal exhibition space are less obviously expressed, but the same desire for a simple means of communicating his

warnings is apparent throughout. Such a change can in theory only be welcomed: too much art in recent years has been absorbed in its own functioning at the expense of reaching out to its potential public. I do feel, however, that when Dye now takes a blown-up photograph of male and female film-stars in amorous profile, litters their faces with the titles of all the studio staff involved in a commercial production, and then surrounds the photograph with thirteen arrow-shaped fragments of this same image, he is in danger of hammering the point home too heavily.

In doing so, Dye fails to tap the central strength of his previous work, which relied on reticence, quietly engineered revelations and understatement. But all these attributes are reinstated in the climax of his show where, in a darkened room leading off the main gallery, an oblong slit of projected film circulates endlessly on a wall. The projector itself is visible, although it is difficult to tell that the image is actually being redirected via three small mirrors, one of which is an oblong attached to the radius of the projector's take-up spool. The result, however, does gradually disclose Dye's intentions, for we find an ordinary sex-film opened to partial viewing through the 'key-hole' formed by the oblong. As we watch the film's characters going through their ritual act, the oblong serves a dual function: it distances us from the illusionism of normal viewing, and simultaneously enhances the voyeurism by providing only a tantalizing glimpse of the film's content. Alienation and titillation are brought into an extraordinary union, and the soundtrack of a voice stating phrases like 'cast an eye over', 'will all be revealed', 'mustn't miss anything' and 'scanning the field' heighten this duality by alternating between lip-smacking exhortation and objective technicalities. We are seduced by this film and removed from its machinations at one and the same time, and the powerful tug of these two options makes memorable amends for Dye's rather too easily organised exposés of filmic manipulation elsewhere in the exhibition.

If this 'key-hole' piece provides an object lesson in how to engage the spectator's fullest attention, while also ramming home a timely warning about the conditioning process, Mary Kelly wants her audience to work much harder and appears to accept the inevitability of the relationship she dissects. Basing her work on psychoanalytic theory in general, and the writings of Jacques Lacan in particular, she displays the results of her various investigations like scientific samples from laboratory experiments. The overall effect of studying a row of twenty-eight boxes, each containing a soiled nappy-liner and a chart itemizing exactly what intakes of food the liner's stain records, does risk turning serious research into a stifling obsession. In this instance, the theoretical back-up which

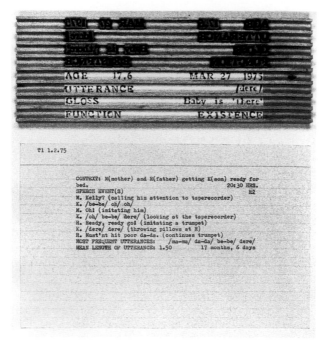

78. Mary Kelly, *Post-Partum Document*, 1975

Kelly provides in an accompanying booklet is not made explicit enough in the work on view. It is all very well *telling* us that the nappy-liners' record of a three-month transition between breast-feeding and solid foods signifies the breaking-away of the child's ego and consequent depletion of the mother's ego. But the boxes themselves do not carry the full meaning of the shift in relationship explained in Kelly's text, and I suspect that her well-grounded knowledge of psychoanalytic ideas may have prevented her from realizing the need to fully *incorporate* these ideas in the exhibited work.

That said, the show as a whole supplies impressive evidence of an intelligent desire to translate theory into an adequate visual form. And Kelly has clearly tried to relate the minutest details of the mother/child relationship she experienced to the largest conceivable context. In her booklet she explains that 'the nuclear family form, under capitalism, requires more participation by fathers in housework and child care while

insisting on the social sexual division of labour'. And the exhibition's somewhat daunting determination to delve into the most exhaustive documentation of her child's utterances and speech events is always informed by a clear grasp of its wider implications. The utterances, for example, are tabulated in twenty-three boxes, and Kelly's decision to print her list of headings below racks of reversed letter-blocks is a visual method of expressing the way mother and child mirror each other's words. The boxes trace the infant's progress from single-word utterances to patterned speech, but they also show how the mother plays a vital part in forming these full sentences.

The most rewarding exhibit, however, is a ten-box record of conversations between mother and child during the crucial period when he left the tight family circle and entered nursery school. Each box displays a coloured drawing made by the child, and on this scribbled background a tabulation of the child's remarks, the mother's reaction and finally her diary-like reflections is printed. Here the cross-currents really come into their own, played out on the surface of drawings whose agitated rhythms reflect the tension and humour of Kelly's relationship with her child. I would like to see her developing such purely visual devices in future work, because the rather academic bias of this exhibition might well stand as one model for the way a tough and self-aware women's art can spring from the growth of a full feminist consciousness.

TERRY ATKINSON
10 February 1977

Terry Atkinson's one-man show at the Robert Self Gallery testifies to one of the most courageous and drastic changes in direction I have ever seen an artist take. Until about two years ago, he belonged to the Art & Language group, who were and still are dedicated to a communal form of philosophical debate about art rather than to the production of art objects. Now, however, Atkinson appears as an individual artist once again; and instead of producing collaborative works which rely on verbal exposition as their principal medium, he has made a whole series of representational pictures with orthodox tools like pastel, etching and lithography, framed them, and hung them on the walls of a gallery. The stock of finding such orthodox images in a space normally devoted to

the most up-to-date manifestations of the avant-garde is considerable. Atkinson's current work would look more at home in a Royal Academy summer show, were it not for his decision to deal with a subject – the First World War – far harsher and more tragic than the timid, domesticated preoccupations favoured by Burlington House.

Alongside this emphasis on mass comprehensibility, Atkinson also attaches a good deal of importance to draughtmanship, technical competence, the element of craft which most people look for in art and often fail to find. The spectacle of an artist visibly struggling with such conventional skills is rare today, when so many have exchanged manual dexterity for the altogether more impersonal and mechanical vehicles of photography or printed texts. Indeed, the principal reason why *Infantryman Eating* fails in comparison with his other etchings can be found in Atkinson's over-anxious desire to delineate the minutiae of the soldier's creased uniform. It is as painstaking a study as the life-class drawings traditionally associated with the Slade, where Atkinson studied in the early 1960s – the difference being that it was copied not from a posed model but an old photograph, like everything else in his exhibition.

The other difference is, of course, that Atkinson has run the gamut of modernist experiment since his Slade days, so his current adoption of mimetic procedures has none of the innocence which a student might possess in his first year at college. This show is the work of an erstwhile leader of the vanguard, a man associated above all with the so-called conceptual movement, and his reversion to a straightforward figurative idiom flies in the face of modernism's central belief in stylistic renewal. He is, in fact, part of an emergent tendency which could be called postmodernism, except that giving it such a label immediately reduces it to one more twist in the avant-garde switchback of innovation and counterinnovation. Atkinson clearly wants to refer through his work to midnineteenth-century France, when Millet, Courbet and others were attempting to develop a form of realism which stands at the opposite pole to the modernists' subsequent belief in the sanctity of the private imagination. These First World War pictures are, without any doubt, on the side of an objective and – so far as possible – truthful response to an historical episode. They do their best to eliminate Atkinson's own subjective feelings, which are channelled into the notes published as a long, diary-like catalogue accompanying the exhibition. Courbet features prominently in this text, along with Marx, books on Realism and Paul Fussell's *The Great War and Modern Memory*. Atkinson quotes art historian T. J. Clark to the effect that 'the prime subject-matter of Courbet's

realism was at this point the social material of rural France, its shifts and ambiguities, its deadly permanence, its total structure'. The passage makes immediate sense as a direct parallel for Atkinson's latter-day attempt to depict the 'total structure' of the First World War. But it hardly explains why, as a neo-realist in the Courbet tradition, he opted for a piece of history rather than the life around him in 1970s Britain.

The answer, I think, takes at least three forms. One is that Atkinson has been employed, throughout the period when he drew these pictures, on a Gulbenkian-funded project working with deprived children in the Coventry area. This, the main part of his life, is wholly concerned with present-day social problems, and he sees no need to deal with it in pictorial form as well. The second part of the answer relates to the self-consciousness inherent in his spare-time revival of realism as a programme for art today. By taking the Great War as his theme, Atkinson is distancing himself from the idiom he employs in these pictures: he is saying, in effect, that he realises the historicist implications of his stylistic turnabout, and that it was therefore appropriate to select a period situated half-way between Courbet's time and today for his subject matter.

The third part of the answer must, however, be the most decisive. For Atkinson's First World War is not an epic bloodbath full of exploding shells, battles and mass slaughter. It is far quieter and more reflective than that, concentrating on moments of lull when a couple of corpses are left inert on the ground, a burial takes place, and soldiers pause to have their photograph taken. Whether squatting in burrows hollowed out of the trench, or interrupted in some everyday function like eating, queuing for tea or guarding, the men all gaze at the camera with the same weary, puzzled defensiveness. Caught up in a conflict over which they have no control, but which they have been conditioned not to question too closely, their doubts about the purpose of all this suffering only become explicit when they fix the lens with a questioning look. The presence of the camera lifts them, for a moment, out of time and encourages them to see the war as the photographer himself must see it, as a 'total structure'. And the futility they find in this new perspective is reflected in their deadened expressions. Atkinson's titles reinforce the hopelessness of their condition, too: one small etching of a grotesquely disfigured head is called *Private For-the-rest-of-your-life Face staring at the camera*.

Although some of the pictures showing dead soldiers covered with flies or lying with arms outstretched in rigor mortis have an elegiac force, Atkinson only becomes agitated when he deals with the commanding officers, both of the German and the Allied forces. In a close-up study of Sir Henry Wilson conferring with Marshal Foch, the etching needle eats

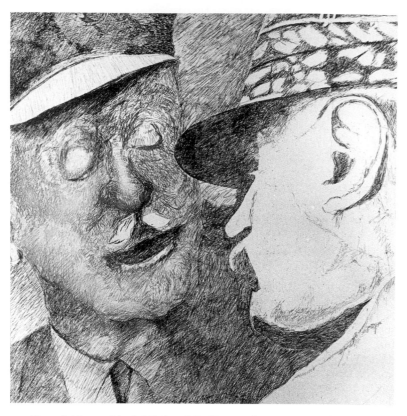

79. Terry Atkinson, *Marshal Foch and Sir Henry Wilson. Supreme Allied War Conference, March 1918*, 1976

its way into the British general's face and turns it into a caricature of blind stupidity. Eyes shut, mouth gaping emptily open, Sir Henry is the gargoyle at the top of an army pyramid which faithfully follows the class system of the nation he represents. And in that sense, Atkinson's main motive is probably the idea of using the Great War as a ready-made exemplar of late capitalist society in the throes of imperial dissolution. He leaves each viewer to decide how applicable that is to the situation we find ourselves in today.

At times too painstakingly literal and at others too indeterminate and slack, the pictures in this exhibition vary in the effectiveness of their approach to evolving a viable realist language. That is why I described

Atkinson's new direction as courageous: in stark contrast to the glibness of so much modern art, he is exposing his uncertainties, failures and partial successes. While the First World War is his theme, he can meditate on his relationship with realism by executing monumental figure-groups like *Burial at Becourt Wood*, which looks back to Courbet's equally ritualised *Burial at Ornans*. But if he decides to apply this same language to a portrayal of the class mechanisms operating in Britain now, his realist references may well look strained. For the Great War marked the final break-up of all the beliefs which had sustained Europe in its religious, political and cultural affairs for several centuries. How, therefore, can a nineteenth-century style be adapted to take full account of the extreme fragmentation which society's 'total structure' has undergone since the harrowing events Atkinson has chronicled here? I very much hope he takes up this thorny challenge in his future work.

ALEXIS HUNTER
17 February 1977

'Whenever I open a newspaper and read about a rape, and the humiliation it produces, I don't think "I'm glad it didn't happen to me." It is like a part of me is involved I feel real anger. And anger that it just keeps going on every day, anger that there is no retaliation.' This is an extract from some handwritten notes which Alexis Hunter has pinned to the wall of her exhibition at the Women's Free Arts Alliance. They hang beneath an eighteen-photo work called *Sexual Warfare*, and help to explain why each image shows the same hand and forearm – attired with red nail varnish and a string of pearls – engaged in acts of outright aggression. The victim is never shown; but the title of the work, coupled with the fact that all the acts signify a feminine agent, imply that the target is male chauvinism at its most oppressive.

The anger which prompted Hunter to make this work remains unmollified, however. For the example of rape singled out in those notes is only the most extreme manifestation of a dilemma with which women artists, like their counterparts in other areas of life, are increasingly dissatisfied. How can the roles of wife and mother be reconciled with the need to be a full-time artist? Why is it still so difficult for women to gain serious recognition for themselves as students within art colleges (a

notorious masculine preserve)? How come the Women's Free Arts Alliance is virtually the sole gallery in London where women artists can hope regularly to show their work? Ought it to be necessary for women to create what amounts to a sexist ghetto like the Alliance in order to gain even the most rudimentary platform for their art? Why is it that the list of thirty leading British artists recently announced for the new Hayward Gallery Annual this summer – an exhibition far more prestige-giving and handsomely housed than the Alliance's cramped offerings – contains only one woman?

All these questions, and a lot more besides, rankle in the minds of women like Hunter, who belong to a younger generation that has grown up surrounded by the promise of sexual equality and now finds itself wondering why it is not as liberated as it is supposed to be. Although in the broadest social terms the feminist movement has done much to enlarge people's awareness of the discrimination women suffer in all areas of life, and legislation like the Equal Pay Act represents the beginning of reformation, strangely little benefit has accrued to art. After leaving art school, the temptation to subsume female characteristics in order to meet the requirements of a male system is so strong that many women artists end up betraying the very identity they should be trying to define. Precisely because women have a harder task establishing a reputation than men ever do, this aping of male conventions is eminently under-standable. But it is also a retrograde step of disastrous proportions, in the sense that the most urgent challenge for women artists consists of stak-ing their claim to be truly themselves in their work.

What forms this revelation of woman's self will take no one yet knows. As a man, I am hardly qualified to speculate, but I would no more want to insist that every woman has a duty to make her art overtly fem-inist than I would want to extol male artists solely because of their abil-ity to produce work redolent of a masculine ethos. Indeed, it is perhaps appropriate for me to point out that male artists must bear just as much responsibility as their female counterparts for demolishing the barrier which has been built up between them. To expect women to undertake this complex operation on their own would be at once wrong-headed and unrealistic: since men are largely to blame for denying women any adequate representation of their standpoint, in art as in other sectors of society, it could be argued that they ought to accept an equal share of the challenge involved in restoring such a fundamental right.

If they neglect to do so, they will be guilty of forcing women into a perennially combative position, whereas the real need now is to move beyond hot-tempered polemics and debate less emotive ways of

80. Alexis Hunter, *Identity Crisis*, 1974 (detail)

arriving at a clearing in the jungle of sexist warfare. In order to transcend polarizing tactics, and stop perpetuating the old male/female opposition, there must be a new desire for integration. It is a pressing priority: as anyone involved with the women's movement will agree, our society is still a long way from witnessing such a positive reconciliation. And even if a woman does succeed in overcoming all the *conscious* clashes of role, identity and ambition within herself, the *unconscious* conditioning to which we have all been subjected in our society is far less easy to locate, let alone understand or surmount. It is inextricably bound up with the image women have been given in our culture, as far back as anyone can remember, and the ramifications of this image are too complex to be grasped without following up all the potent insights that the women's movement has unearthed.

Art has played an exceptionally powerful part in fashioning the definition of womanhood which must now be discredited. But once this patriarchal hegemony has been severed, and replaced by a more egalitarian art which enables women to put forward an alternative view of a world they have as much right as men to interpret, then art itself will be radically transformed. A formidable amount of dismantling has to be undertaken before such a goal is attained: Hunter, a twenty-nine-year-old New Zealander, has no hesitation in calling her exhibition *Towards a*

Feminist Perception, although it should be emphasised that the word 'towards' does express a frank awareness of women artists' inability as yet to define what exactly a so-called feminist perception should either consist of or hope to convey. Hunter's show is, accordingly, closer to an informal and open-ended tour around the artist's studio than it is to the finality of a public exhibition. The Alliance's gallery space is too confined and irregular to admit of anything more than a rough and ready sampling of anyone's work, and she capitalizes on this by alternating framed and mounted artefacts with documentation of work in progress, sketchbooks, notes and quotations from sources as disparate as Lévi-Strauss and Charlotte Corday.

At worst, this commendable desire to use an approach which anybody can understand leads her into banal polemic. (Any adverse criticism I make will be dismissed by some, presumably, as mere male prejudice, but I hope this is untrue.) One colour-photo work, for instance, juxtaposes sides of meat in a slaughterhouse with naked entrants lining up for a 'Ms. All-Bare America Contest', and Hunter draws an over-familiar moral with the subtlety of a battering-ram. But the principal meaning conveyed by this exhibition is its resolve to confront society's sexist taboos, bring them out in the open and – in the best works – explore their ambiguities.

Her most promising pointer towards a full feminist dialectic – as opposed to the bra-burning propaganda employed by so many other women artists – can be found in the third part of an extended series of works called *An Approach to Fear*. For example, a manicured and bejewelled hand progressively rubs itself, in photo after photo, in the kind of greasy machinery usually considered to be classic masculine territory. As we watch this sensual white hand besmirching itself with male grime – the very opposite of all those advertisements which dramatise the passive purification of female skin with soap and water – the entire spectacle takes on the dimensions of an orgy as well. This hand could just as easily be flirting as emancipating itself; and I am fairly sure that Hunter means to imply that feminism can, if conducted wrongly, end up reinforcing the old sexual role-playing. Such complexity in meaning points towards a maturity of attitude which may promise well for the development of a truly emancipated women's art during the years ahead.

SUSAN HILLER
17 March 1977

Susan Hiller's decision to make 305 old postcards the centre of her exhibition at the new – and very welcome – Hester van Royen Gallery is not in itself very surprising. Plenty of artists, Tom Phillips, Richard Hamilton and Marcel Broodthaers among them, have already used the found postcard as an effective springboard for their work. And in recent years the idea of postal art works, which can be made from a combination of words and images, inscribed, and sent to friends all over the world, has proved popular with many artists looking for a way of bypassing the conventional art system. Hiller, however, does not use postcards either as an initial stimulus or as a means of communication she can adopt to suit her own work. These postcards are presented, simply and without any distracting exhibition tactics, as images of interest in themselves; and the corporate title Hiller has given them, *Dedicated To The Unknown Artists*, indicates how concerned she is to prevent herself, as a mediating or manipulative agent, from interfering with our direct response to the postcard-makers' products.

This is not to suggest that she is guilty of mindlessly assembling a mass of raw material and then expecting us to applaud her discoveries, like a collector who imagines there is glory in sheer numbers. Hiller has concentrated solely on one type of postcard – a view of waves breaking against the land, accompanied by the ubiquitous caption 'Rough Sea' – and tabulated every kind of linguistic and visual trait she can detect in a meticulous chart which often borders the images on the wall. Her training in anthropological methods enables her to structure an exhaustive analysis of how the postcards break down into their various minutely differentiated locales, media, colours, formats, subjects and so forth. The visitor is therefore left in no doubt about either the intensively focused nature of the whole exercise, or Hiller's belief that bric-à-brac can be salvaged and studied for insights into the culture which produced it.

All the same, the purely visual impact of the postcards is allowed to dominate the exhibition. The chart sections look crabbed and pedantic by comparison, and make no attempt to encourage prolonged scrutiny, whereas the images are astonishingly attractive and repay the closest attention. Several versions of the same view are often grouped together in single vertical rows or horizontal blocks. The variations in medium from one to the next reveal how difficult it is to distinguish between a straightforward photograph, a retouched photograph, a

28 ST. LEONARDS-ON-SEA. — *Rough Sea.* — LL.

Rough Sea Ilfracombe.

81, 82. Susan Hiller, *Dedicated to the Unknown Artists*, 1972–6 (detail)

painting based on a photograph and an imaginative painting, not to mention all the ancillary devices like signatures, frames, colouring and reproductive techniques which confuse matters still further.

Far from reducing us to a state of utter bewilderment, however, or prompting the suspicion that she is basically interested in visual processes

for their own sake, Hiller's ability to highlight her postcards' total artifice directs us towards their larger meanings. Although it may be tempting to smile at their seeming naïvety when they are glanced at in the junk shop, their presentation here proves that there is nothing artless or innocent about them. The extraordinary prevalence of 'Rough Sea' images, for instance, is a direct acknowledgement by the anonymous postcard artists that the storm-tossed promenade exerts a strong hold over the fantasies of the British public.

In one sense, of course, the notion of sending off a representation of appalling weather as a holiday souvenir is a sick joke, a masochistic acknowledgement of the fact that a week by the seaside, in this country, is more than likely to be ruined by rain. But in another sense, to reduce these images to the level of black *Monty Python* humour misses the point entirely. Several hundred rough seas may look like an hilarious attack on the British climate, but their presence in this gallery testifies to the existence of a strong market demand for maritime apocalypse. Hiller's chart quotes the 'commentaries' written by the postcards' senders, and one of them, accompanying a picture of a dreadful storm at Whitby, gasps at 'the foaming waves hanging like huge cliffs of snow. It was both beautiful and terrible to witness.' Gigantic exploding bursts of water clearly aroused powerful and ambivalent emotions in their spectators who, rather than scurrying for shelter, are invariably to be seen rushing like lemmings to the point of greatest danger. One unforgettable postcard of Hastings in November 1904 shows a large and well-wrapped-up crowd, assembled on a balconied roof above a promenade restaurant, staring transfixed at the vast wave advancing towards them. They seem almost to be daring the sea to engulf them and sweep them away from the mundane safety of the land, and in this respect turbulent waves must be a symbol of all those unleashed romantic yearnings which the British do their best to restrain.

Many of the artists patently shared the awed fascination of the crowd, for their interpretations of the 'rough sea' brief are full of wild, high-flown conceits. In another Hastings postcard, this time in elaborately retouched colour, the breaking wave resembles nothing so much as an outsize wig full of silver curls, an absurd Oldenburg sculpture perched precariously on the sea-front railings. At times reminiscent of the most insubstantial clouds, and at others of dense, burgeoning foliage – one sender told his or her recipient to 'note how the water seems to stand in an [sic] heap' – the foaming particles take on a myriad different identities. Even when the image-maker is a documentary photographer like Fred Judge, whom Hiller singles out in her catalogue to demonstrate how impressive these forgotten postcard artists can be, the trajectories

described by his accurately recorded waves appear almost as unlikely as those in a view of Le Havre, retouched with such clumsy excitement that the water seems to be launching itself *off* the pier and back into the churning sea again.

But in the end, however many orgiastic climaxes are celebrated in pictures which seem to range in their art references from Turner and Monet to Pollock's skeins or Morris Louis's hanging veils, there remains an unavoidable sense of frustration and futility. Waves smashing against Eastbourne's Marine Parade carry intimations of a revolt against the oppressive imperialist bulk of the Victorian hotels standing there. And similar holocausts of water, white against the brooding darkness of Blackpool Tower, can be interpreted with some confidence as a dramatization of sexual struggle in its most elemental form. Even so, none of the postcards proposes the possibility of destruction or even slight damage to the man-made monuments. The hotels stay firm, the tower retains its phallic dominance. And one especially exotic wave at Teignmouth, poised to direct itself at a passing coastal train, has much of the threat drained out of it by the reassuring symbolic presence of a church tower in the background.

Hiller has not found a wholly satisfactory way of uniting the disparate demands of chart and image, and the exhibition should be tighter, more economical, less diffuse. But her alert and intelligent understanding of the postcard's richest implications is more than evident, and it goes beyond the ostensible objectivity of her approach. Waves destroy themselves even as they reach their moment of greatest magnificence; and Hiller, without in any sense straining for significance, manages to equate this paradox with the female dilemma.

These postcards, after all, tended to be written by women, who regarded them as a reassuring link with the domesticity they left behind when on holiday. They may have thrilled to the bravura of the raging sea, but their fantasy of liberation was confined to the tame dimensions of a postcard. It is surely no accident that one of the few handwritten messages visible on the front of the images reads: 'Dear Dol, in the storm of life, when you need an umbrella, may you have to uphold it a handsome young fellow.' Hiller, as elsewhere, makes no comment – she merely enables us to inspect the words. But they, combined with the endlessly thwarted image of the rough sea alongside the message, are comment enough.

ART FROM FRANCE

30 April 1979

There was a time when no self-respecting British artist felt happy about putting brush to palette without a suitably humble pilgrimage to Paris. Touring the studios, galleries and avant-garde cafés there was considered mandatory because, quite simply, French art was the centre of attention. After a while the dominance of Paris was taken for granted. And the British − who, as Eartha Kitt pointed out long ago, need time − were slow to realise that the axis had shifted after the Second World War to New York. The erection of the massive new Beaubourg museum was President Pompidou's attempt to restore the balance. With its escalator rides, circus performers and secure place on the tourists' map of Paris, this 'Pompidoleum' can be seen as a hugely popular *substitute* for the artistic ascendancy which diehard French cultural imperialists would dearly love to re-establish. Buildings alone cannot guarantee a Renaissance, and we no longer feel obliged to cross the Channel in search of Gallic enlightenment.

The trouble is, Britain has now taken its assertion of independence to a ridiculous extreme. Until the current Serpentine survey opened, our interest in contemporary French art had dwindled so drastically that it was difficult to name one living French artist whose work could be seen over here. In Paris, by contrast, Francis Bacon is hailed as a major painter, and earlier this year I co-selected a large exhibition of twenty-seven younger British artists staged at the Musée d'Art Moderne in the French capital. Admittedly, its French organisers started out by suggesting at our first meeting that the show be called 'Does English Art Exist?' (In the Middle Ages, that would have been enough to provoke, if not an Agincourt, at the very least a lightning raid over the Channel). But the show ended up with a more diplomatic title, *Un Certain Art Anglais*, and a gratifying response from visitors.

Now, at last, we have returned the compliment, albeit on a more modest scale with only twelve artists on view. But the size would not matter if the English selectors of the Serpentine exhibition had given it a strong, cohesive impact, persuading us that French art was bursting with dynamic ideas. Sadly, it does not. The diffident tone is set by a cat-alogue foreword from Gilles Plazy, which blows the critic's equivalent of a Gauloise smoke-cloud in our eyes. After the disarming confession that 'it would be difficult for me to justify a selection of French artists made from London', he spends the rest of his page dodging the question of

83. Annette Messager, *Serial Story, 5th Instalment*, 1978–9 (detail)

what exactly the show sets out to define. All too briefly, he notes that artists find themselves 'in the midst of an economic and cultural crisis in France'. So do we, and it would have been fascinating to see how French artists are responding to their equivalent of our continuing debate about art's social role. But the English organisers of the survey sidestep this crucial subject, and con-tent themselves with remarking that 'perhaps the title of our show should be amended to Good French Art That Doesn't Look The Same As Good English Art'.

Leaving aside the dubious assumption that the art of any country has a 'look' at all, this seems a dangerous yardstick for a serious exhibition to adopt. It can easily lead to a superficial emphasis on novelty alone, at the expense of providing a genuine analysis of the real issues at stake in French art today. And it probably accounts for the overall character of a survey that is charming, elegant, sophisticated and – ultimately – bland. Pride of place is given to Louis Chacallis, whose enigmatic warriors, half cowboy and half Samurai, are entangled in parachute straps, stretches of fabric or curved bars. For all their attractiveness, they do not rise above the level of ingenious puppetry, and their playful attitude towards the different styles they

juggle with prevents us from taking them as seriously as Chacallis would no doubt wish. A similar spirit of fun pervades the work of some abstract painters from Nice and Marseilles, who all delight in discarding the conventional stretched canvas.

Interest quickens with the artists using photography, because they attempt to distance themselves from the archness evident elsewhere and turn it to account. Annette Messager's coloured photographs of swooning women culled from glossy magazines are surrounded by strips of abstract painting, and she clearly wants to bring images from mass culture into a new relationship with avant-garde art. The result is not as stimulating as it sounds, and I found that Christian Boltanski's series of *Japanese Garden* photographs more convincingly welded the worlds of commercial and fine art together. The way he combines miniature pebbles and plastic figurines with abstract collages seemed entirely unforced, reminding us that children who gaze at similar displays in shop windows make no damaging cultural divisions between the different kinds of imagery they encounter.

84. Christian Boltanski, *Japanese Gardens I*, 1978

85. Anne and Patrick Poirier, *A Circular Utopia*, 1978

Even so, only two of the exhibitors have a potent effect. Alfred
Courmes, a neglected eighty-one-year-old survivor from the heady days
of Surrealism, does appear to be a discovery worth making. All his work is
riddled with outrageous cross-references between elevated old masters and
popular culture, and even the most subversive of his paintings
is crafted with dogged, meticulous skill. In a wickedly blasphemous canvas
called *The Pneumatic Angelic Annunciation*, the angel has become a Michelin
man who bowls a huge tyre towards a reclining pin-up culled from a 1930s
Indian Tonic Water advertisement. Courmes's real subject is the impossi-
bility of painting a straightforward Biblical picture, now that the death of
religion and the triumph of commerce run hand in hand. But he also gets
in a sly dig at those who myopically study details in a painting rather than
the meaning of the whole. 'Would both the connoisseur and the amateur',

he asks in a caption, 'please pay attention to the fact that the angel is carrying a lily, studied and drawn with particular care. Thank you: the important thing is the lily.'

The other memorable contribution comes from Anne and Patrick Poirier, who specialise in recreating grandiose architectural monuments of the past. As a rule, these large, dramatically lit models are melancholy ruins of civilizations long since destroyed. But this time the Poiriers present a spotless Utopia, made of 140 white plaster pyramids arranged in concentric circles around an empty central arena. The artists got their idea from the vault of the Pantheon, which contains coffers incised with these pyramidal shapes, like inverted ziggurats. So they imagined flattening the vault out, and the rings of terraced structures that result are seen here as if through a thin mist. Deserted and frozen into geometrical stillness, the whole ensemble looks like an inter-galactic cityscape from *Star Wars* rather than a place fit for humans to live in. And although the Poiriers hide their real attitude behind veils of ironic archeological learning, I suspect they intend to criticise the soulless perfection of so many Utopian architects' blueprints. For their contribution alone, the show deserves to be visited. But any proper evaluation of French art today will have to wait until we are given a more comprehensive and committed survey. It is long overdue.

STUART BRISLEY IN PERFORMANCE
21 May 1981

I shall never forget coming across Stuart Brisley when he was nearly submerged in a chipped and rusty bath, with pieces of rotten meat bobbing in the cold water all round him. It was shocking to enter the small, dingy room at the top of Gallery House in Kensington and discover this repellent sight lurking among the shadows. Like the victim of some disgusting, unexplained murder, Brisley lay in silence, breathing in and out while fragments of offal bumped against his cheeks and nose. I could not bring myself to ask him why he was undergoing such unimaginable degradation.

Almost a decade has passed since then, but the memory of that hunched figure doggedly submitting to the terrible stench and slime will not go away. It has, if anything, grown in significance as I have encountered more of Brisley's work and realised that he is far indeed from a mere sensationalist. Using his own body with as much discipline and

86. Stuart Brisley, *And For Today, Nothing*, at Gallery House, London, 1972

resourcefulness as a good sculptor employing clay, wood, bronze or steel, he has developed into the most powerful and consistent performance artist Britain has produced. The ICA's retrospective survey of Brisley's work confirms his stature, and proves that behind the apparent self-indulgence of his ordeal in the water lay an ambition which has nothing to do with melodrama or attention-seeking. Simply because Brisley places himself at the centre of his work, often in a naked state, it does not follow that he is a hopeless narcissist. On the contrary: the gruelling rituals he forces his body to endure usually point *away* from the artist, and make us aware of a more general condition experienced by humanity as a whole.

When Brisley subjects himself to ordeals which most of us would go a long way to avoid, we realise that he acts as an uncomfortable reminder of how vulnerable our so-called civilised behaviour in Western society really is. Over the years I have watched him hanging upside-down within a wooden structure at the Hayward Gallery, pacing hour after weary hour around a podium in a Milan arcade, and digging a hole to live in during an international exhibition at Kassel. On each occasion he managed to embody aspects of life which we spend most of our time trying to forget.

Watching Brisley perform, I usually go through several quite distinct phases of response. At first, my mind recoils from the painful image and

wonders why he insists on presenting such a gruesome spectacle. Then, as time passes and his severely controlled stamina grows more astonishing, I sense in my body what it must be like to withstand the kind of punishing ordeal he invariably pushes himself through. Having started out resenting the slow, repetitive working rhythms Brisley favours, I eventually come to accept them on the fullest mental and physical level. So by the end I have lived through a very intense period with him, and his exertions no longer seem like the masochistic antics of a single, isolated artist. They become a shared experience, and make sense to anyone who has ever appreciated how much suffering there is in the world, how little really protects us from exposure to the brutal conditions which less privileged people undergo.

Not that every Brisley performance highlights humanity *in extremis* without incorporating, at the same time, more precise references to particular concerns. The digging performance at Kassel, for instance, took place at an exhibition where vast sums of American money were being lavished on Walter de Maria's project – boring into the ground with an oil drill simply in order to place a brass rod in the resulting hole. By sweating with a spade in the humid summer sun, Brisley threw into relief the wasteful technological folly which de Maria had devised for his own dandefied amusement. And by building a wooden shelter in his hole, where he lived for two weeks in the most primitive conditions, Brisley also made himself far more available to the spectator than de Maria with his invisible rod.

In an even more explicit way Brisley launched a headlong attack on gross consumption at the Acme Gallery, where he sustained a ten-day fast while the rest of us satisfied our traditional Christmas appetites. Positioned in solitary prominence at the far end of a long table, he had to refuse meal after tempting meal served by a chef who cooked the dishes upstairs. The polite delicacy with which each plate was brought in, placed on the table and left to go cold contrasted tellingly with the savage pangs of hunger Brisley must have felt. When the fast was over he stood up, undressed and flung his naked body onto the table. Then he crawled right through the mess of stale and stinking food until, having reached the other end, he swivelled round with excruciating speed and returned – inch by arduous inch – to his original place. The event was concluded with a candle-lit dinner at the gallery welcoming in the new year, but the enduring impact of the performance came from Brisley's own painful previous abstinence.

It is as if he wants to reduce himself, albeit temporarily, to the level of life suffered by the victims of famine or oppression elsewhere in the world. Only thus, he implies, can someone with his material advantages ever really know what profound privation must be like. But the entire ritual is not carried out for his benefit alone. It is a carefully stage-managed

event, and our participation as viewers is a crucial part of the process. Without an audience, Brisley finds it difficult to continue his performances. He feeds off the possibility that his often harrowing portrayals of humanity in travail might arouse compassion and, perhaps, a greater understanding of what it really means to be alive. Witnessing a Brisley performance, I become acutely conscious that, shorn of my clothes and the comforts which cushion me in everyday existence, I might well be obliged to fend for myself in a similar way. It may involve struggling with another person, of the kind dramatised by Brisley when he and a second naked man fought to stay perched on a specially constructed sloping ramp in an Amsterdam gallery. Slippery with water, the surface was treacherous and both performers constantly slid off, so fast that they must have bruised themselves badly. But however many times they fell, the two men scrambled back up to the top again and submitted their grazed flesh to further batterings.

Judging by the film which Brisley's long-term collaborator Ken McMullen made of the event, the cumulative effect on spectators must have been extraordinary. There seems after a while no reason why either of these panting, crouching figures should make yet another attempt to rescale a slope which has already caused them such agony. But they persist in their efforts, driven by what appears to be an unreasoning yet fundamental urge to survive at all costs. However dehumanised and wretched they become, their determination to strive for the most implausible heights and not accept defeat remains firm.

This is the resolve which runs through Brisley's work. Whether slumped in a paint-spattered wheelchair amid the gloom of a prison cell, slung hazardously on a few intersecting ropes, or crawling on all fours across a courtyard towards a kennel-like hut, his weary form keeps on going. Such persistence implies a basically optimistic belief that, despite the appalling damage society inflicts on so many of its members, the human being still has an undaunted will. Either obliquely or overtly, Brisley has referred over the last fifteen years to the bureaucratic regimentation which reduces people to numbers, solitary confinement in prisons, mind manipulation by the state, torture in Ulster and the concentration camps. They serve as a reminder that the privation Brisley deals with in his art is not simply a figment of his diseased imagination, nor an overheated expressionist outpouring which only proves how self-absorbed he has become. Suffering is all around, and can reduce us to a pathetic, victimised state at any moment. But somehow, although the stench of decay may be overwhelming, the mute figure stretched out in the bath manages to keep his head just above the water.

STAYING POWER

SOL LEWITT
1 July 1971

Nothing could sound milder or more intellectually respectable than the term 'conceptual art', and yet its practitioners' insistence on the artist as a thinker rather than a maker is the most challenging and subversive principle at work in art today.

For however much painters and sculptors of the past can be said to have used their brains as well as their hands, art has remained until now inextricably connected with the physical act of giving mental images visual form. No one, not even the most rigid of abstract formalists, could consider his work complete before it had been laid down on canvas or embodied in bronze. Mondrian often spent weeks worrying over the precise position his rectilinear bands and blocks of colour should assume, adjusting and readjusting the components of his design until they resolved themselves into an authoritative ensemble. And at the other temperamental extreme, the Abstract Expressionists simply did not know what their paintings would be like before the struggle to turn emotional impulses into visible gestures was fought and won. It was impossible to think of their art as existing if it did not assert itself as a presence, a fully realised, tactile object. All the processes that led to the final work – from initial inspiration, through hesitant preliminary doodles to relatively elaborate sketches – were in the end subservient to the desired goal.

And what could be more understandable? The very viability of this branch of creative activity seemed to depend on the production of an artefact: without it, the artist was left only with tentative ideas, of no interest to anyone who could not see those mental embryos grow into a perceptual life. Although many twentieth-century pioneers questioned the fundamental syntax of this activity, simplifying, stripping it down to a purist equation of shape and colour, they all adhered to the fundamental convention behind it. Everybody, that is, except Duchamp, who had the nerve to ask a question that has rankled and borne uncomfortable fruit ever since: why should art necessarily transmit its meaning through optical sensations alone?

The full implications of his question are only now being cogently explored by those who seek to re-examine every accepted preconception upon which the tradition of Western art rests. While most of their contemporaries regard such an aim as a meaningless heresy, contradicting the whole *raison d'être* of a visual medium, this determined minority seeks to escape from the strait-jacket of a primarily manual art. Their

87. Sol LeWitt, Wall-drawing at Lisson Gallery, London, 1971 (detail)

wish to expand boundaries, allowing art to take any form it desires, upsets the entire aesthetic apple-cart and makes value-judgments peculiarly difficult. But that should not tempt us to damn their efforts as merely anarchic or destructive. Rather should we recognise them as a positive force, genuinely extending our notions about what art ought to be and opening up new possibilities for the future.

A lot of groundless fears will, for instance, be allayed by the Lisson Gallery's current exhibition of work by Sol LeWitt, one of the founders of conceptual art. For even though this forty-three-year-old New Yorker is perhaps its most ruthlessly consistent exponent, the work now on view in what amounts to his very first London one-man show is curiously gentle and pacific. Five of the gallery's walls have been covered with spidery pencil lines, so thin and quiet that they could easily pass unnoticed by those in search of revolutionary excess. And yet the method behind these innocuous markings would make most artists rise up in horrified indignation, for LeWitt himself has not traced one single strand of the linear web stretched so delicately across the gallery's white wall-surfaces. He did not even furnish the students who actually drew the works with sketches, as did Rubens when a huge commission meant that studio assistants painted the canvases on his behalf. Neither was he present to supervise the operation, unlike that older deployer of other men's energies,

Andy Warhol. Instead, LeWitt simply sent over bare written instructions from America, and waited until they had been carried out before coming over to view the finished product.

But this ultimate detachment does not argue laziness or cynicism on his part: it is the logical extension of his stated belief that 'the idea or concept is the most important aspect of the work'. So eager is he to stress the importance of this 'concept' that even the instructions purposely leave a lot to the discretion of the executants. The only orders LeWitt categorically issued were concerned with the construction of a six-inch grid all over four of the walls, within which four separate systems were to be worked out. On three of these walls, he specified the primary colours to be used – red, yellow and blue – and insisted that the lines within each square should either be drawn freehand or straight, either touching the edges of the squares or not. But for the fourth wall, he simply wrote: 'Within the six-inch squares draw freehand black lines at the discretion of the draftsman.' In other words, LeWitt wanted to push his conviction that 'what the work of art looks like isn't too important' to a new and potentially dangerous extreme.

How could a personal – and indeed affecting – artistic statement result from such depersonalised specifications? Part of the answer lies in the fact that the wall drawing is not intended to be a self-sufficient work in its own right. LeWitt rejects all the devices of older art – distinctive hand-writing, sensuous display, craftsmanship and facility – in order to ram home his dogged belief in the supremacy of the idea. LeWitt wants to assert the underlying spirit of an art work, and so the visual record of a piece is dedicated to reminding its spectators that they are only looking at the last stage of a chain reaction stretching back to the artist's own motivating initiative. Viewed in this light, the seemingly casual, haphazard brief issued by LeWitt becomes a precise expression of his inward certainty, and connects up with all his previous explorations of the tension between an illogical thought and its logical application. Whatever solution the individual executor arrives at cannot ultimately undermine the structure of the mental process which brought it into being.

Hence the disarming simplicity of these wall drawings: their endless permutations on a terse theme serve above all to prove that art need not automatically devolve upon a definitive visual product. It is sufficient for LeWitt to formulate the basic framework, and if that is strong enough, no amount of subjective interpretations and superficial interference can deflect its message. The calm, classical harmony now whispering from the Lisson's walls bears out the wisdom of his approach with an almost religious intensity and singleness of purpose.

BERND AND HILLA BECHER
21 January 1975

Any artist who decided to concentrate on the wealth of industrial structures that punctuate often desolate stretches of landscape throughout Britain and Western Europe could be forgiven for viewing them with a picturesque eye. For although these coal silos, gasholders, cooling towers and lime kilns once represented the ugliest and most unacceptable face of a countryside raped by the machine, we are now sufficiently accustomed to their presence to value them as extraordinary monuments of human ingenuity. Because they were erected by engineers who cared more about function than architectural propriety, their design constitutes a unique language with its own rules and internal logic; and because most of us are ignorant about the way they work, their external appearance can seem strange, unpredictable and even exotic.

At first sight, this kind of response may be thought to have inspired Bernd and Hilla Becher, who have been tirelessly hunting down and photographing these structures for well over a decade. Some of the results are now displayed at the ICA, and the initial impact of the exhibition does emphasise their surreal, other-worldly character. Each photograph isolates the building from its surroundings and places it wherever possible against a large expanse of clear sky, so that its contours are defined with immense clarity. We are therefore encouraged to look at it almost as a sculptural phenomenon, an imposing presence to be appreciated for its own sake rather than as the mundane tool of an industrialised society. And the fact that the Bechers have called a book of their photographs *Anonymous Sculptures*, not to mention their willingness to present the work in a gallery context as opposed to a museum documenting the history of the machine age, also suggests that they want to turn their subjects into works of art.

But it soon becomes obvious that their aims do not lie in that direction. For one thing, the Bechers refuse to call attention to their pictorial devices in any way. Bernd was originally a painter, and Hilla took photographs of these monuments for him to transform or manipulate in his pictures. They came to realise, however, that the extent and richness of the raw material was in itself far more fascinating than their interpretations, and so the mechanics of the photography they now use as their exclusive medium are kept unobtrusive. In every case the presentation is uniform: the structures are all taken from an identical angle, the amount of picture-space they occupy remains more or less constant and the

tonality of the prints never varies. No 'artistic' intervention is apparent, and each building is made to look as much like the others as possible.

But this is only the beginning of the Bechers' determination to make us see these structures as members of a class. Any impulse we may have to consider them singly is thwarted, not only by the similarity of the photographs but by their grouping as well. They are always shown in a frame which contains a series of nine, and within that series each monument belongs to one generic type. Add to this the way the frames are gathered together according to species – the first section of the exhibition, for instance, consists of eight frames showing a total of seventy-two towers – and some idea can be grasped of how the Bechers call attention to a total grammar over and above particular linguistic units.

The excellent arrangement of the show accentuates this cross-reference system by hanging all the frames on the walls of one large room, resisting the temptation to vary the display with screens which would prevent us from looking at different parts of the survey with ease. We can therefore examine the syntax of a given type and then compare it with the greater syntax of industrial structures as a whole, realizing all the time how the demands of specific functions, periods, environments, materials and scales produce variations on the norm. These variations are manifold, and they grow more absorbing once the norm from which they depart becomes familiar. The Bechers are able to chart a steady process of elaboration through their group of water towers, whereby a primary statement of a ball or drum on a tall column gradually accumulates extra elements in the form of scaffolding or legs, until it finally burgeons into a wholly fanciful range of disguises. Austere, pared-down functionalism gives way to a bastardised breed of architectural quotations, which assume the features of an Indian temple in Münchengladbach, the Tower of London in Oberaussen and a Saxon church in Bischofsheim. The effect is entertaining, especially when most of the structure remains skeletal and utilitarian: the predominantly stark outlines of a winding tower at Bully Les Mines sprouts the unaccountable façade of a French chateau at its base, replacing what would otherwise be a nondescript hut or warehouse with absurd classical pomposity.

After a while, the Bechers' method of amassing their specimens, pinned down with corner hinges like butterflies arranged in neat, rigid rows by a devoted collector, ensures that we no longer look at a particular object so much as a new addition to the existing vocabulary they have disclosed for us. The fifth in a sequence of coal-washing plants loses its singular identity and simply becomes another permutation, full of little incidental changes from the ideal type. The patterns assumed by windows take on a

88. Bernd and Hilla Becher, *Coal Bunkers*, 1974

surprising importance. Varieties of decorative ironwork have a far larger significance than they would normally possess if a single structure was being studied. And it is easy to notice when functional design gives way to a *jeu d'esprit* like the eccentric decoration on a Manchester gasholder, where the surrounding columns are embellished with inverted ice-cream cone forms balancing on fluted vases. There is little essential difference between the poignancy of decay, when windows are smashed and wooden slats are missing, and the equally distressing signs of renewal, whereby the rugged strength of an old building is castrated with anaemic rows of saplings, twee entrance gates or an unsympathetic modern extension.

Occasionally, an identifiable national flavour can be detected: the steeply inclined roof of a washing plant at Kirkintilloch carries

unmistakable echoes of Scottish baronial architecture. Sometimes, too, a structure like the coal silo from Lens takes on surprising animal overtones, and the four protuberances hanging down from its main bulk recall the udders of a cow, each one capped with a round teat. But the Bechers' way of working acts as a rein on such readings, reminding us constantly that these seeming adornments all have their origin in a desire to perform an efficient task, to strengthen or protect. In this sense, they are exploiting the camera's ability to present a far more focused and comprehensive image than the naked eye could ever hope to command, in order to compile a lexicon of their chosen subjects. Rather than documenting or analysing a manifestation of social history, they claim the artist's right to propose a model for a new way of looking at buildings which, because they are allowed to speak for themselves, make us guiltily realise that we have never really seen them before.

MARIO MERZ
11 May 1972

It is unlikely, to say the least, that an Italian artist of today should base his work on the expressive possibilities of a numerical system formulated by a monk called Fibonacci as long ago as 1202. But that is exactly what Mario Merz, whose one-man show is currently on view at the Jack Wendler Gallery, has done for the past three years. Not that his art is in any sense subservient to the order that mathematical procedures presume to impose on reality. Far from it: unlike many of his Renaissance predecessors, who seized on tools like perspective as a means of fortifying their art with scientific clarity and rationalism, Merz employs the Fibonacci sequence because of its links with organic life.

When he first came across the system, in an essay on the relationship between natural growth and mathematical progressions, his interest was aroused by the way in which Fibonacci confirmed his own previous intuitions. Only a year before, in 1968, he had attempted to work with a tree because the progression of its growth – one trunk sprouting two branches, which in turn produce perhaps three smaller branches each – seemed to connect up with the biological structure underlying every living thing. Merz failed, at that stage, to pursue the full implications of his idea, and contented himself with taking a cast of the space between two

branches as a symbol of his determination 'to make art with space rather than objects.' And in the very same year he affirmed his desire to escape from the dominance of physical artefacts by using a phrase he had seen scrawled on a Paris university wall during the student riots there: '*objet cache-toi*.' Those three words, which could stand as a summary of what so many artists were feeling around that time, were translated into neon lettering and placed on an igloo of yellow clay.

The construction made Merz's ambitions abundantly, even poetically, apparent; but he only liberated himself from the finite limitations of a work of art in the old sense when Fibonacci's sequence pointed the way. This unending series is expanded by adding together the sum of the previous two numbers to arrive at the next number: $0 + 1 = 1$, $1 + 1 = 2$, $1 + 2 = 3$, and so on. The rapidly mounting progress of such a simple numerical system corresponded, in Merz's view as much as Fibonacci's before him, to the order of natural reproduction. And it provided him with a flexible, ready-made means of moving beyond art objects towards a vocabulary that would reflect the vitality of the whole natural world. Many years earlier, when he was young and totally unknown, Merz had tried to attain a similar interaction between his work and nature by going out into the country, placing his paper on the ground among fallen leaves, and drawing with a single continuous line until the page was full. It was a comparatively naïve response to the same problem, and Fibonacci at last freed him from the need to think in terms of pictorial or sculptural conventions.

Now he was tied down no longer, for the Fibonacci series did not place any spatial confines on his work. Space became infinite, and the one condition on which any given project rested centred on the natural character of the material Merz chose to deal with. This material assumed many different forms, from the room of a restored Tuscan castle hung with old portraits, to the circular expansion of Frank Lloyd Wright's Guggenheim Museum in New York where Merz contributed to the 1971 International Exhibition. Fibonacci's numbers provided him there with a means of communicating his apprehension of the interior spiral from which Lloyd Wright's gallery springs. Merz thereby transcended the physical limitations of the spiral – even as he defined its essential form – by relating it to an organic system. And he interpreted an existing architectural complex still more comprehensively at the Walker Art Center, Minneapolis, where the staircase, the lift and the 'T' beam ceiling in the gallery were all filtered through the Fibonacci sequence.

Modern buildings have not, however, been the exclusive focal point for Merz's experiments. In the Walker Art Center catalogue he explained

that 'if you put the Fibonacci numbers in an exhibition they are alive, because men are like numbers in a series'. And he had by then already worked with human beings as his raw material. The large canteen of a Naples factory became his subject-matter in the summer of 1971 – not only because of its role as a centre for the feeding that enabled the workers to uphold the capitalist system, but also because the haphazard manner in which the room gradually filled with people was a living embodiment of the Fibonacci sequence. A related project was carried out at a totally different meeting-place during April this year: a restaurant in Turin, where Merz lives, which caters primarily for the city's intellectual inhabitants. The expanding system of numbers, mirroring the gradually increasing groups of diners at the tables, were all recorded in a book of sequential photographs that now constitutes the art work.

But for his current English visit to Jack Wendler's Gallery, Merz selected a different format for the presentation of his findings in two London pubs. And they proved, once again, to be ideal settings for the demonstration of his ideas, for a pub is perhaps the most perfectly 'organic' and spontaneous of all locales. The first one, the George IV in Willes Road, Kentish Town, was subjected to a static examination: ten photographs of its interior are hung on the gallery walls, each one containing the same number of customers as the neon-lit numeral which accompanies it. The

89. One of the photographs in Mario Merz's London pub series, shown at Jack Wendler Gallery, London, 1972

illustration reproduced here, showing a barman serving Wendler and Merz himself, is therefore the fourth in the series, and has a neon '3' placed beside it. Merz prefers a neon fixture to a written number on the wall because it is physically separate and detachable – the spectator is encouraged to think of it solely in relation to the Fibonacci sequence, not as an important object in its own right. And taken as a whole, the numbered photographs did articulate the gradual expansion of humanity in a popular meeting-place, setting it at the same time within a universal system of growth.

The juxtaposition between the haphazard knots of people and the coolly ordered numerical series – the one dependent for its existence on the other – provided the core of interest. And an alternative was visible on a video film, too, relayed simultaneously to provide a different insight on the same theme. This time, a pub called the King of Sardinia, in Somers Road, Brixton Hill, was used; and a soundtrack of conversation, song and background clatter accompanied the film. Merz placed each part of the video within the Fibonacci series by pinning the requisite number up inside the pub, so that they are all visible on the film. But not in an obtrusive way: the camera scans round the room, and dwells on the living enactment of the system rather than the system itself.

CARL ANDRE
18 May 1972

The quiet, unassuming character of the work Carl Andre has made for his one-man show at the Lisson Gallery hardly seems to square with his reputation as one of America's toughest and most rigorous sculptors. Delicate traceries of metal lie in an almost higgledy-piggledy profusion on the floor, looking for all the world like raw materials scattered across an artist's studio. Nothing in their presentation or their format *demands* attention: they are not isolated in a portentous art-gallery manner, and neither do they seek to impress with a bravura display of showmanship. They simply occupy a space, and the visitor is free to pick his way through them, rather than move sedately from one carefully exhibited item to the next.

Gradually, however, it becomes clear that this very lack of physical substance constitutes a challenge to our ideas about what a sculpture

90. Carl Andre, *Sort*, 1972, at the Lisson Gallery, London

should be. Instead of establishing a direct relationship between object and spectator, Andre gently takes away all vestiges of a dramatic presence from his work. No grand vertical structures rear up to confront us with their dominating power: these thin lines of rusting iron adopt a horizontal stance, and are more interested in retaining contact with the ground than in lording it over an audience. For the authoritarian attitude of the artist who creates in order to impress his enlightened admirers is anathema to Andre. He sees himself as an integral part of society, not a lonely genius operating outside it, and this belief is bound up with his entire working philosophy.

The conventional idea of an artist sets virtually exclusive store by the degree of personal talent he is supposed to possess; but Andre prefers to see his work as the product of three completely distinct forces. His own private abilities and impulses constitute one part of this trio, and the other two are equally important: the particular conditions he is dealing with in any given location, and the economic availability of the materials he uses in his work. None of these factors can be divorced from the others, and Andre makes sure that all of them actively contribute to the formation of his sculpture. Hence the disarming lack of any heroic, monumental gestures in the Lisson show. Not only are all the exhibits intimately involved with the floor on which they lie – they also retain the shapes and textures that they possessed when Andre first found them on building sites around London. He has not altered them in any way: just collected them during a series of scavenging expeditions, selected the fragments of industrial waste-matter which appealed to him most keenly, and then joined them

together to make the sculptures. Each of the works consists, therefore, of particles that Andre has removed from one environment and reassembled in another, according to the order that their own character seemed to dictate.

Such a procedure is a far cry from the artist who *imposes* his will on the materials he employs. Just as Andre has robbed his sculpture of any palpable presence, so he has pared the transforming process of art down to a minimum. These metal strips express the artist's sensibility, to be sure, but they are also wedded to their site and derive much of their appearance from the use to which society once put them. Take them away from the exhibition to be dismantled, and they will revert once again to a jumble of assorted remnants without any intrinsic sculptural identity. For Andre has mounted a meticulously thought-out attack on the whole idea of sculpture as a precious commodity: he has ensured that his work exists only when it is in full operation within an appropriate setting. As he himself has explained, 'a good work of art, once it is offered on display and shown to other people, is a social fact'. And it is this belief in an art emerging from an unidealised involvement with our environment which dictates the form of the Lisson Gallery exhibits.

They are, of course, utterly removed from the kind of sculpture that was most admired when Andre first began work in the late 1950s. The emphasis then centred on the values of Abstract Expressionism, with its love of tortured surfaces and *angst*-ridden introspection. The artist's ability to invest his work with a unique, highly charged confessional emotion was considered the supreme test of quality, and Andre lost no time in swimming against the tide. As early as 1958, he was already insisting on retaining the original block-like surfaces of the plexiglass and wood he employed, and confined his alterations to interior drillings or incisions. The influence of Frank Stella, who had studied with him several years before and afterwards shared the same studio, helped him to accept the full implications of his experiments.

Rather than continue cutting into his material, Andre realised that the material itself could take on the force of a cut, and so he began to 'use the material as the cut in space'. The example of Brancusi, who often used found objects as a means of building up his sculptures, likewise spurred him on to combine units of form instead of modelling them. And he considers that he derived the impulse to pursue this line of inquiry from his grandfather, whose whole concern as a bricklayer centred on 'being able to make large structures by using small units'. It is difficult, now, to imagine how much courage and conviction Andre must have needed to create sculpture based on such anonymous, repetitive and

anti-rhetorical constituents. He was directing a brutal slap in the face of the Abstract Expressionists, and his reward was humiliating neglect for several years. But during that time, his experience as a worker on the railroad served to confirm his direction by encouraging him to think in terms of sculpture running *along* the earth, 'more like roads than like buildings'. It made him aware, too, of the relationship which a work could have to its setting: the sight of freight cars lined up in their yards encouraged him to think of sculpture and environment as inseparable.

The link between Andre's art and his life is as close as that, and the work he then proceeded to create, throughout the latter half of the 1960s, can be seen as an exhaustive investigation of the new possibilities he had uncovered. Each succeeding project became the testing-ground for a further reduction of the sculptural object to its most basic components, and it is high time that London was given a full-scale survey of this achievement. But for the moment, the Lisson exhibition serves as a beautifully controlled introduction to Andre's work, housing a group of twelve pieces which exemplify his determination to produce an art springing directly from an engagement with the very fabric of society.

MARCEL BROODTHAERS

19 June 1975

It is probably true to say that artists who hold exhibitions at the ICA do not relish thinking about its precise geographical and cultural associations. And yet the building is situated in The Mall, with its inescapable overtones of State ceremony, Trooping the Colour and the Queen's official residence all adding up to an awesome affirmation of establishment values at their most explicit. In order to reach the ICA's galleries, visitors usually pass through Admiralty Arch – with Horse Guards Parade a prominent nearby landmark – or walk beneath the Duke of York Monument, so that by the time they enter their destination some powerful totems of national militarism have been encountered. Nor does the conditioning stop there. Nash's formal, ambassadorial architecture makes itself felt inside, too, especially upstairs in the two huge reception rooms which Barry Barker has just turned into an exhibition area called the New Gallery. Here the grandeur of the salon is apparent at every turn, and most contemporary art will be anxious to pretend that the elaborate

moulded ceilings and general aristocratic elegance has no connection with the work on display.

It therefore says a lot about both the attitudes and the independence of Marcel Broodthaers, whose exhibition inaugurates the gallery, that he has not only responded to the ICA's context but made it an integral part of his approach to the show. The work 'décor', printed in flowing script on his poster, announces clearly enough how he took his cue from the idea of these two rooms as highly theatrical arenas, inside which appropriate stage props could be placed. And it is also an ironic use of the word, for the props themselves are permeated with references to the theme of war declared in Broodthaers' subtitle to the exhibition: 'a conquest'. Naked aggression and polite artifice are consequently the two main elements in the show, just as they are in the military pageants which take place outside the gallery; and he makes sure that the one cannot possibly be divorced from the other. War is presented through the lens of European history, particularly the Napoleonic period when Nash's Mall was planned, and so the martial spirit with which Broodthaers confronts us is governed by the principles of good breeding and gentlemanly sport.

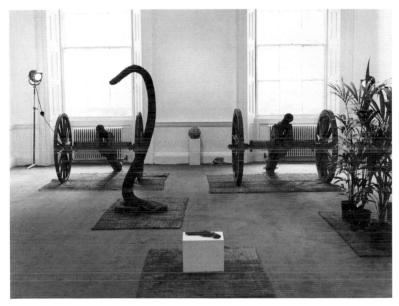

91. Marcel Broodthaers, *Salle 'XIXe siècle'* from *Décor. A Conquest by Marcel Broodthaers*, ICA, London, 1975

The contents of the inner room spell out this double-edged scenario with great precision. At the far end, a pair of cannons glower ferociously at everyone coming through the door. But their viciousness is soon tempered by the realization that they are only dummies, that their potential ammunition is restricted to a ball of dried flowers of the kind normally displayed at a smart society fête or wedding reception, and that they are resting on patches of harmless artificial grass. It looks neatly mown, more suitable for a stately game of bowls than for flying cannon-balls; and this mocking cross-play between images of destruction and *politesse* runs through the rest of the room as well. A gigantic python rears up threateningly from the middle of the floor, and yet its connections with the equally sinuous forms of two candelabra positioned at either side soon make it lose all predatory menace and appear instead more like an Art Nouveau lampstand. Or rather, there is a constant exchange of meanings from python to candelabra and back again, giving both types of object a dual identity which conveys the threat of death and the courtliness of the salon at one and the same time.

Broodthaers thrives throughout all his work on the use of metonymy, substituting the name of an attribute for that of the thing itself. And although he employs objects rather than words in this exhibition, the same process is applied here. Two crabs, for instance, face each other in a corner of the gallery, pincers outstretched and ready for combat. But their sinister presence is offset by the miniature playing-cards lying between them on the table, itself covered with a layer of green baize. Both war and game are thereby referred to through adjuncts, which for all their solid reality as objects in an exhibition are used as pointers to abstract meanings, not as ends in themselves. Over in another corner, a pair of liquor barrels, one for gin and one for rum, one with a tap and the other stopped up, sit on a table. Their significance, however, lies in their relationship with the film still from a Glenn Ford western called *Heaven with a Gun* placed on the wall behind. Parallels are drawn between the thirst for drink and the thirst for violence, and this addiction is the real subject Broodthaers is aiming at.

It would be a mistake, then, to treat each cluster of props too much in isolation. The whole room is treated very much as a unified environment, lit in several places by the lurid red and green lights of studio lamps which enhance the idea of war as a studied, rehearsed ritual played out according to rigid codes. And so the two barrels cannot be separated from the two ornate chairs placed nearby, their carving and red plush seats standing for a more refined form of addiction than Glenn Ford would ever aspire to. He holds a rifle in the film still, handling it with

curiously reverential care; while across the room a real pistol lies like a precious sculpture on a neat, white plinth.

Broodthaers wants us to pick up these unlikely correspondences and reverberations: they are at the heart of his poetic purpose, and will linger on in the memory long after the objects themselves have all been returned to the hiring shop (like real stage décor) at the end of the show. But these meanings are by their very nature incomplete, working towards a definitive statement about war and European culture rather than supplying one. In this respect, Broodthaers' allusive methods are like the jigsaw puzzle of the battle of Waterloo laid out on the garden table in the second gallery. Two-thirds finished, it contains a substantial amount of the whole scene without supplying the final pieces which would make it self-sufficient. We are encouraged to look elsewhere in order to complete the jigsaw's visual picture and Broodthaers's mental one: at the four easy chairs grouped round the table, the parasol open above it, and the reproduction of the battle on the jigsaw's box cover. Waterloo, fought one hundred and sixty years ago this month, is presented there as a toy pageant, full of picturesque explosions and heroic gestures acting out a pantomime of conflict.

War becomes an entertaining diversion for the idle rich who might sit in these chairs, sunning themselves and playing games. But its colder meaning is also represented by the showcases of pistols positioned on the walls of the second gallery. They are laid out like specimens in a glass box, certainly, and an explanatory diagram of a pistol hangs above in a gold frame to remove them even further from the reality of violence. Even so, their implications are clear enough, and the ranks of rifles leaning against the walls above the showcases are also impossible to avoid. Broodthaers manipulates all these different images so that they amount to a decorous yet chilling demonstration of war as an extension of the imperial life style, conceived and controlled within surroundings which contain potted palms as well as an armoury. His exhibition displays a world of charades concocted by a European civilization that channelled its aggression through theatrical ritual. But like the make-believe fantasy of *Alice in Wonderland*, which Broodthaers admires so much, undertones of perverted cruelty and sadism are never very far away.

ROBERT RYMAN
14 December 1972

It is rare nowadays, when every conventional artistic medium is being questioned with such intensity, to find someone as wholly involved in painting as Robert Ryman. And it is even more unusual to discover that this forty-two-year-old New Yorker, whose first English exhibition is now being held at the Lisson Gallery, is a painter good enough to command the respect of the most searching innovator. For if painting is dying, Ryman turns out to be the most healthy pall-bearer at the funeral. And he prolongs its life, purely but by no means simply, through a determination to concentrate on the properties of paint itself. Where other artists tussle with brushwork, colour, composition, the process of painting or the shape of the picture, Ryman concerns himself with pigment.

The canvases on show at the Lisson seem at first glance to form part of a very ordered progression, which explores what happens when a series of horizontal white bands are dragged across a surface either once, twice or several times. But although Ryman does tend to work in groups, he never operates in a preconceived way at all. The aims and feelings with which he starts off are always subservient to the act of painting, always liable to be changed or even confounded while the work of art is actually being made. And the pictures in his present exhibition bear out this approach by striking a middle course between finality and improvisation. They may look as if they were carried through with a methodical certainty about the size of the brush to be used, the type and consistency of the paint, the relationship of the white coats to the deep brown canvas behind, and the need to strip the image of everything that could deflect attention from the paint's vaporous surface. But a closer examination makes you aware at the same time of a refined, tremulous sensibility, judging, altering and reappraising the picture's development every inch of the way.

To me, the main fascination of Ryman's paintings lies in their ability to contain the most acute doubts and hair's-breadth hesitations within a blissfully serene framework. They had to be executed with single-minded confidence and dash – for one thing, the paint he used here dried immediately it was applied; and for another, Ryman attaches as much importance as would a musician to the need for an unlaboured performance. If one of his pictures is not carried off satisfactorily the first time around, then he would rather abandon it than attempt to correct the errors with overpainting and alterations. Which is not to suggest that

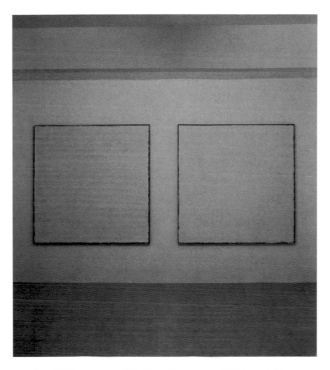

92. Installation view of Robert Ryman exhibition at Lisson Gallery, London, 1972–3

the image must conform to his expectations: the sense of surprise, of something that exceeds his greatest hopes, is for him the ideal It can be seen operating in the Lisson canvases, where the calm order of the horizontal stripes hold an immense variety of incidental activity. Viewed near-to, they are alive with a surprisingly anarchic rhythm of flicks, darts or drips of paint dancing across the canvas; and even the more thickly coated pictures turn out to have many different strata and densities beneath their apparently uniform façades.

Such diversions are not allowed to disturb the two flawless squares of gloss which Ryman has painted straight on to the gallery walls. But they, in their turn, are given a breathing vitality in other ways: the contrast between their gleaming, light-reflecting surfaces and the matt emulsion of the surrounding walls; the nicety of their relationship with the size of the wall they are painted on; and above all, through the edges of the

squares, wavering and straggling as they show how delicately attuned Ryman can be to the drama of a meeting between one texture and another.

Edges, in fact, mark a high point in his work, whether in paintings or the series of seven aquatints also displayed at the Lisson. They are the most visible manifestations of Ryman's scrupulous wish for an honest and open art, which frankly declares its interests and does not try to hide or obscure anything. Here, at these contours, nothing is ever defined with geometric certainty. The layers of paint, no less than the fine grains of the aquatints, are permitted to find their own boundaries, reinforcing once again Ryman's decision to stress the intrinsic quality of the materials he uses.

It would be hard to imagine a more thoroughgoing demonstration of paint's ability to touch our nerve-ends, or of the reason why an artist as gifted as Ryman continues to believe in painting as the best vehicle for his ideas and aspirations.

JOHN LATHAM
24 June 1976

Although John Latham's retrospective exhibition at the Tate Gallery employs a great variety of media, ranging from photographs and written texts to sprayed paint, film and canvas hung on motorised metal rollers, books predominate wherever you look. Just as they still provide the main system of storing and disseminating knowledge within our society, so they run through the last twenty years of Latham's work, a constantly recurring reference-point for anyone seeking the key to his overall attitude.

Not that he handles books with reverence, or uses them – as many other contemporary artists do – to publish and explain his ideas. Charred, battered, torn, painted and otherwise defaced, their pages hang down from the surfaces of enormous wall-reliefs like remnants from some global conflagration. In only a few instances can their contents be read, and even when a clear page of print does appear among its blackened neighbours to encourage a reading, the likelihood is that it will turn out to be a segment cut out of its original position and then replaced in reverse. Hence Latham's invention of the word 'Skoob', which sums up the way he inverts the normal role books are expected

to play. Instead of offering a concentrated, legible storehouse of information about the world, they become dismembered and illegible symbols of a burned-out culture.

Precisely because books have such a primary status in literate societies, any attempt to destroy them immediately raises the bogey of the Nazi bonfires, with their terrifying determination to eradicate freedom of thought. And it is certainly true that replicas of the eight-foot-high *Skoob Tower* on view at the Tate, each of which contained stacks of books in cube form, were ceremonially burned outside institutions like the British Museum in the early sixties. The spectacle caused shock and deep offence, as Latham intended it to. But rather than exploiting destruction as an end in itself, or amounting to a specific attack on literature, the smoking towers signified his belief that society had to rid itself of a compartmentalised way of thinking. Books, which divide knowledge up into branches or categories and reflect the increasingly specialised character of our culture, were therefore chosen as an apt target. And by reducing them to ashes or to a cluster of fluttering pages, Latham hoped to direct attention towards his concept of a time-based view of the world.

This notion, which underlies everything Latham has attempted during the period surveyed in the Tate show, arose from his contact with Gregory and Kohsen in the fifties. They proposed that the only way to overcome the chronic barriers which prevent one branch of science from communicating with another was to see the basic unit of the universe as an event, not an atom. The advantage of establishing such an event-structure was that it set up a system of comparison which cuts across disciplinary boundaries altogether. Everything can be gauged according to the length of its time-base, thereby facilitating a unified view which fights against our tendency to deal with the world in isolated, disconnected fragments. The growing awareness of ecology in recent years has, for example, shown us all the dangers of pursuing short-term profiteering at the expense of long-term natural resources. Myopic habits of thought, or what Latham more vividly calls our Mental Furniture Industry, are to blame for failing to encompass the totality of events making up the universe. And books, which tend to be the guardians of that industry, are therefore an appropriate focus of attack.

All this might suggest that Latham is more of visionary scientist than an artist. But he effectively scotches accusations of that kind by casting his cosmology in very specific terms. The *Skoob Tower* is a succinct method of asserting, through an object with obvious sculptural associations, that there is no reason why artists should restrict themselves to a medium as exclusive as sculpture any longer. Separating art activity into pigeon-holes

of that kind is one more symptom of the specialization Latham finds so blinkered. Better by far, he argues, to see the artist as an Incidental Person, capable of standing outside the narrow categories of 'painter' or 'sculptor' and affirming, on behalf of all those people who are confined to fragmented job-roles, a time-based totality.

Hence Latham's refusal to set any orthodox limits on his function as an artist. The striped paintings to be found in this exhibition are not a part of the investigation conducted by many painters over the past few years into the fundamental properties of the medium they employ. To Latham, such an aim seems absurdly ingrown: the thirty-six stripes to be seen on the canvas attached to his *Time-Base Roller* each represent an area of human knowledge, graded according to the time-base. The sequence starts on the left with short-term events like physics and proceeds to the right, ending up there with long-term cosmology. In a similar way, his *One Second Drawings*, which look at first glance like a cross between Seurat's pointillist dots and the more abstract stippled technique of a painter like Ian Stephenson, are in the end more to do with building up a whole cluster of what Latham calls 'least events' – one-second bursts of paint from a spray-gun.

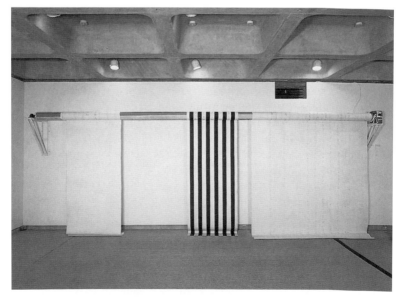

93. John Latham, *Time-Base Roller*, 1972

Although traditional forms of art abound in his show, then, Latham uses the conventions of painting, sculpture and drawing in order to affirm the importance of priorities lying beyond space-based objects. That is why the Artist Placement Group, an organization which has employed his ideas as a springboard for placing artists temporarily within industrial companies and government departments, is at pains to stress that the production of traditional art objects should not be regarded as the goal. The brief agreed upon by APG artists and the institutions which take them on is far more open-ended than that. True to Latham's time-base, it sets greatest store by the artist's ability to extend across disciplines, to find an imaginative way of pointing to the long-term purpose of a factory, nationalised industry or development corporation.

A number of artists have been involved in APG placements over the last decade, and Latham's own seminal contribution is represented at the Tate. His *Offer for Sale*, which couches APG's proposals in the format of a share offer document produced by Slater, Walker, uses business language to outline a value system directly at variance with the one normally found in such publications. In this sense, Latham's strategy here is the same as his attitude towards the use of painting or sculpture: the thought-habits he wishes to change, whether they concern the use of pigment on canvas or the motives of an industrial firm, can best be redirected by taking existing practice as a foil for his new priorities. Latham himself is currently placed with the Scottish Office, where he has spent his time examining problems of urban and rural renewal. Once again, he focuses on the structures he finds there, like the enormous slag-heaps which sprawl across the landscape, and proposes an entirely different way of looking at them. Far from recommending that they be removed at colossal expense, or turned into attractive gardens, Latham suggests cherishing them for what they are: dramatic mountains of waste, each with its own quirky profile and local identity, which link the past both with the present and the (hopefully) regenerated future.

Now in his mid-fifties, Latham has been an isolated figure in British art for far too long. His influence on a younger generation of artists, who have drawn strength from his notion of the artist as an agent for social change on the broadest of all possible fronts, has been considerable. This Tate tribute, overdue as it is, begins to set the record straight.

DAN FLAVIN
20 December 1973

It would be fair to say that I never sit down to write about art without acknowledging the fundamental absurdity of my task. Trying to verbalise about tactile or visual sensations which have nothing whatever to do with words, and everything to do with the act of looking, touching or responding, is an aim wide open to deflation by the reader. It also exposes the writer to inflation, the blowing up of a silent interaction between himself and the art work into a windy literary approximation which sacrifices the original experience for the sake of rounded, felicitous phrasing. A battle is always fought between the unclassifiable memory of an encounter and the overwhelming urge to parcel that memory up inside a definitive sentence. The reassuring attractions of a neatly turned opinion win almost every time.

I am made particularly aware of the problem by Dan Flavin's exhibition at the Lisson Gallery, incredibly enough the first English one-man showing for a forty-year-old New Yorker who has long been respected and admired in both America and Europe. For Flavin's work is so self-sufficient, so complete in itself, that it seems more than ever a betrayal of the satisfaction he offers to lard the exhibits' own spare merits with fatty verbiage.

To be formally purist, I could restrict myself to recording that each of the pieces on view consists of fluorescent light tubes, purchased by the artist and assembled by him in various combinations, with acute attention paid to the siting, the shades of colour and the interrelationships between the component parts. But this would be a merely factual account, even if I dissected the construction of the works more fully, and it takes no account of their numinous presence, their identity on the gallery walls.

Alternatively, however, I should be just as guilty of misrepresentation if I disregarded physical analysis and concentrated on evoking their sensuous effect alone, describing the soft phosphorescent glow which appears to pulsate from even the coolest exhibit, wrapping not only the tubes themselves but also their immediate surroundings in a quasi-religious haze of light.

Which is the less inadequate approach, the objective or the subjective? The answer is neither: a closer approximation can be found somewhere in the middle, beyond the reach of any stumbling observations or metaphors I could possibly formulate. And yet it would be dishonest of me to pretend that I am not excited by the prospect of tackling

94. Dan Flavin, *Untitled (to Barbara Lipper)*, 1973

such an impossible challenge, even if the knowledge both of near-futility
and of distorting the works with clumsy misconceptions mocks every
sentence I write.

Perhaps it would be wisest – or at the very least most sensible – to
focus on one piece only, an untitled corner construction dedicated to
Flavin's friend Barbara Lipper, and examine my difficulties with one spe-
cific example in view. It is the sum, to begin with, of six unexceptional,
standardised lengths of tubing: two light blue stretches (the words azure
and lapis lazuli are both too bright to convey its softness) placed hori-
zontally at top and bottom, supported in between by a couple more,
grouped together at left and right. The blue tubes shine outwards, pale
and clear; the verticals project their colour inwards, darker and more
fuzzily defined. And while their metal backs confront us with a surpris-
ingly intricate sequence of functional decoration, punched with holes,
slits and more complicated indentations, the horizontal tubes present
steady, uninterrupted bars of light to the spectator. This unwavering blue
therefore acts as a foil for the vertical tubes' decorative waywardness, and
also holds down the dazzlingly pretty blend of pink and tomato red
which those four tubes cast on the corner behind the work.

Already, then, Flavin makes us aware of a balancing feat, poised between the rival claims of rectilinear rigour and nebulous sweetness. This amalgam of opposites likewise applies to the larger connotations of the piece as well, since the inescapable aura of churchlike devotion is brought into head-on collision with the fact that no one part of the work conforms to the special, precious and highly-wrought qualities a real altarpiece or pious image is traditionally supposed to possess. It is defiantly practical, even banal, in its method of assembly, and yet the seductive mysticism which links up with Flavin's abortive training for the Catholic priesthood as a boy is immediately and inescapably apparent.

Both poles are contained in this extract from his autobiographical essay, where he recalls how 'in time, I grew curiously fond of the solemn high funeral mass which was so consummately rich in candle-light, music, chant, vestments, processions and incense – and besides that, I got fifteen cents a corpse serving as an acolyte'. The throwaway sting placed so cunningly at the end (Flavin is a good writer as well) counteracts the cloying love of ritual without destroying its potent appeal, and the corner piece performs the same function.

Solidly tangible and as concrete as a sculpture which controls and articulates the precise area it occupies, this ambivalent work at the same time spreads its influence over the rest of the room, feeding colour across ceiling, floor and opposite walls until it takes on the properties of an environmental painting which infiltrates every square inch of neighbouring space. Minimal in structure, it ends up emanating resonances comparable with the most densely organised of jewelled icons. Simple to describe in terms of physical content, it ultimately confounds all attempts to translate the nub of its identity into verbal language. And at that point, more than usually dissatisfied with my shortcomings, I am obliged to stop.

TADEUSZ KANTOR

23 September 1976

It is not often that an artist is demonstrably capable of displaying his work, at full stretch and with an impressive command of the different media he employs, in both a theatre and a gallery. A growing number of artists are electing to use the exhibition convention as a pretext for performance alone, and, conversely, theatrical pioneers like Edward Gordon

Craig can have their graphic studies shown in an art gallery without any sense of undue contradiction. But Tadeusz Kantor, whose retrospective at the Whitechapel Art Gallery confirms his reputation as one of Poland's most prominent senior artists, has also succeeded in arousing enormous interest among the theatre profession with his Cricot 2 Theatre Company's run at the Riverside Studios in Hammersmith. I cannot easily think of anybody else who could straddle both these camps without either being accused of falling between two stools, or of appealing to one end of the art/theatre polarity at the expense of the other. On the technical level alone, the stagecraft in Cricot 2's presentation is formidably single-minded and gives ample evidence of arduous, stringent rehearsal. While the Whitechapel survey is informed by a sophisticated understanding of how to infuse the painting tradition with a freewheeling use of found objects, drawing, written texts, mannequins, and a plethora of diverse materials.

So how can Kantor's central identity be defined, in view of the fact that he has devoted most of his life to blurring the boundaries between live drama and static art works? One answer, which Cricot 2 does its best to encourage, is that his theatre is heavily biased towards a form of mime in which snatches of dialogue play second fiddle to predominantly visual tableaux. Although Cricot 2 is alive with the most frenetic and aggressive action, strident enough to mount a direct assault on its audience, all this action is punctuated by a series of caesuras, whereby the manic gesturing constantly freezes into still life. Apart from providing a necessary antidote to all the hectoring activity, which would otherwise surge onwards in an unbroken and wearying flood of gesticulation, these pauses serve as a reminder of Kantor's need to organise his players into monochromatic masses. The minimal number of props on his stage — rows of school desks, a wooden chair, a bicycle contraption, a window frame, a broom and a crudely constructed lavatory — are treated more like sculpture than functional apparatus. Moreover, the spectators are never quite sure at any given point whether they are looking at real actors or inanimate dummies: the performance begins with a motionless congregation of effigies, and Kantor refuses to distinguish with any clarity between humans and mannequins throughout his 'play'.

All these strategies suggest that he wants his theatrical work to be seen, at heart, within an art context. The spoken word does have an important role in Cricot 2's battery of expressionist techniques, and members of the audience who understood Polish often laughed at the verbal exchanges hurled from one corner of the claustrophobic little stage to the other. But the fact that Kantor did not bother to translate

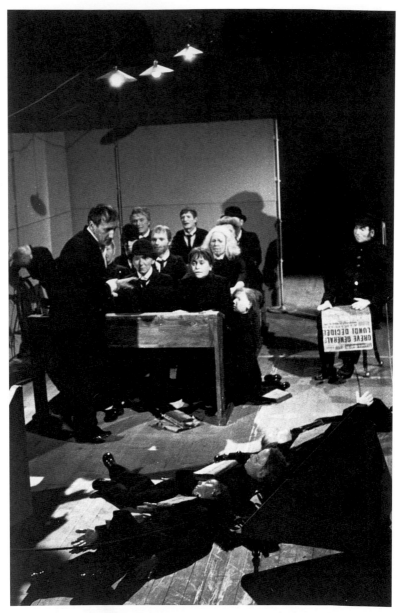

95. Tadeusz Kantor, *The Dead Class*, performed by the Cricot 2 Company, 1976.
Photograph by Ian Knox

these exchanges, combined with the preponderance of robot-like stuttering and the gunshot repetition of single words, suggests that a conventional playwright's text played little part in his overall aims. Besides, Kantor himself was present throughout the proceedings, a lugubrious and sometimes sardonic figure gliding through the various areas of action in order to conduct them with darting thrusts of the arm and hand. The analogy with a puppet-master was inescapable, and it effectively destroyed whatever pretensions Cricot 2 might otherwise have had to full-blown theatrical illusionism. The artist as maker was on view, making clear with a strong whiff of dictatorial vanity that his performers were but putty in his fingers, to be shaped, moulded and pulverised at will.

As if to reaffirm this equation of theatre with animated sculpture, one of the Whitechapel exhibits looks like a stray from the Cricot 2 production. It is a mannequin of a uniformed schoolboy seated stiffly at his desk, and Kantor has ensured that no one misses the connection by writing the title of the Hammersmith performance – *The Dead Class* – on a pillar nearby. The difference in mood between this mute child and his Cricot counterparts does, however, pinpoint an important divide in Kantor's work. Whereas the performance is ferocious in its tactics, and sustains a relentless level of attack, the exhibition is predominantly meditative and forlorn. It comes as a relief after the excess of melodrama provided by Cricot, whose great flaw (in *The Dead Class*) is an inability to realise that one-and-a-half hours of frantic exaggeration progressively fall foul of the law of diminishing returns. Expressionist *angst* soon begins to pall unless it is set off against other, less ranting areas of feeling, and Kantor the director is guilty of numbing repetition. His gallery art, by contrast, presents his alter ego, which is softer and far more content to rely on a cool demonstration of what he calls 'emballage'. Kantor coined this term, which derives from the French verb *emballer* – to wrap or pack – in order to distinguish his favourite working methods from collage or assemblage. Both these familiar devices are prominent in his art, but by replacing them with the all-inclusive 'emballage' Kantor hopes to stress that formal invention is in no sense his main aim. The paper bags, umbrellas, tins, planks and sacks frankly incorporated in his art works are not to be valued for their own intrinsic properties. Far from representing material entities which make self-sufficient statements, they are all selected as dramatis personae in his involvement with 'objects of the lowest rank'.

Like the howling freaks who people the Cricot stage, they are drawn from the detritus of society, and from them Kantor develops his rhetoric

of rubbish. This rhetoric is at its most overt in performance, where it soon becomes as tedious as a street-corner orator who does not know how to vary his delivery. And it is at its most covert in the Whitechapel exhibits, which rely wholly on the object itself, split open, tied up, left dangling or sprayed with paint. These inert presences are altogether too mute to carry the charge of emotion Kantor seeks, and the 'emballage' process only grows effective when humanity and objects are brought into conjunction with each other. In *The Dead Class*, the most powerful moment occurs near the beginning, when the degraded and stupefied clowns leave their desks and then reappear, accompanied by the deafening strains of a Viennese waltz, carrying child puppets. Supporting these helpless emblems of the past and the future on their backs, or else swinging them wildly from side to side in angry despair, the cast performs a frenzied dance around the classroom. It is a genuinely horrific dramatization of the human predicament at its bleakest, trapped by its childhood conditioning at the same time as it passes that conditioning on to its own offspring. And at the Whitechapel, the same combination of figure and baggage carries an albeit less savage force in works like *Man with Suitcases*, a hollow, faceless scarecrow bowed down by his luggage and implicitly condemned to a journey without destination.

Kantor here comes close to the pathos – and the sentimentality – of the Greek artist Vlassis Caniaris, whose similar figures refer to the plight of European immigrant workers. But the heightened gestures of *The Dead Class* contain a strain of Kantor's own partially Jewish background, and the single most abiding image in all his work is that of the dispossessed wanderer, rootless and absurd. One of the strangest exhibits places a head copied from Velázquez's infanta paintings above a large canvas satchel, as if to suggest that even Spanish princesses are not immune from the futility of life's dustbin. And another, specifically Christian dimension is introduced in some acrylic and ink pictures covered with studies of bowler-hatted men dangling, crucifix-like, from coat-hangers. Images like these, both in performance and in emballages, align Kantor with the bitter negation of T. S. Eliot's *The Hollow Men*, who are all reluctantly obliged to recognise that 'This is the dead land'.

DON JUDD

31 January 1974 and 2 October 1975

Although Don Judd has been at pains over the past thirteen years to stress the intrinsic properties of his sculpture – its scale, volume, surface, colour and relationship between exterior and interior – he has also shown a concern for the space in which it is placed. One of his most widely known works, an untitled stack of seven galvanised iron units executed in 1965, brings into active play the wall supporting the units, the ceiling and the floor: all three are obliged to take their part in the structure of the piece, and they are indivisible from it. At the same time, however, he has carried out plenty of free-standing sculptures which make no such unusual demands on their immediate environment, and it is only recently that these architectural considerations have become more emphatic.

They were made very clear in his memorable one-man show at the Lisson Gallery last year, where both the principal exhibits were built into the rooms they occupied and could not easily be imagined outside that context. They inaugurated a pronounced shift in Judd's work, away from objects sitting on the floor or ascending a wall in regular blocks and towards a more environmental approach that responds directly to the space at his disposal. Both the large pieces at the Lisson entirely altered our perception of the rooms in which they were displayed; they half-filled their allotted galleries, looming up in front of us like giant intrusions closer to structural alterations of an interior than man-made artefacts. Nothing was allowed to disturb this elemental impact. The $3/4$-inch stretches of plywood which would normally be used on building sites were not textured or polished to hide their rawness; the screws holding them together were left exposed; and no attempt was made to marry the pattern wriggling across one separate section of the wood with its neighbours. In other words, Judd was at pains to emphasise the anti-illusionist, anti-symbolic, anti-craftsmanship bias of his work, and for all their considerable size these sculptures were the very opposite of bulky or monumental. They were what they appeared to be: thin wooden sheets which did not carry with them a massive weight, did not suggest any metaphorical allusions or make dramatic gestures, and definitely refused to assert the artist's ego in anything other than a bluff, practical manner. So we were left with an impressive and satisfying physical reality, not lending itself to verbal translation of any kind and insisting that it should be seen for what it was and nothing else.

96. Don Judd, *Untitled*, 1975, at Don Judd exhibition, Lisson Gallery, London

Some working drawings for these pieces are on view at Judd's new Lisson show, reminding us of how subtly balanced they were between the environmental and the sculptural, of how they suggested a growing involvement with dictating the precise conditions in which his work should be seen. Unlike most sculpture, remaining at the mercy of its exhibition space even if it tries to dominate that space either through sheer bulk or through dynamic tactics, Judd aimed at a state of peaceful coexistence. The main question prompted by the announcement of Judd's new exhibition centred on whether he would allow his sculpture to be subsumed even more in its display area.

The answer, supplied by two series of six plywood boxes arranged in the same pair of rooms he used before, reaffirms Judd's need to control the dimensions of each individual piece. They are all twelve inches high and twenty-four inches wide (a double square), and there is no suggestion here that they would ever have to be altered in order to fit into a different setting. Hanging in severe and self-contained isolation on the Lisson's white walls, their top surfaces nearly six feet from the floor, they appear proudly attached to the importance of retaining their present form. After a while, however, it becomes apparent that these suspended volumes – all open at the front to emphasise how far they project from the wall surface – are still directly related to the space they inhabit. Upstairs, they are placed at intervals of a half, thirds and quarters on the

three respective walls at their disposal; while downstairs they hang exactly in the middle of the room's six sections.

In this very general sense, therefore, they are intended to honour the gallery for which they were made, even if they no longer rely on it to provide them with part of their structure. The upshot is that Judd has it both ways, holding on to the compact identity of each separate box and simultaneously provoking an acute awareness of the overall architecture at their disposal. There is nothing dramatic about the way they affect space, and none of the surprises which often accompany fully environmental art is permitted here. Judd enjoys his chosen materials, never attempting to hide or alter them. His strategies are openly explained and scornful of any mystification about how a particular sculpture is constructed.

In the downstairs gallery, for instance, the boxes' back planes are situated about half-way through them, rather than lying flat against the wall as they are upstairs. Out of the most 'banal' component parts, one slight displacement like this movement forward from the back of the box encourages us to think very hard about the role of depth in sculpture. Variations in the gallery's lighting make this shift more complex. Such areas of ambiguity soften Judd's otherwise rigorous lesson in sculptural grammar, and admit an intriguing element of chance into the work of a man who has long since proved himself impressively determined to channel our attention towards the object and the space it so confidently articulates.

EVA HESSE
24 October 1974

I never have anything but sympathy for an artist who is hyper-sensitive about the way in which work is disseminated. Unlike writers, who know that their words can be faithfully reproduced by the most unpractised publisher, artists are often quite scandalously betrayed by the quality of the illustrations in a magazine or book. And whereas composers dismayed by a bad performance of their work can comfort themselves with the thought that accurate scores are easily available, most artists have to accept that there is no satisfactory way to assimilate their work outside experiencing it in the original. Even then, in terms of an exhibition, the signals which artists' work should rightfully emit are subject to all kinds of interruptions. It may be placed with a whole group of other artists

who are so alien that they succeed in obscuring or distorting what it was trying to do. The gallery owner might attempt to impose a presentational format which seriously contradicts the character of the work, and insist that certain vital exhibits are left out of the show, either through lack of space or because they may not sell. Novels are never published with half the pages missing, and concerts never abandoned half-way through. But artists are constantly being compromised by the vagaries of a distribution system which rules that, if they are lucky, small sections of their work will be shown to a limited public every so often. The best exposure they can ever hope for is not a best-selling record or a paperback which can be bought and enjoyed by millions, but a retrospective survey probably held just before or – more likely – after their death.

These miserable inadequacies have bedevilled the artist for so long that they are usually accepted as an inevitable evil and not commented on. Sometimes an individual like Richard Long, whose care over the context in which his work is displayed has become legendary, draws attention to the problem and attempts to control it as much as possible. But on the whole, the relegation of original works either to the artist's own studio or to the houses of a few wealthy collectors is borne without too much complaint. The advent of an Eva Hesse exhibition at the Mayor Gallery would not, therefore, normally provoke any remarks about such short-comings. London ought to be grateful that this enormously influential artist has at last been given her first British one-woman show, and critics expected to concentrate on analysing the works on view. I cannot do so, however, without asking a few questions about whether this particular exhibition does proper justice to the artist it purports to celebrate.

Hesse died in her early thirties four years ago, and so the problem of how best to present her work has been all too brutally taken out of her hands. The Mayor Gallery operates within small premises, and it has tried hard to provide the maximum amount of space by supplementing its usual brace of rooms with an area at the back normally used as an office. A catalogue, with a factual introduction by Linda Shearer and ten illustrations, is on sale to furnish any curious visitor with background information, and it is surprising that as many as thirty-three sculptures and drawings spanning the entire range of her active career have been placed on show. All honour, then, to a gallery with the good sense to make up for London's failure both to exhibit Hesse before and, most notably, to negotiate for the large Hesse Memorial survey shown in several major American museums last year.

But that said, is the Mayor's offering in any sense doing Hesse's memory or her achievement a service? Would she herself have been pleased

97. Eve Hesse, *Untitled*, 1966, at Mayor Gallery, London, 1974

with the way in which the English public is now being enabled to sample her work? I think not. Despite everything the Mayor has tried to provide, we are offered at best a tiny and fragmented aspect of her art, neither substantial enough to give us a full and realistic idea of her stature nor insignificant enough to encourage larger London galleries to stage a

more comprehensive retrospective in the future. It falls between these two stools, and I doubt if Hesse would have agreed to be shown at half-strength if she was alive today. Most of the sculptures need far more room to breathe than they are granted here: the sense of constriction is acute, and further aggravated by the miscellaneous gathering together of pieces executed at wholly different times in one congested space.

It is possible to register the transition from the early drawings, which still employ a vocabulary derived from Abstract Expressionism, to the moment around 1965 when she began to use materials like latex, rubber hose, electrical wire and rope in order to reach out for an amalgam of painting and sculpture entirely her own. The spiky, rasping and overtly sexual side of her personality appeared then, and it found expression in a number of different forms, encompassing painted reliefs, hanging clusters, random groupings, boxes containing objects and combinations of these alternatives. Something of Hesse's affection for and understanding of materials is conveyed, as is her relaxed and non-hierarchical ability to use whatever medium suited her best, without worrying about its status or the fact that she invariably straddled the boundaries separating one medium from another. In so doing, she showed a healthy disregard for rigid categories, and succeeded in welding an approach to form which possesses much in common with Minimal art to a more neurotic and nakedly confessional content, usually associated with the outpourings of Expressionism.

It was a remarkable union of opposites, and in the best works shown here the very feminine sensitivity of her materials makes the sinister and malignant forms they assume all the more affecting. But we are simply not given enough of a body of work to decide how far she was able to develop this language. We need to know whether the slightly perfunctory character of the exhibits found fruition in major pieces which have not been included here, or whether her tragic death prevented Hesse from fulfilling herself completely. If I was an artist, I would be most unhappy with any exhibition which failed to provide an answer to that question, especially if it marked my début in a foreign country. And I really feel that galleries, along with the owners or dealers whose loans make a show like this practicable, ought to worry more about showing off artists in whom they believe to the best advantage. Nothing less will do.

HOWARD HODGKIN
20 May 1976

Right in the middle of Howard Hodgkin's retrospective exhibition at the Serpentine Gallery, a small gouache called *Memoirs* has been included as an unobtrusive reminder of how he was able to announce his future direction at the early age of sixteen. Apart from its cartoon-like emphasis on line, which would later be replaced by an even more pronounced preference for broadly handled brushwork, this little study is astonishingly prophetic. The concentration on figures in a room, the need to stress the objects inhabiting that room as much as its human occupants, the reduction of furnishings and people alike to a flat pattern, the odd decision to let the picture-edge slice off the head of the lady reclining on the sofa – all these elements can be found in Hodgkin's mature work.

But perhaps the most telling pointer in this gouache is its fascination with memory. As the title suggests, Hodgkin is already taking a scene he experienced at first hand (when he stayed at the decapitated lady's Long Island home) and using it as a springboard for his own meditation on how we proceed to select, rearrange and finally transform the meaning of that scene in our imaginations. The original response to a particular combination of personalities and environment is never lost sight of, and Hodgkin has continued to rely on just such a stimulus throughout his subsequent career. At the same time, however, he is acutely aware that painting a picture in commemoration of his response leads to an exploration of the recollecting process. So everything in *Memoirs* – the grotesque enlargement of the lady's spiky hands, the red carpet's hard glare, and the seated man's equally fierce eye staring at his companion's bejewelled ring – has been distorted to coincide with Hodgkin's own interpretation of the scene several years after he witnessed it.

Memoirs was executed in 1949, and the fact that the exhibition only takes up Hodgkin's work again towards the end of the 1950s must reflect his inability to pursue the implications of this gouache during the intervening period. But those missing years did, at the very least, witness his evolution from draughtsman to painter. From now on, there is never a hint of the sixteen-year-old who used gouache simply as a means of filling in the linear framework of his design. As if in recognition of paint's ability to replace the categorical definition of line with a more allusive alternative, Hodgkin's brushstrokes do their best to avoid pinning his subjects down inside one set of contours alone. Whereas *Memoirs* was

98. Howard Hodgkin, *Grantchester Road*, 1975

content to adopt a figurative idiom which crosses Ben Shahn with Edward Burra, Hodgkin's more mature work learns from influences as disparate as Matisse, Pollock, Vuillard and Indian painting that a whole variety of stylistic approaches can be adopted within one picture.

We therefore find clear references to a head, a window or a doorway coexisting with far less representational areas which refuse to be confined to a specific function. They are all unified, however, by Hodgkin's consistent refusal to pretend that he is dealing with anything other than pigment at its most raw and direct. His paint usually looks as if it has been squeezed straight from the tube, unmixed, and then applied in such a way that the workings of the brush are never disguised. A whole vocabulary of gestures, ranging from dabs and blobs to long, straggling sweeps and sudden flicks of the wrist, are allowed to lie on the surface of his pictures as a set of naked material facts. Their impact is as immediate as the marks that children make when they decide, without attempting to hide the wilfulness of the artifice involved, that a person or thing they know

well can be translated into colours and configurations many stages removed from literal appearances. Hodgkin shares the joy of a child as well: his work revels in the most immediate expressive possibilities of paint, and he clearly would not mind being accused of clumsy naïvety if it ensured the retention of this simple, sensuous delight in the basic properties of the medium. Never for one moment are we permitted to forget how a given picture has been carried out. The preliminary markings are not wholly covered up once Hodgkin has changed his mind and replaced them with alternatives. On the contrary, each successive step in the work's evolution remains frankly visible underneath its restatement, so that we can trace the development of his shifting attitudes from start to finish.

But − and the qualification is a vital one − this honest declaration of the fundamental mechanics of painting is not regarded as an end in itself. The main reason why Hodgkin offers such a rich and stimulating experience lies precisely in his recognition that it is insufficient to elevate the exposure of process into an ultimate goal. Although he provokes an awareness of the painting as object, not least through his fondness for using slabs of wood whose thick frames are incorporated in the fabric of his compositions, his sights are still firmly set on the subject-matter which he first began to deal with in *Memoirs*. The way he handles paint is an analogue for the way he reacts to people and places. They are the starting-point, and his acute understanding of how a picture can be constructed is inextricably bound up with his no less profound ability to register every nuance of his feelings about a person and a location.

In painting after painting, Hodgkin enables us to see how the bare representational bones of a subject are augmented, refined and made more supple by the free play of his response to visible reality. The swoop of a friend's back, the way a figure sits in a chair, and the importance of the wallpaper, furniture and architecture seen in a house, are duly observed and fed into the structure of the picture. Their presence there is indistinguishable, however, from the cumulative layers of memory and association which are also loaded on the painting by Hodgkin's need to take all possible aspects of his relationship with the subject fully into account. He permits us to see this attentive, scrupulous registering of his attitudes in action, as he admits to himself that an area of the picture already completed needs to be modified by a new formulation. Hodgkin's paintings are full of second thoughts, cancellations, changes in direction, the pictorial reflections of a man who constantly says to himself: 'no, this is *not* the nub of my feelings about the subject − it will have to be blocked out in favour of an entirely different emphasis.'

His father, Eliot Hodgkin, was an eminent horticulturist, and it is hardly fanciful to see in these pictures a related belief in nurturing things over an extended period of time; in planting a diverse group of forms and colours within bordered-off areas; in drastic pruning for the long-term good of the painting's overall growth; and in the sudden flowering of exotic blooms. Moreover, one of Hodgkin's great strengths as an artist is his determination not only to build on the lessons learned from previous work – the most recent pictures on show at Waddington Galleries II include some of his most confident statements to date – but also to regard each new painting as a fresh beginning. There is never any suspicion that he capitalises on a success by turning out a glib series. The struggle to arrive at an exact equation of form and content is obviously re-enacted every time he starts again, just as a gardener is constantly obliged by a seasonal cycle of growth and decay to revitalise his existing achievements.

The very opposite of facile or safe, Hodgkin's work is therefore inevitably prone to failure. Some of his pictures, like *Mrs Nicholas Monro*, lose themselves in the labyrinthine complexity of their intentions. Others, like *Bathroom Mirror*, exclude too much of the visual incident on which he thrives. But the risks are well worth taking, for when Hodgkin succeeds he produces memorable testaments to his double awareness that people cannot be divorced from their multi-layered social context, and that painting itself cannot be divorced from its roots in everyday experience.

PATRICK CAULFIELD AND ROBERT MANGOLD
18 December 1975

In many ways, it would appear difficult to believe that Patrick Caulfield's exhibition at the Waddington Galleries II and Robert Mangold's show at the Lisson Gallery are products of the same broad cultural context. Both are painters, and both are nearing forty (Caulfield was born in 1936, Mangold a year later). But at this rudimentary point their differences become glaringly apparent.

Caulfield thrives on a high level of representational content, whereas Mangold eschews figurative references altogether and confines himself to a wholly abstract interplay between line and colour. His austere geometrical elements constitute a kind of ultimate refinement, an ideal purity of language which would never want to muddy itself with the illustrational

details Caulfield so lovingly delineates. The rigorous limitations imposed by Mangold's use of the square, the circle and triangle imply a radical belief that there is no longer any sense in transcribing the external appearance of the world on to canvas. Caulfield, however, still subscribes to the traditional idea of the canvas as a window, looking out at this very world and setting down a factual account of the accumulated objects it contains. He presents us with a pictorial warehouse stuffed full of props, utensils and incidental scenery, while Mangold not only empties that warehouse of all distracting clutter but refuses to admit even its bare architectural framework as the legitimate concern of art.

Two sharply alien interpretations of the activity called painting are therefore elaborated here, and they remain at loggerheads with each other. Caulfield maintains that the painter has every right to feed off the profuse data supplied by everyday observation: his version of reality embraces everything from an ordinary telephone placed on an occasional table to the florid forecourt of a building encrusted with caryatids, pilasters and rusticated columns. People may be virtually excluded from the scenes he chooses to record – the only person allowed into his exhibition is a tired waiter leaning over a ledge in a deserted restaurant, no more than a background key to the atmosphere of the picture as a whole. But their absence is amply compensated for by Caulfield's ability to invest inanimate scenes with a strong human presence.

In a large painting called *Sun Lounge*, for instance, the easy chairs are uninhabited, and yet the mood of arid relaxation which their owners must be experiencing is apparent everywhere, in the inert cushions, the despondently dangling lamp fixtures, the empty vases and the bleary band of white sunlight straggling across the redundant heights of the room. Caulfield knows exactly how to make the supposedly mute outward trappings of existence stand in for the people who at other times must move through them. Another huge picture entitled *Entrance* is dominated by the brutally repetitive pattern of a cast concrete screen lining the porch, its crude circular ornamentation reflecting the mass-produced life-style enacted within the house itself. Even the brightly tinted blooms scattered throughout the surrounding herbaceous border, which should ideally alleviate this sterility with a leaven of natural growth, are depicted as so many vulgar stereotypes fit only for a cliché-ridden advertisement in *Homes and Gardens*.

In other words, Caulfield sees no reason why his work should be frightened of appropriating all the descriptive paraphernalia which abstract painting avoids, and exploiting art's capacity to hold up an illusionistic mirror to visible reality. Mangold, by contrast, regards that kind

of recording as irrelevant, an archaism which detracts from the modernist painter's attempt to define the 'essential' identity of the medium he employs. To Mangold, the overriding priority lies in a singling-out of painting's fundamental properties: its physical presence as a two-dimensional object hung on a wall, its flat, all-over surface, its basic vocabulary of line, colour, tone and hue. Everything he does is devoted to enhancing an awareness of these inherent devices, and so the contents of each picture are indivisible from its overall structure.

A painting called *Four Arcs Within A Circle* is just that, nothing more nor less, and the satisfaction it offers depends on the extent to which it articulates its own internal logic. The four black arcs, growing progressively larger as they hug the contours of the painting in a clockwise direction, call attention to the circular character of the picture as a whole. But at the same time they demonstrate, with an elegant economy of means, how the arcs forfeit more of the circles they signify as they get larger, and also how the two largest arcs are obliged to intersect each other in order to fit into the space at their disposal. Although the dull yellow ground is instantly recognisable as a Mangold colour, and has a distinct sensual effect which enhances the attractiveness of his tightly knit union of ends and means, it in no way interferes with this geometric exposition. On the contrary: the paint is rolled on in a single, undifferentiated coat, calling no more attention to itself than the ready-made colour of the paper Mangold uses as a given ground for his preparatory drawings.

The peculiarly muted quality of all the colours in this exhibition, whether they be buff, deep maroon or something still more difficult to classify, reflects the self-effacing character of Mangold's work. It is withdrawn and anti-rhetorical; and just as he never resorts to a display of strict mathematical consistency in his geometric equations, so he always executes his lines in a discontinuous freehand to avoid any suggestion of unnecessary panache. Mangold enjoys and understands his medium enough to realise that a pursuit of flawless precision for its own sake is a side-alley which detracts from his main aims. When, therefore, he inscribes a white triangle and a black square within an overall square of subdued orange-yellow, dividing the canvas into halves, quarters and eighths, there is no hint of a rigid mathematical exercise. It is first and foremost a delicate combination of painting and draughtsmanship, carried out according to a finely honed sensibility which would far rather court the irregularities of freehand than sacrifice them at the altar of mechanical perfection. The presence of the artist as mark-maker is evident wherever you look.

The same can also be said of Caulfield's work, even though he translates

99. Robert Mangold, *Red Distorted Square Circle*, 1971

everything he represents into a network of simplified black lines. The idiom he employs is as 'debased' as many of the implements and architectural styles depicted in his paintings. It is a hybrid idiom, partly derived from the comic-book conventions which Lichtenstein used as the basis of his early pictures, partly from the *faux-naïf* clarity of do-it-yourself manuals, and partly too from the fanciful charm of a children's cartoonist like Tintin's Hergé. Caulfield applies this very formal style to the description of a chair-leg and a daffodil alike, and yet he always ensures that his lines wobble in places, so that his paintings run no danger of ossifying into a facile formula. He likewise shares Mangold's insistence on a flat coat of colour, thereby preventing his undeniable delight in illusion and perspectival recession from disrupting the integrity of his picture-surface.

It is true that he employs an often scalding diversity of colours within a single work – his *Café Interior: Afternoon* sets pink against scarlet, orange swearing at ice blue – and that he includes a heresy like the tourist view of a Swiss lake inside his otherwise skeletal rendering of *After Lunch*. But these quirks and departures are all of a piece with his omnivorous appetite

100. Patrick Caulfield, *After Lunch*, 1975

for the banality of domestic and commercial settings, their contents as much
as the buildings themselves. In Caulfield's best paintings, this banality
becomes genuinely extraordinary, informed all the time by a disciplined
understanding of what Mangold would consider to be the fundamentals of
the medium they both explore with great consistency and resourcefulness.

Polar opposites they may be, but the strength of these two exhibitions
proves that any responsible account of painting today cannot pretend
that the 'impure' representational tradition is either more or less viable
than its 'pure' abstract equivalent.

JAMES ROSENQUIST AND AMERICAN TRADITION
5 December 1974

One of the advantages of travelling round several apparently disparate exhibitions each week is that it forces you to make connections between artists, epochs and attitudes which would normally be considered in isolation. Such a task can, of course, lead to an unfruitful state of mind, where nothing is ever studied in any depth and no conclusions are arrived at apart from a generalised acknowledgement of the variety of art. There is an alternative to that kind of fair-minded catholicity, one which reminds you that tradition should be seen as a living force shaping and giving continuity to aspects of art that seem to demand treatment as special, unprecedented cases. But what possible point could there be, for instance, in discussing together Winslow Homer's exhibition at the Victoria and Albert Museum and James Rosenquist's one-man show at the Mayor Gallery? Apart from the fact that both men share an American nationality, no other obvious links bind a late nineteenth-century naturalist painter who recorded a predominantly rural world with a Pop artist still only in mid-career who immerses himself in the imagery and rhythms of urban life.

The selection of Homer's work, sent over here from the Smithsonian's Cooper-Hewitt Museum and consisting very largely of preliminary sketches rather than finished oils, shows how diligently he aimed for a direct, unforced and accurate portrayal of pastoral man's straightforward relationship with nature. Except for a group of early studies exploring both the picturesque and the tragic aspects of the Civil War – Homer's notably well-balanced outlook could take an objective interest in the regalia of a Zouave's uniform even as his subjective pity was aroused by the wretched plight of some walking wounded – his main ambition was to interpret the spirit of pioneering Americans on land and sea alike. If the implications of his programme were panoramic in scope, and embraced a highly dramatised vision of the ocean as an elemental force against which humanity pits its strength, the pictorial results are modest and unassuming. 'When I have selected the thing carefully,' Homer once explained, 'I paint it exactly as it appears.' And however large a comment on American existence is carried by the subjects he chose, the quiet fidelity with which he transcribed the face of that existence gives his work a homely, local air. For all its universality of theme, Homer's art ends up looking provincial in the best sense of the word. His barefoot watermelon boys, so democratically divided between the black race and the white, belong squarely within the folk

genre of Huckleberry Finn; and his determination to avoid an Impressionist enquiry into light and colour in favour of linear definition and solid modelling identifies him as a cautious conservative, operating outside the mainstream of international experiment.

He therefore appears to stand light years away from Rosenquist, whose commitment to the frenetic and man-made environment of the modern city is as wholehearted as his desire to reflect the oblique, fragmented character of that environment in pictures which disorient anyone attempting to read their multilayered meanings. Where Homer describes and explains, Rosenquist juxtaposes and mystifies. The older man makes sure that the place of a girl shelling peas or a tree scattered with the confetti of apple blossoms is securely defined in relation to a larger natural order. But his present-day successor is equally careful to construct an anarchic universe unconstrained by any laws of gravity, perspective and visual legibility. A child of the consumer, admass society, Rosenquist has stated that 'I try to get as far away from the nature as possible'. He disengages himself from the perceptual as well as the rural innocence of Homer's America, substituting instead an exclamatory yet quizzical style demanded by the tempo of modern commercialised city life. The repertoire of signs and symbols he employs are either drawn directly from the supermarket, the car showroom and the television screen, or they are turned into that kind of advertisement by the all-pervasive billboard of Rosenquist's imagination.

The paradox lies, however, in what happens to all this glossy, hard-hitting material once it has been arranged on the picture-surface. For Rosenquist uses images and strategies which would normally be associated with quick-selling instant communication in order to produce a recondite and not at all plain-spoken art. A street hoarding blows up its imagery to ram the message home more clearly, but he enlarges a Coke bottle, a varnished fingernail or a filter-tip cigarette so that it loses its usual identity and contrasts uncomfortably with the different proportional scale of the object placed beside it. Commercial artists adopt a boldly simplified idiom and broad, sweeping brushwork so that nobody is in danger of misunderstanding the focus of the advertiser's interests; and yet Rosenquist – who served an apprenticeship as a billboard painter actually deploying these same techniques – manages to turn the purpose of that style on its head by submerging all identifiable content in a liquid bath of colour, melting and softening his subject-matter into a different level of reality altogether.

He succeeds in offering the extraordinary spectacle of an artist who brandishes and flaunts his raw material with such zestful ingenuity that

it finishes up taking on more mystery than it would if handled by a so-called 'private' painter wholly divorced from public imagery of any kind. A 1962 picture in the Mayor Gallery exhibition is called *Smoke* not simply because it contains a close-up of a mouth enjoying a king-size cigarette, but because it literally wreathes the entire composition in a smoke-screen of reversals and inexplicable contrasts. The space between the two cans of beans registers as a more solid form than the cans themselves; an actual perspex box projecting from the surface of the middle can is found to be empty; and the presence of the inhaling mouth finally suggests that the whole sequence of images is nothing more than the idle dream of a man relaxing with a quick cigarette before he begins work again. The dream itself means nothing; but the fact that it is organised in this disjointed and elliptical way, and is saturated with references to the standardised products of urban civilization, proves that Rosenquist is attempting a wide-ranging, poetic comment on the American way of life today. As Lawrence Alloway points out in his new book on *American Pop Art*, 'Rosenquist does not evoke the nineteenth century, but he does have a sense of America as a large but united place, in which all kinds of bonds exist between people and objects.'

So did Homer, even if his visual methods and bias towards the rural aspects of American society divorce him from Rosenquist's freewheeling metropolitan concerns. Indeed, the stimulating reason for looking at these two artists in relation to each other is that, over and above their manifold differences, both painters are united by their ambitious desire to root their work in a broadly based response to what they variously see as the essence of the American experience. That aim constitutes a tradition. It may not be easily identifiable, and only the accident which brought these two exhibitions to London at the same time pointed it out to me. But to turn from Homer's version to Rosenquist's suggests that one of the strengths of American art can be found in their shared involvement with a particular society, and that the unambiguous way in which Homer could depict the interaction between man and his surroundings will never be recaptured by the world Rosenquist so ambiguously portrays one hundred years later.

A small, limpid watercolour sketch of two girls quietly savouring the isolation and calm of a trip in a makeshift rowing-boat shows how instinctively Homer responded to the unaffected pleasures of country people in the late 1870s. And a large, overheated oil painting of a comparable boating subject in the mid-1960s shows how Rosenquist deals with the urbanised continuation of this pleasure, taking into account that the grinning couple who push their sleak craft out into the water are by

101. Winslow Homer, *Two Girls in a Rowboat*, 1876–80
102. James Rosenquist, *TV Boat*, 1966

this time camera-conscious, posing like mannequins in an advertisement and viewed, inevitably, through the all-pervasive television screen. From *Two Girls in a Rowboat* to *TV Boat*: the comparison is painful and yet well worth making. For such pictures reveal, more eloquently than any text-book, the full extent of a country's moral loss.

RICHARD HAMILTON
17 March 1970

Pinning the saucy, razzle-dazzle glamour of the slogan Pop on to an artist like Richard Hamilton is tantamount to accusing him of showbiz super-ficiality. The trivial values of the world reflected so accurately in his work are dangerously seductive: they might easily succeed in swamping his underlying seriousness, infecting his pictures with a joky, throwaway lev-ity that soon teeters into obsolescence. Nothing dates more rapidly than yesterday's trendy innovations, and Hamilton could well be cutting his own throat by attempting to mirror the topical obsessions of the moment. The possibility hangs like a huge question-mark over the Tate Gallery's new exhibition of his work, a retrospective display of twenty years' activity that submits his reputation as the big daddy of Pop to the acid test. How can a man who seizes so eagerly on the commercialised fodder of our post-war consumer society – the electric toasters, fashion magazines, Chrysler cars and men's underwear ads – ever hope to retain his relevance once his subject-matter has disappeared down the prover-bial waste-disposal unit?

Hamilton faces up to the charge with disarming candour – indeed, he seems positively to welcome the scepticism that his work inevitably arouses. It was, after all, one of the risks he had to take when he helped to organise the epoch-making exhibition called *This is Tomorrow* at the Whitechapel Gallery back in 1956. His section of the show, with its delib-erate celebration of images culled from advertising, comic books and film publicity, outraged English opinion at the time. The critics viewed them as the subversive gestures of someone who was plotting to pollute fine art with the worst products of American sub-culture. But Hamilton, with a flair that can only be termed prophetic, sought rather to extend the range of art by unearthing the raw material for a new kind of picture-making: one that would embrace the ephemeral kitsch bombarding the sensibilities

of the city-dweller and acknowledge its powerful hold over contemporary civilization.

As it happens, his temerity was justified, and the collage he executed for the exhibition's poster now looks like a clarion call for the army of English pop artists who would take the sixties by storm. Mr Universe, briefly clad in a natty little pair of white swimming trunks, flaunts his fatuously over-developed physique while his ideal wife poses in a bikini on the sofa. They are pictured in a living-room stuffed full of ironic comments on urban affluence: a tape-recorder, an outsize tin of ham, and a vacuum cleaner that extends way beyond the caption proudly asserting that 'ordinary cleaners reach only this far'. The patient cataloguing of possessions soon becomes claustrophobic, and there is no escape through the window, where the view is entirely taken up by a cinema with giant hoardings on its floodlit façade. Other, more subtle references have been inserted, too, like the *Young Romance* strip cartoon framed on the wall next to a portrait of a Victorian ancestor, the photograph of the earth from a research rocket placed on the ceiling, and another photograph of people on a beach that successfully stands in for a carpet. All these different emblems, cut out of magazines and put together with masterly compositional control, add up to a devastating summary of mid-century materialism. Husband and wife are just as pre-packaged as the goods that surround them; and as a final derisive touch, Hamilton has put a king-size lollipop into the muscleman's hand, with the ubiquitous word 'POP' splashed across the wrapping-paper.

This small, densely organised collage is the key to Hamilton's progress, a truly pivotal work. It marks a decisive break from the bloodless abstractions and tentative experiments that preceded it, and inaugurates the encyclopaedic series of statements about life today that followed. Hamilton went about composing them with the zeal of a professor preparing an exhaustive thesis. Each separate picture is the outcome of a prolonged period of study, research and meditation – a coolly analytical procedure that banishes spontaneity and improvisation in favour of carefully calculated precision.

All this intellectual rigour can become stifling. A Hamilton picture has to be worked at rather than enjoyed, and the unwavering supremacy of brain over heart gives the exhibition an oppressive air of academic deliberation. Hundreds of different references – some of them wilfully esoteric – jostle within the confines of one picture-space, and the eye is forced to travel over them like a forensic expert looking for clues. There is nothing, here, of the full-blooded enjoyment of Pop that Hamilton's American counterparts specialise in: trained at the Slade and the Royal

103. Richard Hamilton, *Fashion-plate (cosmetic study X)*, 1969

Academy, he remains true to his origins by ensuring that even the zani-
est subject-matter is tamed with infamous English good taste.

But at least the deadpan dryness guarantees that he rides triumphantly
over the pitfalls lying in wait for anyone who deals with the transitory
froth of Pop. Hamilton's pictures are built to last, and their levels of mean-
ing are bound to become clearer as time relegates their ostensible content
to obscurity. Every square inch of his images is exquisitely considered:
each passage of paint, collage or blown-up photograph has been added
only when the artist is entirely sure of its effect. If his anxious care over
tiny details maddens occasionally, the results invariably have an impressive
ring of authority about them. And technical command is always matched
by a clear-sighted ability to extract the universal significance from a

theme. The destructive abandon with which Marilyn Monroe cancelled out photographs that displeased her is transformed by Hamilton into a dramatic symbol of her own tragic suicide. The extreme artificiality, too, of the cosmetic disguise assumed by fashion models becomes a sinister mask when submitted to his unerring scrutiny.

This is his method. He circles like a haughty eagle over his prey – the swarming mass of visual material that constantly assails our waking lives – broods over his choice, and then swoops down to claim it for art. By the time it reappears in his pictures, Pop trivia has been put firmly in its place by one of the most canny, alert and imaginative artists at work in England today.

JOE TILSON
23 March 1970

The timing is propitious. Exactly a week after the Tate confirmed Richard Hamilton as the prime progenitor of Pop, Marlborough New London has followed through with a one-man show by Joe Tilson that serves as a reminder of another strong Pop talent. Not that Tilson shares anything in common with the older artist, apart from a mutual dedication to the top-ical and the immediate. Where Hamilton is allusive, refined and oblique, Tilson is straightforward, outspoken and defiantly uncouth. Hamilton reinterprets his material in terms of a fastidious, inward-looking, almost lyrical taste that belongs to an intrinsically English tradition, whereas Tilson breaks out into a brash, extrovert, roughly-carpentered language that is not afraid to make bold, public statements.

While Hamilton only reveals himself slowly and shyly, Tilson stakes everything on instantaneous impact. Right at the beginning of the exhi-bition, he wades wholeheartedly into battle in a jumbo-sized panel splat-tered with no less than 169 insistently-repeated wooden reliefs of the word 'YES'. They jut forward from their background in chunky forthright capital letters, browbeating the spectator with the same noisy aggression that Andy Warhol employed in his celebrations of Campbell's soup cans and bottles of Coke. Both men enjoy a brazen frontal attack, but Tilson seeks a deeper, more thoughtful response.

He is a profoundly literary artist, meditating not only on the precise meaning of 'YES', but referring back as well to a writer whose work has

104. Joe Tilson, *Page 1, Penelope*, 1969

a special meaning for him: James Joyce. In the catalogue, he reproduces the famous closing passage from *Ulysses* – 'and yes I said yes I will Yes' – and quotes Joyce himself, who states that 'the book must end with yes. It must end with the most positive word in the human language'. Tilson's choice, then, is intended as an act of homage to an essentially affirmative collection of letters, joyful and explicitly tied up with the idea of sexual abandon.

Realising the exact origin of Tilson's inspiration obviously enhances the meaning of his work; but how much of this can be construed from an examination of the pictures themselves? The question is a vital one, for many of the images in this exhibition are drawn from sources far less familiar than Joyce's classic novel. The whole show is based on the unifying con-

cept of a series of newspaper pages, and while some of them ironically parody London's underground press – *Snow White and the Black Dwarf*, or *He, She and It* – others are hard to identify. Who recognises the *Bela Lugosi Journal* without being a specialist in the vagaries of American journalism? And how exactly are we supposed to benefit from the long-winded philosophical extracts from Marcuse or Robert Duncan that Tilson scatters, more or less at random, in among his silk-screen photographs?

It is easy to understand the connection between a Yeats poem, where the poet complains that a beautiful girl distracts his attention from politics, and a liberal sprinkling of girlie pictures. And it is not hard to enjoy the way in which Tilson's Pages play off the appeal of the printed word against the attraction of the pictorial image. He wants to engage our senses completely, so that we read the words in a linear way, from beginning to end, while the non-linear photographs sink into our subconscious with an altogether more subversive stealth.

All this stems from his fascination with what he calls 'the environment of the mind': how the human brain comprehends through the wide variety of communications available to twentieth-century man. When he presents a selection of photographs of the dead Che Guevara, for instance, the intention is not to glorify a martyred revolutionary. Tilson's aim is detached, non-partisan. He wants us to think about how events are reported, the channels through which reality is filtered before it is presented for our consumption.

It is an admirably thoughtful programme, and one of direct relevance to a society that reacts to the world at one remove, following the progress of a fiercely emotive issue like the Vietnam war through the distorting mirror of the news media. But is it possible to grasp the full implications of Tilson's ideas without knowing about the preoccupations of the artist behind the picture? He presents his photographs and texts with such baldness – printed on soft canvas pillows sandwiched neatly into symmetrical wooden compartments – that the casual spectator might take them simply for a gallery of the artist's favourite pin-ups.

Tilson is prepared for this, of course, and freely admits that some people will react to his work on a disastrously superficial level. It is a risk he is willing to take, along with the inevitable danger that present-day figureheads like Malcolm X, Luther King or Ho Chi Minh might fade into obscurity as time goes on. A hundred years from now, it may take a text book of supplementary information to decipher the meaning of the Jan Palach screen-print which juxtaposes photographs of Soviet tanks in Prague with equally moving pictures of doomed Biafran youths lining up for enlistment. The comment on different kinds of self-sacrifice is

effective enough now, but what will be left for posterity to understand and enjoy?

It may seem unduly lugubrious to harp on this potential source of weakness. Tilson enjoys living for the present so much, and is so alive to the business of reacting to the current of everyday events, that it is almost churlish to question the viability of his standpoint. His solidly-built constructions, four-square and monumental, are bound to survive. And yet the doubt persists, threatening to invalidate the whole premise on which Pop art rests. ' "History", Stephen said', Joyce writes in another passage from *Ulysses* quoted in the catalogue, 'is a nightmare from which I am trying to awake.' Tilson has succeeded in casting off that nightmare and plunging straight into the heart of contemporary life. He is awake, and his work is exhilaratingly fresh, directly appealing to this instant in time. It recharges us, forces us to look at our environment with more perception and awareness. But what is the price to be paid? It is a question to ponder.

R. B. KITAJ
28 April 1970

In order to hack out some kind of coherent pathway in the bewildering jungle of modern art, critics tend to fall back on a system of labelling as elementary as it is misleading. Painters who threaten to run wild and defy all verbal analysis are hurriedly lassoed and branded with a catchphrase before they have a chance to upset the critical apple-cart. These nicknames often start off as terms of mild abuse, like Impressionist, Fauve or Cubist. Sometimes they have a professorial ring about them, when two different labels come together and an unwieldy conglomerate such as Abstract Expressionism is produced. They can even be coined by the artists themselves, the Futurists or the Vorticists, who preferred to dream up their own identities before the commentators did it for them. The whole process has been gathering speed during the past decade, with a monotony worthy of the Old Testament: Pop begat Op, which begat Kinetic which begat Minimal. It succeeds in alienating the public, who watch the movements rising and falling like the hemlines of the latest fashions. Art, which used to be thought beyond the reach of passing trends, has become as prone to obsolescence as last year's motor car. And artists have become the victims

of the situation, shutting themselves up inside rigid theories that rule out representation on the one hand, and abstraction on the other.

It is only when someone like R. B. Kitaj arrives, a painter who triumphantly succeeds in evading such facile classifications, that the system is shown up for what it is: at once arbitrary and tyrannical. For Kitaj, an Ohio-born artist who settled in London over a decade ago, hops between the various conflicting isms as convincingly as he combines the Anglo with the American in his personality. His latest exhibition at Marlborough New London, more of a retrospective than a one-man show, displays a dazzling talent for amalgamating different pictorial idioms within the confines of one picture. In one corner of a typical painting, a figure straight out of strip-cartoon land will emerge, suggesting that Kitaj shares Lichtenstein's fascination with the imagery of the comic-book. But just as the critic hauls out the Pop tag-name from his collection of instant labels, he notices that the cartoon figure is surrounded by a cluster of geometrical shapes – an area of paint which could have come straight out of the vocabulary of an abstract artist like Mondrian.

The bemused writer is thrown off-course: he must either produce another label, or decide that the game is up and throw the whole lot into the nearest journalistic rubbish-dump. He knows that he has met his match. As he lets his eye travel over the surface of a Kitaj picture, he begins to realise that this particular painter knows his history of modern art as well as (if not better than) he does. And he rapidly comes to the conclusion that Kitaj refuses to confine himself in any way, welding together realistic portrait-heads, decorative patterns and abstract diagrams into an absorbing private alchemy which creates its own terms of reference.

This kind of detached approach to painting had a great liberating influence on a whole generation of English artists. When Kitaj spent some time at the Royal College of Art at the end of the fifties, his freewheeling example encouraged students like Hockney to include their own personal interests in a new figurative art. Of course, Hockney's private references were always a good deal more straightforward and lighthearted than those of his older mentor. He played the *enfant terrible* to Kitaj's *eminence grise*. But it remains true to say that Kitaj did give a number of painters who felt unhappy with abstraction the confidence to bring representation back into their pictures.

Perhaps only someone in his unique, transatlantic position could have done such a thing. Kitaj was a man who had come from a country where painters were setting the pace for the world. Young English artists looked across eagerly to New York for the latest developments, feeling that they had to come to terms with pioneers like Pollock and match them step for

radical step. But Kitaj provided another alternative, and was already securely entrenched in his own position. His new exhibition proves that, while his younger English associates have changed and evolved since those early days, he has adhered with remarkable consistency to his own principles.

Just as he has never wavered from one strong line of development, so he has never been afraid to use material that could easily be criticised as wilfully obscure. Kitaj cannot resist using picture-titles like *Trout for Factitious Bait* or *Primer of Motives (Intuitions of Irregularity)*. And the contents of the paintings behind the titles can be equally mystifying. Incidents from political history merge with fragments of books he has read, and these esoteric references can become irritating. There seems to be a perverse element of pride in the way Kitaj shows off his elaborate learning, his wide knowledge of literature. He has even paraded this side of his make-up in fifty screenprints of book covers, many of which simply reproduce the original cover without any interference by the artist. They display a weakness for whimsicality and self-indulgence that easily becomes boring. Who wants to know about the books he reads, let alone see them perpetuated in an expensive portfolio?

Fortunately, Kitaj reserves such folly for the screenprint medium, and his paintings – abstruse though they may be – usually have a poetry of their own that rises above the donnish origins of their imagery. In a great painting like *The Ohio Gang* of 1964 it does not matter if we are ignorant about this strange slice of America's underworld. Our pleasure resides in the skill with which Kitaj has brought together all the elements in the picture – the moustachioed gangsters, the pin-up nude, the hag in her foundation garment, and the old crone pushing the child in the pram – and fashioned his own individual harmony. The dryness of the paint, laid on sparingly and then scraped down to the grain of the canvas, matches the dispassionate control Kitaj exerts over every detail. Even though he enjoys describing clothes, bodies and faces in a straightforward manner, he is still prepared to chop them up and play around with them, like so many parts of a jigsaw puzzle.

He always reserves the right to do whatever he likes – elongating an arm here, blocking out the bottom of a figure with a rectangle of plain colour there – according to his idiosyncratic sense of pictorial poetry. The painting cuts, changes gear and moves from one spatial dimension to another with all the speed of a film – Kitaj once said that 'movies must be a prime animating factor for me' – and plays tricks with style. The old woman's hair gradually detaches itself from its descriptive role, and floats in the air as a series of abstract coloured lines. Two giant bands of yellow and orange cut off the top right corner of the picture, but they do not

105. R. B. Kitaj, *The Ohio Gang*, 1964 (detail)

intrude or seem out of place. They simply add their own brand of tension to the composition, one more ingredient in Kitaj's bizarre hotchpotch of disparate styles and ideas.

And yet, behind the dictionary of quotations and the encyclopaedic references that this picture contains, there does lurk one obvious ambition for the critic to pin down. Like most of Kitaj's paintings, it is concerned with the human figure on a grand scale, and the artist has him-

self admitted that 'of all my hopes, my hope for forging a great figurative art is certainly the greatest'. *The Ohio Gang* goes a long way towards fulfilling those hopes, and for all its startling modernity, it links up with the oldest traditions in Western art.

DAVID HOCKNEY
14 April 1970

With his gold lamé jacket, blonde rinse and freakish spectacles, David Hockney's life-style sidled into the myth of the Swinging Sixties before he had even left art college. He was snapped up by a press hungry for Outrageous Young Things, dubbed a camp extravaganza, and then mercilessly over-exposed as a hipster prodigy who revelled in his own spectacular ego-trip. The man and the mood of the moment slotted together with faultless ease. Hockney, as much as the Beatles or the miniskirt, rapidly become the outward symbol of a new national temper: cool, offbeat and casually ironic.

The paintings that poured out of his studio gave substance to the legend, fortified it with unmistakable proof of instinctive visual flair. At a time when contemporary English art was grappling rather doggedly with the implications of abstraction, Hockney's sunny insouciance was acclaimed with sighs of delighted relief. Here, at last, was a light-fingered punner who was not afraid to pass over rigidly theoretical programmes in favour of a pot-pourri of different stylistic conventions. He leapt, unperturbed, from Pop Typhoo Tea packets to toilet-wall graffiti, mixing together satire, obscenity and sheer high spirits into a stylish confection that always ended up with its own, instantly identifiable, tang. Hockney threw anything and everything into paintings that became pictorial diaries. Quotations from Walt Whitman sprawled beside passages of paint guying Abstract Expressionism; a torch-carrying Olympic runner tripped up over a faulty seam in the fabric of a canvas.

Behind all the jottings, the squibs and the autobiographical indulgence, real talent was discernible. Cheekiness was only the façade for a wary, knowing artist, who was at pains to conceal his conventional skills beneath an overlay of offhand irreverence. The two qualities came together in his *Life Painting for a Diploma*, where a sensitive, academic drawing of an art-school skeleton was juxtaposed with a sly copy of

a he-man from *Physique Pictorial*. But for the most part the young Hockney was content to imply his competence, hint at his mastery of elegant line and seductive tones in light-hearted caprices that studiously avoided any suggestion of profundity. And it is only now, as he advances into his thirties, that these early paintings can be enjoyed for their command over form and colour rather than for their effervescent wit. The Whitechapel Art Gallery has provided the opportunity with a hefty retrospective display of a decade's activity, and it succeeds in charting the progress of a rake who gradually sobered up.

The student paintings, for all their vivacity, look lightweight and slapdash up against the technical mastery of more recent work. Just as Hockney never committed himself to one style in those early pictures – preferring to stay on the sidelines and make wised-up comments on other ways of painting – so he never cared a lot for patient, executive skills. The paintings were dashed off with a haste entirely in keeping with the inconsequential nature of the images. One of the best early pictures, *A Grand Procession of Dignitaries in the Semi-Egyptian Style*, is nothing more than an inspired exercise in pictorial juggling, performed with a marvellous sense of design that would have assured him a successful career as a graphic illustrator. But compared with the care and thought Hockney has recently begun to lavish on his canvases, all that youthful exuberance often looks merely callow.

A visit to California at the end of 1963 was a revelation, providing him with a reality of sun and swimming-pools that was just as attractive as the fantasy-world of the student work. 'Pretty' and 'glamorous' are adjectives constantly reiterated by Hockney as essential requirements, and California's air-conditioned, super-heated nirvana directed his attention away from artifice towards external appearances. At first, the new naturalistic approach contained the old familiar elements of stylistic mockery. The patterns of light dancing on water in a pool were formalised into hard-edge abstractions that contrasted wryly with the realistic treatment of sunbathers lying nearby. Old habits died hard, and Hockney still persisted in making stylistic comments even while he studied the effects of light and the architecture of Californian villas with a new spirit of scientific inquiry. But eventually, his tongue left his cheek altogether and he found himself painting a photograph of a splash with painstaking fidelity. Fragments of water, exploding upwards from the placid surface of the pool, are as fresh and vital as their surroundings – palm trees, sun-baked villa and empty deck-chair – are arid. The uneasy combination of splash and deserted environment introduces a note of mild surrealism: Hockney, after all, could never be caught painting a straightforward naturalistic picture.

106. David Hockney, *Le Parc des Sources, Vichy*, 1970

Or could he? In the last couple of years, he has produced some landscapes – a castle on the Rhine and a Californian seascape – that take down the facts of the scene with disconcerting literalness. One in particular, an early morning view of St Maxime in vivid violet hues with a puce reflection of the sun dappling the water, has the artificial gloss of a tinted postcard. 'I took a photograph of the scene and I was so impressed with it that I just painted it like that,' says Hockney, without seeming to realise the dangers of such a submissive approach. The picture is orchestrated with immaculate care, naturally, but the end-product has a blandness that relates it to chic department-store prints. Hockney, hopefully, has far too much native wit to wallow in such a conventional quagmire for long.

At the moment he seems to reserve the full force of his imagination for graphic work: the Grimm suite is full of the old mocking versatility and sly charm. But there are signs in the latest painting on show, *Le Parc des Sources, Vichy*, that the surrealist mood is growing. It was present even in the recent double portraits, of course – Geldzahler and Scott are placed in a sterile atmosphere of non-communication – but they were still realistic enough for a Royal Academy summer show. For all their skill, they excluded too much of the essential Hockney, and the Vichy landscape goes some way towards re-establishing him as a deft conjuror. The motif

of the seated foreground figures, seen from behind as they stare into the distance, brings back Hockney's obsessive interest in the idea of a painting within a painting. The mysterious back views recall Magritte's famous portrait of Edward James, and the whole picture is executed with a painstaking precision worthy of that great surrealist. The in-jokes and the irresponsible changes of gear in the earlier work have vanished altogether, and in their place is a calm, unswerving, clear-eyed objectivity.

Whether this will grow into a surrealism as original and personal as the student japes that first established Hockney's reputation remains to be seen. He is magnificently gifted, a born artist, but he must not be content with elaborate displays of technical prowess. If his natural vitality and perception are properly allied to his new sense of craftsmanship, he could develop into one of the greatest artists this country has ever known. But if it is not, and he slips back into a brainless pursuit of prettiness, he could just as easily deteriorate into a facile decorator. The choice is his, but anyone at all interested in the future of English art will be anxiously watching him make his decision.

RICHARD SMITH

21 August 1975

By starting his Tate Gallery exhibition with a section of new work, and then leading straight through to the earliest group of paintings on view, Richard Smith brings the full cycle of his development so far into sharp focus. A period of fifteen years separates these two rooms, and the changes they reveal could not be more striking. Whereas the early pictures all adhere to the format of an easel painting, and hang singly on the wall, most of the recent works are stretched like banners on exposed aluminium rods and presented in clusters, piled on top of each other, grouped together as interrelated sequences, and in one instance free-floating from the middle of the gallery roof.

What is more, these physical differences are paralleled by a radical shift in Smith's attitude to subject-matter. The 1960–1 paintings all conduct a lyrical love-affair with pop images: a broken heart sinks to the bottom edge of a canvas called *McCall's*, a reference to a women's magazine; a lush globe full of brushstrokes smeared on like lipstick carries the title *Revlon*; and eighteen tobacco-coloured lozenges form a spinning hexagonal

tribute to the brand-name *Panatella*. The 1975 works, by contrast, are far more muted in their appeal, and replace this overt involvement in the glossy world of consumer advertising with titles which are either abstract and factual (*Threesquare, Grey Slice*) or else restricted to something as sober as the pages of a diary. To reinforce this pronounced shift in his attitude, Smith's handling of paint has become discreet and subdued, too, renouncing the ragged gestures which once reflected his own excited response to the admass imagery of New York. Vestiges of the old free-wheeling brushwork are still apparent now, but they are subservient to an all-over density which stresses the entire colour field rather than localised flurries of mark-making.

So much has changed, and yet it would be a mistake to conclude that the seven exhibitions which constitute Smith's retrospective merely chart the progress of an artist who insists on a regular shedding of skin so that he can assume a new identity. Each section, reconstructing in itself the contents of a one-man show he has held during this period, presents a fresh solution to the problem of how to embody his shifting ideas about the activity called painting. The decision to conceive his retrospective as a series of individual exhibitions does indeed mirror his ability to pass the gallery test every time he shows, never falling foul of the familiar accusation levelled at artists who helplessly repeat themselves. Far too observant and quick-witted to be guilty of reiteration, Smith's career bears the hallmarks of a temperament given to drawing back, assessing the results of each phase in his work and gaining the impetus to continue from a fastidious questioning of his own adequacy. In a sense, of course, all worthwhile artists engage in a similar cross-examining process, but Smith's self-criticism is closer to an instinctive reflex action. And it ties up, in turn, with the way he advances towards and then retreats from the prospect of subject-matter.

In the early sixties, Smith operated from the premise that there should be open links between the form his work assumed and its starting-point in visual reality. By the time he exhibited at the Kasmin Gallery in 1963, there was a direct marriage of the two. Shaped canvases extending in giant boxes upwards, downwards and even across the floor were in one respect a literal answer to his dissatisfaction with the limitations of the flat rectangle. But in another respect, they refer to the larger-than-life impact of commercial packaging projected through giant hoardings, cinema screens, neon displays and department-store windows. Although specific sources are sometimes difficult to pin down – *Staggerlee*, for example, contains a row of repeated circles which could be based on anything from traffic lights to illuminated clock-faces – the broad seam

of inspiration is clear. Works like *Piano* and *Gift Wrap* have retained much of their exhilaration intact, and it is a vitality that derives both from the mass-reproduction techniques permeating urban life and from the attempt to push a wall-based painting as far into the viewer's space as it can possibly go.

The next sequence on display, however, the twelve panels adding up to *A Whole Year a Half a Day*, withdraws from this joyful engagement with pop material altogether. The more abstract side of Smith's personality, which is concerned with formal properties and the structural character of painting, asserts itself at the expense of the vivid contact with city life celebrated four years before. Now time and memory, articulated through the progressive folding-over of a rectangle into a triangle, predominate as themes, suggesting that Smith had recoiled from his previous appetite for visible appearances. Always oblique in his treatment of representational content, as if worried that cigarette packs or blown-up billboards might destroy the transforming power of art unless held at a distance, Smith goes through phases when he excludes such imagery completely. Hence the pared-down minimalism of *Clairol Wall* in 1967, which successfully hides its origin in an advertisement showing a blonde girl with different yellow hair-tints in every shot.

Without the catalogue to tell us, it would be impossible to glean this information from *Clairol Wall* itself, and this exclusion is a palpable loss. We are left with an immaculately carried-out but rather bland sequence of formal permutations, an elegant purist exercise in joining together eight folding parts into one multiform whole. The structural ambitions of the work are interesting and yet finally insufficient: Smith is such a tasteful and attractive artist that he needs to grapple with the vigour and awkwardness of concrete imagery to prevent him from appearing complacent.

That is why *Riverfall*, shown two years later at the Kasmin Gallery, is such a tonic. Reacting to the rural surroundings of Smith's new home in Wiltshire, this enormous green wall of a painting filters its bank of streaming foliage through a sensibility reared on the menthol colours of cigarette advertisements. Its blurred amalgam of sprayed and brushed oil blended with polyurethane suggests not only the soft-focus techniques of commercial photography, but also the glimpse of a landscape which modern man catches during a fast car or train journey. The stepped bottom edges of the five canvas sections contribute to this sense of undulating pastoral hedonism, rather than simply representing another restatement of Smith's experiments with the shaped canvas.

Technical innovation is thereby not allowed to become an end in itself, or degenerate into the merely decorative and playful: it actively

contributes towards a painting which defines our mid-twentieth-century inability to look at nature through eyes unaffected by the values of an admass communications system. Smith has done nothing better than *Riverfall*, which with *Piano* and *Gift Wrap* already looks like one of the most enduring English paintings of the sixties. But he must guard against losing sight of their strong roots in contemporary visual experience, and indulging in resourceful variations on the theme of a painting's structure alone. Discussing his recent kite and banner works in a diary written last December, Smith asked himself: 'is it time to resort to the regular four-square canvas? Doubts about my use of unconventional supports for my canvasses – does it lead to my avoiding of issues in painting?' His answer, for the time being at any rate, was no; but I hope the next cycle in Smith's fluctuating development will say yes instead.

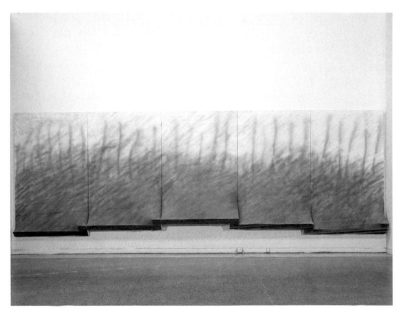

107. Richard Smith, *Riverfall*, 1969

BRUCE LACEY AND THE LIVING-ROOM
20 October 1970

The majority of human beings pass through their lives without ever making anything that can be kept, after they have died, as a record of who they really were, what they thought, or how their individuality expressed itself. There are photographs, of course, mostly of smiling, posed faces which bear little relation to the complex personalities lurking beneath the outward façade. And there are children, who carry with them hereditary characteristics and a miscellaneous jumble of memories of their parents that finally disappear when they, too, meet their deaths. Only the artist possesses the ability to leave posterity with a vivid account of himself and his deepest feelings: read Van Gogh's letters, study his pictures, and the whole man comes alive immediately. Such people are duly revered as unique geniuses. They are probed by scholars, dissected by psychoanalysts and constantly reassessed by critics. But despite the fascination they arouse in the public mind, most of us feel no need to construct lasting monuments to the nature of our own egos. While the artist wants to step aside from the flux of life, pause, and reflect on his own particular situation, the rest of humanity is content to accept the passage of time, come to terms with transitory conditions and make no attempt to interpret the underlying meaning of existence.

This is one of the great divisions of sensibility dividing the artist from the average person: the one combats the shapeless quality of everyday life by seeking to impose a wilful order on to its chaos, whereas the other can manage quite happily without yearning for some grand overall structure. Indeed, the non-artist probably could not bear to conduct an autopsy on the vagaries of his career. It would infuriate him to dwell on the inconsistencies, frustrations and absurdities, disturb him to try and account for the meaning behind every action. The whole business smacks too much of morbid introspection. Better by far to get on with *living*, savour the present moment and leave the artist to worry over the inner significance, the fundamental mystery. Why try to meditate on the unsolvable unless you have the requisite desire and talents to do so?

And yet, strangely enough, there is one area of life in which everyone − without exception − succeeds in projecting private self into a solid outward form: the home. People who would never dream of spending five minutes on a drawing, a poem or even a hasty diary entry are capable of lavishing years constructing their ideal environment, a place of retreat and comfort which can approximate remarkably closely

to the way they approach the business of coming to terms with life. Enter a friend's living-room for the first time, and it will soon provide a wealth of extra information about him – his limitations, foibles, merits and eccentricities. Not solely through his possessions, the style of his furniture or taste in wallpaper, but the total effect of the ensemble. Rooms invariably have a strong emotional mood about them, and constitute a kind of summary of their occupiers' essential being. Only imagine how moving it would be to go back into the living-room of your childhood, with everything still arranged in the haphazard domesticity of family life, and it is easy to realise how eloquently that space can speak for an entire chapter of your existence. Leave a home in which you have spent some formative years, or watch it being demolished wall by familiar wall, and the odds are you will be left with a palpable sense of loss.

When a man moulds his living space, then, he is unconsciously vying with the artist by creating an albeit temporal statement about his way of looking at the world. And the ICA has tried to turn this situation on its head by commissioning ten artists to make their own special sitting-rooms and exhibit them in a gallery normally reserved for works of art. The result, as might be expected, is more valuable for the thoughts it provokes than the rooms themselves, which linger in an uneasy region half-way between interior design and the environmental art that has recently seized the imaginations of those dissatisfied with the traditional media of painting and sculpture. If artists interested in constructing environments are given a gallery space and *carte blanche* over how they should use it, they are free to make something as universal in its implications as any other form of art. But by limiting them to a specific idea, within a dictated and unexciting box-like space, the ICA virtually forces them into sidelines like satire, whimsy and decoration.

Most of these rooms would look more appropriate in a witty colour supplement take-off of fatuous life-styles. It is fashionable at the moment to laugh about kitsch, and this show is full of easy giggles about flying ducks, garden gnomes, plastic flowers and aspidistras. Entertainment abounds everywhere; but – and this is the point – how much more intriguing it would be if ten *real* rooms had been uprooted and transplanted to the ICA. There, divorced from their usual context, they could demonstrate just how liberally people pour their prejudices, dreams and received notions into that hallowed space they call a 'lounge'. As it is, most of the artists in this exhibition lose out in comparison with the fascination of the reality they try to comment on. A lot of them seem unhappy about being tied down to one literal concept of their set theme,

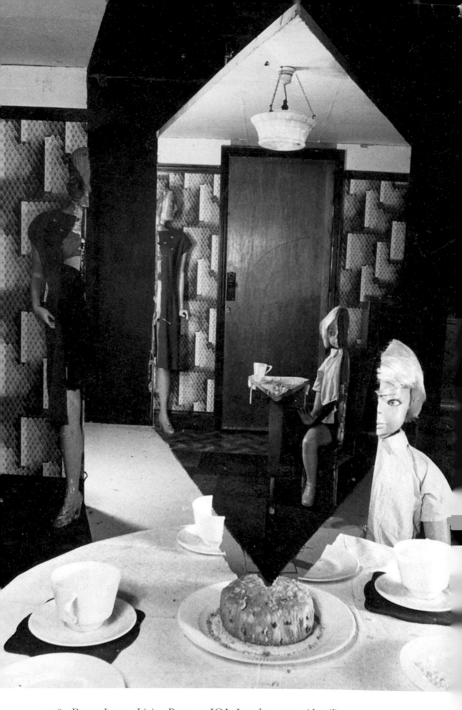

108. Bruce Lacey, *Living Room*, at ICA, London, 1970 (detail)

anyway. Several even avoid answering the organisers' question about the precise location of their rooms, and Gerard Wilson actually states that his is 'not intended for "somewhere" or "someone"'. They should ideally have been left to themselves, and granted the artist's fundamental right to complete freedom of expression. Then their work might be far more impressive, and certainly not pale so drastically beside Bruce Lacey's contribution, which succeeds best of all simply because it supplies the nearest equivalent to an actual sitting-room.

Walk into his suburban interior, and a feeling of intense sadness and nostalgia grips you immediately. The Cosiglow is still flaring in the grate; the assorted debris of domestic life is scattered around in desolate heaps on floors, tables and in opened drawers; and the family is represented, too, as a group of dummies sliced in half and stuffed with external symbols of their obsessions – soap-powder packets inside the wife, packets of sweets in the children. The entire room is cut open as well, so that all human activity has been suspended and laid bare. It is exposed for us to ponder on the peculiar stew of claustrophobia, love, boredom and tension that boils up inside the confines of anyone's home. By constructing such a compassionate elegy, Lacey makes the entire show worthwhile. But in future, artists should not be allowed to squander their abilities in an area of activity where Everyman is perfectly capable of beating them all the time.

CLAES OLDENBURG
30 June 1970

Enter the Oldenburg exhibition at the Tate Gallery, and you will know at once how Alice must have felt when she quaffed the bottle labelled 'DRINK ME' and shrank to the proportions of a ten-inch midget. Only this time it is not Dodos, Caterpillars and Mad Hatters that loom into view but the outsize flotsam of some bloated American Dream turned Nightmare: giant fag-ends tumbling over the edge of an ashtray like the prow of a ship, huge chips stacked up against each other into a pile of lumberjack's logs, and hamburgers as big as a house. You gasp, blink and laugh out loud at this Wonderland of Pop paraphernalia. Oldenburg has constructed the apotheosis of the adman's fantasy, a rank jungle where consumer goods mushroom into monuments and lipsticks lord it over

Piccadilly Circus as a cosmetic substitute for Eros. Gormandizing his way through the foodstuffs of his adopted America, this Swedish-born sculptor beats his big-thinking countrymen at their own game. No gum-chewing Yankee imperialist could possibly have thought of installing in his penthouse a light switch as gargantuan as Oldenburg's four-feet-square version. And not even Rockefeller himself could conceive of a ten-feet-high electric fan made of vinyl stuffed with foam rubber.

They would not want to, either. For Oldenburg's world, despite its irresistible humour, is a subversive creation that mocks the very things it appears to celebrate. The products of our much-vaunted materialist society are reduced to a risible rubble before our eyes. When he draws an adding machine as a projected sculpture, it sags down in a shapeless jumble of disconnected spare parts. Typewriters, washstands, pay-telephones and toilets disintegrate into heaps of squashable kapok and dangle from their pedestals, waiting to be consigned to a junkyard of instant obsolescence. Objects that have a purely functional use are transformed into absurd surrealist whims: a giant saw is bent into a useless triptych of polyurethane foam, its cutting edge a ripple of impotent curves. Beside it hangs another, even larger saw made out of flag cloth, gently swaying in the breeze. And as you laugh at the undeniable wit, the

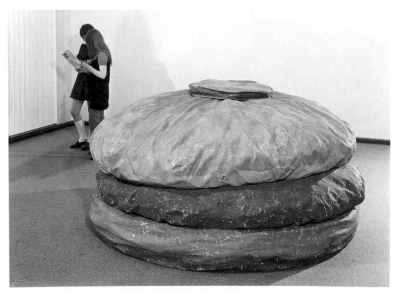

109. Claes Oldenburg, *Floor Burger (aka. Giant Hamburger)*, 1962

sheer cheek of the artist's invention, it becomes clear that all these mind-boggling extravaganzas are engaged in a dialogue about the nature of outward appearances.

If Oldenburg's talent consisted merely in blowing things up into plastic monstrosities, he would be worth no more than a glance – you would pause for a moment, smile and then pass quickly on. But behind the anarchic indulgence lurks a canny stylistic conjuror who quietly succeeds in forcing his banal subject-matter to undergo a complete metamorphosis. Although he has not really changed one single element of his electric fan, it has become a gigantic insect encased in a shining black skin, while the long flex dangles down on to the floor like a sinister feeler, tangled and inert. The transformation has been engineered simply through a radical change of scale and medium; and with Oldenburg's unerring sculptural sense, the trick works almost every time.

Gradually, as the original Pop meaning of the objects is forgotten, the formal qualities of the shapes assert themselves very strongly. Once you have enjoyed the satire built into the idea of erecting a colossal drainpipe in a Toronto park, you begin to realise that he has not chosen this particular item for its joke value alone. At heart, he has selected it as a striking minimal form, a stark crucifix that looks more like an abstract sculpture than a machine for disposing waste water. Oldenburg manages to make it work on the twin levels of exhilarating entertainment and deeply serious non-figurative construction.

He would not wish it otherwise. The man who wrote that lyrical, Whitmanesque statement of intent back in 1961 could never be satisfied with total abstraction, nor feel happy restricting himself to one rigidly theoretical style. 'I am for an art that takes its form from the lines of life itself,' he declared, making a clear stand against the Abstract Expressionism of older-generation artists like Pollock, Kline and de Kooning, 'that twists and extends and accumulates and spits and drips, and is heavy and coarse and blunt and sweet and stupid as life itself.' A former journalist who still regards himself essentially as a 'communicator', Oldenburg throws himself into the stuffing of our everyday environment with the gusto of a gourmet.

He is gentle enough to envisage a king-size teddy bear in an industrial waste-lot, and anti-establishment enough to design a chapel in the form of a Swedish extension plug. He is a natural clown with an enormous streak of the showman, a megalomaniac obsessed with superhuman scale who nevertheless executes drawings as tender and delicate as Fragonard. Revelling in the wide variety of his projects and the different qualities of the materials he uses, he still succeeds in imposing his

own unmistakable personality on everything he does. And whether it is the austere geometry of his *Three-Way Plug*, the lighthearted fun of the dissolving tea-bag, or the mysterious canvas version of a Chrysler Airflow, his complete involvement is always evident.

Intellectually, he spans a multitude of different movements – Dada, Surrealism, Pop, Minimalism and Conceptual Art – and yet the end result is astonishingly endearing, warm and lovable. It would be difficult indeed to think of anyone else, painter or sculptor, dead or alive, who can both dazzle the mind and tickle the funny-bone. Even as you laugh with him, Oldenburg is forcing you to think hard about the world he commits himself to so wholeheartedly.

ED KIENHOLZ
4 June 1971

The emotional temperature pervading Ed Kienholz's exhibition at the ICA is startlingly at variance with the mood normally to be experienced in modern art shows. While most established radical artists still concern themselves with the vocabulary of abstraction, effectively removed from any vestige of direct comment on everyday existence, Kienholz is interested only in forthright, highly charged gestures which reflect his immediate involvement with life now. Instead of indulging in the rarefied ambiguity of non-figurative art, with its subtle evasion of outward reality, he is not afraid to mount the pulpit of crusading rhetoric and lambaste his audience's collective conscience. Where other men deal in multiple allusions and complex metaphors, this latter-day Savonarola from Los Angeles barges his way straight to the heart of a human situation. And just as he has no time for the sophisticated interplay of formal elements favoured by many of his contemporaries, so he discards their continuing attachment to the orthodox media of painting and sculpture.

A Kienholz does not hang on a wall or spread itself across the floor, waiting to be inspected. It invites you inside, makes you welcome like a benevolent host and then assails you with a barrage of unashamedly emotive images. Step into the ICA exhibition and you will find yourself invading the privacy of a down-at-heel lounge, full of empty chairs and sofas which cry out to be inhabited. But then, even as you prepare to sit down and assimilate the atmosphere of shabby gentility, disturbing symbols

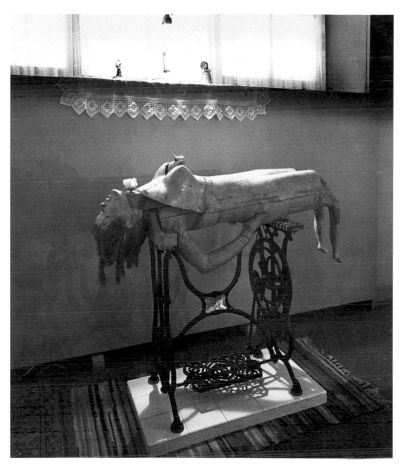

110. Ed Kienholz, *Roxy's*, 1961 (detail)

destroy the cosy domestic aura. The severed dummy of a prostrate girl lies straddled across the base of an iron sewing-machine, her left breast torn open by an emergent rat. A bedraggled dressing-table strewn with the accumulated debris of a tart's cosmetics fills a corner, its air of degradation summed up by the paint-streaked female head dangling down from the mirror's vulgar frame. The sagging body of an old woman, who could only be the brothel's Madame, rises out of the faded furniture and sprouts into a grotesque animal's skull, all bared teeth, hollow eye-sockets and pendant jewellery.

The nightmarish sequence of horrors proliferates as the room is surveyed, and along with it an almost fastidious attention to period detail: a glowing juke-box playing hits from the forties, a jingoistic portrait of General MacArthur saluting potential recruits, and a pile of wartime magazines littering an occasional table. For Kienholz has set out to recreate, on his own unrelenting terms, the atmosphere of a famous Las Vegas whorehouse called Roxy's; and he has turned it into a cemetery peopled with relics of despair, frustration and helpless neglect. The effect is as melancholy as a *memento mori*, but there is no overt moralizing – only a formidable array of sad, decaying effigies, illuminated by the yellowing light of lamps that someone forgot to switch off. Despite the savagery of individual objects, the prevailing feeling is compassionate, even elegiac, movingly commensurate with the sentiments of the sampler on the wall which warns us that:

> There is so much good in the worst of us,
> And so much bad in the best of us,
> That it little behooves any of us
> To talk about the rest of us.

The homespun, folksy sentences, woven into an embroidered masterpiece of household kitsch that Kienholz has lovingly preserved and pressed into service, can stand as the yardstick by which to gauge the intentions of the entire exhibition. For no one is immune from the ferocity of these ten tableaux, the assembled fruits of Kienholz's activity since he first displayed the brothel piece at a Los Angeles gallery in 1961. Many of the visitors who peer in at his backstreet room, where *The Illegal Operation* has just taken place, have undergone abortions; and they will doubtless shrink back from the awful implications of the bag split open to ooze a dribble of concrete matter. Even more members of the public suffer from jaded marriages, and they will recognise themselves in the bedroom scene containing a middle-aged couple who can only make love with the impetus of sexual fantasies growing out of their heads like giant thought-bubbles. And everyone is confronted with the prospect of harrowing senility dramatised in *The Wait*, where an emaciated crone slumps in her armchair, memories slung round her neck inside glass jars, old photographs piled up on a nearby table as a reminder of the past, and a real budgerigar chirping in its cage to fill the silence of her own lingering deterioration.

Such themes, rooted though they are in a particularised knowledge of Americana, easily extend from the local to the universal. They combine the hard-hitting simplicity of a Punch and Judy show with the heightened

realism of a polemical documentary, and these two seemingly contradictory impulses are constantly juxtaposed within the confines of one artefact. Human figures, often cast direct from a plaster mould built around a living model, are butchered and smeared with the violent distortions of Kienholz's uninhibited imagination. Found objects, dredged up from intensive research into a precise period of time and laid out like exhibits in a museum of social history, are weirdly interspersed with emblems worthy of the most fantastic surrealist sculptor. The resultant *mélange* is unsettling: even as spectators enter into the spirit of *Back Seat Dodge '38*, with its faithful adherence to the trappings of pre-war American life, they are shocked to discover that the man seducing his girl in the back of the car is nothing more than a transparent coil of chicken wire.

Although Kienholz stages his outbursts with the overt theatricality of a medieval player – it is significant that he borrowed the name 'tableau' from costumed presentations seen during his youth at rural churches – he draws stylistic inspiration from a devious variety of sources. Immediately you press your head against the bars of *The State Hospital*'s prison-like door, the sickening smell of the dormitory beyond wafts through the window. But inside, along with the bare iron bedsteads and the chamber-pots, a comic-strip bubble of neon tubing curves around the uppermost sleeping figure, introducing a note of wild fantasy into an otherwise dauntingly realistic scene. Sometimes, Kienholz's penchant for grotesque symbolism teeters over into melodrama: the fibreglass rockets of pain shooting up out of the pregnant woman's stomach in *The Birthday* look forced and merely sensational once the initial shock has been overcome. They represent the weakest side of his determination to assault the sensibilities, and descend into a brand of corny literalism not altogether absent from other pieces like *While Visions of Sugar Plums Danced In Their Heads*.

However, this love of frank emotionalism pays spectacular dividends in the rich, corrosive irony of *The Portable War Memorial*; and when it is properly allied to a totally thought-out environment the result is unforgettable. To experience *The Beanery*, probably the finest of all the tableaux, spectators are forced to squeeze themselves into the narrow, claustrophobic tunnel of a sleazy bar, attacked on all sides by smells, noises and the life-size figures of silent drinkers. These hunched, lonely presences seem interned in a long vault of boredom and negation, desperately attempting to kill the time that ticks on so mercilessly inside the clocks that Kienholz has substituted for their faces. They are corpses, desiccated by disappointment and aimlessness, and yet each form crowds in on our consciousness with such overbearing force that it ends up appearing more real than

reality itself. The preacher's diatribe here coincides with the artist's vision, and the combination makes most other modern art look thin-blooded, wanly aesthetic and dangerously detached.

BILL BRANDT

12 May 1970

Even though photography first revealed its godlike power to create man in his own egotistical image well over a century ago, we still cannot bring ourselves to think of it as an art form rather than a useful functional device. The photographic image is snubbed at every turn. Where the humblest home will hang a *Hay Wain* in the hall, the snapshot languishes between the yellowing pages of a holiday album in some obscure bottom drawer. We do not seem to have recovered from our ancestors' amazement at the accuracy of the camera, and realised that the lens is just as capable of distorting outward facts as Van Gogh when he sat down to paint his sunflowers. But perhaps this built-in prejudice, so narrow and so blindly élitist, is finally beginning to be eroded. Contemporary painters are bringing the photograph back into their work, regarding it as a source of interest rather than a dangerous rival to be avoided at all costs. A versatile performer like Andy Warhol could never bring himself to paint a conventional portrait, but he feels perfectly happy clicking the shutters on his sitter and then twisting the resulting negative into his own work of art. Richard Hamilton, likewise, can take an ostensibly simple seaside postcard and blow it up, frame by frame, to the point where a small detail of bathers on the sands becomes a mysterious constellation of unidentifiable, abstract blobs. These men operate within the rarefied realm of so-called fine art, but they would surely not belittle someone's talent simply because he worked with the camera as opposed to a paintbrush.

A master photographer like Bill Brandt, who has taken England as his visual material for most of his long professional career, ought never to become the victim of such woolly distinctions. The outstanding landmarks of that career are now on display in a sensitively arranged exhibition at the Hayward Gallery, and they should be enough to dispense once and for all with the fallacy that photographs play second fiddle to paintings. One of the most striking qualities of the show is the unity of mood tying together every single picture: Brandt, as much as the most

individual artist, has carved out for himself a personal territory that is instantly recognizable. Brandtland is a place of shadows, essentially, a penumbral region where faces loom out at you, full of anxiety and introspection. Tragedy hovers in the air, but it is never overt: the plight of a Durham coal-miner imprisoned in his hovel is implied by the honesty of the portrayal, not hammered home as a propagandist message.

The most moving images suggest a situation, give out a series of subtly observed facts and leave us to project our private feelings into the scene before our eyes. One marvellous 1938 picture of smartly dressed figures, drinking pre-dinner cocktails in a Surrey garden, catches the encroaching gloom of the evening landscape so acutely that its murkiness suddenly seems to threaten the leisured elegance of the party guests. Up against the solemnity of the brooding trees, the humans appear both vulnerable and anachronistic, the last fragments of a social order that the world war was soon to destroy. It is a poignant statement, but Brandt does not sentimentalise or preach: he simply chooses his viewpoint, deliberates over every inch of his composition, and waits for the right time of day. In other words, he transforms his raw material into a pictorial poem with the boldness and freedom of a painter interpreting the view from his studio window. The difference lies solely in the medium at his disposal, not in the quality of the final message.

The daring liberties that Brandt has been willing to take as a photographer are nowhere more clearly paraded than in his series of female nudes, a protracted suite of studies carried out over a period of more than fifteen years. A second-hand wooden Kodak, with a wide-angle lens and an aperture so small that he could not see through it, enabled him to approach this time-honoured theme in a totally fresh way. Thighs, breasts and bellies are all presented in extreme distortion, lifted out of their natural context and equated with pebbles, blocks of marble or pendulous fruits. Sometimes – inevitably – the strange angles look like technical tricks, and the picture does not seem much more than a display of professional skill. But when the distortion is fully justified, and meets up with an underlying idea as original as the viewpoint, then the result is entirely natural, even inevitable.

An outright masterpiece such as the 1953 beach scene, where the nude glides away from startling close-up into an abandoned sweep of dazzling white flesh until it is caught up in a whole complex of stones, rocks and craggy cliffs, becomes a symphony of sensuous textures and fulfilled curves. The body itself, its brightness defined by nothing except a tangle of sheer black, windblown hair, is an unforgettable combination of stylization and earthiness: the crease in the buttocks is peppered with goose-

pimples, and yet the contours of haunch and shoulder are as simplified as the most radical Moore carving. It is an outspokenly romantic picture, in which human forms are so bound up with the landscape where they lie that the whole complex locks together in one fulfilled harmony of limbs and land, skin and sky.

But it is to the portraits that we constantly return. For Brandt has produced a formidable gallery of character studies unlikely ever to be surpassed. Here is an enormously rich collection of celebrities, most of them highly original personalities in their own right, and yet all seen through the same subjective lens of Brandt's camera. Whether we end up gaining an insight into the character of the sitter, into the photographer's own inner emotions, or just our own deepest feelings about the human condition, is impossible to tell. Brandt seems to divine the essence of an individual so well: the flushed face of Dylan Thomas leaning against the glass partition of a pub, his youthful features already sagging and blurred with drink; or the two Sitwells, Edith imperious and aloof, Osbert rubicund and bejowled, posed like stuffed mummies among the bric-à-brac of Renishaw Hall, dowdy beneath the glitter of Sargent's family group hanging above their heads. A whole era in English culture is summed up by such an evocative picture, just as Forster sitting in an armchair at King's appears to be fading away as slowly and gently as the Indian-summer sun dappling the walls of his cloistered study.

It is the portrait of Bacon, however, that sums up so much of Brandt's real strength. The painter is caught, standing motionless in a raincoat on Primrose Hill. The path behind is soggy with puddles and the mush of fallen leaves; a solitary lamp-post flares up, pallid and unconvincing, against the last flickerings of a sunset on the horizon above. Dusk is approaching but the afternoon still lingers on, and the atmosphere is heavy with uncertainty and apprehensiveness. Bacon himself, unshaven and bleak, stares frowning out of the picture, lost in his own depression. His left eye, half hidden in shadow, is scored and bruised like a boxer's after a prize-fight. He looks weary and yet determined, battered but full of resilience. Soon he will walk on down the path, the sun will set, and the unique conjunction of man, mood and landscape pass. But Brandt was there to ensure that his camera caught this moment of time, welded all the disparate elements of the scene into one dramatic unity, and ended up with a distillation of the bitterness, tempered with hope, that constitutes a great tragic vision. It is a photograph, of course, but no painting or sculpture, symphony or poem, could conceivably do more.

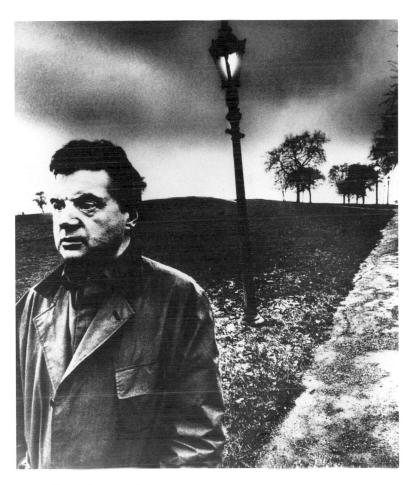

III. Bill Brandt, *Francis Bacon*, 1963

GEORGE RODGER

5 September 1974

At one time, in the not-so-distant past when photography was far more uncertain about its identity than it is today, the word 'photojournalism' was considered rather derogatory. Photographers used to have such an inferiority complex about visual art that they all felt bound to ape artists' ethics as much as possible, and the idea of being a hired camera carrying out reporting jobs for magazines smacked too much of the market-place. The photographer, it was felt, could only dignify his calling by executing what *he* wanted to do, not some unscrupulous editor. How else could his work be personalised, and escape from a habit of mind which looked for sensational impact, rating hard-news value high above the supposed aesthetics of 'fine' photography?

The pendulum has now, very laudably, swung so far in the other direction that one of the photographer's prime functions is seen as recording and witnessing, taking its cue from the visible facts which an aperture can trap rather than from woolly notions about the supposed relationship between photography and painting. In other words, the photographic medium is beginning to grow up and define its intrinsic abilities. Among the many advantages of this newly independent climate is that a man like George Rodger, who has never thought of himself as an artist at all, can be recognised as one of the most considerable British photographers of the twentieth century.

The exhibition of his work at the Photographers' Gallery is one of the best arguments I have seen for the merits of the photojournalist's approach, and Rodger himself deserves credit for consciously helping to dignify his calling. The Second World War made him realise just what a powerful instrument he had at his disposal. Although he had previously worked for the BBC, the *Tatler*, the *Illustrated London News* and other magazines besides, it was *Life* magazine's commission to cover the war in England for its American readership that caused him to see his work as a positive agent, more beneficial in its effect than the posting in RAF bombers which Rodger had tried to secure when hostilities commenced. 'Desperately we needed American aid – war materials, fuel, food and money – and in my pictures, published almost weekly, I could show not only how much we needed it but also what we did with it when we got it,' he explained later.

The most admirable aspect of his war pictures is, however, their restraint. Instead of launching an all-out polemical attack on the sensibilities of his

audience, searing their consciences with images of suffering and horror which might in the end have blunted their response as effectively as shots of napalm and famine victims in the mass media today, Rodger subjected himself to a tight discipline. The urge to build up an emotive scene always plays second fiddle to his respect for the quieter but ultimately more compelling reality which he could observe. Nothing could be more factual or straightforward than his study of Piccadilly Circus in 1940, showing Eros entirely hidden by a pyramid of sandbags as a protection against bomb damage. But Rodger knew how eloquent this symbol of a beleaguered nation might be, and his subtlety paid off. This grim encasement is not simply a measure of England's plight, for it is surrounded by a circle of enormous hoardings which vigorously exhort the public to 'Take up the Challenge!' and buy National War Bonds. The message of defiance in adversity was ready-made, and Rodger had the sense not only to notice it in the first place but to allow it to speak for itself.

In a similarly self-effacing way, he shows us a group close-up of Coventry boys who were dug out of their bombed houses after a raid. The photograph's very lack of artful composition concentrates attention on their extraordinarily cheerful expressions, conquering obvious weariness, bruises and bandages. It is also one of the few pictures which reminds us of Rodger's presence behind the camera, not in an egotistical way but as someone who has probably told these boys a joke to raise their spirits a little. His war photographs are obviously the work of an optimist who believes in the values of humanism. A London family is shown homeless on the pavement after a raid, their belongings heaped up like rag-and-bone merchandise behind them. But they are sufficiently uncowed by their misfortune to be absorbed in looking at their shoes to see if they are dirty, and the mother's carefully brushed hair and neat clothes show how determined she is to keep up her usual standards of decency.

Such a picture reveals Rodger's acute sense of social observation, his understanding of the rituals and conventions which govern humanity in any society. When he shows people in Coventry looking at lists of the dead and wounded pinned up outside their gutted Town Hall, he stresses the ceremony of their corporate sorrow as they stare at the doomed names with the rapt attention of worshippers at Mass. And as a measure of Rodger's range, the absurd, cocky humour of the Phoney War is perfectly caught in a shot of two smiling pressmen on the Dover cliffs, sitting beside a tombstone which reads: 'RIP. Here lie three Pressmen. Died Waiting. 1940.' Its very tone is given an extra edge by the ludicrous inadequacy of the guns assembled like so many childish

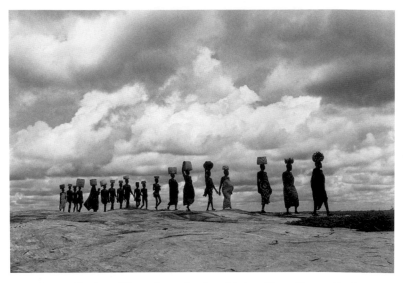

112. George Rodger, *Women Returning from Market, Aluma Plateau, South Sudan*, 1949

peashooters on the sandbag barrier: all the jokes in the world would not have saved them from destruction if Hitler had fulfilled his promise to invade. In his own subdued, unforced way, Rodger managed to summarise whole periods of the war in such images, but he never acquired too exalted an idea of his role. By the time he found himself among the first troops to enter Belsen, he realised the element of sheer inhumanity inherent in taking 'nice photographic compositions' of the carnage he found there. So he turned instead to countries like Africa after May 1947, when he helped to found Magnum Photos with Cartier-Bresson, Capa and others in order to guarantee creative freedom within an uncensored photographers' cooperative.

Rodger's African pictures are a moving affirmation of Magnum's independent stance. The human body is invariably the subject, but it is never seen in isolation. Rather does the totality of a people at home with nature come through with great conviction. Rodger once again proves his innate respect by viewing his native subjects with admiration and sympathy, not as bizarre fodder for a cameraman who has no time to acquaint himself with tribal customs. Time and again, the natives are shown to be at one with their surroundings. The flailing limbs of bracelet

fighters echo the equally contorted branches of the tree behind them, and young girls dancing before drums at Kao village in Kordofan look like frail saplings growing out of the shadows at their feet. Rodger's Africans are rooted in their landscape with the inevitability of Easter Island carvings. When he silhouettes a procession of Bari women from Equatoria Province returning from market, each balancing a different-sized container on her head, they could all be mistaken for statues erected on that desert plateau centuries ago.

Here is a photographer who knows his subjects so intimately that he is able to cast all his Western preconceptions and prejudices to one side and simply view these tribes as part of humanity. Indeed, it is hard not to suspect that Rodger may enjoy their company more than ours. For there is a gravity about the picture of an old man, carrying the sacred spear of the Bunyoro tribe across a network of lengthening shadows, which suggests that their spiritual beliefs are deeply held and inviolate beyond our imagining. Photojournalism can here be said to reach an affirmative peak in its development so far, and Rodger uses it to mount a most convincing plea for the preservation of societies we should respect and envy, not seek to improve.

KENNETH MARTIN

22 May 1975

It is typical of Kenneth Martin's character as an artist that his retrospective exhibition at the Tate Gallery is a spare, compact and modest affair. No striving after excessive grandeur or showmanship, which so often mars these occasions and gives the lie to a substantial reputation, has been allowed to detract from the lucid presentation of his thoughtful and persistent development over the last twenty-five years. Each successive stage in his work is charted with appropriate simplicity, and we are invited to share in a process of discovery rather than stand back and view a grand old man's achievement with dutiful respect. Martin himself would not want it any other way. His whole temperament is utterly opposed to the idea of arriving at a series of magisterial and finite conclusions. Instead, he places a consistent emphasis on learning, working towards, restating any number of times in the hope of arriving at a closer approximation to the ideal he knows it is impossible to attain.

Not that there is any feeling of inadequacy or futility in Martin's attitude. The paintings, drawings and sculpture are always complete enough statements in themselves: it is just that they would never dream of advancing any undue claims about resolving all the issues with which they deal. Their scale is generally very small, as if in recognition of their status as stepping-stones leading on to further investigation. And they cluster in groups, so that the whole notion of a summarizing masterpiece is exchanged for a communal endeavour which produces permutations on the theme of growth, change and the part played by chance in any exploratory undertaking.

That is why so many of Martin's works have an element of movement built in to their structure. Hanging down on threads so delicate that they would snap with the weight of anything more ponderous than he would wish to construct, his little screw mobiles refuse to rely on one fixed identity. They are static enough to assert a considerable physical presence, certainly; but at the same time a slight rush of air, or even the disturbance caused by someone walking near them, displaces their equilibrium and sets them rotating into a whole range of alternative configurations. For every second that the motion lasts, a new and quite distinct reading of the work offers itself, continually modifying the one before. So the principle of flux and metamorphosis embodies Martin's own belief that there can never be any such thing as a terminal resolution of an idea.

The moment we begin to grasp the underlying framework of a mobile, it twists into a mystifying rearrangement of the forms involved; and even when his sculpture is completely static it still has the possibility of infinite variation implicit in its organization. Every piece of gleaming brass or bronze is added to its neighbours, segment by segment. They therefore seem resolved and yet open to a different set of combinations should the need arise. Their poise is precarious rather than final, like a house of cards which could easily be knocked down and restacked according to another set of instructions. And they encourage us to imagine how these optional alignments might be set up, so we are drawn into an active relationship with works that positively welcome audience participation.

The openness and humility which Martin's flexible philosophy displays is surprising if set against his determination, at the end of the 1940s, to embrace a totally abstract language. In terms of the romantic and predominantly figurative art flourishing in England at that time, and of his own naturalistic painting throughout the previous two decades, it was an extreme decision to take; and Martin's work was frequently accused of sterility and intellectual coldness. But this criticism was more of a reflection on the provincial timidity of most English art than an accurate

113. Kenneth Martin, *Chance and Order 10 (Monastral blue)*, 1972

response to the art Martin then began to execute. It is true that he has, almost alone among those artists in England who have espoused abstraction at some stage in their careers, been undeviating in his commitment to abstract principles since 1950. His single-minded refusal to admit any references to descriptive appearances is a hallmark of this exhibition, and sets him apart from our national weakness for literary content and a style which plays abstraction off against renegade figurative elements. In terms of the broad constructivist tradition, however, he has done no more than continue a way of working practised in European art for around sixty years. And his adoption of an abstract programme was in no sense the action of a rigid fanatic.

Quite the reverse: the predominant quality of his first non-representational paintings lies in their improvised caution, as Martin began to educate himself all over again in the basic grammar of art. The break from his previous work, which had attempted to simplify the complexity of nature, was total. Now he started off with simple components, and gradually built them up into a complex structure parallel to, but in no sense

imitative of, nature at her fullest. It was a complete reversal of Martin's working priorities, and yet it did not mean he now set out to produce an art so complicated in structure that no one could grasp its fundamental elements. All the way through this exhibition we are constantly made aware of *how* each tiny section of metal is added to the other links in the chain, and *why* they curve out in such elaborate spirals from the vertical rod suspended through their centre. In other words, they enable us to reconstruct Martin's own procedure when he assembled them: attention is directed all the time to the process of growth, evolution and variation springing from a simple initial sequence of forms.

Although there are many highly polished and carefully painted objects in his show, then, none seeks to present itself as the last word on the particular theme it deals with. They are all used as foils, seemingly authoritative statements which nevertheless highlight the possibility of other alternatives in the future. 'Chance and Order', the title of Martin's most recent series of drawings and paintings, therefore sums up the doublethink running through all his work. For him, the throw of the dice is as important an ingredient in life as the shaping power of mathematical systems, and he would never allow some kind of ideal harmony to exist in his art if it was not allied to an awareness of dynamic change. Without this awareness, Martin's work might easily be nothing more than shiny playthings suitable for an executive in leisure moments. With it, he manages to transcend that level altogether and prove that art does not have to be either monumental or definitive in order to earn lasting respect.

A SCULPTOR'S POEMS
3 July 1975

Because Carl Andre is one of America's most prominent middle-generation sculptors, it would be natural to interpret his new exhibition at the Lisson Gallery entirely in that light. The walls are lined with horizontal rows of white paper, placed next to each other without any intervals and xerox-printed with typewritten words arranged in various patterns or sequences. They look like poems, and that is how Andre himself describes them; but their presence in an art gallery suggests that he wants them to be seen, at least partially, as the work of a man whose public reputation rests on his sculpture. By doing so, he does of course

114. Carl Andre, *I left my stable. At passed*, 1975

risk misunderstanding: it might easily be assumed that these typed sheets represent some kind of conceptual sculpture, verbal instructions as a substitute for physical objects. The temptation should be resisted, however. Andre started writing poetry before he began making sculpture, and the two activities have run side by side in his work ever since. The fascination of this show therefore lies in the correspondence to be drawn between his use of these two separate media, rather than in any mistaken belief that his words are a form of alternative sculpture.

During a cassette interview which *Audio Arts* have issued to coincide with the exhibition, Andre explains that, as a child looking through his parents' books, he found the shape of poetry on a page more interesting than prose. And by placing his own poems in a gallery context, he certainly

makes us aware of their visual structure before we are able to move nearer and read them properly. The words are closed up into tight, solid blocks; repeated below each other so that they form long, vertical stacks; enclosed within ranks of horizontal lines which define the space they occupy; and sometimes carefully separated to allow the blank paper between a positive role in the design. All these strategies, and many more besides, are comparable with Andre's methods of making sculpture: it is possible to draw an analogy between the way he places physical units on a floor and the way he places word units on a sheet of paper. His poetry gives a strong impression of the act of typing, of metal keys hitting white paper with black marks which punctuate the area at their disposal with the force of a cut. There is never any sense of an even flow. Sentences are made entirely subservient to individual word-clusters which assert their own identity, just as each single particle of brick or metal in Andre's sculpture resists being swallowed up by the object as a whole.

Alongside the palpable quality of this poetry, another parallel with his sculptural activity presents itself as well. If Andre relies for his raw material in sculpture on pre-existing elements, often culled from scrapyards and waste lots, so likewise does he use as a starting-point for poetry ready-made texts, some of which are similarly neglected. Other texts, like the Bible or the writings of Emerson, are widely referred to today; but it is still true to say that the way Andre handles them can be compared with his sculptural practice. In a long poem on the aviator Charles Lindbergh, for instance, selections have been taken from two published sources and alternated, thereby producing meanings which arise out of those texts without having been intended by their authors. Andre's sculptures operate like that, too: they take their cue from the character of the particles he has found, and yet they are recombined to arrive at a new statement. They can also be taken apart again and returned to their original condition, in the same way that Andre's words could be extracted from his poems and reincorporated in the texts where they belong.

It is unwise, however, to push the sculptural links which this poetry possesses too far. Andre's physical objects may carry overtones of the environment where they were found, but their extreme minimalism discourages any associations we might want to attach to them. His poetry, on the other hand, is meant to be read close-to as well as surveyed from a distance, and the associations it contains are obviously an important part of the work. Whereas it would be difficult to guess from Andre's sculpture that he was at all involved in the history and landscape of his home town, several of the poems base themselves on autobiographical memories of Quincy, Massachusetts, or the writings of eighteenth-century figures like

Abigail Adams, the wife of America's second president, who came from Quincy. Andre obviously uses the perspective which these historical texts provide to distance himself from issues he would find it difficult to deal with clearly if they were anchored in his current experience. The United States' colour problem, very much a present-day reality, is rehearsed in his poetry through material drawn from the clash between John Brown, who attempted to liberate the black slaves through violent action, and Emerson, a philosophical sympathiser who nevertheless harboured doubts about Brown's determination to break the law. Colour images play an important part in this poem, revealing how Andre manipulates his documentary source material to dramatise opposing attitudes towards the racial dilemma. Its contemporary relevance is plain, as is its attempt to evolve new forms for poetry which relate more to visual art than they do to older, musically oriented poetic forms.

The most literal example of this search is a short poem about Myrtle Avenue, a coloured ghetto area in Brooklyn, which actually uses red print on a painterly yellow background to envenom Andre's protesting comments on the privation of life there. But in general, the starker option of black and white is employed, and apart from some recent poetry written by hand, the appearance of the words and the structures they assume are dictated by the capacity of a typewriter. This built-in limitation gives the work a tautness and disciplined restraint it might not otherwise have had if Andre felt that any kind of printing was available to him. One of the handwritten poems seems to be an outburst on the strains and pressures of coping with demands from art dealers, and it is significantly less effective than the more controlled, oblique emotions he conveys through a hard and bitter textual analysis of accounts rehearsing the history of Montezuma and the conquest of Mexico. The passion here is no less apparent, but it is channelled through an exploration of events from the remote past, and this act of removal enables Andre to utilise his essentially ordered, anti-rhetorical approach to both poetry and sculpture. For all their innate differences, these two media are seen in his work to be related parts of the same enterprise; and it comes as a welcome corrective at a time when the arts in general are too compartmentalised to share a fruitful dialogue with each other.

LATE HEPWORTH

17 February 1970

Although Barbara Hepworth has been lucky enough to achieve an almost legendary status within her own lifetime, the honour is, paradoxically, double-edged. She has become an institution, a part of art history, and it has grown difficult to look at her work with fresh eyes. Everyone knows what a Hepworth looks like: the ideas that she and Moore once fought to establish have long since been accepted. They have become the standard sculptural clichés of our time, and it is tempting to hurry past Hepworth in search of something more challenging and unfamiliar.

The temptation should be resisted. This sixty-seven-year-old woman is still as active and prolific as ever, and a massive exhibition of her latest work, taking up both branches of the Marlborough Galleries, is proof positive of her continuing vitality. Such a show of strength is all the more surprising from one who produces placid forms. Hepworth is, in many ways, the absolute antithesis of Moore – where he is rugged, brutal and strongly allied to 'primitive' sculpture, she is smooth, calm and essentially classical. It is no accident that some of her most successful works should have sprung directly out of the excitement of a visit to Greece in 1954. Even the titles of those majestic wood carvings – *Corinthos*, or *Curved Form (Delphi)* – bear witness to the inspiration of the Greek landscape; or rather, the interaction between humans and their surroundings that has fascinated her throughout a long career.

Hepworth has always been dedicated to expressing 'the fundamental and ideal unity of man with nature, which I consider to be one of the basic impulses of sculpture'. This is the mainspring of her work, and the best sculptures in her latest exhibition are those that deal most directly with this obsession. One of the most satisfying is the enormous *River Form*, expanding lazily outwards from a central hollow tunnelled out of polished American walnut. It looks like a place of shelter, a natural womb created by the seasonal action of wind and rain rather than the conscious hand of a sculptor. The equation has worked: Hepworth succeeds in transmitting her own feeling for nature into sculptural form, and we can explore that relationship as keenly as she does.

The enfolding shape of a womb constantly recurs in her work. Sometimes, as in *Hollow Form with Inner Form*, she becomes quite specific and wraps a small vertical figure up inside the circling arms of an outer casing. But they do not combine together with as much organic conviction as the far smaller *Pierced Hemisphere with a Cluster of Stones*, where

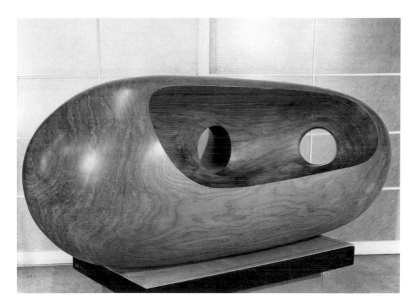

115. Barbara Hepworth, *River Form*, 1965

two lumps of marble and slate nestle inside an egg of Hopton wood stone. The different materials have been selected with fastidious care, and serve as a reminder that Hepworth started life insisting that a carver should remain true to the particular stone he works with. Her later adoption of bronze casting directly contradicts this belief, and her work in this medium still seems far too sleek and streamlined to convey the identification with nature she aims for. Perhaps the colour that she so often applies to her bronzes is an attempt to counteract this machine-made effect, but unfortunately the garish blues painted on to a piece like the monumental *Two Figures* of 1968 only increase the aggravation.

Hepworth has her limitations, and it is only when she exploits her formidable talents as a direct carver that her work really impresses. The most commanding of her recent sculptures, the huge *Two Piece Marble (Rangatira)*, gains much of its impact from the complete understanding of the material used. Marble is a heavy substance, but white marble has a translucence which manages to alleviate that heaviness. Hepworth knows just how to play off one quality against the other, and *Rangatira* shows this knowledge in action. The composition is simple: one horizontal block balanced on top of a vertical one. It could be merely squat

and oppressive, but the upper block is perched so precariously on its supporting base that an exciting tension results. The work has both composure and instability, lightness and weight. It can be read either as a natural outcrop of the landscape or as a metaphor of a human figure. It is as mysterious as a prehistoric monolith, and yet no combination of forms could be more straightforward.

Only the most consummate skill could contain all these contradictions inside one sculpture, and Hepworth demonstrates once again that she is still in possession of all her former powers. She may be an institution, but a work like *Rangatira* warns us not to take her for granted.

BARNETT NEWMAN
6 July 1972

Sometimes, by an extraordinary and very timely coincidence, the arrival of a new exhibition in London throws new light on thoughts and feelings which a preceding show has only just aroused. Last week, discussing Patrick Heron's Whitechapel retrospective, I wondered whether his art had suffered from an urge to protect his creative impulses from a highly developed critical intelligence. And now, with the advent of a major survey of Barnett Newman's career at the Tate Gallery, this very dilemma is presented with renewed force. For although Newman never engaged in the kind of professional reviewing which Heron used to practise, the fact remains that his first real contribution to the heroic years of American painting lay in polemical essays. And the central strength of his achievement clearly resides in a determination to infuse his work with the cerebral power displayed in those early writings. Unlike Heron, whose art seems always to have shied away from the potentially inhibiting power of his critical faculties, Newman only began to operate at full strength when his theoretical intelligence was satisfied by the pictures he produced.

Before then, in the thirties and early forties, his artistic ambitions were paralysed by the knowledge that everything he made fell short of the direction he knew art should be exploring. All the established American painters at work around him were foundering in a provincial timidity which bore no relation to the mainstream strength of modern art. But Newman, even while he diagnosed their short-comings with unerring accuracy, could not bring himself to leap out of this blind alley. As his eventual solution would

demonstrate, the true way forward required a degree of imaginative daring unprecedented in the history of American art.

He was simply not prepared to take such a step without prolonged and often agonizing deliberation, and so he prepared himself by composing a whole series of lengthy, carefully considered papers on the problems facing the would-be radical. A less resolute temperament would probably have despaired over this inability to express new ideas in any medium other than the written word. But Newman did not lose sight of his overriding desire to paint. Every time he destroyed an unsatisfactory group of pictures – and he insisted on eradicating almost all his work over a fifteen-year period – he must have viewed this drastic measure as a positive act. Even during the time when he abandoned art altogether, Newman was gradually bracing himself for the moment of recognition.

Only by facing the full implications of his awkward, desperately demanding talents could Newman satisfy his own deepest urges. And the first room of pictures at the Tate reveals just how halting and unaccomplished he was willing to appear for the sake of this one great priority. In order to realise the size of the risk Newman was prepared to take, it is worth remembering that he was over forty when he executed these tentative canvases. Most other artists, particularly nowadays, would have given up the struggle long before then: the prevailing need to confront the world with a fully formed persona at an early stage virtually rules out any possibility of striving at such a painful level in middle age. But Newman's obstinate integrity despised the facile options which must have presented themselves to him. He was after nothing less than wholeness; and hindsight enables us to see that the strong, clean verticals dominating several of these otherwise confused and anxious pictures eventually led him to overcome his inhibitions.

It appears obvious enough now that a vocabulary of such verticals, disposed against a flat field of uninterrupted colour, would soon provide him with the syntax he had desired for so long. In 1946, however, nothing seemed more pre ordained; and if it had been, then Newman would doubtless have failed to grow into the artist he succeeded in becoming. No blinding revelation accompanied his sudden decision to cover a small canvas with dark-red pigment, lay a strip of tape down the centre and then paint it over with a lighter red. Newman merely thought he was testing possible colours; and yet the analytical side of his sensibility somehow prevented him from going further, from spoiling an impulsive experiment which ultimately – after eight months of searching scrutiny – announced his maturity as an artist.

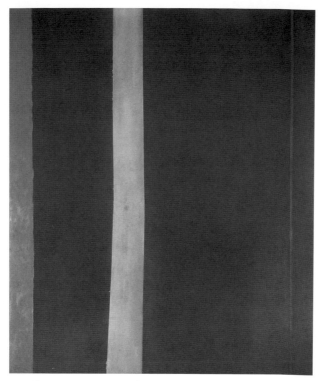

116. Barnett Newman, *Adam*, 1951–2

In my view, the way in which that pivotal picture, *Onement I*, was cre-
ated highlights the finest quality of Newman's work. For however final and
authoritative his later paintings appear, they are permeated with an edgy
tension which stems from a ceaseless urge to question their validity. Even
as monumental statements like *Vir Heroicus Sublimis* and *Shining Forth* (*To
George*) assert their power, they implicitly ask themselves whether they
might not lapse into diagrammatic banality the next moment. They main-
tain a dialogue, the whole while, between the Newman who wants to
make it new by the most extreme means available, and the Newman who
wonders if those very means might court final emptiness.

His Tate exhibition is, in the true sense, shocking. It confronts you with
the spectacle of a daring innovator pushing himself to the furthest limits,
and only preventing himself from toppling over the edge to disaster by

exercising a calculating sense of control. It represents, in other words, the triumph of a man who has never allowed his abandon to seal itself off from his critical stringency. By refusing to let go of either faculty throughout those early years of failure, Newman finally achieved more than any of his Abstract Expressionist compatriots. He never repeated himself, never resorted to rhetoric or self-indulgent gesturing, always insisted on starting afresh with each new picture – and thereby finished up with a body of work as adventurous as it is considered. Keeping these two seemingly incongruous impulses constantly in play, the rashness and the deliberation, Newman was able at last to turn his dangerous duality into a source of enduring richness.

MAN RAY
24 April 1975

Man Ray is the perfect example of an artist whose name and reputation are far more widely known than the work he has produced. There are practical reasons for this: his large retrospective survey now at the ICA is the first of any great substance to be held in London, and Roland Penrose's new book is likewise the only sustained attempt since 1924 to examine Ray's career. There are personal reasons, too, foremost among them the elusive character of a man whose art and life belong far more to France than to his native America. It seems almost unbelievable that an artist so closely identified with the Parisian avant-garde in general and both Dada and Surrealism in particular could have been born some where as inappropriate as Philadelphia. But the fact remains that Ray was brought up in Brooklyn, and spent his formative years learning about contemporary developments in art from the limited number of provincial outlets which New York could offer before the First World War.

Leaving aside questions of national identity, however, Ray's art remains so difficult to grasp because it demands to be seen more as an overall *attitude* than as an independent series of exhibitable works. Apart from the earliest section of the ICA show, which contains the pictures he executed at a time when his ambitions were directed almost wholly towards painting, a spry and inventive mixture of media is apparent everywhere. By 1921, when he made the decisive move from New York to Paris, Ray had made it more or less clear that he would never again be restricted to one

means of expression alone. His desire to continue painting was still strong, but it had come into contact with notions derived from his friendship with Duchamp, whose cynical views on the human condition were matched by an impatience with the idea of confining an artist to purely pictorial avenues. I suspect that Ray was not entirely happy about this clash of interests: whereas Duchamp himself gave up painting in favour of other pursuits, Ray has continued to paint a large number of pictures throughout his life. Taken on their own, they make up an unsatisfactory body of work, in that the perfunctory way they are executed is not matched by any obvious desire to reformulate the painting tradition.

The result is, all too often, a picture which looks like a hastily carried-out version of something Magritte, de Chirico or Ernst did with far more conviction and enjoyment. Ray seems to take scant pleasure in the actual process of painting, its brushwork, colour or texture. He appears anxious only to finish the job as quickly as possible, to convey the idea without bothering about the niceties of its pictorial form, and this bias tallies very well with his preference for collage, airbrush painting, assemblage, simple line drawings, film and above all photography. Here he can indulge his quicksilver temperament without having to worry about a laborious medium – and, more important still, without having to abuse it. In his autobiography, Ray admitted that he had never 'engaged in such a sustained effort over one work as in the writing of this book', a remark which shows how much he thrives on being able to leap like a nimble grasshopper from project to project before anything weighs his agility down with problems of manual construction.

For Ray sees himself, when he forgets about the call of painting and casts himself in a Dada mould, as a humorous *agent provocateur* rather than a maker of substantial artefacts. He appears to operate most successfully when presented with a situation or a series of objects which he can turn, with a minimum amount of physical drudgery and a maximum amount of light-fingered wit, on their heads. The most obvious instance of this strategy is the steam iron he bought from a shop and then glued with a neat row of tin-tacks, thereby making it completely useless and at the same time giving it a sinister new meaning. But many of Ray's assemblages involve a similar kind of logic-twisting, whether on the ready-made level of suspending a cluster of coat-hangers from the ceiling to form a flock of birds in flight, or on the punning level of 'letters' that fall out of a real metal postbox as a pile of white letters from the alphabet. They are gentle exercises in identity changing, little jokes which Ray wants to share with us and not falsify by building them up into grandiloquent works of art. That would be pretentious and beside the point, for

117. Man Ray, *Cadeau*, 1921/1963

Ray remains close enough to Duchamp to aim for the essence of an idea without the clutter of its visual elaboration.

But he is also enough of a painter to harbour ambitions in that direction as well, and although his paintings suffer from neglecting most of the advantages which pigment offers, photography has given him a useful middle way out of the dilemma. The camera freed Ray from the tedium of picture-making and yet encouraged him to think pictorially, a combination that suits his particular disposition best of all. He could, for example, apply the steam-iron and tin-tacks approach to photography and come up with the combination of a nude female back inscribed with the two sound-holes of a violin. Moreover, the neat play on the woman/musical instrument metaphor is enriched by the Ingres-like pose which the nude adopts. It gives what would otherwise be a pleasant conceit memorable visual form, a comment as much on the sex-object role of the naked female body in Ingres' art as on the meaning of Ray's title, the *Violon d'Ingres*.

The satisfaction afforded here lies in the careful, not to say subtle, application of a deliberately planned idea. But Ray also thrives on chance, and in his rayographs he evolved a method of marrying the use of accident to his visual powers. Once again the method which he hit upon – making distorted photographic compositions from groups of ordinary objects placed on sensitised paper underneath a light – liberated Ray from any cumbrous techniques. It invited him to make swift variations on an improvised theme, drawing on anything to hand in his pockets or his living-room. The results show how eagerly Ray responded to transforming keys, candles, springs and light bulbs into free-floating compositions. They hover within an indefinable black space, as if liberated from their own weight and the normal constraints of gravity. There they glide, tumble, curve and swoop around each other with the effortless grace of a dancer.

In purely photographic terms, these eerily bleached monochrome prints are a bastard form of expression, entirely ignoring the camera's usual recording function. As a union between art and one aspect of the photographic process, however, they represent Ray's most eloquent solution to the challenge of how to relay his poetic, gadfly imagination through channels that do not depend on the mystique of craftsmanship. In other areas Ray did not find so adequate an answer, but he deserves to be remembered for his willingness to explore a variety of alternatives to painting and sculpture still being investigated by his successors today.

YVES KLEIN AND PIERO MANZONI IN RETROSPECT
15 March 1974

The timing of the Tate Gallery's double exhibition of Yves Klein and Piero Manzoni is, for once, fairly appropriate. Although it would have been more relevant to look back on their achievements perhaps four or five years ago, when many of the issues they raised were being hotly debated and developed by a younger generation of artists, it is still worth stopping for a moment in 1974 and asking ourselves how both these men contributed to a dialogue by no means ended today.

Why show them together? Klein was French and Manzoni Italian; they met once or twice, but were never friends; and in some crucial ways their work is contrasted to the point of extreme opposition. Fundamentally,

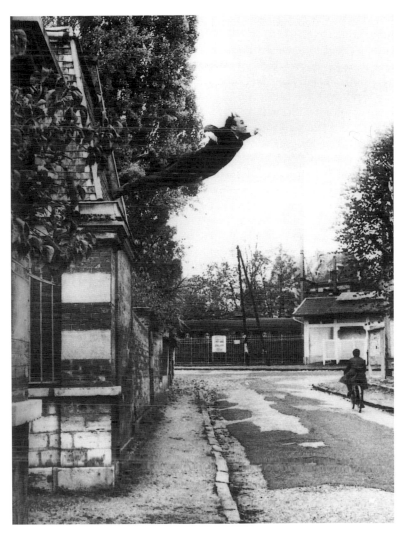

118. Yves Klein, *Leap into the Void*, 1960

however, they shared during their short lives (Klein was only thirty-four at his death in 1962, and Manzoni barely thirty when he died several months later) a desire to repudiate the notion that art should only channel itself into unique objects which evolve in style along with their makers' own personal ideas and emotions. Not that either artist threw tradition out of the window: Klein pretended to throw *himself* from the first floor of a building in 1960 to produce a photograph called *Leap into the Void*, but both he and Manzoni adhered throughout their careers to the orthodoxy of objects hanging on walls. What they refused to do was subscribe to the notion that their own paintings, reliefs, sculptures and other offerings should conform to a set of aesthetic rules and internal relationships which needed to be judged in the accepted way. Klein's monochrome blue pictures do not depend on that kind of formal language at all: they vary according to size, hue and texture alone, and their uniform, rolled-on colour excludes even the handwriting of a personalised brushwork.

In other words, any possibility of creating an illusion is ruled out altogether. The four large International Klein Blue canvases which fill the first room we enter at the Tate are flat surfaces of pulsating colour, nothing else; and when that same all-pervasive ultramarine is applied to sponges, paper cartons, a life-size plaster cast of a friend or a little reproduction of the *Victory of Samothrace*, Klein never tries to hide the reality of the object he has painted. He wants to present us rather with a refined, universally applicable sensibility, something which uses the convention of the art object as a foil to stress the immaterial nature of his true concerns. In this respect, Klein prophesied the more recent development of an art that depends more heavily on concept than on physical fact: even the large painting called *Homage to Tennessee Williams*, which looks superficially like a hamfisted Abstract Expressionist picture, actually consists not of the artist's manual gestures but of smeared imprints pressed on to the paper by female bodies, and Klein simply directed this laying-on of human spore at a distance.

From here, it is only a step to a far-reaching dematerialization of art. After exposing his picture-surface to the markings of pure phenomena – the imprint of painted rushes and reeds on the river-bank, spots of spring rain, the scorches of a flame-thrower – Klein took his programme to its logical conclusion in the last few months of his life. He reduced his own work to a written receipt, which 'stood in' for what he called an Immaterial Pictorial Sensitivity Zone, and handed it over to a collector in return for a pile of gold leaf. Then, if the buyer agreed to burn his receipt, Klein simultaneously cast the gold on to the waters of the Seine, thereby ensuring that nothing remained of the art beyond a spiritual transaction

and photographs of the ceremony he and his patron had performed.

Because Manzoni also aimed at an ideal monochrome, in his case a completely white surface, and paralleled Klein's desire to free art from its dependence on an illusionistic object, he has been accused of being the Frenchman's disciple. It is certainly true that Manzoni was very impressed, at a formative stage, by Klein's 1957 blue painting exhibition in Milan. And Klein reacted unfavourably when Manzoni later knocked on his door in Paris and introduced himself with the words: 'You are the monochrome blue and I am the monochrome white, we must work together.' But there are vital, almost polar differences between the two men, and on one level they have to do with their separate nationalities. Despite the multiplicity of Klein's activities, he does uphold the virtues of painting in a definably French way, and this bias points to a mystical strain in his temperament which spurns the physical world in favour of an absolute abstraction. Manzoni, on the other hand, consistently adheres to the material fact of a canvas stitched in squares, a gesso doorknob, polystyrene with cobalt chloride, glass fibre, cotton wool, felt, kaolin and straw.

When Klein wanted to escape from the art object, he held an exhibition in an empty gallery and used gold as a symbol of purification. Manzoni, however, clung to the baser side of life even when he dispensed with his white surfaces and conducted more conceptual experiments. He stamped extremely inky fingerprints on to real hard-boiled eggs and then asked the people visiting his exhibition to eat them – a far more earthy affair than Klein's bare gallery walls. The robust, peasant feeling in Manzoni's half of the Tate survey is absent from Klein's section. If the Italian wanted to emphasise that he could make an art work merely by selecting something, like Duchamp, he chose a real naked woman and signed her sexually provocative body with a puckish grin on his face. Klein, by contrast, whose early mastery of judo helped him to think of picture-making as a form of spiritual exercise, would only allow the female body into his art as an ethereal blue imprint, with which he had no direct contact. In this sense, Manzoni plays Caliban to Klein's Ariel, with Duchamp hovering in the background as Prospero, the benevolent father-figure.

Since their untimely deaths, a legion of other artists have taken up the implications of Klein and Manzoni's work, sorting out the separate strands of thought and developing them into fully fledged inquiries in their own right. Manzoni's 'living sculpture' has formed the basis of some younger artists' whole production, and his unadorned presentation of a given material has likewise been followed through. The monochrome ideal is still pursued with vigour (witness the large mixed exhibition

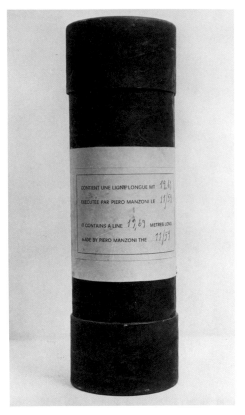

119. Piero Manzoni, *Line 19.69m*, 1959

called *Basically White* now to be seen at the ICA), while the verbal status of art has been subjected to intense specialised analysis. As a result, Klein and Manzoni have come to look positively gentle and innocent in their ambitions, poetic almost to a fault. The greatest irony, however, is that their work appears from our vantage-point to be disconcertingly tasteful, in spite of Manzoni's defiant declaration that 'I am quite unable to understand those painters who, whilst declaring an interest in modern problems, still continue even today to confront a painting as if it was a surface to be filled with colour and forms according to an aesthetic taste which can be more or less appreciated, more or less guessed at.' Now, through no fault of their own, these two defiant prophets are in danger of being confused with the very value-system they once set out to undermine.

INTERVIEW

A VISIT TO BACON'S STUDIO
4 October 1971

When Francis Bacon's retrospective exhibition of 134 paintings opens at the Grand Palais in Paris on 27 October, it will mark the highest honour France has ever paid to a British artist. But Bacon himself does not relish the prospect. 'I won't enjoy seeing the Paris show,' he told me, 'beyond being curious to see what the hell all those pictures look like. It was the same with my Tate Gallery show some years ago – I was extremely drunk when I saw it and I simply thought: have I really done all this stuff?'

With most artists, such a detached attitude towards worldly reputation could look suspect, even insincere; with Bacon, however, the unconcern seems entirely commensurate with his whole outlook on life. His personal circumstances, for one thing, are extraordinarily modest. The man whose paintings can now fetch as much as £40,000 each lives in a ramshackle Kensington mews, and as soon as you try ringing at the front door it becomes quite obvious that the bell does not work. 'I do hope you haven't been waiting outside for ages', he says apologetically, opening the door in response to my knocking. 'I don't actually *want* the bell to work, because if I did, I'd have to see all sorts of terrible people I don't want to see at all.'

Inside, the surroundings are hardly less makeshift. A steep flight of wooden steps – 'rather like a ship, isn't it?' – leads up to a surprisingly small, shabby studio, its walls covered in a flurry of random brushstrokes. Canvases are stacked up everywhere, confining the potential working space even more drastically, and the windows are blocked out, leaving what little light there is to filter in through the skylight alone. How can those large triptychs possibly be executed in such a cramped environment? 'Well, I know it seems strange,' Bacon admits, puzzling almost at the perversity of his own requirements, 'but I've tried painting in a larger studio and it just doesn't work.'

Across the passage, likewise, the scene is one of disorder rather than luxury. A huge mirror leans against one wall, its glass severed by a dramatic crack; William Blake's life-mask sits palely on a desk-top; and an accumulated debris of art books lies scattered over every available surface. The whole flat could only be inhabited by a man whose inner, imaginative life was so absorbing that external details scarcely mattered. And this impression was confirmed immediately I started interviewing Bacon, for it became apparent at once that the usual social props

attendant upon any first meeting – small talk, the banter that establishes a preliminary rapport – simply were not needed. So central are the problems of making art to Bacon's existence that he was ready to discuss them without any prompting on my part. 'People tend to think of me as an Expressionist, because they think they see violence and horror in my work, but it isn't true,' he says, leaning forward across a bare wooden table with an urgency that can only come from a strong desire to converse and share views. 'What I'm after is a *seizure* of life: I want to get hold of the immediacy which illustrational painting misses, and so I am forced to explore the irrational, the subconscious, accidents.'

Bacon rejects abstraction, for it seems to him to avoid this fundamental subject-matter altogether. 'Abstract art automatically deteriorates into decoration,' he insists. 'I've looked at it all, and none of it goes deep enough – even the Cubists are in a sense nothing more than a decoration on Cézanne.' But this does not mean that he retreats to the other end of the painter's spectrum and embraces representation. 'Most figuration is so intensely boring because it merely catches the surface of things: I aim to make an image which both contains the outward appearance and at the same time unlocks valves of sensation. So you see, whatever the motif, I can only ever start off with a series of abstract marks and try to finish up bringing it back somehow to a figurative image. If I could throw a lump of paint at the canvas which would resolve itself into an image, that would be marvellous. But I can't, and so I struggle with the alternatives, all of which are illogical and perhaps impossible to achieve.'

While he is talking, one is aware the whole time of the physical passion behind Bacon's words. When he says he wants to 'make things as *raw* as possible', his arms shoot out in front of him so that both hands can stretch up and clutch the meaning he is attempting to convey. Sometimes, the bodily gestures are a substitute for verbal coherence, as he becomes overwhelmed by the complexity of his theme and lapses into silence. But more often than not, the fists are clenched at the exact moment when he says that he wants 'to paint a nose with all the violence of a real nose', and the combination of speech and movement immediately gives a vivid insight into the motivation behind all those exclamatory pictures. You realise, all of a sudden, that Bacon is not being fanciful when he disclaims the elements of anger that most spectators see in his work. To him, disturbing and distorted forms are no more than the inevitable outcome of his own peculiarly intense and dramatic vision of life.

It is a complicated, highly ambivalent vision, which enables him on the one hand to say with complete conviction that 'I'm essentially optimistic, always grateful when I wake up each morning and discover I'm

120. Francis Bacon in his studio at Reece Mews, London, 1970

alive', and on the other hand to declare, without a hint of morbidity, that 'even when one is in a strong sun, casting a black shadow, death is always with you'. Putting it another way, Bacon claims that although he doesn't 'consciously look for violence', he does suspect that he hasn't got 'as many veils as most people have screening them off from life. Every time I enter a butcher's shop I am made aware of the violence which custom protects us from.' He is at pains to reject the accusations of Grand Guignol that such a remark often elicits, and writes off the celebrated series of screaming popes as an outright failure. 'I know they never came off,' he admits, calmly and without regret. 'Making them scream was melodramatic, I can see that now, even though at the time I wanted above all to paint a mouth with the beauty of a Monet.'

The statement highlights the gap separating Bacon's own intentions from the response accorded to his paintings by the public – a gap perhaps aggravated by the fact that 'I start off with a very definite idea of what I'm going to do on the canvas, but it always finishes up very differently in the end.' The unpredictable nature of his working methods means that Bacon is playing with fire when he paints, invariably ending up with a picture which disappoints him so greatly that it has to be destroyed. 'Painting touches on the nervous system in a way that the other media cannot do,' he insists. 'It *traps* life in a particularly tangible, physical fashion.' But when the pictorial electricity he seeks in his art runs out of control, then the misunderstandings begin. Bacon is the first to admit the high failure rate in his work, and this helps to account for the rough handling he has usually received from the critics. Despite his immense international stature, greater now than ever before, he remembers recently 'looking through all the reviews I've had from my Marlborough shows over the years and realizing that all of them, virtually without exception, were bad.'

He told me this without the slightest trace of concern, for Bacon must by now be used to his position as a lonely outsider, running completely against the mainstream development of modern art. Where other artists dispense with representation, and along with it the entire convention of the easel painting, he stubbornly clings to the great tradition of past European art. Velázquez and Rembrandt feature more largely in his conversation than any contemporary figure. He seems enormously knowledgeable about the whole history of art, and is extremely critical of most current developments. 'Young artists today think that choosing a new medium is the answer,' he says, 'but it usually turns out to be a *substitute* for creation rather than the thing itself. Everyone wants something new, including me, but of course it won't *be* new unless you have the compost

of the past as well. The past nourishes you, and denying that source of nourishment is like cutting off one arm to make the other better. I've never felt the need to reject the past. I feel I relate to tradition very strongly. But I won't ever know whether I'm really any good because it takes such a long time for things to fall into place. And there's no point in worrying about what you feel you *ought* to be doing in terms of the historical evolution of art, either. You can only do what your impulses demand, and that doesn't mean I see myself as the last of a line. The possibilities of oil painting are only just beginning to be exploited: the potential is enormous.'

For Bacon, the future seems to lie in an even more intense examination of his own inner emotions. 'Painting is like telling the story of your life', he says. 'When you look at a Velázquez portrait you don't think about Philip IV – you think about the painter's own thoughts and feelings, and this is what concerns me more and more.' So much so, in fact, that Bacon is at present planning the most sustained and ambitious project of his entire career. 'After the Paris show I'm going to deliberately set about painting an autobiography', he said. 'Someone offered me a lot of money once to write the story of my life, and I refused: what's the point, unless you are Proust? But painting is quite another matter, and I can remember the progression of my life very clearly from a very young age.'

How would such a scheme fit in with the kind of pictures that are associated with Bacon? He gave the answer himself when he told me about his memory as a four-year-old of 'walking up and down a pathway lined with cypresses at my Irish home, dressed in a bicycling cape which I used to borrow from my brother.' The image makes sense instantly: it could have come straight out of a Bacon painting, and it probably will if he manages to fulfil his project. 'I hope to crystallise time through this series in the way that Proust did with his novels,' he said. 'It's the most rewarding thing I could possibly do, and it'll probably absorb my energies right up until the end. The autobiography will only end when I myself die.'

GALLERIES AND ALTERNATIVE SPACES

THE STATE OF THE TATE
March 1969

Sir John Everett Millais, Bart., President of the Royal Academy, stands with full Victorian assurance outside the Tate Gallery, his bronze face streaked with successive layers of bird-lime. Usually a pigeon is there too, perched on the knight's noble curls, looking for all the world as if it had just laid an egg and broken it, streaming, on the Olympian features beneath. The symbolism is ready-made; before the Tate has even been entered the visitor smiles at this bathetic statue, its absurdity an apt preparation for the greater madness that lies beyond Sidney Smith's redoubtable façade.

Is it a gallery, or a charnel house? Where else outside Madame Tussaud's could you find, crammed into one narrow arcaded corridor, the marble rhetoric of Rodin's *The Kiss* confronting Bryan Wynter's rotating kinetic construction? The machine moves round, its winking lights failing entirely to warm the frigid flesh of those poor shivering lovers. What other country would be content to let an unparalleled bequest by its finest painter languish in a setting that would disgrace a fifth-rate provincial gallery? The Turner rooms have in fact recently been 'improved' – which means some pitiful budget has allowed white net curtains to be stretched over them. They lower the height of the original ceiling, marginally increase the light, and look patently ridiculous.

The catalogue of folly is endless. Monumental Moore bronzes that can only come alive in a sweeping landscape have been crowded into clinical rooms; and conversely, a bright yellow Caro that cries out to be stepped into, around, over, across – this too is duly snuffed out in a corner. Everything, from an heraldic Tudor full-length to a brazen diagram by Stella, suffers in rooms built to house Alma-Tademas. Whether or not the good Sir Lawrence's sweetmeats ever fitted these surroundings is now impossible to judge. They have been shut away for decades now, gathering dust alongside the major part of the Tate's holdings in the basement.

Down there, the desolation is total. An effort has been made to hang the things on racks that can be trundled out for the inquisitive student. But at some point, clearly, the flood of unwanted canvases became unmanageable: now they lie around, propped up against the walls three or four deep. Some have been draped with polythene so that they are virtually invisible; others are hidden by glass fronts smeared with accumulated grime. Beneath the dirt lurk marvellous images – a Turner sun setting over Petworth lake, some Bomberg figures trampling in a

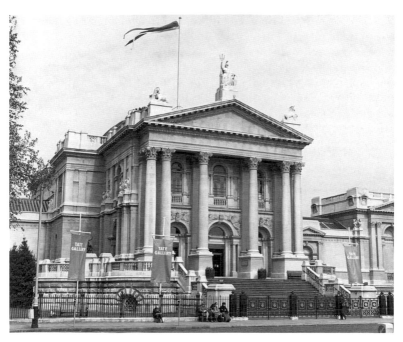

121. The Tate Gallery, London, in the 1970s

Vorticist mud-bath. Here absurdity loses all traces of the humour it provoked upstairs. In the gallery itself the exhibits are at least being seen – they are hung, they are on view. But in the store even the scholar has to make a special appointment a week in advance before he can glimpse the works he wants. And he has to specify them, on a list: nothing can be discovered or revalued on a chance ramble. Well over half the Tate's collection is just piling up here, despite the Director's claim that a policy of rotation is now operating. Some, doubtless, come and go, but there remains a hard core of unwanted and unloved paintings and sculpture that might as well have been destroyed for all the use they are put to. These Forgotten Victorians and Ageing Young Contemporaries are the dropouts of the art world; for just as society packs its unwanted old people away into homes, so the paternal Tate trustees decree that these particular artists are not worthy of the public's attention.

Such incongruities are all part of the schizophrenia inherent in the overall function of the Tate – it houses British painting and modern foreign art under one bursting roof. The present building was never

designed for such a purpose, and this dual role should not be regarded as anything more than a regrettable folly. Now that the trustees smell a meagre government grant in the air, they all too understandably snatch at it and produce a compromise plan which perpetuates the present system. A few more rooms have been proposed, a restaurant with a view of the Thames, and a real solution set aside for a decade when once again the Tate will have to admit that most of its possessions are hidden from view. We will be back where we started, and lumbered with a faceless modern addition in place of the quirkily individual portico that is so much a part of the character of Millbank. Far better to be realistic now, and admit that the Tate as it stands could – with a largely remodelled interior – serve admirably as a national gallery for British art.

In imaginative hands, the whole concept of displaying paintings would be transformed. Each picture could be accorded the space due to it, instead of being crushed up against its neighbour. The Tudor galleries, for instance, ought to be displayed along the lines of the inventive 'Long Gallery' at Stratford's Shakespeare Quatercentenary Exhibition. There, set in their context with the judicious use of hangings, furniture and other period accessories, those handsome patterned effigies looked ravishing. If the Tate adopted such methods, visitors would enjoy the exhibits for their own sake, rather than view them out of a sense of historical curiosity. The same applies to other periods of English painting. What could not be made from a really cunning arrangement of Hogarths, properly lit, spaced out and without those sheets of glass that reveal nothing except the spectator staring anxiously at his own murky reflection? A roomful of choice Gainsboroughs would provide a truly seductive experience. The Jeu de Paume in Paris has the right idea: each painter is given a room on his own, so that in the *Salle Cézanne* it is possible to soak yourself in the personality of one man, and one only. It is the very least a great artist deserves, no more than his due as a profoundly individual personality. Stubbs' work, for instance, proved to be a revelation when hung *en masse* and alone in the Mellon exhibition at the Royal Academy. Instead of being yet another English horse-painter, he asserted himself as a deeply original and exciting artist in his own right.

As for twentieth-century art, there is only one conceivable solution and it has been obvious for years: select a central site and build. An architectural competition should be held for the design of the new gallery, and one chosen which is both individual in itself and as flexible as possible. No one can tell what form the art of the future will take, what size it will be, how it will have to be displayed. On this count alone the trustees are crazy to think that their few extra galleries could possibly do

justice to the rapidly changing character of contemporary art. In order to justify the enormous amount of money expended on it, the new building will have to be large enough and adaptable enough to take on the most megalomaniac 'environment' imaginable. It must also be a striking example of contemporary architecture, so that it can inspire in itself and take its place as a vital part of the modern movement exhibited inside its walls.

Centralised institutions should not be decried *per se*. London is the capital city, millions of people live there and they must have the facilities their numbers deserve. Artists always need a focal point, a favourable shelter which understands what they are trying to do, buys their work and helps them in the least dictatorial way possible. The building ought not to be a dauntingly labelled 'Museum of Modern Art' so much as a workshop like the ICA, with plenty of social facilities and a totally unstuffy atmosphere. If we cannot treat the art of the past as something living and enjoyable, at least we could with our own century put an end to the mentality which treats Matisse or Bonnard as if they were part of some infinitely complex exam syllabus.

'Be realistic,' cry the trustees, 'idealism is all very well, but where do we get the money from?' It is up to us. If we want the facilities badly enough, we will find the means. It is as simple as that. An appeal fund could be launched in the press and on television, industries and foundations approached, and a nationwide lottery instituted. All this may not succeed, but unless it is attempted no one will know if we care or not. Until then, Sir John's smeared face will continue to serve as an eloquent visual image of a national disgrace.

UNITY AND MEANING AT KETTLE'S YARD
11 February 1971

In one of those off-the-cuff episodes of iconoclastic high spirits at which Godard used to be so skilled, Anna Karina and a couple of teenage friends run through the entire Louvre in about two minutes flat. The contrast between their freewheeling zaniness and the dozy impassivity of the guards is hilarious. Pitched against the superhuman proportions of the Grand Galerie they look like diminutive puppets, determined to deflate the pomposity of the architecture lording it over them.

And fair game, too, for museums are still one of the last diehard strongholds of Public Dignity. Exactly why remains a mystery: the dull solemnity with which nations automatically show off their accumulated loot to each other may be taken for granted, but it perplexes nevertheless. A defence could, indeed, have been mounted for the man who stole Goya's *Duke of Wellington* by maintaining that he had been in the National Gallery for a whole day and the stifling boredom had affected his brain. He ought to have pleaded victim of circumstances, for you *are* victimised in galleries: the only feasible way to conquer the vast acreage of the British Museum is to climb on a bicycle and pedal for your life. Wheelchairs would be the ideal antidote for the inevitable exhaustion, of course, preferably equipped with a sound-proof hood inside which you could be as outspoken as you wished without fear of ruffling the hallowed silence all around. It seems absurd that these aesthetic emporia, erected to display some of the most exciting artefacts ever created, should make an uninhibited response by the spectator appear impossibly indiscreet. In such an atmosphere, even a sneeze assumes the dimensions of a *faux pas*.

But it is not really wheelchairs that are needed: rather a complete reappraisal of the environment within which pictures can best be appreciated. Previous centuries dodged the problem altogether by equating an art gallery with a cathedral. Their obsessively multi-tiered hanging was presumably designed to give visitors the same feeling of awed veneration that a Gothic vault inspires, and merely to modify the same tradition today is senseless. A great picture is perfectly capable of exerting its own unique appeal, and ought ideally to be set apart from its neighbours rather than hung with them in a uniform row of visual monotony. Most museums' holdings, after all, have nothing in common apart from the fluke of acquisitive fate that brought them into the same depository. Strung out along the walls of interminable rooms, they seem in their crowded haphazardness to celebrate nothing more exalted than chauvinistic pride, and make the public associate the whole idea of art with a peculiarly confused sense of ennui.

To do justice to a good painting or sculpture requires at least a quarter-of-an-hour's intensive scrutiny – which is no more than would normally be accorded to the reading of a poem. Now this is difficult. There are the distractions of other exhibits waiting to be seen, as opposed to the single-minded attention that a book can be given in an armchair; and we are simply not trained in the art of looking as we are in the art of reading. Although we ought to be. The majority of people find it congenitally impossible to survey a picture for more than a couple of minutes:

they become restless and their eyes glaze over or wander elsewhere. Surely the least a gallery can do is to help focus the attention by segregating each item, creating an individual space around it that will emphasize its singularity. A quattrocento predella panel requires a totally different presentation from a baroque altarpiece, and the only way to do them both justice is to break up the deadness of 'museum rooms' into an infinitely varied series of particularised areas.

Hanging a work of art clumsily is tantamount to publishing a novel with half the pages missing. It is not enough to buy, preserve and document them in a scholarly fashion: they were made to be enjoyed, and enjoying them entails seeing them clearly, singly and in the appropriate setting. This is the ultimate *raison d'être* for any gallery, and if its possessions are displayed as historical phenomena or barely visible curios that only school parties would think of trailing around, then we might as well pack in all the talk about culture. But if art means as much to us as we profess it does, we must insist that this heritage is shown off with as much flair and thought as is lavished on the performance of a symphony. The Barber Institute in Birmingham creates miracles of concentration simply by dividing its rooms up into bays of three pictures, and sophisticated display techniques could do more, far more.

Now this has its concomitant dangers: some people might find a very personalised presentation misjudged. The undeniably imaginative way in which Milan now exhibits Michelangelo's *Rondanini Pietà* arouses by its very daring as much resentment as it does admiration. Works of art are all too easily dwarfed or distorted in some way by unconventional hanging, and a large picture which can only be seen close-to may be irretrievably blunted when hung inside a house where the rooms are too confined. But at least private collections have been assembled with some notion behind them of why art is worth creating and preserving at all. In museums, such a motive is often hard to discover.

The lesson is driven home at Cambridge University's new modern art gallery in Kettle's Yard, where the ethos of a vast mausoleum has been successfully replaced by the inviting ambience of a private house. Preserved in the surroundings created by its curator and former owner, Jim Ede, the collection's domestic informality draws enthusiasm from undergraduates who would never dream of sampling the more orthodox pleasures of the Fitzwilliam Museum. Every afternoon Ede delights in admitting the most committed philistines into his fastidious world, where matchbox-size Ben Nicholson reliefs rub shoulders with polished seashells and even a light-switch takes on the status of a sculpture, its inner workings laid bare by a glass front.

122. Brancusi bronze on the piano at Kettle's Yard, Cambridge

Those who find the bleached elegance of Kettle's Yard uncongenial would doubtless argue that they prefer the neutrality of our national picture warehouses, where no idiosyncratic taste has been allowed to interfere with their appreciation of the work itself. But even they would have to admit that Ede's brainchild has a shaping intelligence, a unity and a meaning which the grandly comprehensive parade cannot hope to emulate.

The prevailing sensibility at his house belongs to England in the thirties, and the pale delicacy of Christopher Wood, David Jones or the Cornish primitive Alfred Wallis is perfectly matched by the furniture, flowers, found objects and incidental hangings scattered in among them. The ensemble makes sense: it adds up to a coherent testimony to a way of life which regards art as an integral part of everyday existence. An imperturbable Brancusi head lies sleeping on the piano; a cheeky little Miró hangs as casually as a postcard near the fireplace; and a marvellously energetic Gaudier-Brzeska flaunts its mastery on top of a tree-trunk. Everything corresponds, in the house as in the extension which Sir Leslie Martin recently designed next door. Only money is now lacking, to the tune of £150,000, and anyone who hungers after viable alternatives to the museum malaise will want to contribute towards the future continuation of the Kettle's Yard achievement.

No collection as restricted as Ede's can afford to rest on its laurels. But how can this cache be expanded without losing its present character and degenerating into just the kind of monolithic hoard which I have been at pains to denigrate? Ede plans to keep his own arrangement intact, and expand from this nucleus. Fine, if only it could be believed that the money either for further acquisitions or even for the housing of possible gifts would be forthcoming. At the moment it patently is not. The university prides itself on its Fitzwilliam treasures, but gives precious little money for the new galleries so urgently needed for their proper presentation. It does not even acknowledge the interest that undergraduates have in the visual arts. Only a slight push is needed for hundreds of them to revive the delight they once knew in making pottery or sketching at school. The requisite materials ought to be as accessible as the sports grounds and training facilities that litter the town.

Oxford provides this service, and quite rightly regards it as no more than duty in a university worthy of the name. At present, the only concession Cambridge makes to modern art is to rear an admirable succession of architectural monuments to its own magnificence. The enlightenment that the standard of design in these new colleges would suggest is entirely spurious; a more accurate reflection of Cambridge's attitude to living art would be a thoroughly parsimonious series of neo-Gothic toilets.

This is why Kettle's Yard is so desperately important. If only it could be made clear that this project will not turn out to be just another boring millstone of a gallery, then an enormous number of undergraduates would give it their support. If only the emphasis of this appeal fund could be resolutely laid on the active, participatory role to be played. A modern art gallery in Cambridge should base itself not just around a collection of works of art, but also the studio facilities to which anyone can go at any time of the day or night in order to make something. If Kettle's Yard were to become a centre where people could shout about Gaudier as well as murmur politely, could sit down and draw him, could carve their own idea of a sculpture – then, visual awareness would spread among the student population with the same rapidity as drugs, suicides or unintentional pregnancies. They deserve to be relegated to the crushing obscurity of a museum; art very definitely does not.

CONFRONTING THE GALLERY NETWORK
21 October 1971

As a dissatisfaction with the traditional media of painting and sculpture grows more widespread among younger artists, so their impatience with the whole commercial system hardens into outright antagonism. The hostility assumes many different forms. Some see no connection whatsoever between the direction their work is taking and the confines of a normal exhibition space: they operate on too large a scale, perhaps, or else concentrate their attention on a landscape environment that has nothing to do with the enclosed urban artifice of a dealer's room. These objections are real enough, but the deepest and most irreconcileable dissent occurs with artists who reject the entire object/spectator relationship perpetuated by a gallery context. For them, the exhibition convention militates against the possibility of dismantling the barriers separating art from its potential audience. Not only does it create an automatic rift between exhibit and viewer; it also implies the need for a self-sufficient artefact, which is precisely what many artists now want to break away from. And on another level altogether, the intervention of a dealer can drastically affect the character of his protégé's work, changing him from a free agent into little more than a slave. How many times have we witnessed the emergence of a major talent who formulates something new and individual only to be encouraged by dealer and collectors alike to regurgitate this one recognizable statement for the rest of his life? Once a small slice of personal territory has been allotted to one artist, indelibly associated by the art establishment with his name, it requires a formidable amount of creative stamina to avoid remaining safely within this neat strait-jacket.

It is against such a limiting and oppressive background that Martin Maloney's work should be viewed. For he expends most of his energies on an attempt to fight our gallery-oriented system in an openly aggressive way. Five years ago, his first one-man show of paintings in New York made him realise how constraining the exhibition format had become, and ever since then he has cast around for a viable alternative. Land art seemed to supply the solution for a while, existing as it does outside the usual commercial framework; but he soon grew uneasy about the loss of communication which this activity engendered. The work only existed in one private, relatively unattainable place, and any attempt to share the piece by displaying a photographic record within an exhibition seemed to bastardise his original intention. Ultimately, Maloney decided that it

was no good bypassing the public, or presenting them with a pale shadow of his experiments. And yet his hatred of the existing channels through which an artist has to pass in order to reach an audience increased as well. How could he avoid on the one hand the dangers of the narrow, voracious art world, and on the other the absurd isolation of his existence outside?

An answer began to be formulated earlier this year, when a Brussels dealer allowed Maloney to shut himself away inside a gallery for a week, cut off from everybody save at mealtimes, and work on a book of poetic statements published after the 'exhibition' finished. It was a solution of sorts, in that the stalemate produced by a conventional show had been evaded and the public made aware of his true intentions in a carefully considered series of messages sent out through the post. But it still did not come to grips with the central dilemma posed by the gallery set-up, and the offer of another space at the Lisson Gallery in London prompted him to tackle the problem along another, more direct avenue. This time, he was determined to stake everything on the act of communication itself, and yet nothing was resolved in his mind beyond this idea of intercourse when his occupation of the Lisson began. A printed poster had been issued, cast in the form of ten phrases which played around with the basic concept in an elusive, contradictory manner: 'one to one', it starts, then becomes 'three two one', and later still 'one through one'.

No equivocation, however, accompanied his other decision — to remain on the gallery premises all the time, ready to confront each visitor and argue with them, so that the verbal medium of the poster would be supplemented by the physical presence of his own body. He aimed above all at bringing the public face to face with the question of contact, thereby cutting across the intermediary obstacles inevitably set up by a gallery context. And he succeeded, too, up to a point; dialogue was exchanged, participation did occur. But only partially. After a while, even the most sympathetic visitor tended to withdraw his response, discouraged by the disturbing lack of a frame of reference.

And so Maloney fell back on words once again, painting the walls of the basement room black and chalking up a number of statements which would help to provide the missing guideline. Some of them were deliberately provocative, scrawled like graffiti to spark off an instantaneous reaction; and others, written alongside, were sober and reflective summaries of his ambitions. Reading them, from one wall over to the next, is akin to sharing a train of thought, and in that sense they bring the spectator closer to the workings of the artist's own mind than would have been possible in a more traditional exhibition. Upstairs, a dedicatory photograph of

**INTERCOURSE
A PUBLIC PLACE
A PRIVATE SPACE
ONE PART OF A TWO
PART PIECE
THIS FORMING
FOR EMMY HENNINGS
WITH WHOM NIGHT
AFTER NIGHT AFTER
NIGHT**

MARTIN MALONEY

FROM 6th OCTOBER
WITHIN AND WITHOUT LISSON GALLERY
57 LISSON STREET, LONDON, N.W.1 01-262 1539
OPEN 11 A.M.—7 P.M. CLOSED MONDAY

123. Martin Maloney's invitation card to his
show at Lisson Gallery, London, 1971

the Dada poet Emmy Hennings gives a further clue to his intentions, for
she used to read her poems at the Cabaret Voltaire in Zurich with such
inflammatory passion that the audience was shocked into responding.
Maloney likewise wants to startle and hurl polemics: he often sends bit-
terly hostile messages to the galleries he hates most of all. But in terms of
the Lisson project, he is trying to jolt people into thinking about the dis-
advantages of the gallery as a conveyor-belt for art, the difficulty of saying
something new within such a context, and the need to move away from
neatly framed objects hung on a wall towards a more immediate form of
communication. The method he has chosen is messy, confused and unde-
fined, to be sure. But making mistakes is a part of the overall intention, and
during the past few weeks Maloney has sometimes cancelled out a partic-
ular chalk statement after one of his visitors raised a valid objection.

Working with the spectator and sharing his difficulties is for Maloney
a more important priority than the production of a refined artefact – or

rather, it *should* be. I think the main reason why he has attained only half a success at the Lisson is because of an unresolved conflict between these two polarities: the raw energy of Life, and the structural control of Art. The neatly inscribed and numbered sentences on the basement's fourth wall show his need for this structure, and point to a lack of conviction in his enactment of the whole 'exhibition'. For all their aggression, his printed works reveal a sensitive, almost lyrical temperament, strangely at odds with the man who wants to attack and subvert. It is as if he attaches so much value to the creation of a poetic book that the live action of his presence within the gallery is not as intense as it could be. But then, Maloney would be the first to admit the disparity, and it hardly matters: he has managed to become a catalyst for change, provoking his audience and fighting the system on its own ground. That, surely, is achievement enough.

THE WHITECHAPEL'S FUTURE
27 January 1972

The arrival of a full-scale Leon Kossoff exhibition at the Whitechapel Art Gallery, which has been faced with possible closure for many months now, prompts me to consider what role such an institution could play in the future. For one thing at least is clear: the Whitechapel *can* continue to function, albeit with funds considerably more modest than its last director – Mark Glazebrook – thought necessary. Not that shortage of cash was the only reason why he resigned. Another, equally complex question centred on the very identity of the gallery itself, caught uneasily between the greater resources of nationally subsidised institutions on the one hand and powerful commercial dealers on the other.

A short answer is, of course, that the Whitechapel has no preordained part to play in the dissemination and promotion of contemporary art. A uniquely independent constitution ensures that it becomes whatever its director wants it to be: and, under the ebullient leadership of Bryan Robertson, it managed for many years to mount trail-blazing shows which were instrumental in dragging English artists out of their post-war provincialism. Not only did the Whitechapel give London its first real introduction to Pollock, Rothko, Kline, Rauschenberg and Johns – it also fostered the growth of a whole new generation of home-grown talents

who were aware from the outset of avant-garde developments on an international level. For more than a decade Robertson made his gallery into a prime source for everything provocative and challenging, while simultaneously managing to persuade his cumbersome board of trustees that the Whitechapel's duty to the local East End community was not entirely neglected.

But by the time he left in 1968, this sense of consistent excitement had dwindled. The formation of conceptual art was taking place elsewhere, quietly usurping the overwhelming dominance of American painting and British sculpture; and Robertson had neither the impetus nor the inclination to start all over again with a fresh movement. Besides, the wind was also being taken out of his once full-blown sails by the Tate and the Hayward Galleries, both wealthier organizations and determined to stage the kind of prestigious blockbusters which had previously made the Whitechapel famous. And so Glazebrook, his successor, found himself saddled with a dilemma: how to steer a middle course between these new giants and private galleries like the Lisson, Situation and Nigel Greenwood, who were prepared to experiment with the most controversial younger artists.

His solutions were fragmentary and inconclusive; and they were accompanied by an increasingly rebellious chorus of dissent from local borough councils which helped to finance the Whitechapel and felt that their needs were being overlooked. But however unsatisfactory Glazebrook's brief reign may be judged, some positive points of departure for the future can be selected from his exhibition programme. The retrospective surveys of Hockney, the Martins, Jack Smith and now Kossoff represent one kind of valuable and relatively inexpensive contribution: airing the work of artists in mid-career, who might not otherwise receive any chance to reveal their progress in central London. Such exhibitions might lack the magnetic appeal of artists who are breaking through to new definitions and more contentious conclusions about the nature of their own activity. Yet a healthy artistic community must always provide room for those who have, inevitably, gone past the period when their art exerted its most potent influence on the sensibilities of contemporaries. It is simply not good enough to let the spoilt darlings have their definitive fling at Millbank or South Bank and leave humbler spirits to the vagaries of a dealer's whim. They must be accorded their share of space as well, and so also must the distressing number of package shows from abroad which cannot be slotted in to Arts Council or Tate schedules.

The outstanding example here was the Don Judd exhibition, which came over ready-made from Eindhoven in 1970 and gave us one of the

124. Leon Kossoff, *Portrait of Rosemary Peto, No. 1*, 1971

most deeply satisfying experiences of the year. It cannot be stressed too often that the Whitechapel's principal room remains the finest display area in the city, providing an unlikely blend of monumentality and warmth which the aggressive pyrotechnics of the Hayward so conspicuously lack. While the one invites, the other bullies: space at the Whitechapel becomes

a source of expansion and relief, whereas at the Hayward it is used as a threat, an arid desert which paradoxically clamps down on everything placed within its clinical walls. Judd's unswerving feeling for volume was allowed to assert itself freely and without clutter or fuss; and at the moment Kossoff's far more turbid anxiety can be seen as if for the first time inside this chamber of calmness and light, where the furrowed ridges of his piled-up pigment are used to embody a genuinely haunted vision of life. For this reason alone, the Whitechapel should always be regarded as a space which any artist is privileged to find at his disposal, and it ought never to be forced to put aside these superb exhibiting qualities in favour of a more educational or purely administrative role.

I have, however, purposely left until last the most vital of all the Whitechapel's possible functions: an open house for those young artists who are at present greeted with far more enthusiasm and opportunities abroad than they are over here. England has for too long threatened to retreat back towards the narrow and timid insularity which Robertson attempted to combat when he first took over at the gallery. Dealers, critics and public alike are woefully unwilling to admit that the most original developments in art today have largely been allowed to flourish elsewhere, unseen and unsung by a nation bent on cherishing the recent past rather than admitting that each succeeding year brings work which continually attempts to upset prevailing aesthetics.

We desperately need to be fully exposed to these new forces, to have information on them readily available so that their true value can begin to be assessed. A start has been made by a handful of private dealers, and they will hopefully grow in numbers and resources soon. But the Whitechapel has already proved, with exhibitions by Roelof Louw, Gilbert & George and Richard Long, that it has precisely the right facilities for this kind of work. And not just in terms of gallery space, either. The next director should be in an ideal position to befriend these artists and display them with a flexibility of movement and programme planning denied those in control of our national institutions. He is answerable neither to the Government nor to the demands of a commercial enterprise; and he must turn that advantage to the most courageous account if the Whitechapel is to help shape the 1970s with the same verve it employed a decade ago.

ART ON A BILLBOARD
18 February 1972

Ever since artists began to make images that approached, in their view, a state of total abstraction, confusion has arisen over the extent to which they actually did escape from old forms of illusion. Paintings or sculpture ostensibly referring to nothing outside the reality of their own internal structure became rather less autonomous once the preliminary shock of novelty had worn off. Kandinsky's first brave, non-figurative works are now seen to be riddled with landscape overtones; Mondrian's ruthless grids can be interpreted today as mystical symbols of his feelings about the universal order underlying everything; and even Stella, who insisted on his independence from any external representation, is besotted with evocations of targets, mazes or archways. However hard they try to purify their work of these allusive meanings, implications that do not spring directly from the visual experience offered by the artefacts themselves crowd in. And museums, which inevitably end up housing the finest examples of all such attempts to free art from its descriptive bondage, add another kind of obstacle. Their hallowed context bestows a respectability and security on the exhibits, sealing them off still further from their original, subversive purposes.

This is the formidable problem which the French artist Daniel Buren has spent the last few years trying to counteract. He is airing his work in London this week, sponsored by the Jack Wendler Gallery, and the chosen location – a billboard situated at 59 Shaftesbury Avenue – goes a long way towards explaining the precise nature of his attitude. For Buren wishes to avoid the cultural stigma that every normal exhibition outlet automatically forces on the art it displays. The current selection of a 20 ft by 10 ft hoarding, which juxtaposes his 'poster' with an enormous advertisement of a Haig whisky bottle, is therefore not intended as a specific comment on commercialism in art. Or rather, only by the way. It should properly be seen as the latest variation in a whole series of previous experiments with alternative sitings: all over the streets of Paris, outside and inside the windows of a Stockholm gallery, and across the entrance doors of a gallery in Milan, thereby preventing would-be visitors from sheltering inside their habitual aesthetic temples.

In other words, Buren wants to liberate his work from all the usual ways art is raised to the status of mythology. And the apparent indifference he shows to the question of location serves to highlight the unchanging character of the work itself. For the Shaftesbury Avenue

125. Daniel Buren's billboard stripes in Shaftesbury Avenue, London, 1972

design is restricted to the same unwavering progression of vertical stripes, each measuring 8.7 centimetres in width, which has been the format assumed by all his other work over the last seven years. Just as he denies his images any finalised outward appearance by constantly ringing the changes on their size and public positioning, so he abolishes all trace of those traditional qualities art is supposed to consist of. Even the choice of a pale purple for the 35 stripes in the London piece was made by the printer rather than by Buren himself. He does not care about the intrinsic effect of purple: all that matters to him, in his effort to divest the work of those qualities leading to illusionism and irrelevant meanings, is that an attachment to one single colour should be avoided. And so, for every successive experiment, different colours are employed without any order of preference. Even the attractive hue used on the Shaftesbury Avenue site is – to use Buren's own words - stripped of 'all emotional or anecdotal import'.

But the most powerful weapon in his battle to bring the spectator's whole attention to bear on the picture's visible facts remains the element of repetition. By endlessly reproducing an indentical series of vertical stripes, Buren is destroying any trace of the conventional inspiration or imaginative insight we have always demanded from art. He realises that if he ever created a unique, exclusive object, its very uniqueness would

immediately symbolise values which have to be abolished in his search for a particular kind of neutrality. The risks Buren willingly takes are enormous, of course: using banality as a deliberate weapon means that he leaves himself wide open to being branded a vulgar enemy of art. But brutal tactics are necessary if we are to be made aware of the picture as a truly self-contained entity. Gradually, as the sheer anonymity of these immutable stripes frustrates our appetite for all the normal aesthetic pleasures, our exhausted eyes are prepared to entertain the disturbing possibility that Buren is proposing a new type of art altogether. His stripes leave the spectator utterly alone, deprived not only of the diverting external references most other artefacts contain, but also of the formal qualities we have always been trained to look for.

The enormous poster now on view in Shaftesbury Avenue puts a stop to all that: it is an art object which attacks the basis of all art objects, a revolutionary theory that insists you measure up to a visual experience for its own sake. And the critic, confronted by subject-matter unconnected with anything outside itself, has finally to confess that all attempts to classify this disquieting presence in the normal manner are doomed. Only Buren's determination to confound our well-oiled ways of seeing triumphs in the end.

NEW ART AT THE TATE
9 March 1972

Up until now, living artists have only been granted exhibitions at the Tate Gallery when their achievements are safely canonised by history books and establishment opinion. Except for an isolated experiment with a young trio from Los Angeles some time ago, the emphasis has traditionally rested on the grand retrospective, a comprehensive parade usually undertaken towards the end of the subject's life. By then, most of the controversial bite has disappeared from the work on view: the visitor is encouraged to genuflect with a faintly detached form of reverence as yet another embalmed god is laid to rest within the Millbank Mausoleum. And although such ceremonies provide the critic with an ideal opportunity to summarise an idol's significance at a safe distance, it must be said that the whole activity smacks too unpleasantly of being wise after the event. There is a place for obituaries, of course: definitive judgements

can only begin to be made when a complete corpus, stretching right up to an artist's final years, is assembled. But any museum of modern art which restricts its exhibition programme *exclusively* to these funeral processions is failing to react in a positive manner towards current developments. It should, ideally, possess the space and initiative to organise an alternative programme as well – one that sets out to present, without any of the pomp attendant upon the retrospectives, a continuous survey of new work by far younger artists.

Now this need in no sense pre-empt or encroach on the preserves of the pitifully meagre number of private dealers who are prepared to support experimentation and unknown quantities. Most of them do not command the resources of a nationally subsidised institution, anyway; and if an artist is really worth looking at, we ought to welcome the chance of seeing him at the Tate as a supplement to his normal airing inside a private gallery. The museum would, inevitably, lay itself open to bitter accusations of favouritism and partisanship if this scheme were adopted. But the Tate runs that risk already with its necessarily invidious acquisitions policy, and its staff must by the very nature of their jobs be prepared to commit themselves to the work they respect with far more passion than the curators of historical collections. Only then can they play a truly vital role in the growth of contemporary art, and appease the anger of all those who claim that the Tate is nothing more than a repository for objects which have long since ceased to have any direct bearing on the concerns of today.

What, moreover, should it do about the ever-growing number of artists who no longer concern themselves with the creation of physically constructed paintings and sculpture, preferring instead to work with their own bodies, written statements, photographs or participatory events? The Tate cannot always support such people by purchasing a unique artefact and enshrining it in a permanent display area; but some way has to be found out of the present paralysed situation, whereby a vast cross-section of potent new activities are simply being ignored, bypassed in embarrassed silence or else actually rejected by the buying committee.

I would like to be able to report that the seven exhibitions now in progress at the Tate are the result of a deliberate attempt by the Gallery's decision-makers to atone for all their shortcomings in this direction. And yet the sad truth of the matter is that these shows, by six young British artists and one senior German visitor, only came about because another, extremely well-established painter decided to postpone the retrospective which had originally been planned for this selfsame period. Would Michael Compton, the organiser of the substitute offering, have been able to mount it under less extraordinary circumstances? I hope so,

because I want to see the Tate putting on a regularly staged series of sequels to the present venture. But I would be more optimistic about the likelihood of such a scheme if the present seven shows had been the first fruit of a genuine change of heart on the part of museum officials.

As it is, the haphazard nature of the enterprise, which mixes together a heterogeneous gaggle of individuals who have little or nothing to do with each other, bears all the marks of a hastily conceived in-filling operation. The choice of seven artists, as opposed to double or treble that number, would suggest that some kind of internal connection binds them all together. And yet no shared aims, apart from a generalised desire to avoid traditional media, links up Craig-Martin's playful use of mirror images with Law's sombre pictorial ambitions or Arnatt's alert verbal and photographic devices. This lack of thematic coherence would be understandable, even welcome, in a large mixed exhibition which consciously set out to cut across narrow allegiances. But it is disturbing to find a relatively small number of artists showing together without any real common denominator to justify their selection.

And Joseph Beuys, who paid a one-day visit to the gallery in order to propagate his political ideas through open discussion, stands utterly outside all the British participants. He came over from Germany specifically to conduct a marathon non-stop discussion on his belief in the interaction

126 Michael Craig-Martin, *Faces,* Tate Gallery, London, 1972

between the freedom of art and the freedom of the people to decide by direct vote the way in which any nation should be run. It was curious indeed to watch this intense, charismatic man exhorting his audience to exercise 'your constitutional rights by direct democratic pressure in the form of referenda' within the rarefied context of a modern art museum. His plea for 'popular control of the administration at all levels' seemed sublimely irrelevant when directed, not at the man in the street, but at a clique of art *cognoscenti* who had come along primarily to stare at a celebrated avant-garde personality at work.

Language difficulties made Beuys less persuasive as a talker than as a dramatic presence, and the whole event seemed concerned merely with an ingrown aesthetic Utopianism which bore no relation to the lives of those who would never even consider visiting an exhibition. The project became rather more pertinent at a second performance the following afternoon in the Whitechapel Art Gallery, where I found myself sitting next to ordinary passers-by who had obviously wandered in to the debate out of sheer curiosity. All the same, Beuys's enterprise would have carried more conviction if he had stayed in London for a month or more, spreading his message to a wider public rather than performing a star turn for the benefit of critics and artists alone.

The other three contributors to the Tate show have yet to appear: Tremlett is exhibiting there today and tomorrow, McLean is staging a one-day 'retrospective' on Saturday, and Fulton starts a twelve-day slide show on Sunday. They will all be worth visiting, and it is certainly heartening to see them exhibiting their work at a national museum. But if the Tate is really determined to grapple wholeheartedly with the problem of encouraging conceptual and post-object developments, it will have to think of this current show as a tentative beginning rather than a solitary, stop-gap end in itself.

CRITICAL CONDITIONING
15 June 1972

Although it would be humanly impossible for a critic to deliver an utterly detached and objective judgement on a work of art, it is still rather alarming to consider how many irrelevant factors could conceivably affect his appraisal of any exhibition he sees. There is, for one thing, a very

real danger that the physical fatigue induced by a large show may jade his responses, making him incapable of enjoying the artefacts on view. Then there are more personal barriers, like a severe headache or depression, which may cause him unknowingly to censure an artist for seeming dullness and sterility; or else a mood of euphoria might suddenly arrive, bathing everything around him in an aura of vitality and heightened significance. You don't have to possess an especially volatile temperament before such pressures become apparent, and it would be optimistic to suppose that the power exerted by a good work of art automatically cuts through a spectator's temporary physical or mental disposition.

It is, likewise, impossible to dismiss the effect which immediate surroundings might have on your opinion of an exhibition. Not only can poor display facilities compromise the appearance of the items on view: the character of the gallery itself might well be instrumental in determining a visitor's reaction to the objects it houses. Different kinds of institutions create their own particular expectations, after all. When you enter a gallery with a reputation for radicalism, such as the Whitechapel, you are probably braced for a sharper, more challenging experience than the altogether more familiar and predictable sensations which a Tate retrospective usually offers. A grandiose historical survey at the Royal Academy inevitably needs to be approached in a more vigorous spirit than a small water-colour exhibition held in an intimate setting. And a show organised by the artist himself in his studio arouses more initial sympathy than a selection of blue-chip Old Masters laid out like so many potential investments in some plush Bond Street venue.

It would of course be absurd to overstate the problem, and see the critic as a man whose judgement is positively assailed by elements which have nothing to do with the art under his scrutiny. Someone with strong feelings will carry round with him a whole host of prejudices anyway, and the most stimulating criticism often comes from the man who voices his partialities with one-sided intensity. But we would like to think, all the same, that even a patently biased observer roots his opinions in a close and rigorous examination of the work itself rather than a cloud of generalised preconceptions. The great critic is perhaps the writer who can play off particular reactions against broader beliefs with consistent flexibility, always reserving the right to be swayed by an entirely unforeseen encounter which might confound even his most deeply held convictions. It is all the more disturbing, therefore, to find this precarious balance of opposites upset by something lying wholly outside the quality of art alone.

Everyone has come up against that phenomenon, usually in surroundings so seductive that they induce a willing suspension of all the

critical faculties. The little chapel at Monterchi which contains Piero's pregnant Madonna, for instance, creates such a perfect environment for the painting that I remember capitulating to its beauty before I had studied it at all closely. And although I am no fanatical admirer of Tiepolo, the Villa Valmarana just outside Vicenza is set down in an intoxicating landscape which simply made me rejoice in his fresco cycle preserved on the villa's walls. To equate the choicest regions of Italy with Hyde Park may at first seem like pure bathos, and yet I do experience a similar kind of feeling whenever I visit the Arts Council's Serpentine Gallery there. It does not, obviously, offer anything like the same level of richness as Tuscany or the Veneto; but I nevertheless find myself predisposed to enjoy the exhibitions mounted in this converted tea-room regardless, almost, of their merits. And my readiness simply to receive pleasure from the Serpentine's shows does actually get in the way of any attempt to evaluate what I see inside its rooms.

Now this may have something to do with the fact that the gallery's policy is dedicated to airing young and relatively unknown artists who have never displayed their work in London before. Something, but not much. Other exhibitions in town are held by people in a similar position, and I do not make a point of extending unqualified charity to them as well. No, the answer is rather to be found in the whole ambience of the place. Far removed from the claustrophobic commercial circuit, and positioned against a backdrop of grass, trees and water, it appears to call for a change of pace. You stroll across lawns to reach it, past holiday crowds of children, sunbathers, or old people asleep on benches. And once inside, the gallery seems to be full of a catholic cross-section of the public, most of whom would never dream of entering a West End dealer's forbidding portals. They wander through here, treating the shows as one more hedonistic event in an afternoon full of boating, lazing or eating ice-cream; and their attitude, combined with the pastoral calm of the park and some of the most attractive exhibition rooms in London, does rub off on you.

A lot of the art displayed at the Serpentine, which aims to stage several diverse one-man shows at the same time, is necessarily second-rate. And it could not be otherwise: only a certain number of artists from any generation genuinely sustain interest. But there is still considerable satisfaction to be gained from seeing a lot of able and intelligent talents attempting to strike out a path for themselves through the thicket of alternative styles proliferating today. Other, privately run galleries are able to achieve far higher standards and a more single-minded view of the direction being taken by contemporary art, naturally. And yet there is

room for an institution that sets out to be a bran-tub, mixing together an assorted jumble of personalities within the framework of one exhibition. The results have such a congenial, democratic air that I find it hard to carp, even though the Serpentine's weakness for what can only be called fun art does not appeal to me at all.

At the moment, the gallery is half-way through an ambitiously conceived festival which will show no fewer than ten separate enterprises within the space of one month. Most of them centre on performances, invariably of a rather whimsical and eccentric character: the Bradford Art College Theatre Group, which inaugurated the festival with a satirical dramatization of *The Building of the Union Pacific Railway*, did not really rise above the level of a church-hall panto. Succeeding events, like Stuart Brisley's *You Know It Makes Sense*, were at once more serious and more powerful. But the prevailing tone of the month's activities has so far been dictated by a very English brand of nonsense humour, summed up in the current antics of four men known as the John Bull Puncture Repair Kit. In other circumstances, I probably would have found their jokes wear-

127. Stuart Brisley in performance at Serpentine Gallery, London, 1972

ing pretty thin; and yet the delighted reactions of the visitors, along with the beneficent atmosphere of the Serpentine as a whole, prompts me to recommend as many members of the public as possible to sample these bizarre, inconsequential happenings.

BROADENING ART'S AUDIENCE
6 September 1973

Until very recently, one of the great disgraces perpetrated by museums and galleries in this country was their almost total lack of interest in education. Apart from regular series of public lectures, which have for many years performed a valuable function in making people aware of their national heritage, astonishingly little thought was given to the problem of introducing the layman to the art objects he owns. Great paintings and sculptures, it was generally considered, should stand on their own merits, unhampered by any attempts to explain them or set them in appropriate surroundings. A widely prevalent feeling held that showmanship was rather vulgar, smacking of the market-place rather than the dignified – yes, and rarefied – regions that art rightfully inhabits. It could also be claimed that the chronic shortage of both space and money from which the British museum service has traditionally suffered likewise militated against an ambitious, outgoing educational policy.

But practical setbacks can be overcome, however modestly, if enough energy and determination is applied; and there are no defensible excuses for the miserable way in which curators all over the country neglected the whole question of courting the massive percentage of the population who still, even today, never dream of visiting their local or national galleries. Their apathetic and often downright hostile attitude surely constitutes a pressing challenge to all our museums. Now, as before, gallery officials are mainly recruited from men and women with academic backgrounds: people trained in art history and the importance of acquisitions or conservation but not in the techniques of the proselyte. Whereas an ideal museum system, which viewed itself as a dynamic instrument of social change and improvement, ought to consider education as a goal at least as vital as the amassing of bigger and better Rembrandts.

The situation is slowly beginning to improve, and yet the old prejudices still linger on with depressing obstinacy. Exhibitions are constantly

being mounted according to the highest and most exacting standards of scholarship, but with little or nothing included in their presentation to explain fundamentals to those unversed in the history of art. Display, preservation and lighting techniques are being improved all the time and yet no one does anything to help the beginner grasp the overall context, encourage him to realise how, why and when different schools, movements or individuals managed to flourish.

It is a difficult task, admittedly. Museums were built primarily to house unique and fragile works of art, and most of them simply do not have either the staff expertise or the wall-space to devote to explanatory texts, comparative photographic material or special installations which would help visitors understand that most altarpieces were painted for a very particular kind of environment, or that many large Renaissance paintings were executed with special public and private locations in mind. Besides, it can be convincingly argued that the clutter with which a well-meaning curator might surround his holdings could well detract from their essential impact, and that the best forms of presentation are always the simplest. But we will never know without experimenting, and mistakes can on many occasions point the way forward to inspired new solutions. Galleries are still, on the whole, far too stuffy and reserved; and while their hallowed dignity might appeal to the connoisseur, it too often acts as a repressive dampener on those who have always suspected museums of being the preserve of aesthetic snobbery.

How heartening it is, therefore, to walk through the Tate Gallery and discover, right next door to the first of the Turner rooms, a queue of excited, expectant children waiting to enter their own specially devised play area! From now until October 6 the Tate's unusually enterprising Education Department – which has tried over the past few years to find some thoughtful and provocative new avenues for the public to explore – has taken over a gallery normally occupied by the permanent collection and turned it into a participatory adventure for kids of primary-school age. They are the ones, of course, who tend to get left out of attempts to suggest fresh ways of looking at and thinking about art. Incapable of understanding most of the verbalizing which adults can absorb, and usually too restless to keep up any sustained level of curiosity when travelling through even the most temptingly arranged exhibitions, this is the age-group that remains ignored. Yet it also contains, at an extremely formative and impressionable stage, the potential gallery-goers of the future; and if they can be told that art is accessible rather than remote, enjoyable and not at all dull, the museum visit stands a fair chance of becoming a compulsive pleasure when they grow up.

Realizing this obvious but overlooked truth, Terry Measham of the Tate decided to invite a team of teacher-designers to create a room which would translate some of the basic experiences which art offers – visual, tactile, manipulative and spatial – into the language of a fun fair. And they have carried out their brief to the letter. The child enters through a winding, expanding and contracting tunnel which offers various types of textural sensations in its walls, soft floors, hanging clusters and sudden transitions from darkness to light. Then he finds himself in a perspective section, which consists principally of a coloured wooden path wriggling its serpentine way along the floor until it reaches the wall and is continued as a painting into the far distance. Other, rather less obvious and therefore perhaps less graspable perspectival schemes are displayed on partitions, but they act as a prelude to the successive delights of an upside-down room viewed through a bewildering range of peep-hole mirrors; a small labyrinth of smoked-glass walls which confound expectations of space; a participatory colour room where blue circles turn black when you slide a red shade in front of them; and – most spectacular of all – a rowdy noise chamber which really does live up to the notice claiming that 'walking about changes the sounds'.

128. Kidsplay exhibition at Tate Gallery, London, 1973

It would be easy for me to discuss how each of these varied sections attempts to tell children, in the vocabulary of a game, about the several properties of art experience. And I could just as readily point out how some contemporary artists' work – the Los Angeles environmentalists, Michael Craig-Martin, Larry Bell and Joe Tilson – seems to have inspired several of the ideas implemented here. But at the risk of appearing to snub the serious purpose of an educational experiment, it would be almost ridiculous to do so. What really matters is the children, and I spent a large part of my time there watching their reactions. They loved it, naturally. Running through the tunnel, peering open-mouthed at the mirrors, pacing past the glass and alternating between laughter and amazement in the deservedly popular sound room, kids of all dimensions thought it was a huge treat.

Whether or not they fulfilled the aims of the organisers and realised that 'there are often close relationships between art activity and play activity' cannot honestly be determined by an adult spectator: they should really be writing my column this week and telling you themselves. But what seemed to me significant and constructive about the whole enterprise was that they were all, obviously, learning to associate art galleries with genuine exhilaration. And this simple connection, which is also being achieved in a wing of the Geffrye Museum in Kingsland Road, where children are successfully encouraged to do art as well, goes a long way towards making amends for those dreary decades when museums reserved themselves for *cognoscenti* and shut everyone else politely but firmly out.

OPPOSING ENTRY CHARGES
6 December 1973

An open letter to Norman St John-Stevas, newly appointed Minister for the Arts:

Dear Mr St John-Stevas,
Although I normally devote this column to a review of London art exhibitions, your recent appointment raises vital issues which ought to be discussed by any art critic worthy of the name. And the most pressing of these questions, the principle of charging an entrance fee to visit

our national museums, was airily dismissed by you on Tuesday as a row which 'belongs to the past'. It does not: the row, in fact, could be only just beginning to show its true teeth, and it is simply not good enough for you to declare with a shrug that 'Parliament has decided a charge should be imposed and I accept the will of Parliament'.

This is nonsense, and you know it. The only legislation Parliament has passed is an *enabling* Bill, coupled with the proviso that all proceeds from the charges go straight to the institutions concerned for minor structural alterations. Which means, effectively, that the trustees of every museum still retain the freedom either to defy the idea of charging altogether, or to announce that they only need a portion of the income which full charging would provide for their structural work and that one or more free days per week can therefore be introduced.

I am afraid that most trustees will only opt for the second of these alternatives. They could easily refuse to agree with the entire admission fee scheme, and the Government would be powerless to stop them; but their timid response to Lord Eccles's bullying tactics over the past three-and-a-half years argues that they do not have the necessary courage or independence to do so. It is a pity, because this plan ought to be resisted with the utmost strength. The right to use our galleries without paying at the door has been inviolable for well over a century, and people will not use England's great national collections as regularly as they have always done if they have to dip into their pockets every time they want to spend an hour looking at the objects they own.

You yourself, Mr St John-Stevas, described this week how much childhood visits to museums helped your spiritual growth; and so you must realise that this squalid project hits at all those members of the public who will not be able to afford the cost of taking their families along to the galleries with the frequency they would like. I know just how much my own youthful ability to feed my appetite for art would have been curtailed by the imposition of even a small fee, and I shall want my children to enjoy a similar privilege in their turn. Take it away, and you destroy a precious symbol of our society's rightful priorities, as well as forfeiting your personal credibility as a politician who has already defined his 'missionary' role, dedicated to helping a nation which 'does suffer from spiritual starvation'. Do your entry charges alleviate that starvation in any imaginable manner? Surely not: they will create yet more hunger and associate culture in ordinary people's minds with the image of an élite wealthy enough not to worry about paying for their spiritual food.

Is this what a Minister for the Arts should be doing, especially someone who has asserted that he is 'interested in arts that involve the community'?

129. Norman St John-Stevas (now Lord St John of Fawsley) in the 1970s

Do you really want to be remembered as a socially divisive agent, who failed to act on the worthy principles you mouthed when first taking up your office? We all pay taxes for the upkeep of these museums, and quite rightly so, but why should we be asked for further contributions when we go and enjoy them? It is an abhorrent thought, and I do not know of one trustee who welcomes the prospect of actively discouraging would-be visitors in this fashion, let alone flouting the wishes of all those benefactors who so generously gave their collections to the nation on the implicit understanding that no one should ever be penalised for wanting to see them.

That is why your first and perhaps greatest test as a Minister will be over the museum charges controversy. For every board of trustees will be meeting shortly to decide what form their official reaction to Parliament's enabling Bill should take; and if they have any guts at all, you will hear them proclaiming that they are prepared to forego building a new lavatory, extending a restaurant or mending a hole in the roof if

those sacrifices mean that as many as seven days in the week can be freed from the shackles of Lord Eccles's monstrous imposition. In other words, the need for structural improvements is far less urgent than the duty to fight this proposal every inch of the way. And if you then decide to counter-attack with the blackmail which every trustee expects the Government to employ, cutting down on the annual acquisition grants of the museums and galleries that oppose you, I believe you will discover that many institutions are also willing temporarily to relinquish their purchasing powers in order to preserve themselves from the threat of turnstiles.

But I doubt whether you will want to stoop to such sorry manoeuvres. This is, after all, your first ministerial appointment, and you would be foolish to alienate the sympathies of those who care most about art in this country at the outset of your new career. You ought to be working with them rather than forcing them to implement something they find fundamentally unacceptable; and they, ideally, would like to support you over every measure you take. There is so much to be done in England to make everyone more aware of the arts, to encourage them to participate and take advantage of the enormous enriching pleasure to be gained. Money obviously plays an important part in any policy of expansion and dissemination, but the creation of a proper climate within which the arts are regarded as a living necessity rather than an inaccessible luxury does not depend on finance alone. It requires goodwill and hospitality, the capacity to extend an open, permanent invitation to all sections of the community; and it seems to me inconceivable that you will throw away the chance to establish this much-needed general attitude for the sake of a miserable piece of political dogma which insists that museums should help to pay their way.

They can never subsidise themselves, and should not be expected to perform such an impossible feat. They offer a service as essential as our schools and our hospitals, a standard as life-affirming as the humanist values which lie behind all the most positive and worthwhile achievements of the country as a whole. I, and millions of others who agree with me, would be delighted to congratulate you on your appointment if we knew that your aims were sincere. But if they are not, and you persist in adhering with blind rigidity to the disgraceful plan which you have inherited and which flies in the face of everything we value most highly, do not be surprised when you encounter the most adamant opposition.

<div style="text-align: right">

Yours sincerely,
Richard Cork

</div>

THE NATIONAL GALLERY'S WIDER ROLE
12 June 1975

The opening this week of a substantial and much-needed extension to the National Gallery comes at a time when the whole purpose of the art museum is being subjected to intense debate. It is neither possible nor desirable for such an institution to think of itself simply as the conserver, cataloguer and purchaser of prime art works. Those activities may have been sufficient in the past, when galleries thought it was enough to ensure that their possessions were publicly available to interested visitors, but now the argument takes a far wider form. Emphasis is placed, not on satisfying those who would frequent a gallery anyway, but on attracting the great majority who never think of going near it even once in their lives.

That priority raises a number of other questions as well. Would it not be preferable to exchange the notion of a huge, centralised treasure-house for a series of smaller and more widespread collections which could attract local loyalties and play a more accessible role in the life of every community? Why shouldn't the enormous sums of money devoted to the acquisition of yet another Titian be channelled instead towards promoting a greater awareness of what a gallery can offer, and providing the kind of educational facilities which might make art both comprehensible and necessary for society in general? Above all, perhaps, ought not the museum to justify its heavily subsidised existence by presenting its contents as an adventure of the human imagination which everyone can share, rather than as a cultural edifice which only a few privileged initiates would want to enter?

These are large questions, as challenging as they are difficult to resolve, and the National Gallery's new building acknowledges their awkward presence. The confident grandeur of Wilkins's original façade, which presides over Trafalgar Square like a temple devoted to the greater glory of imperial Britain, has now given way to a more anonymous and discreet architecture designed by the Department of the Environment. Its external walls of Portland Stone and flame-textured granite look expensive, certainly, but at the same time its refusal to indulge in Wilkins's classical magnificence reflects the uncertainty of our present-day attitudes towards the idea of a museum. Apart from a polygonal block isolated on the corner of the pavement to announce the National Gallery's name to passers-by, it manages to avoid any suggestion of its function: the glass entrance could just as easily lead through to a prestige suite of offices, and the hall within is indistinguishable from the foyer of an embassy or an airport.

130. The National Gallery's Northern Extension, opened in 1975

Our inability to evolve a recognizable language for the modern museum is therefore readily apparent, and no amount of slate flooring or travertine walls can hide the curious vacuum which results. It is as if the physical and spatial characteristics of the old public gallery tradition – high-quality materials, imposing height and a solidly constructed staircase leading to the main exhibition rooms on the first floor – have been deployed without any clear set of beliefs to back them up. Where Wilkins would have been positive about the relevance of the style he chose, the most significant aspect of this extension is the clash between monumental dignity and functional convenience.

Just before the exhibition is reached, for instance, a forbidding room on the right offers a more or less institutional history of the National Gallery since its foundation. But beyond this area, which is scarcely calculated to make museum novices feel at home, a bright and welcoming lecture room will be showing a continuous programme of films to supplement the art works hanging elsewhere in the gallery. This is an excellent idea, and will no doubt prove as popular as the rooms reserved for smoking and reading respectively on the floor above. They lead through to a seminar area, which can be booked by teachers who want to encourage their parties to talk about the exhibits they have seen; and yet there is, inexplicably, no provision for coffee or light snacks which would make for a more friendly and hospitable atmosphere.

In other words, the building as a whole is in a state of transition, caught between architectural concepts still allied to rigorous ideals of mind-improvement, and the pleasure principle which the National Gallery's staff would obviously like to foster. Since Michael Levey took over as Director, a far greater concern for public availability has made itself apparent through such innovations as the regular newsletter, children's competitions and the admirable Painting in Focus series, which extracts one picture from the collection and brings its full meaning alive with background information and comparative visual material. This initiative is now carried forward in the presentation of the inaugural exhibition, where the ambition behind Painting in Focus is widened out to offer what Levey describes as 'a fresh context in which to see for a few months some of the Gallery's own Renaissance paintings – Northern as well as Italian'.

Although most of the pictures on display are very familiar, therefore, their juxtaposition here in terms of themes like portraiture, antiquity, the beginnings of landscape and the reinterpretation of religion produces an enormous range of new insights. Dürer's northern Renaissance is no longer segregated from Bellini's southern equivalent: they are both seen as related facets of the same enquiring spirit. And the decision to supplement paintings with a selection of exhibits drawn from various public and private collections means that the Renaissance is presented more accurately as a movement which extended to sculpture, ceramics, furniture, metalwork and tapestries. Art is consequently seen not as an isolated phenomenon, artificially divorced from the other objects which would have surrounded it during the painter's lifetime, but as one particular form of expression employed by a society which saw no reason to draw any rigid distinctions between different media.

Nor does the exhibition aim itself at devotees of the National Gallery alone. Quite the reverse: succinct written introductions to each section

are directed at the visitor who may not know anything about the Renaissance, as is the audio-visual commentary on the period installed in a space roughly half-way round the suite of rooms. Both the display and the catalogue, in fact, are dedicated to the non-specialist, resolutely preventing the survey from becoming the preserve of the expert who needs little encouragement to frequent the gallery anyway. At every step, efforts have been made, with hanging banners, raised platforms, inter-linked arches and set-pieces like the interior of a painter's studio seen through wrought-iron gates, to counteract the somewhat oppressive and cavernous character of the rooms.

Rather too many efforts, maybe. The arches block our view from one area of the gallery to another and occasionally call too much attention to themselves at the expense of the exhibits. The inclusion of so many steps is likewise hard on anyone whose disability makes it difficult to move round the gallery with ease. But I sympathise with the motives behind all these devices, distracting though they may sometimes appear. It is no longer enough to build costly extensions and expect the public to greet them with gratitude. The museum itself must come out to meet its potential audience, and I look forward to observing how the National Gallery evolves new ways of meeting this challenge now that it has, at last, been given more space to breathe.

ENDANGERING EDUCATION AT THE TATE
7 August 1975

Almost two years ago, the Tate Gallery's Education Department managed to stage a full-blown and very noisy play event for children right in the middle of the rooms housing the permanent collection. It was as sur-prising as it was successful. An enormous number of kids had a thor-oughly good time trying out the various entertainments, which per-formed the unlikely dual feat of providing all the fun of the fair and introducing a whole range of references to the experiences offered by art. And there was also considerable symbolic value in the positioning of the event: an integral part of the Tate's overall function, it really did encourage children to think of the gallery as a place where their needs could be met, where they could perhaps move from the visual, tactile and spatial games designed for them to the art works normally considered

the preserve of adults alone. The whole event represented a palpable victory for everyone who would like to see museums reaching out for a new kind of audience, rather than catering only for the initiate and wondering why the great mass of the population has never developed the gallery-going habit.

It would therefore have been reasonable to assume that the experiment bore repeating, and that unashamedly high-spirited play environments might become a regular part of the Tate's education programme. But two years have passed, during which time the children who could at one stage have come to view the gallery as a regular source of fun and relaxation have probably gone back to thinking of the Tate as the preserve of grownups. Even now, with the advent of a similar experiment called Tate Games, they are not particularly encouraged to penetrate the classical portico at Millbank and encounter actual works of art. Instead, a simulated portico has been painted at the entrance of a tent, pitched squarely outside the gallery on one of the lawns which people normally use as a place where they can sit, eat ice-cream and recover after the hard physical slog of a large exhibition. It may be more practical to confine the play area to such a segregated location, and less alarming for the guards and gallery staff who have to concern themselves with the safety of the permanent collection, but the fundamental effect is unfortunate, implying that a museum is one thing and primary education quite another.

However many references the tent may contain to the objects on display in the Tate itself, no demonstrable attempt has been made to encourage children to walk inside this once-more hallowed domain. As for the diversifications on offer within the tent, they also seem confused and blunted in their appeal. Whereas the previous play area was single-mindedly directed towards children, and made clear that parents could participate only as guardians helping to prevent their offspring from suffering an overdose of excitement, its successor tries a more sophisticated approach. This time, adults are invited to join in as well, and the official handout quotes Johan Huizinga's somewhat forbidding statement that 'a certain esotericism is as necessary for art today as it was of old'. True, Huizinga goes on to declare that 'wherever there is a catch-word ending in "ism" we are hot on the tracks of a play community', thereby giving a clue to the art-as-game idea dramatised inside the tent. But how are children expected to react to the initial device of constructing a walk-through labyrinth inspired by Duchamp's last painting, 'Tu m'', which is supposed to make 'the entrant move away from colour into darkness and finally towards the dematerialization and the liberation of the object'? No self-respecting six-year-old would ever respond to such a lofty notion,

131. Tate Games exhibition at Tate Gallery, London, 1975

and the kids I saw did not even seem to know how to respond to the labyrinth simply on the level of fun. Bored no doubt by the final chamber, 'hung with liberated pieces of canvas' and paint 'dripped to the floor in anticipation of Jackson Pollock', several of them had settled down in its darkest corridor so that they could trip up unsuspecting visitors.

Although it was an ambitious idea to appeal to children and adults alike, Tate Games ends up satisfying neither. The Painting Machine, for instance, which invites us to manipulate dripping brushes over a circular piece of paper until its splattered surface is ready to be hung up like an exhibit on the wall behind, is hardly calculated to appeal to adults for more than a minute or so. And children are likely to be unenthusiastic

about a game which does not allow them to handle the paint itself with the freedom which art lessons at school usually encourage. A perspex lid prevents direct access to the paint, ignoring the fact that most children love to cover themselves with the stuff. Pollock did it, so why can't they?

The same objections apply to the big mural copy of Waterhouse's *Water-Nymphs* painting, a titillating Victorian favourite which we are invited to disfigure with coloured chalks. It may be amusing to embellish the fair nymphs' proffered breasts, but does this institutionalised wickedness compare favourably with the kicks to be got from executing a genuinely illegal graffito on a poster in the Tube? I think not, just as I doubt whether young or old will be very interested in the three-dimensional version of Mondrian's *Composition in Grey, Red, Yellow and Blue*. 'Don't climb on our version, but do walk inside it,' says the Tate handout, giving with one hand and taking away with another. The idea, presumably, is to make Mondrian's somewhat forbidding, purist painting more accessible by equating it with a coloured climbing-frame in an adventure playground. But whoever heard of a climbing-frame which nobody is permitted to climb? It stood notably neglected in its corner while I was there, and I'm not surprised.

Far too many of the games fell into this uncomfortable no-man's-land, half-way between simple toy and complicated diversion. If children can hardly be expected to respond to the fruit-machine full of 'critical clichés', adults attuned to the far more taxing delights of Scrabble will not find it an absorbing challenge either. And who exactly is the jukebox of recited artists' statements aimed at? One of our more conservative citizens has apparently written to the Tate's director complaining angrily about Oldenburg's Pop manifesto, with its references to 'everyday crap', but I doubt if anyone else will be comparably stirred. Lacking the full blooded participatory excitement of its predecessor, which won children over with a noise chamber, an upside-down room and a dark tunnel full of immediate textural sensations, Tate Games neglects its true clientele by straining for intellectual respectability. It is a pity, because the Tate's Education Department has already proved how enterprising and inventive it can be when its resources are concentrated on a more focused objective. The tent should be dismantled, and attention redirected towards making the gallery itself a place where children can really expect to play.

MUSEUMS AND SOCIETY
23 October 1975

It may seem paradoxical that last weekend's European-American Assembly on Art Museums, which brought together over forty museum directors from Europe and the United States to discuss a wide range of mutual problems and possible solutions, should have been held at a grand eighteenth-century mansion marooned in the autumnal Oxfordshire countryside. Designed by James Gibbs with the same dignity and restraint which characterises his London church, St Martin-in-the-Fields, Ditchley Park stands apart from the rest of the world in acres of private land, and is only open to the public for a few weeks during the year. The rest of the time it is devoted, through the Ditchley Foundation, to international conferences on political, economic, educational, social and other subjects, a handsome setting for debates which are meant to be reflective and self-examining. But the air of aristocratic privilege permeating Ditchley was, at the same time, a double-edged ambience for men and women whose institutions can all too easily be accused of adopting too remote and rarefied an attitude towards the vast mass of the public that never penetrates art museums at all.

This, to my mind at least, was the dilemma overshadowing every discussion and lecture held there during the weekend. Whatever the particular topic under scrutiny, be it staff, education and exhibitions, collections and acquisitions or administration, the larger question of the museums' relationship with the society they exist to serve dominated the proceedings. The opening sentence of the guidelines for the first meeting on Friday afternoon – 'art museums today have a dual responsibility to scholarship and to the general public' – succinctly summarised this thorny problem. And it was symptomatic of a growing awareness of the real crisis involved here that nobody, not even directors from the most recherché of specialist old-master galleries, minimised the importance of reconciling the scholarly and popular functions of a museum.

The general consensus of opinion about the urgency of this issue arose from the feeling that public galleries will have to fight hard for their survival during the years ahead. Many participants, including Sir Ernst Gombrich who gave a witty and stimulating lecture on the *raison d'être* of museums, viewed the prospect of public hordes and vulgarised standards with alarm. But even the diehard élitists acknowledged that the buildings in their care would be forced to become far more accountable to the taxpayer in future, now that funding from wealthy private individuals is

Report of the European-American Assembly
October 17-20, 1975
Ditchley Park, Oxfordshire, England

Art Museums:
A European-American
View

The British Museum
London

The American Assembly
Columbia University

132. Cover of the European-American Assembly's
Report, 1975

increasingly giving way to direct municipal or state subsidy While vocif-
erous support was expressed for the idea that museum staff should be
fully equipped with the art-historical expertise necessary for highly
researched exhibitions and catalogues, for instance, the ability to com-
municate with a wide audience was emphasised at the same time.

At the moment, of course, these two aims are often at loggerheads.
There are still far too many directors, particularly at provincial galleries,
who are academically trained and spend most of their time cloistered in
libraries, pretending that the alienated urban reality of the audience they
should be attracting does not exist. Reaching out for that audience, either
through neighbouring schools, an energetic public relations department or
audio-visual techniques which appeal to visitors unversed in the finer
points of catalogue entries, is too often equated with a betrayal of faith in

the quality of the art works themselves. They, it is argued, are self-sufficient and do not need any special pleading: the public should come to them and feel grateful. A distinct whiff of this attitude came across from George Heard Hamilton's lecture, significantly entitled 'People Pollution', in which he took a perverse delight in explaining how difficult it was for anyone except the most determined explorer to visit his collection – the Sterling and Francine Clark Art Museum, sequestered in the mountain fastness of Williamstown, Massachusetts.

Strangely enough, it was the American directors, belonging to a society which has always taken pride in its openness and democratic flexibility, who at times appeared most detached from the populist cause. Whereas the majority of European museums were founded from the outset with the broad needs of the public in mind, and have traditionally been reliant on governmental support, their American counterparts largely depend to this day on private patronage and testify to the everlasting glory of millionaire benefactors. Nowhere else in the world do museums have the gall to insist on an entry charge of up to £1.50, but in cities like Boston and New York such punitive levies are becoming the norm. Nowhere else, likewise, are museum trustee boards so thickly populated with rich collectors who donate their possessions as an offset against tax. Mrs John D. Rockefeller, the President of the Museum of Modern Art in New York and a supreme embodiment of this system, came to the conference unaccompanied by any of MOMA's curatorial staff. And the Whitney Museum in New York was similarly represented by one of its trustees, Arthur G. Altschul, a partner in Goldman, Sachs & Co.

In Europe, by contrast, a far greater concern for the ideological role of the museum was evident. The Dutch and Scandinavian representatives were particularly clear about their function within society, and the West German contingent proved – perhaps inevitably – very apprehensive about the dangers of political pressure being used to exploit museums as instruments of propaganda. Compared with them, English directors seemed distinctly complacent about political interference of any kind. At one point, I suggested that trade union leaders, teachers or social workers could broaden the outlook of museum trustee boards, and one English director replied that this would be opening the door to political interests. He did not appear willing to concede that the existing trustee system, composed very largely of pillars of the establishment, was highly politicised already, albeit in the most covert and gentlemanly manner.

National differences apart, however, there was a general agreement about the desirability of increasing the kind of contact which this conference represented. Sir John Pope-Hennessy, the British Museum's

director and an incisive chairman at Ditchley Park, made a plea for more concerted co-operation between different countries over the legality or otherwise of exporting art works from their native contexts. He instanced a Renaissance bronze which he had been anxious to acquire in Rome some years ago, before being informed by the Italians that an export licence would never be granted. Having bowed to that argument, he was annoyed to discover that the bronze had been mysteriously smuggled into Switzerland and sold from there to an American museum, and that the Italian authorities did not even issue a murmur of protest.

But as long as museums set such store by the amassing of bigger and better booty than their rivals, this piracy will probably continue. The mystique of the treasure hunt and the final, triumphant coup is very strong among the richest directors, as is the belief that it is somehow rather admirable to compete with neighbouring galleries over purchases which should not, in an ideal world, be duplicated in any way at all. There is everything to be said for better liaison in this respect, so that different museums can define their separate areas of interest rather than blindly attempting to build up identical collections at each other's expense.

One of the most encouraging paragraphs to emerge from the joint statement formulated in Monday morning's final meeting began with the forthright declaration that 'strong opposition was expressed to the principle of charging entrance fees for admission to permanent collections' – a remarkable statement considering how many museums ignore that principle at the moment. Even so, there was not enough general recognition of the reason *why* entry fees should be abolished. Far too many people still see the museum as a forbidding and aloof edifice, totally unable to offer them anything except a frosty reminder of their own educational inadequacies. Until the directors who felt so pleasantly at home in Ditchley last weekend make a positive effort to confront this problem, and reach out to the millions who do not even know what the word museum means, their splendid isolation in Oxfordshire will continue to mirror the shortcomings of the institutions they cherish.

AN ALTERNATIVE SPACE
13 May 1976

During the past few years the rapid acceleration of inflation has meant that artists, particularly those based in London, find it increasingly difficult to provide themselves either with the studio space or the public outlets on which their survival depends. I am not talking here about the fortunate but small number of men and women able to rely for their income on sales of work and part-time teaching posts, although the current recession in the contemporary art market has not helped them maintain the standard of living available during the relative boom in the 1960s. They are still able to devote a reasonable amount of time to their own work without enduring real hardship, whereas the great majority of artists – especially those too young to gain the attention of commercial galleries on the one hand and the art-teaching fraternity on the other – are now confronted with a bleak situation. The high cost of rented accommodation is caused by the same broad combination of economic factors which obliges dealers to avoid taking risks with anyone incapable of guaranteeing a return on their mounting overheads. And so it looks as if an urgent, radical overhaul of the structures supporting the artist must take place, in order to ensure that art as a whole is not crushed by our diseased capitalist system.

The colossal housing boom of the early 1970s was, of course, the first dramatic sign in this country of the runaway inflation to come. Space to live and work in therefore became the initial aim of the seven artists who formed the Acme Housing Association in the winter of 1972. Their status as an Association enabled them to secure from the GLC and the London Boroughs property due for eventual but not immediate demolition, and a nominal rent was granted on the understanding that all repairs and outgoings would be met by the occupants. Acme, who also had to promise that it would vacate these properties on time when they were finally required for development, started off in the spring of 1973 with two derelict shops in the East End. Their occupants reinstated the facilities which the shops had originally contained, and more houses were then transferred to the Association. As a result, the idea of providing a similar service for other artists came into being; the Arts Council made grants available towards the cost of studio conversion; and then, in 1974, the GLC started to supply money for the initial cost of repairs to more houses which it transferred to Acme's increasingly proficient hands. Subsidies were thereby coupled with self-help, as the artists taught themselves how to renovate the buildings they were given. And now Acme

133. The Acme Gallery in Covent Garden, London, 1978, after an explosive Cripps performance filled the space with smoke

manage a total of 117 properties – principally located in the East End but also including a group of studios made available by Hammersmith Borough – which together house 167 artists. With weekly rents still kept down to around £4, and a committee of management drawn from the tenants themselves, Acme is clearly helping to meet a desperate need.

However, the opening this month of the Acme Gallery at 43 Shelton

Street signifies the Association's new awareness of the acute shortage of exhibition space in London. Housing artists only constitutes half a victory if they cannot find anywhere to show their work, and so it was entirely logical for Acme to approach the GLC, obtaining after two years of waiting and negotiation a handsome old building originally used by the market traders of Covent Garden. Its four floors have been converted, with the aid of grants from the Gulbenkian Foundation, the Greater London Arts Board and the Arts Council, into three main areas: a darkroom in the basement, a lower and an upper gallery on the two floors above, and an office in the top storey. So far as exhibitions are concerned, a pair of spaces each almost sixty feet long are now available, both overlooking the delightful Japanese Water Garden which represents another pointer to the way Covent Garden's sleeping potential could be awoken in the future. And Acme have sensibly decided that the gallery policy will be controlled by a changing committee of artists, judging applications on their merit from anyone who is prepared to send in documentation and/or be interviewed in person. Successful applicants can expect the gallery to take a fifteen per cent commission on work sold, and they will also have to meet the costs of transport, mounting and so on. But the gallery itself is prepared to meet all the normal running costs of exhibitions, including a share of the necessary publicity.

Acme explains that 'we want artists to feel that the gallery space is there for them to use and alter to suit their exhibition requirements, and we hope that artists will work closely with us in the organization of their shows'. Some idea of what the gallery offers can be gauged from the opening show, in which twenty-eight-year-old painter Mike Porter, who has never before been given a one-man exhibition, is able to display no less than thirty-nine works dating from 1973 to the present day. It is a substantial survey, far bigger than most artists could expect to receive from a commercial dealer, and Porter also benefits from an illustrated catalogue with a supportive introduction by Clive Phillpot. The work itself – abstract, and employing a variety of materials like paper, glass, corrugated iron, plastic and wood – is not yet mature or individual enough to sustain such a comprehensive airing. It would perhaps have been better to restrict Porter to one floor only, concentrating on the strongest and most resolved exhibits like *No. 2*, in order to give the other space over to a second artist.

Nevertheless, I warm to Acme's obvious desire to treat the work shown here with the seriousness it deserves; and I look forward to following a future programme which promises to embrace film and performance as well as paintings, drawings and sculpture. (The gallery would lend itself to open discussions and seminars, too.) This venture deserves

a maximum amount of support from everyone who cares about the plight of our art community, and artists wishing to apply for exhibitions should contact Shirley Read at the gallery.

IMPRISONING ARTISTS' BOOKS
19 August 1976

Whatever artists choose to do can, it seems, become grist to the exhibition mill. Even when they develop a means of production specifically intended to bypass normal exhibition outlets, the results end up, stripped of their renegade pretensions, safely nestling in a gallery's womb.

Or should I say tomb? That, at least, would approximate more closely to the effect of the Artists' Books survey at the ICA New Gallery, which sets out to chart the growth of the book as an alternative art medium, particularly over the past five years. For this show, so admirable both in its compilation and its recognition that books have now evolved into an integral part of contemporary art practice, nevertheless manages to freeze the life out of them and incarcerate their withered corpses in a prematurely historical vault. Not only have 160 specimens been filed to exhaust the zealous reader: the press release also reveals that 'the organisers hope to add new works as they are published', thereby ensnaring them before they have a chance to reach their public in more appropriate ways. The irony is almost unbelievable.

To be fair to Martin Attwood, who is principally responsible for the selection of this Arts Council touring exhibition, the catalogue does admit that 'it is far better to read or look at books in private'. But although he ends his introduction by hoping that the survey 'will encourage you to establish this private relationship with these books', such a sentiment fails to make proper amends for the contextual distortion which this show inflicts – no doubt unwittingly – on its subject. The fact remains that just about every reason why artists make books has here been turned on its head. The display structure housing the publications is carefully divided into areas which simulate the privacy Attwood mentions, as well as supplying a variety of shelves, screens, cases and corners where the books can be respectively laid out, pinned up, stacked and hung. Are any of these resourceful strategies really suitable, however? No reader would reasonably want to dangle his or her books from the ceiling, or cut them

up and paste them on the wall. The catalogue points out that Dieter Roth, one of the most ingenious book artists, actually invented the hanging method because it 'emphasises the physical weight of a volume'. But this fanciful and somewhat perverse device can hardly be applied to books produced by other artists, who are quite content to let readers register weight through the simple act of picking a volume up in their hands.

Admittedly, spreading books out on surfaces and placing them on shelves are both sensible ways of recreating normal reading conditions; and yet the chains and straps attached to each volume as a security measure are scarcely calculated to encourage the visitor to handle the exhibits at ease. In this respect, the only adequate facilities are to be found in the adjoining room, where comfortable chairs replace the forbidding stools provided next door, and tables heaped with a miscellany of unshackled books do stimulate the desire to read and enjoy. But so far as the 'official' section of the survey is concerned, the whole network of motives which prompted artists to use the book form in the first place is everywhere traduced.

One of the prime attractions, for instance, was the element of mass production, with its ability to escape from the unique, expensive art object and provide something which anyone could afford to buy. Multiples were, of course, introduced with much the same end in view; but whereas they rapidly turned into yet another art-market pawn, their editions carefully limited by dealers with an eye for profits, books are relatively unlimited and can easily be reprinted. With a few notable exceptions, the items in this exhibition are as cheap as they are readily available, and they can be obtained through the post, libraries or bookshops (most dealers do not stock them, for obvious reasons).

No one would ever guess, however, from the atmosphere of rarity which the Arts Council show automatically creates, that these manacled items can be purchased like ordinary paperbacks. Nor is it easy to appreciate here that books are free from the viewing conditions which even the most reasonably priced screenprint demands. They do not need to be mounted, framed, sympathetically lit and hung in a suitable space: their great asset is their simplicity of access, the accommodating and unprecious way they can be stuffed into pockets and read on a rush-hour tube. In this exhibition, by contrast, the notion of the book as a tool to be treated as the reader requires is hedged round with restrictions. Over and above the handle-with-care sanctity of their presentation, the very fact that they are displayed as exhibits in a gallery makes a nonsense of their true function.

134. Sol LeWitt, a page from *The Location of Lines*, Lisson publications, London, 1974

The organisers would probably maintain that I am overstressing the problem of context, and that most visitors will instinctively understand the unavoidable differences between an exhibition convention and normal usage. But I am concentrating on the mechanics of the show rather than its contents precisely because of my belief that context *can* control our reactions, to an extent which should never be underestimated. A gallery carries a whole host of meanings, largely derived from the purposes it has traditionally been intended to serve. And artists' books can claim no special immunity from those meanings, secure in the knowledge that in reality they stand outside the gallery system. The reverse is the case: the *raison d'être* behind these books is severely compromised by their reabsorption within the very structure they set out to reject. Having taken such a step, it is all too easy to imagine them castrated still more thoroughly by becoming little more than collectors' items, and eventually – who knows – being acquired by the Tate Gallery as fit companions for good old unique art objects. If Duchamp's ready-made toilet/fountain

can be sold in a limited edition to museums, so too can 'mass-market' books.

We need look no farther than the catalogue of this exhibition to discover how the transformation takes place. There, in a provocative essay called 'Textual Art', Brandon Taylor is already taking his cue from the viewing conditions prompted by this show to discuss the books in purely formal terms. Throughout his article, Taylor plays down the plain fact that most of the volumes were intended to exchange formal priorities for those of documentation, theoretical debate and other working methods which refused to rely wholly on visual considerations. He argues that 'a page or lay-out of text stands without internal distinctions of order as an uninterrupted, smoothed-out, rectangular presentation, a flecked array of forms which are seldom if ever organised positionally within the rectangle as right-sided or left-sided, superior or inferior'. And in order to prove how important all this is to the book artist, Taylor then equates his 'flecked array of forms' with non-compositional American painting of the 1960s. He even declares that, since books of art theory are often difficult to comprehend, their visual manipulation of text masses is as important as their verbal content.

While it would be foolish to deny that the artists who made these books did not take their visual impact into full account, Taylor's interpretation rides roughshod over their primary desire to escape from the tyranny of an enclosed dialogue about the art object as art object. Artists' books were produced to open out this dialogue and affirm, by means of writings, diagrams, photographs and much else besides, that art should address itself to far wider and more cross-fertilised horizons. Any attempt either by exhibitions or their catalogues to misrepresent such aims should therefore be exposed and resisted.

AMERICAN INDIAN BLUES

7 October 1976

The contrast could not be more revealing. At the Hayward Gallery, a lavish exhibition of *Two Thousand Years of North American Indian Art* has been mounted as part of the interminable American Bicentennial celebrations, under the joint patronage of the Duke of Edinburgh and Nelson Rockefeller backed up by a shoal of all-white Anglo-American Volunteer

Committees. But at Artists for Democracy, a small decaying gallery in Whitfield Street, the present-day descendants of the men and women whose work is fêted on the South Bank have scraped together an angry polemic called the *American Indian Movement 1976 Exhibition*. The Hayward survey has assembled, with diligent scholarship and a flair for showmanship, almost seven hundred exhibits, most of which are illustrated in a catalogue containing an American museum director's patronizing statement that 'perhaps we are still a little shocked at having to admit what fine sculptors, designers, and craftsmen native American artists were and are'. Whereas the Whitfield Street show's collection of xeroxed protest leaflets, photographs and drawings, all dominated by a picture of an Indian imprisoned behind the bar-like stripes of an upended American flag, is dedicated to demonstrating the AIM's belief that 'the U.S. Government's treatment of Indian people amounts to a scandal bigger and more severe than Watergate'.

In view of the almost unbearable irony in America's decision to mark its two hundred years of independence by displaying the culture of a people it all but destroyed, I would like to think that the main motive here is atonement. And Ralph T. Coe, the Hayward show's principal organiser, does describe 'the overriding purpose of this exhibition' as an attempt to ensure 'that this art should at last be properly regarded for the sake of a better understanding among peoples'. The proffered pipe of peace has not, however, been accepted at Whitfield Street, where the AIM hopes that its struggle for the 'sovereign rights, treaty rights and eventual independence' of the Indian people will be 'considered a realistic and serious alternative' to the Hayward bonanza. In order to further that end, the AIM has put on view a hard-hitting compilation of statistics about the plight of the one million Indians in America today, asserting that their rates of unemployment, infant mortality, suicide, alcoholism and poverty are far higher than the national average. Documentation of the notorious Wounded Knee siege in 1973 hangs near an exposé of how native Indians are now being affected by air and water pollution, while a cartoon shows two depressed Indians sitting next to a Bicentennial Parade poster and asking each other: 'What Do You Suppose The *Next* Two Hundred Years Will Be Like?'

The Hayward exhibition fails, of course, to provide any kind of direct answer to these political allegations. In all fairness, it does provoke an awareness of the exploitation and butchery which the Indians suffered at the hands of their white conquerors, and a series of elegiac quotations from Indian writers lamenting their fate fills the rooms with a terrible sense of waste and grief. But these apologetic gestures confine themselves to the past alone, and they are in the end offset by the magnificent vitality of the

135. Installation view of American Indian exhibition, Hayward Gallery, London, 1976

exhibits. Totem poles, feathered head-dresses, masks, carvings, jewellery, canoes, moccasins and even a full-size wigwam buffeted by October winds on the sculpture court are all presented with exemplary care. And attempts have been made, in the consistent use of natural wood no less than in the bed of stones laid out for a spellbinding display of masks on poles, to recreate the environment from which this heterogeneous mass of artefacts and utensils originally came.

It is all very seductive, and the growing determination which this show evinces to preserve, explain, cherish and place in historical perspective can only be applauded. Even so, there are severe limits attached to any exhibition's ability to evoke a vanished context, and by placing these items in handsome, spotlit isolation it is alarmingly apparent that their original purpose is traduced at every turn. Far too often the showcases full of superbly decorated jackets, dresses and shirts look like expensive shop-windows from some trendy boutique, cashing in on the undoubted fashion for the ethnic produce of a people who are now being engulfed by our nostalgic yearning after the 'simple life'. I have a neighbour whose walls are festooned with rugs and blankets that clearly derive from generalised Indian prototypes, and there can be little doubt about the potent appeal which the Hayward's garments and hangings possess for city-dwellers in search of their pre-industrial roots.

The catalogue acknowledges this attraction, and by explaining how 'our spiritually and physically cramped lives have led us to seek catharsis in works of art that express vast continuums of space and imaginative release', it admits that the urban civilization which once reared itself up on the ruins of pillaged Indian communities now suspects what values were lost in the stampede for capitalist expansion. But the fact that these exhibits are referred to as 'works of art' proves (if proof were needed) that no *direct* criticism of the American way of life is mounted at the Hayward. We are invited to admire exotic fragments of an alternative culture from a distance, not encouraged to realise that the way of life from which they have been salvaged might hold lessons for us in any future attempt to change our own technological society. The result, inevitably, is distortion on a massive scale, as we wander past clusters of tiny bird and animal carvings displayed without reference to their original function as effigy pipes; past a huge brown bear painted on wood and presented as mural-sized art rather than as the centre partition in an Alaskan chieftain's house; past rows of hypnotically carved animal faces which look more like sculpture in the conventional sense than frontlets once meant to be worn ceremonially on the head; and past an hallucinatory eagle with terrifying eyes which gives no hint of its initial purpose as a grave marker.

I would be the first to concede that it is enormously difficult to evolve exhibition techniques which would correct this imbalance, and replace the notion of pure aesthetic delight with a more realistic idea of the practical part these objects played in Indian life. But if such attempts are not made, we will continue to misinterpret the true significance of the Hayward's contents, and play into the hands of commercial interests which have everything to gain from equating Indian relics with the investment-oriented art of the museums. 'These treasures have become high priced "art objects"', the catalogue declares at one stage. And instead of pointing out how the priorities of the art market blithely distort the real meaning of things which were never intended to be frozen into inutility behind protective glass, the writer is content to conclude that their ever-increasing financial value 'signifies the advancement of American Indian art to the status it deserves. In other words, the fact that a chieftain's deerhide mantle is insured in this exhibition for three-quarters of a million pounds – and will doubtless be worth more now that Indian art is becoming widely known outside its native country – ought to be welcomed as a definitive recognition of its proper worth. What a fate for a garment that once formed part of a culture which saw no need to draw distinctions between objects of menial use and objects of ceremony, which did not use the word

'art' but instinctively expressed the harmonious totality of man and nature in everything it made!

Only one section of the Hayward survey comes near to providing an antidote to the sealing-off of art from life so evident elsewhere: the photographs Edward Sheriff Curtis took for his monumental books on *The North American Indian*. For here we find a Nakoaktok chief's daughter seated imposingly, with a ring through her nose, on a platform supported by the kind of carved, grimacing figures to be found marooned in the rest of the Hayward's rooms. There they are shown simply as sculptures, rare acquisitions for the potential collector. But in Curtis's photograph they are placed in context, as adjuncts to the daily life of a woman who appropriated their sinister presence in order to reinforce her standing within the tribe. Like the bird perched so mysteriously on the head of an Apsaroke Indian in another Curtis photograph, these carvings once had a *raison d'être*. We have almost lost sight of it in our desire to enclose Indian culture inside the white man's notion of art. And the dignified independence of the lost society depicted by Curtis likewise suggests that the AIM has good reason to deplore the equally fenced-in confinement of Indian life today.

A DEMORALISING CUT
11 November 1976

The swingeing cuts in government spending which have already gravely affected most areas of our lives are now beginning to slice into the all too vulnerable network of national museums and art galleries. It would be impossible to argue for exempting these institutions from such a comprehensive and unavoidable programme of austerity measures, even on the grounds that the enormous benefits offered by art should be more than ever available today, when so many working people face the desolation of an unemployed existence. But it *is* possible, indeed crucial, to debate publicly the ways in which economies should be made and decide what a museum's overriding priorities are, thereby ensuring that they are not shorn off by an indiscriminately money-saving axe.

The proposal by Dr Roy Strong, Director of the Victoria & Albert Museum, to disband his entire Regional Services Department shows just how urgent and necessary this debate really is. Ordered by the government

to slash the Victoria & Albert's staff from 700 to 620 by April 1978, Strong has decided to solve what he so rightly calls his 'agonizing' dilemma by putting 'into abeyance' the department which organises and sends out a vast range of exhibitions to regional museums and art colleges. In a speech to his staff, he explained that 'the care, preservation, display and elucidation of our own great collections here in South Kensington . . . must surely come first'. And so, according to this criterion, he has allowed the blade to fall on the one department 'which is extraneous to the central function of the Museum'. The logic is clear, especially in view of Strong's belief that any alternative attempt to administer the cuts more evenly across the full spectrum of Victoria & Albert departments would bring about 'an irreversible collapse of learning, scholarship and public service'. It is an apocalyptic prospect, and one which I think has been deliberately cast in the most heightened language. Strong is a shrewd political animal, and may in fact have chosen the Regional Services Department as a victim simply in order to rouse the loudest amount of protest. But in the absence of certain knowledge about his motives, we are obliged to presume that he considers the Regional Services – founded as an integral part of the Victoria & Albert in the middle of the nineteenth century – to be, in the last resort, dispensable.

I find it dismaying that Strong can even contemplate the dissolution of a department which performs the vital task of providing Britain with a continuous and richly varied series of touring exhibitions. From its inception, it carried out this crusading task with infectious zeal: in the 1860s, it sent forth in a specially constructed railway truck a 'Circulating Museum' of no less than 900 objects which were seen by 429,000 visitors. And this laudable Victorian determination to disseminate art among as many different people and unlikely locations as possible, has since been built upon to such an extent that in 1975–6 Regional Services mounted 880 individual showings throughout the United Kingdom. Compared with the Victoria & Albert itself, which attracts just over one million visitors each year, these travelling exhibitions are seen by more than three times that number. An impressive total of 7,000 objects are on the road at the moment, servicing a policy which has extended from a survey of Etruscan art loaned by the British Museum to recent photographs by the young land artist Hamish Fulton.

A lot of these exhibitions are, of course, modest in size: the smallest shows on offer, for an equally small hiring fee, consist of sixteen basic frame-units. But as I can myself testify from my own years in the regions, the presence of a Victoria & Albert survey in an otherwise benighted corner of the country is often as miraculous and sustaining as manna to

the Israelites. Anyone who has lived only in London can have little conception of what it is like to be based in an area where works of art and exhibitions are not in plentiful supply. For all these districts, which amount to the greater part of Britain including Northern Ireland, the disappearance of the lifeline set up by Regional Services will be a catastrophic blow. And the Arts Council, which is the only other body to supply touring shows on an even remotely comparable scale, cannot hope in these belt-tightening times to fill the resultant gap.

In terms of national priorities, therefore, there is no doubt that a greater proportion of the population is reached by the Regional Services Department than by the museum for whose sake it is being sacrificed. And London would undoubtedly suffer less from cuts administered across the board within the Victoria & Albert than would the country as a whole if this travelling exhibition circuit is terminated. Scrap the Regional Services, and you fly in the face of the *Wright Report* and the more recent *Redcliffe–Maud Report*, both of which stressed the need to decentralise from London and construct locally instigated support for the arts throughout the nation. Regional Services was poised to participate in this devolutionary process, and in his speech at the last Museums Conference Strong himself outlined his future plans for the department, which would be granted a considerable increase in funds. Now, however, he baldly announces that 'the onus of providing a regional service must be laid on those national museums and galleries, on the Arts Council and Museum Area Councils who have not suffered these crippling cuts'.

His statement does not make sense. Does Strong honestly believe that any institution will somehow escape the cheese-paring commands which the Victoria and Albert has received? Surely not, for the terrible truth is that nobody else will be able to come forward and replace the work of Regional Services for a very long while. As a joint letter from ten leading provincial museum directors pointed out in *The Times* two days ago, the deprivation they all face will be immense. And everybody with the slightest knowledge of how local authorities operate realises that, if Regional Services is jettisoned, they will take it as a heaven-sent precedent to justify their own notorious unwillingness to subsidise art activity in general. 'Most local authorities are just waiting for an excuse to do even less than they have ever done', one seasoned member of Regional Services told me, 'and if our Department is thrown out of the window they'll have the best excuse imaginable'.

The biggest irony surrounding this controversy is that Regional Services, far from being a layer of luxurious cream which can be

skimmed off the Victoria & Albert's milk like a wasteful legacy from the affluent sixties, does give astonishingly good value for money. The present annual budget for putting up all its hundreds of showings amounts to only £50,100, or roughly the same sum that would be required to stage a couple of large exhibitions in London. Moreover, the museums and art schools which between them share the travelling shows on a fifty-fifty basis, send back to Regional Services hiring fees which total around £19,000 in the current year. This money, slightly augmented from existing funds, enables the department to acquire a considerable number of contemporary art works. They have been purchased with outstanding intelligence and adventurousness in the past, and an important source of national patronage for living artists will vanish if Regional Services is dispensed with altogether.

Even so, the main issue at stake here concerns the function of the museum service, and how best it can further the interests of the greatest proportion of our population. According to the museum directors' letter in *The Times*, the destruction of Regional Services 'would mean that a major responsibility of the national museums had been abrogated'. The claim is not exaggerated, for one of the most positive developments within the present-day museum structure has been a growing awareness of the importance of education. Whether at the Tate or the National Gallery, education officers have managed within newly created positions to pioneer a more outward-looking and non-élitist attitude towards the collections in their care. It is no good continuing to spend huge sums purchasing, preserving and cataloguing art objects according to the highest scholarly standards if no concomitant steps are taken to encourage the public to enjoy them. The Regional Services Department is the oldest-established organization in the world devoted to the active, proselytizing circulation of national collections, and its abolition would signify a crushing vote of no confidence in the whole principle of reaching out towards the huge public which has never had its interest in art aroused. For a Socialist government to accept Strong's proposals would in this sense be a gross betrayal of its ideological convictions, and I urge Mrs Shirley Williams to ask the Victoria & Albert to reformulate its plans forthwith.

Strong maintains that 'there was no way of reaching the cuts by axeing horizontally without paralysing every department to utter ineffectiveness'. But I am reliably informed that a Victoria & Albert staff committee, which was originally briefed by Strong to examine how the cuts could be administered with the least pain, recommended that they be made across the board and at all levels. Strong rejected their proposal because it apparently

did not quite meet the government's demands. If a compromise agreement along the lines suggested by the staff committee is not arrived at by Mrs Williams and Strong, however, the museum service's fundamental duty to make art available to the people will receive an utterly demoralizing setback.

After writing this article, I organised the signing of a protest petition which David Hockney agreed to present with me to Shirley Williams on 15 December 1976. It was signed by seventy-nine people concerned with the visual arts in Britain, and their names are printed with the petition's text in Studio International, *1/1977, pp. 78–9. But the Regional Services Department was duly axed. The loss is incalculable.*

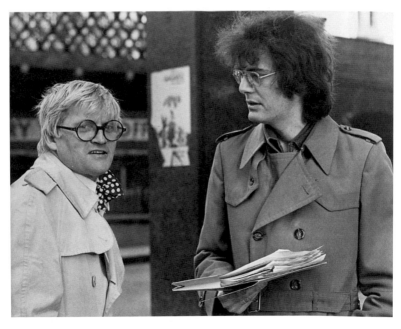

136. David Hockney and Richard Cork delivering the V & A petition to Shirley Williams's Ministry, 1976

ART FOR THE BLIND
18 November 1976

My first thought, on entering the Tate Gallery's *Sculpture for the Blind* exhibition, was to ask for a blindfold so that I could at least approximate to the condition of the sightless visitor. After all, to be deprived of eyes is to me a disability far more terrible and unimaginable than deafness, although informed opinion argues that loss of hearing seals you off most completely from contact with the world. To someone like myself, whose sight is an especially central part of everyday existence, the impossibility of continuing to absorb visual matter in general – and art in particular – is a prospect too daunting to be contemplated without the help of a prop which would simulate blindness.

I happened, however, to go into the exhibition with a group of blind schoolchildren, and the comparative ease with which they made their way around the sculptures proved that to shut out my sight artificially would not bring me very much nearer to their experience. People who have been blind for even a short time are considerably more aware of the problems involved than I would be: they are used to making the sense of touch stand in for their eyes, and thereby comprehend a surprising amount about the objects in front of them. Watching their hands run expertly over the various surfaces made me realise how much more attuned they were to tactile signals, how natural an activity it was for them to grasp something and let fingers do the job which I would instinctively assign to my sight.

Moreover, their method of enjoying sculpture seemed a more appropriate response to three-dimensional artefacts than the usual keep-your-distance relationship fostered by museums, whether at the Tate or anywhere else. Looking round the show, I saw everyone feeling, probing, stroking, prodding and playing with the exhibits in a spirit of eagerness which contrasted well with the alienated way we normally survey sculpture, our hands held in absurd abeyance. These blind visitors, many of whom had probably never been inside an art gallery before because of the innate futility involved, were questioning and testing the works with an enviable sense of discovery, precisely because lack of vision prevented them from any easy assimilation of the objects as wholes.

Eyesight makes the rest of us very lazy. We tend to think we have understood a work of art merely by glancing at it and registering its existence. A sightless person offers a corrective to the prevalent notion that seeing is comprehending, and even the most tentative physical contact

with a good sculpture affirms that only prolonged, intimate exploration can disclose the full range of meanings it embodies.

Encountering such an object in a private context automatically prompts me to run my hands over its contours. It is the obvious course of action to adopt, and any sculptor would be worried if his work failed to elicit this primary reaction. But because museums, in their inevitable concern over the damage which repeated touching can do, normally forbid tactile engagement of any kind, I felt inhibited to the point of outright embarrassment when confronted by the first item in the show, Maillol's lifesize *Venus with a Necklace*. I was being required to feel this bronze nude in an uncomfortably self-conscious manner, as if an official had ordered me to make love in public. Maillol's goddesses are available to be caressed in abundance at the Tuileries Gardens, as any tourist in Paris knows. At the Tate, however, it seemed almost voyeurist to even think about handling the Venus's breasts or buttocks – until a couple of blind girls came up and started laughingly to compare the soft valley of her spine with their own more bony equivalents.

Once this initial awkwardness had been overcome, my hands made me aware of elements I never noticed before in fenced-off encounters with museum sculptures. Their range of textures, visible to the eye but not fully apprehensible, now offered themselves to the closest attention, so that the broken modelling of a Degas dancer could be clearly distinguished from the altogether more cylindrical rotundity of a Laurens bather. The increasingly bland and impersonal surface of Hepworth's later work – so paradoxical from a woman who always stressed the sensual qualities she wanted her materials to possess – is very evident in the 1964 *Two Figures (Menhirs)*, a slate piece which looks machine-made rather than carved and should be displayed with one of those 'untouched by human hand' guarantees.

I also became conscious of the relative temperatures of different materials: where the green hornton stone Moore used in his 1938 *Recumbent Figure* was warm to the touch, despite the weathering to which its pitted skin had been exposed, the serpentine stone employed by Epstein in his African-inspired *Female Figure in Flenite* was colder and, correspondingly, more smooth in its slopes and fertile curves.

Anyone able to see Epstein's carving understands at once that it is an image of pregnancy; but it is questionable whether a solely tactile examination would tell a blind person as much, since the swollen hump of her stomach feels surprisingly modest when it is traversed by hand. Conversely, other exhibits can only be comprehended properly with the help of investigative fingers. Laurence Burt's welded steel *Helmet I*, for

instance, possesses a fairly complex interior which is too dark and hidden behind the menacing frontage to be fully visible, and the same applies to Moore's related *Helmet Head No. 6*, with its sentinel-like inner form lying exposed but partially available to the touch alone. Such pieces imply the sculptor's willing permission to roam freely within them, not only to aid a comprehensive appreciation of their total structure, but also to emphasize that an observer can get closest to the act of making by handling the work in much the same way as the sculptor must have done.

Besides, the four Degas statuettes, all but one of which show women caught up in a set of informal attitudes like resting hands on hips, peering at the sole of a foot and pulling on a stocking, are intimate and animal enough to deserve our fondling. They are not intended to be treated as awesome or hallowed works of art, and their infectious spontaneity suggests that Degas – whose own eyesight was deteriorating into blindness when he modelled them in wax – drew comfort from their surrogate ability to stand in for the nubile dancers he was once capable of savouring with his acute powers of observation.

By stopping short only of allowing us to pick up these little bronzes and carry them away in our pockets, the Tate's Education Department and its enterprising Assistant Keeper, Terry Measham, go further than they have ever done towards counteracting the barrier which museums always erect between art as it ought to be dealt with and art as it is processed for our consumption in an institutional context. Measham originally wanted the entire exhibition to be blacked out, so that visitors with normal eyesight would be presented with an experience akin to the darkness of the blind. As it is, the lighting is subdued, playing down individual colours to the point where they cease to have much importance. But even if the light was at its usual level, this show would be equally rewarding for blind and non-blind alike.

It proposes a model for ways of presenting sculpture and other touchable media which should be taken up and implemented on a more permanent basis, for there is no conceivable reason why selected objects ought not to be accessible to our hands at any time. The Tate's Conservation Department, which is notorious for the strictness of its regulations, apparently does not consider that many items in the collection could be exposed to this degree of contact. And although every visitor is required to go through a cleansing ritual of soap, water and talcum powder before approaching the exhibits – rings and other jewellery must be taken off fingers, too – a number of works have already been banned to the non-blind because of damage inflicted during the first few days of public sampling. I am afraid, however, that the Tate may be over-circumspect in its attitude

137. Visitor exploring Henri Laurens' *Bather (Fragment)* at *Sculpture for the Blind*, Tate Gallery, London, 1976

towards conservation. Does it *really* matter that much if the Laurens *Bather* has had the patina rubbed away on her nipples? I am sure Laurens himself would have taken this loving form of erosion as an apt compliment, and the *Bather* looks sufficiently robust in construction to withstand even the most lusty depredations which her admirers could inflict. Plenty of sculptures positioned in outdoor locations are exposed to the vagaries of climate, bird lime and inquisitive hands, and *Eros* does not seem to have suffered as a consequence. For the sake of the penalised blind, and the rest of us as well, I hope the democratization of the nation's art will be carried beyond this one, very welcome, initiative.

CRUMBS FROM THE QUEEN'S TABLE
7 February 1977

Although everyone knows that the Queen owns one of the largest and most magnificent art collections ever to be assembled anywhere in the world, no one outside a privileged royal circle is able to look at the treasures it contains in anything like their entirety. The Silver Jubilee Exhibition of pictures by masters like Titian, Rembrandt, Duccio and Monet, just opened at the Queen's Gallery, is a pleasant enough survey which traces the formation of the royal collection from Tudor times right up to the present day. But the Queen's Gallery itself, a modest and somewhat cramped space which occupies half of a Buckingham Palace chapel originally built for Queen Victoria in 1843, cannot hope to house anything more than a fraction of the collection as a whole. Sir Oliver Millar, the Surveyor of the Queen's Pictures, admits in the catalogue of the present exhibition that 'it would scarcely be possible in so small a compass to give a true impression of the riches of the Queen's collection'.

So where can her loyal subjects go, after they have paid their 30p to see the 146 items assembled at the Queen's Gallery, to view the full 'riches' of the royal pictures? Their options, as it turns out, are surprisingly limited. Windsor Castle houses a small selection of the paintings and an equally modest amount of drawings. At Hampton Court another smattering, crowned by Mantegna's superb *Triumph of Caesar* cycle now memorably installed in the converted Orangery, is available to anyone who takes the labyrinthine tour through the apartments. A number of the best and most fragile Hampton Court pictures, including paintings as outstanding as Gentile da Fabriano's *Madonna and Child with Angels* altarpiece executed for a Florentine church in 1425, have been transferred on indefinite loan to the air-conditioned safety of the National Gallery. And the monumental series of Raphael tapestry cartoons, which Cromwell bought for £300 at the sale of Charles I's collection – unrivalled in its day and, ironically, sold by the order of Cromwell himself – have been on view at the Victoria and Albert Museum for many years.

Apart from these familiar portions, however, it is more or less impossible to gain access to a comprehensive viewing of the collection in its entirety. Scholarly catalogues have been, and continue to be written on aspects of this royal iceberg, only the tip of which is permanently visible to the public gaze. But the majority of art works remain secluded behind the imperturbable façade of Buckingham Palace where, carefully pre-

served and enjoyed by nobody except the occasional favoured guest, they are let out in tiny quantities to the Queen's Gallery for special exhibitions. This system, the inauguration of which in 1962 was hailed as a gracious gesture by a monarch anxious to share her booty with the rest of the nation, has turned out to be no more magnanimous than throwing left-over crumbs to the ducks. Every year a new selection of items surveying themes like *Royal Children, George IV and the Arts of France*, or *Animal Painting from Van Dyck to Nolan*, is unveiled to the public, who duly go along to stare at marvels they have never seen before and are never likely to see again. Under-publicised, and displayed in a gallery which makes only a half-hearted attempt to identify itself to people searching for it around the side of Buckingham Palace, these exhibitions vary wildly in quality and interest. Whereas the *Dutch Paintings* show held in 1971–2 understandably holds the record attendance figure of 240,000, this must be compared with an equally understandable but pathetic 20,000 when *Stamps from the Royal Collection* were installed in 1965–6. And although it may well be that 25,000 visitors is all the Gallery can expect to attract when it puts on surveys as dull and jingoistic as the 1967–8 *Royal Review of the British Soldier*, the fact remains that their presence in the gallery excludes from view a whole range of crucial pictures which should never, ever be allowed to languish unseen in Buckingham Palace.

What exactly are these pictures? It is very difficult to gain a comprehensive notion, and when I asked the press office at Buckingham Palace how many works of art the royal collection contained, my request was greeted with genteel incredulity. But several of the Queen's Gallery exhibitions have given enticing indications of their quantity and quality alike. The *Dutch Paintings* show, for instance, included no less than six Rembrandts, most of which count very high in his work: an early but meditative portrait of his mother, the monumental *Shipbuilder and his Wife*, the *Lady with a Fan*, and *Christ and the Magdalen at the Tomb*. Add to that a superb Vermeer, three lyrical Cuyps, a commanding Hals portrait, two first-class de Hoochs, and masterpieces by Ter Borch, Ruisdael and Steen among many others, and you have a representation of seventeenth-century Dutch painting worthy of any major museum.

Nor does this even begin to exhaust the resources of the Queen's collection. At the drop of a hat (or perhaps a tiara) it would be possible to mount substantial surveys devoted to the work of one artist alone: Rubens, Gainsborough, Canaletto, Van Dyck, Leonardo, Holbein, the list is seemingly limitless. In 1972–3, for example, 181 prime drawings by Michelangelo, Raphael, Leonardo and their contemporaries were displayed at the Queen's Gallery, selected from a staggering total of more

than 1,200 drawings by Italian artists of the sixteenth century alone. The overall value of the collection is well-nigh incalculable, and if it was ever grouped together under one roof and opened up for our inspection, the result would be a sensation.

In such a context, it is little short of scandalous that the public are not granted access to this sumptuous hoard. Although technically the Queen is the legal owner of all these breathtaking pictures – and I have no room here to enumerate the furniture and other applied arts which the collection also encompasses – protocol ensures that neither she nor her descendants will suddenly decide to sell them off for a kennel of corgis and a stable of polo-ponies. And since the cost of maintaining the various buildings which house the pictures is borne by the taxpayer, why on earth should we not be allowed to view the objects we pay to preserve, whenever we like? If a special gallery section of Buckingham Palace were to be opened to the public, free of charge and on a permanent basis, the Queen's Gallery record of 240,000 visitors would be multiplied in a matter of months once people had heard about the extraordinary wealth of art elsewhere in the Queen's London home.

I am not necessarily arguing that the Queen sacrifice every one of her possessions to public viewing: the pictures could be hung on a rotating basis, and so she need hardly put all thirteen of the paintings which Stubbs carried out for the Prince of Wales in the 1790s on show at the same time. But at the moment, only one of those Stubbs pictures – a wonderfully spirited canvas of William Anderson with two saddle-horses, which makes one long to see more paintings from this series – is viewable at the gallery. And it does seem an appalling nonsense that the British royal collection is not as available as its French or Spanish equivalents, which are displayed for everyone to enjoy at the Louvre and the Prado respectively. I cannot imagine that the present royal family would feel cruelly deprived if such a move were made. Neither the Queen nor the Duke of Edinburgh is well known for a love of art; their own additions to the collection have been very modest and sporadic; and the Queen, after all, only spends a third of her time in Buckingham Palace, where the major part of these treasures is stored.

Besides, the advent of the Jubilee would seem to offer an appropriate moment for the royal family to prove its supposedly democratised willingness to let the people savour far more of the pictures than can ever be let out, through the back door, at the Queen's Gallery. A small step in that direction is being taken in March, when the Royal Academy opens an exhibition called *This Brilliant Year*, consisting of 'great and royal' Victorian paintings drawn largely from Buckingham Palace, Windsor,

Balmoral and Osborne. The Academy has already explained that 'perhaps one of the most exciting aspects is that a large proportion of these works have never been seen by the public, nor have they been reproduced, and so they are almost unknown'. But the loyal affiliations of the show's organisers naturally prevent them from going on to deplore the fact that these pictures have so far been hidden from view, and that they will presumably return to the same obscurity after the exhibition ends in July.

I would suggest that tender royalist discretion must not be allowed, for one moment longer, to prevent us from demanding a more enlightened attitude, both from the Queen and from those who advise her on how best to deal with the collection she has largely inherited. If the royal fam-

138. The original Queen's Gallery at Buckingham Palace, London

ily wants to ensure that it survives to witness another round of jubilee celebrations in the future, it should take the elementary step of sharing all those hoarded possessions which ought – in the name of any genuinely egalitarian society – to be available to us all.

THE FIRST HAYWARD ANNUAL
26 May 1977

In choosing exhibitors for the newly inaugurated Hayward Annual, which will attempt each year to 'present a cumulative picture of British art as it develops', Michael Compton admits that he has been guided by a 'flagrantly partial' enthusiasm for 'the artists I know about and believe in'. The same priority was upheld by his co-selectors, Howard Hodgkin and William Turnbull, and all three men have been quite open about their willingness to plump – 'within our knowledge and prejudices' – for the artists they admire most. If the result inevitably looks like a backslapping old boys' reunion, in which Hodgkin and Turnbull were 'encouraged' to display their own work, the organisers cannot be blamed. They have, admittedly, aroused justified feminist ire by including only one woman among the thirty artists chosen for this two-part instalment, and to make matters worse she turns out to be Turnbull's wife. But in promoting themselves and their friends with such astonishing thoroughness, they are simply carrying out the brief which the Arts Council expected them to fulfil.

Given these ground-rules, it does seem necessary to question whether the Hayward Annuals ought to be dominated just by a set of rudimentary 'I-know-what-I-like-and-I-like-what-I-know' criteria. And in the event of such a policy continuing, we must ask: who selects the selectors, and what kind of interests do they represent? The cursory catalogue introduction offers no clues as to the voting mechanism (if any) which gave Compton, Hodgkin and Turnbull the go-ahead to indulge their every preference. But it is a fact that all three men stand, in their various ways, for the British modern art establishment. Compton exerts enormous influence over major, official exhibition policy, not only at the Tate Gallery where he is Keeper of Education and Exhibitions, but also at the Arts Council, where he is a member of the Exhibitions Committee which determined and approved the Hayward Annual series. Hodgkin

and Turnbull both show at the recently merged Waddington and Tooth Galleries, now the most powerful dealer in contemporary British art and a conglomerate which seems to be expanding its empire all the time.

What does this background information have to do with the character of the 1977 Annual? A great deal. As many as seven of the fifteen artists included in Part One are permanently attached to Waddington and Tooth, and two of the others have shown with Leslie Waddington in the past. Walking round the survey is therefore oddly akin to visiting the W & T premises in Cork Street, and indeed I have already seen a surprising amount of this Annual on view there in successive one-man shows. The impression of a shop-window for one London dealer is unfortunately inescapable, prompting me to propose that the Hayward Annual ought, on the contrary, to be an event where the many artists *not* fortunate enough to be backed by the West End dealer circuit have a chance to air their work. If this means that an open submission system should be set up, whereby anyone can enter their work for a jury selection, then so be it. Such a system may lead to a far more ragged and uneven show than the bland assembly displayed there now, but at least it would escape from the cosy image of a charmed circle maintaining a stranglehold on all the principal exhibition outlets beyond the Royal Academy.

For the truth is that, with the exception only of Hamish Fulton, Nigel Hall and Keith Milow – none, significantly enough, within the Waddington and Tooth camp – the contributors to Part One made their reputations either in the late 1950s or early 1960s. 'No artist has been included because he or she is little known or needs to be encouraged', Compton explains in his terse catalogue introduction, thereby accounting for the strong period flavour of the collection. Visitors hoping to find out something about the work which adventurous young artists are producing in this country today will be sorely disappointed at the Hayward. Fulton, whose romantic landscape panoramas seem to look nostalgically back at the great age of Victorian topographical photography, is as much in love with the past as Hall and Milow, both of whom are fond of openly referring in their work to the influence of a previous generation.

But no one could be quite as locked in a 1960s time-capsule as Peter Phillips, whose formidably proficient hymns to big cars, expensive sex-object blondes, Elvis and machinery seem trapped forever by a fascination for admass and the boom economy. His large, hard, frighteningly materialist paintings do their best to pretend that nothing has changed for fifteen years, just as Nicholas Monro's joky fibreglass figures of an effete cowboy or tumbling waiters are still allied to the old Pop notion

that kitsch can be reclaimed for 'high' art. He manages merely to look whimsical and over-frenetic, while Bernard Cohen's paintings suffer from a comparable desire to assail the viewer with a plethora of gaudy bric-à-brac. He is like an artist who, confronted by the realization that he has nothing new to say, resorts to a frantic form of embroidery and ends up with the painter's equivalent of a Victorian screen covered in transfers. By contrast, John Hoyland's abstracts are forthright and unfussy, reminders that vigorous attack is elsewhere virtually absent from an exhibition where even Allen Jones's shameless leather-fetish chauvinism has lost its bounce.

The handsome white compartments, which give each participant plenty of space to show an adequate body of work, tend at the same time to neutralise the exhibits and make them appear unhealthily concerned with stylishness for its own sake. Anthony Caro's two sculptures are, for all their physical dimensions, full of dandified blooms of colour, throw-away gesturing and a playful attitude towards steel. Both he and Turnbull appear to be marking time, as opposed to Patrick Caulfield's steady enrichment of a by now supple idiom or Kenneth Martin's continuing ability to extend his chance and order dialectic as he grows older. Martin is the most senior artist in the show, and yet his open-ended willingness to acknowledge the principle of change makes him look like the

139. Nicholas Monro, *Waiters' Race*, 1975, one of the exhibits in *Hayward Annual Part I*, 1977

youngest contributor. Part Two of this first Annual, which will open at the Hayward on 20 July, had better make amends for its forerunner's middle-aged spread. But judging from catalogue illustrations of two large paintings which Peter Blake plans to show there, both commenced in 1964 and 'still in progress', I have my doubts.

Peter Blake was so incensed by criticisms of this exhibition that he hung, in his contribution to Part Two of the 1977 Hayward Annual, a framed 'open letter to three art critics' – Paul Overy of The Times, *Caroline Tisdall of* The Guardian, *and myself. He attacked us for our hostile reaction to the Annual, and claimed that the Waddington & Tooth gallery 'is the largest in London, with a number of the best painters and sculptors in the country, so it would seem logical that a high percentage of the artists in this show might be with the gallery.' He also revealed his dismissive attitude towards younger artists by insisting that 'anyone who is likely to be in this exhibition, is also very likely to have worked during the sixties.'*

When Blake's letter was published in The Guardian *on 20 July 1977, alongside my unrepentant reply, the newspaper's correspondence columns were filled with so many heated letters about the controversy that* Art Monthly *concluded: 'there probably has never been such a flourishing contemporary art correspondence.' It was bitterly expressed on both sides, bringing into the open a profound rift between established interests and those working for change in British art.*

SOUNDING THE ALARM

THE DECLINE OF THE RADICAL CARTOON
19 May 1970

Like a butterfly in high summer, that dazzles and amuses for a brief, hectic life-span before fading away to an untimely death, the newspaper cartoon seems doomed to disappear as surely as the events which inspired it. Forced into existence by the voracious demands of a journalistic deadline, and dedicated to the most topical of issues, it ends up as the stale reminder of yesterday's news peering out through the stains of a crumpled fish-and-chip wrapper.

Nothing is more tedious than annotating the precise meaning of a gallery of caricatures, a political scandal or an esoteric *cause célèbre* in the hope that a cartoon will retain its humour. So much of its impact depends on a knowledge of current headlines – a cabinet reshuffle, a heart transplant or the dangers of the Pill – that its full message is destroyed by the advance of time. A large part of the public's enjoyment of a cartoon derives from the pleasure of recognizing the reference, joining in a conspiracy of understanding with the cartoonist as he builds up his own personal vocabulary of Nixon's noses, Wilson's wiles and Heath's teeth. Dispense with this instantaneous comprehension and the cartoon rapidly becomes a bore, its vivacity and lightness of tone rendered unbearably ponderous. Shades of meaning, elaborate allegories or ingenious symbolism soon degenerate into obscurity, and there is no reason why anyone should take on the tiresome task of reconstructing the necessary historical framework to elucidate outworn old jokes.

What hope, then, for the unfortunate cartoonist, when the odds are loaded so heavily against his work retaining its relevance? The question is begged by a comprehensive survey of newspaper cartoons at the National Portrait Gallery, its witty title, *Drawn and Quartered*, appearing to refer to the cartoon's built-in obsolescence as much as to its ability to dissect the happenings of the day. Doubt is implicit in the very style of the exhibition, with its reliance on films of cartoonists at work, flashing images of a day in the life of Giles on multiple screens, and Vera Lynn belting out 'We'll Meet Again' every five minutes on a recorded tape. The attempt to inject some fun into the show seems at first somewhat strained, as if the organisers were determined to avoid weighing the whole display down with lengthy explanations and academic footnotes. The dilemma is particularly apparent in the second room, conceived as a darkened circus tent where slides are projected in quick-fire succession on the upper perimeter of the walls. The idea pays handsome dividends. A photograph of Chamberlain's fateful

post-Munich press conference is followed by a carefully selected series of cartoon reactions to the blunder, ranging from *Punch's* jingoistic John Bull shaking the premier by the hand and praising his moral rectitude, through to Low's trenchant damnation of the treaty. The whole spectrum of contemporary British opinion is brought movingly back to life: the *Punch* drawing helps us to understand how the nation was fooled into believing in Chamberlain's weak-kneed bargaining, while Low's dramatic portrayal of the broken Prime Minister retreating from the conference-table with Britannia limping on crutches can be seen as a prophetic and devastatingly acute summary of a tragic political mistake.

The cartoon needs this kind of imaginative resuscitation, and if the historical event is important enough, it is still possible to respond to the power of the cartoonist's satirical attack. But down below the flickering slide-show, on the walls of the tent itself, several densely packed ranks of framed drawings bring back all the old problems. The temptation to let the eye skim hurriedly over these comments on controversies long since settled and forgotten is a strong one – only a pedant would have the patience to research every nuance of feeling contained in these outdated images, and even then he would be hard-pressed to squeeze a whole-hearted laugh out of them. Only occasionally does an outstanding cartoon impress with its astonishing insight into the real implications of an event. Will Dyson's penetrating comment on the 1919 Versailles peace agreement, for instance, where Clemenceau, departing from the meeting, is arrested by the sound of a naked child weeping in a corner, sums up the mistakes that would eventually lead to another world war – the child is labelled, with uncanny accuracy, '1940 Class'.

The cartoons that succeed in retaining some of their original force are, in fact, the work of radical, left-wing minds who were never afraid to plunge into extremism. Will Dyson is one of the heroes of the exhibition, with his committed front-page drawings for the *Daily Herald* showing a consistent concern for the oppressed worker, the suffragette and the pauper. If many of the wrongs he exposed here have since been righted, the quality of his conscience is timeless; and the problem of poverty and hunger is still as relevant now as it ever was at the beginning of the century. There is a palpable pleasure to be gained, too, from the force of his whiplash line, sprawling over the page with a spontaneity that puts many present-day draughtsmen to shame. Coming as he does immediately after the studied deliberation of the high Victorians – Tenniel's style is as respectable and dignified as the moral virtues extolled in his cartoons – Dyson's executant vitality can be seen as a remarkable innovation, full of much-needed freedom and panache.

The great Globe itself and all which it inherit, is too small to satisfy such insatiable appetite

140. James Gillray, *The Plumb-pudding in Danger; or State Epicures taking un Petit Souper*, 1805

The exhibition performs a valuable job by reinstating reputations like Dyson's, which have remained in the shadows far too long. And it points out, more disturbingly, how mild-mannered contemporary cartoons are compared with the uninhibited vision of James Gillray, that great pioneer of political and social satire. His marvellous picture of Napoleon and Pitt carving up the plum-pudding of the world is a masterpiece of caricature, combining wit, perception and a positively surrealist fantasy in equal measure. Gillray's conception of the globe as a culinary delight, which imperialist leaders seize on with epicurean glee, is an inspired conceit in itself, and the act of slicing it into pieces is a savage metaphor of human greed. Pitt approaches the feast with characteristic English propriety, calmly and fastidiously appropriating a large portion of the oceans aided by a knife and Neptune's trident. Napoleon, by contrast, attacks Europe with malicious delight, bending over the table, eyes staring, as he gouges out a hefty chunk of pudding with a vicious military sword. Everything in the composition is faultlessly executed, carefully thought-out and harmoniously balanced – and yet it is infected at the same time with a wild, high-flown sense of the absurd. The madness ought to contradict the sanity of Gillray's professional

artistry, but it does not. Instead, the two abilities cohere and produce a memorable testimony to man's insatiably acquisitive nature. We can see, now, the truth of his comment on imperialist aggression more plainly than perhaps his contemporaries could at the time. His imaginative vision may be extreme, but it is no more nor less horrifying than the reality of history. No cartoonist has since proved himself capable of equalling Gillray's passionate insight into evil in all its grotesque manifestations.

Most of the other cartoons in this exhibition appear conventional, even polite, beside the ferocity of this magnificent colour-print. Perhaps the price of such an obsessive concentration on the dark side of life is too heavy for other cartoonists to pay: Gillray eventually went mad, and tried to commit suicide by throwing himself out of a window. His grisly fate is not to be wished on any other practitioner of the art, but the rest of the cartoons in the show would have increased staying-power if they encompassed a little more of Gillray's manic commitment to the implications of world events. Only a great interpretative mind can lift the cartoon out of the rut of the everyday, and invest it with qualities that are impervious to the passing of time.

THE NEED TO DISPLAY ART WITH FLAIR
26 November 1971

However much I deplore the dogmatic, bullying way in which Lord Eccles has forced our unwilling museum trustees to accept his entrance fee proposals, his insistence on the value of improved buildings and display techniques does remain timely. Not that new methods of presentation should ever be regarded as *more important* than acquisitions: the Minister for the Arts is horribly wrong if he thinks our stock of great art does not contain serious gaps. But he is certainly correct in implying that nothing, not even the most exciting treasure, can ever come properly alive unless it is exhibited with flair and imagination. And these are precisely the qualities which most of London's major galleries lack. In a few places, sustained attempts have been made to show off works of art with the care they deserve. Yet the results, if at the National Portrait Gallery, are regarded as gimcrack showmanship; and if at the British Museum, astounding miracles. There is, of course, nothing in the least miraculous about the new Ethnographic room at Burlington Gardens: its contents

demand the modern display which has been installed there, and we should not consider this setting as in any sense exceptional. Rather should it be the norm – and the fact that it is not highlights the sorry state of affairs at all the other national institutions.

Take the National Gallery, where chronic overcrowding will in a few years be relieved by the completion of a recently announced new extension. Will the access of this extra space really inject some vitality into the gallery's presentation of its masterpieces? I doubt it. The rooms already modernised within the existing building are conspicuous for their lack of sensitivity towards the exhibits hanging on the walls. In the early Italian section, for instance – which the visitor usually enters first and therefore judges most acutely – the wonderful panels by Duccio, Sassetta and their contemporaries are placed in an environment that can only be described as clinical. Sophisticated lighting devices, designed above all to protect the pictures from the damage of daylight, impose a disturbing haze of artificiality over everything in sight. It seems to veil the paintings rather than show them off; and my immediate impulse is always to take them down and carry them outside for a proper look, like the shopper who has to escape from his neon surroundings to discover the real colour of a garment he plans to buy.

The shortcomings do not end there. For how can such panels, originally executed as sacred images to be hung in the intensely devotional atmosphere of a church or private chapel, ever be fully understood without some indication at least of their proper context? It would not be easy avoiding whimsy or melodrama in the attempt to provide that context, but experiments ought surely to be made. At the moment, the only exhibit which has been displayed with any real understanding is the Leonardo cartoon. Why cannot other items be given similar attention, by curators who realise that every great picture inevitably poses its own presentation problems? Masaccios and Monets are the product of totally different cultural forces, and a flexible framework should be devised to acknowledge this diversity. After all, when the passage of time eventually allows the disruptive elements of modern art to penetrate the National Gallery's portals, the need will become still more apparent.

Foreign visitors might well enquire, too, why none of us has ever bothered to complain about the quite scandalous viewing conditions at the Wallace Collection. Here, in surroundings which should be ideally suited to the enjoyment of Lord Hertford's magnificent bequest, masterpieces by Watteau, Fragonard, Rubens and Delacroix can only be glimpsed with difficulty behind their glass coverings. The large pair of early Rembrandt portraits must be the least-known of his paintings

141. The Courtyard at Somerset House, with parked cars

in the country, despite their accessibility: they are so dark that the spectator finds a mirror-image staring disconsolately back at him whenever he tries to peer through this protective barrier. The reason is that absence of air-conditioning means the pictures have to be protected in this way; but why was this fault not remedied many years ago? The Wallace Collection was given to us, and we should honour the gift by looking after it with all the expertise at our disposal. The glass must be dispensed with immediately, and a concerted programme of cleaning and restoration instituted as well. Anyone who doubts the urgency of these proposals should go to Hertford House and examine Velázquez's *Lady with a Fan*, a portrait every bit as superlative as his *Juan de Pareja* sold recently at Christie's. Or rather, it *would* be as fine, if we all woke up and insisted that this grimy, frighteningly cracked canvas was rushed away for an emergency operation without delay.

The catalogue of horror is endless, and I could easily extend it to chart the inadequacies of our other national repositories. But it is more pertinent to emphasise how the *Evening Standard*'s current campaign to convert part of Somerset House into a gallery might serve as an exemplar of constructive change. Some sceptics consider that a Georgian palace cannot be converted into a first-class exhibition arena. They are wrong. The most cursory visit to the Grand Palais in Paris, where two large exhibitions of

Bacon and Léger have now been mounted, will show how an old building can be so radically transformed that it becomes a superbly equipped modern gallery. By moulding their nineteenth-century palace into an efficient machine, complete with close-circuit television, cinema, library and restaurant, the French have gained something ten times as desirable as our much-vaunted Hayward Gallery.

Somerset House does not necessarily have to be treated with such lavishness, but it remains true that large prestige international shows could conceivably be staged with great effect in the Strand. Alternatively, it might just as profitably be used as the showcase for British art which London has always wanted. Turner, who left his vast horde of paintings and watercolours to the nation on the express condition that a special gallery be erected to house them, could at last have his wishes granted. And it would be equally gratifying to see the wonderful store of Constables now uncomfortably isolated at the Victoria and Albert Museum transplanted to surroundings which celebrated their merits more resoundingly. These are just three of the possibilities Somerset House encourages us to consider: but whatever solution is ultimately adopted, one thing is clear already. Much remains to be done before we can claim that our national heritage is shown off with the panache it so desperately needs, and Somerset House could take the initiative. That, surely, would be achievement enough.

THE ART COLLEGE MALAISE
22 June 1972

It is, in one sense, no indictment of the diploma shows now on view at London's leading art schools to say that they bear the heavy imprint of established styles all over them. Students are by definition impressionable, and they can hardly be expected to assert their personalities with an independence which normally remains the prerogative of maturity alone. But there is a vital difference, all the same, between aping the received ideas of older men and submitting their achievements to the acid test of your own private needs and aspirations. The distinction becomes all-important when college exhibitions are surveyed, and it has to be said that this year's crop appears to possess only the haziest notion of the gulf separating imitation from creation. Not that any of the par-

ticipants would be prepared to entertain such an accusation: no self-respecting artist *consciously* sets out to execute work which pays servile homage to standards laid down by a senior generation. *Unconsciously*, however, almost every one of them has ended up conforming to an image of the student's role which the existing college environment inevitably cherishes.

Going round the diploma offerings, a rigid compartmentalization is at once apparent: little notices direct the visitor to Painting, Sculpture, Printmaking, Graphics, Textiles and all the other separate departments with which the students are expected to align themselves. And inside each section the products on display dutifully mirror the classification they fall under, with scarcely a hint of interdisciplinary movement or cross-fertilization. Everybody, it seems, has plumped for one exclusive activity; and once the decision is made, the student soon begins to think along the well-worn lines implied by the very existence of the department in question. There is very little sign, anywhere, of the searching inquiry into priorities and function which distinguishes much of today's most positive art. Neither is there any real evidence that the exhibitors have ever thought about questioning the continuing viability of the media they employ. Instead, they seem content to assume the mantle of 'painter' or 'sculptor' wholesale, hauling out the canvases and brushes, the welded metal or the fibre-glass and settling down to make the kind of objects which their adopted profession has always regarded as appropriate.

Working safely within a given tradition is no sign of weakness in itself, so long as the premises on which it is based have been rigorously considered and understood. But when such an acceptance is unaccompanied by any demonstrable proof that the dangers of embracing tradition for its own sake have been avoided, conformity begins to look suspiciously like complacency. And to judge from the various diploma shows I have visited over the past week, this is precisely the snare which has imprisoned the vast majority of their contributors. Wherever I went, one over-riding direction prevailed in the painting departments: a return to figuration, often of the most literal and straightforward nature. Room after room of life-class nudes, standing, sitting or sprawling in studio settings, proliferated in each college, all anxiously attempting to transcribe the tones and contours of a model's sagging flesh. Or else there were portraits of suburban families, the artist's friends motionless in misty interiors, domestic still lives arranged on mantelpieces and lyrical landscapes based on conventions which even the Impressionists rejected.

Occasionally, the odd glimmer of a personal imagination stood out –

Kevin Burrows at the Royal Academy, leaning on a curious mixture of Magritte and early Lucian Freud but managing at the same time to assert a vision of his own; and Christopher Moore at the Royal College, using a painstaking pre-Raphaelite technique to explore the minutiae of a landscape or the witty, sometimes poignant overtones of animal life. On the whole, however, no one was able to reveal with any conviction the reasons for retreating towards realism: they did not add a new dimension to its expressive possibilities, or suggest that the woolly stylistic clichés they employed could somehow become relevant again. The preponderance of lifeless academicism was often so stifling that I began to wonder whether some time-machine had not whisked me back from 1972 to a more insular and reactionary age. Most of the Royal Academy students would not have looked at all out of place among their elders in the Summer show upstairs; and a disheartening number of painters at the Slade were behaving as if the Euston Road School was still the most potent force in English art today.

No comfort could be derived from the abstractionists, either. Although it was a relief to come across pictures which felt able to move beyond the pervasive obsession with Truth to Appearances, they likewise appeared to be marking time. Even the toughest and most resourceful of them – John Fairbank in the Royal Academy canteen, Michael J. Bennett and Dave Taborn at the Slade postgraduate show – gave no indication of genuinely extending preoccupations which have been explored both in America and England for well over a decade. And most of the other abstract paintings looked like arid exercises, performed by timid conservatives who prefer to reiterate rather than push on towards statements which could renew the language they used.

The same desultory feeling of hiatus permeated the sculpture shows, too. The Royal College's contributions were typical here: each student operated within a tired convention, from Billy Lee's kinetics and John Alder's hybrid symbolism through to Harvey Hood's four-square constructions in steel and wood. Roderick Coyne's multi-media projects did at least evince some determination to go beyond physical objects and explore the possibilities of a more conceptual approach, and yet his initiative was not paralleled anywhere else. A wealth of different materials was brought into play by the Chelsea sculptors, it is true, but this freedom only encouraged a brand of whimsical over-elaboration which dissipated all its energies in picturesque flourishes – the curse of so much British art.

It was a relief, after such displays of frothy emptiness, to come across Nick Raynsford, who had decided to forget about these stylistic games

142. John Alder's *Sphere* at Royal College of
Art, London, 1972

and concentrate on an alternative scheme for the new World's End hous-
ing development. He rightly damned the existing project as a 'disastrous'
folly which 'will be all but intolerable for the people who will have to
live there'. And I warmed to his belief 'that artists should be increasingly
involved in the design of the environment, and also that this offers one
channel at least where the barriers which divide the vast majority of
people from the small "artistic" minority can be broken down'. Here was
a student who had managed to escape from the narrow cul-de-sac
inhabited by most of his contemporaries.

After so much disappointment, I began to conclude that the colleges
are now actually paralysing adventurous developments by keeping the
students inside a structure which no longer serves to encourage impulses
to rethink standpoints, and move outside the old divisions between alter-
native media. Hence the chronic rigor mortis affecting so many of their
exhibits, and hence also the decision taken by a Chelsea painter, Brett
Bailey, to disown all his college work and display in its place an essay set-
ting down his profound disillusion. 'At the end of four years of formal art
education, I find myself unwilling to accept and unable to believe in the
tradition to which I have been exposed', he writes, hitting out at what he
feels to be the artist's 'institutionally defined' status. 'Most of the work I
have done I now believe to be based upon biased conventions and

unchecked assumptions, accepted by me temporarily in an attempt to embrace the role of artist'. Accordingly, Bailey has formally rejected the criteria of the diploma show; and although his action is a purely negative one, my own experience of this year's graduates prompts me to sympathise with his defiant stand against a system that threatens to squash all trace of experiment out of the artists it is supposed to foster.

THE POLITICAL MANIPULATION OF ART
4 January 1973

The exhibitions opening today at three major London galleries may be trumpeting forth a loud and extravagant 'Fanfare for Europe', but I would like to blow a disenchanted raspberry at the motives behind them. For at a time when all our museums are crying out for bigger grants, more staff and new buildings, and when their trustees are being blackmailed by Lord Eccles to accept the disgraceful imposition of entrance charges, the Government suddenly pours money into some spectacular shows simply because they score a political point. If the Foreign Office had been allowed to implement the full Hollywood vulgarity of its project, works as precious as the *Mona Lisa* and *The Night Watch* would have been endangered by a journey to England. The Louvre and the Rijksmuseum quite rightly refused the request to send prized exhibits to London; but they did agree, along with museums from the other member nations, to send scarcely less important possessions to a meaningless array of *Treasures from the European Community* at the Victoria and Albert Museum. None of the works assembled here ought ideally to be moved, however worthwhile and scholarly the cause. How, therefore, can the Government justify this miscellaneous jumble of nine paintings, sculpture and *objets d'art*, which have been brought together for no better reason than to celebrate the enlargement of a trading club?

In his foreword to the exhibition catalogue, Sir Alec Douglas-Home declares that it enables us to 'see examples of our common European culture over more than a millennium of our history'. But what on earth does he think is displayed in far greater depth, and at no extra expense, within the permanent holdings of our own national collections? The Foreign Secretary would have us believe that 'all these works have been chosen by the governments of the European Community to represent an aspect of

143. Michelangelo's *Bust of Brutus* on display at the Victoria & Albert Museum, London, 1973

what their countries have achieved'. And yet the show itself reveals those lofty-sounding sentiments to be no more than empty bromides.

Why has Italy agreed to ship over Michelangelo's *Bust of Brutus*, the portrait of a Roman who distinguished himself by brutally murdering his emperor and former friend? Does Belgium honestly think that it has demonstrated anything with the loan of a so-called Rubens painting, which may in fact be by Van Dyck and which contains four distinctly non-European studies of a *Negro Head*? In what way is France's

contribution to a bigger and better Market symbolised by La Tour's picture of a *Card Sharper*, who is clearly bent on cheating his corrupt and decadent companions out of every new penny in their pockets? And how on earth do Holland, Luxembourg, Ireland, Germany and Denmark consider that their own future functions are summed up through items as diverse as a portrait of Rembrandt's son in the habit of a Capuchin friar, a medieval Bible from the Abbey of Echternach, an early Christian chalice, Emperor Maximilian II's drinking cup or a pair of Bronze Age wind instruments? The Government presumably imagines that reviewers will be so dazzled by the value and beauty of this eccentric parade that they will fill their columns with paeans of ecstatic critical praise. But I refuse to sit back and analyse works of art when the reason for their presence here cries out to be denounced in the strongest possible terms.

The second exhibition, which gathers together sixteen of Aelbert Cuyp's paintings at the National Gallery, is mercifully conceived on a more sane basis. Cuyp is in my opinion one of the greatest Dutch artists, and his high reputation during the nineteenth century was due almost entirely to the enthusiasm of English collectors. They rescued him from an undeserved obscurity, and it is no exaggeration to claim that the whole development of landscape painting in this country was affected by the magnificent Cuyps which could be studied over here. Take any characteristic picture by Richard Wilson, the Norwich school, Constable or Turner and the influence of this unaccountably shadowy artist from Dordrecht is soon apparent. Unlike Claude, who taught them how to organise their paintings in accordance with highly artificial rules and encouraged a nostalgic feeling for the classical past, Cuyp proved that the same kind of heightened poetry could be extracted from the most humble scene.

Concentrating on views of unexceptional rivers, ordinary farms and low-lying plains, inhabited by the most lumpish peasants and animals, he managed to invest them with an atmosphere at once majestic and beneficent. The unmoving cows, moored ships and horsemen are all reduced to an absolute stillness by the golden light which permeates every square inch of his impeccably organised compositions. Everything, from an ordinary dock-leaf to the contour of a cloud, is transformed into an ideal tranquillity once it has been submerged in this pervasive glow; and nothing – not even the hunter who aims his gun at the ducks in the Marquess of Bute's *River Landscape* – really seems capable of shattering the trance.

Although Cuyp's mood is exalted, he never seems to be cooking up emotions that the subject itself does not deserve. The magic of mundanity is disclosed everywhere, and it is this unforced, democratic vision of a world replete with seasonal fulfilment which must have appealed to the

English temperament. Within the space of no more than fifteen years, Cuyp moved from conventional stillness through to a maturity which unified all the separate components of his early landscapes in one deliquescent envelope of heat-haze and sun-rays, where the encrusted texture of a bull's haunches carries as much dense feeling as the distant silhouette of a sail melting into its own disembodied reflection. No wonder that he seems to have given up painting entirely for the last thirty years of his life: the decision would appear shocking if applied to any other artist, but Cuyp attained such a flawless equilibrium between his internal moods and the external scenes depicted that he was able to put away his brush before he reached forty with a justified sense of completeness.

He provides us with a memorable exhibition, and the connections between Cuyp and England ensure that the choice is appropriate for European entry. But once again, this Government's failure to grant its able organiser more space to assemble the full retrospective Cuyp deserves, and time to write a more substantial accompanying catalogue, should be castigated. There is, quite simply, no good book on Cuyp to which visitors can refer; and by slotting this show into a hastily devised 'fanfare' rather than according it the treatment which an artist of Cuyp's stature deserves, we are left with our highest expectations only partially fulfilled.

These reservations do not, however, apply to the third exhibition, *The Impressionists in London*, which fills the whole upper floor of the Hayward Gallery. Sisley's Hampton Court and Pissarro's Norwood have changed so drastically in the intervening years that their truthfulness now looks like an impossible idyll. But the stretch of the Thames which fascinated Monet and Derain – the other two painters included in the show – has scarcely altered; and their interpretations can be compared with present-day reality in the most rewarding way by looking through the Hayward's panoramic windows. Suddenly, this bullying and infuriating gallery comes into its own, and this is only one unexpected bonus in a survey collected with an efficiency which defeats all the governmental odds mustered against it.

Why could not our own painters have distilled London's misty essence with the acuteness that Monet, Pissarro and Sisley brought to their views of Westminster, Hyde Park, Hampton Court Weir, Penge Station or Crystal Palace in the early 1870s? These pictures now seem to have the fresh delicacy of Impressionism's youth, and look even more fragile against the laboured canvases which Pissarro and Sisley executed later on. Only Monet succeeded in deepening and enriching his idea of London when he returned at the end of the century to paint his prolonged series of Charing Cross Bridge, Waterloo Bridge and the Houses of Parliament. The exhibition organisers have wisely decided to show as

many of these pictures as possible, rather than concentrate on what they consider to be the best examples, and the idea pays off. Monet himself always stressed that the later London paintings were conceived as a unified group, and it is wonderful to watch him turning the murkiness of these Thames views into the kind of dissolving, other-worldly nirvana which he would later discover among the water-lilies at Giverny. The chance to see such paintings *en masse* goes a long way towards atoning for the madness at the Victoria and Albert Museum; but it should never, ever, enable us to forgive the Government's inept and thoughtless handling of the whole sorry affair.

SUMMER CHARADE AT THE RA
4 May 1973

The Royal Academy's new summer exhibition happens to coincide with the 250th anniversary of the birth of its first and greatest President, Sir Joshua Reynolds. What, I wonder, would he think of his institution's latest offering, which was designed by the Academy's Instrument of Foundation in 1768 as an annual event 'open to all artists of distinguished merit'? The answers are fairly obvious. On a statistical level, Reynolds might well have rested content. No less than 8,000 works were submitted for selection this year, from which a resounding total of 1,265 exhibits have been put on view. Such massive numbers compare favourably with the modest 136 items contained in the Academy's first summer show; and the buoyant £100,000 sales commanded by the 1972 exhibition are likewise calculated to appeal to the good Sir Joshua's financial acumen. He would also be gratified to learn that the survey is still the best-attended annual exhibition of contemporary art in Britain – over 60,000 people visited it last summer, amounting to a display of popular interest which the most prestigious Tate or Hayward Gallery event would be delighted to receive. Could Reynolds therefore be at all unhappy about the 1973 instalment, bolstered as it is with the outward trappings of success and public acclaim?

I believe he would be shocked, disheartened and deeply offended, not only by the standard of work on display, but also by the stark fact that pitifully few of the artists most respected by serious, informed opinion in this country have bothered to contribute to the exhibition.

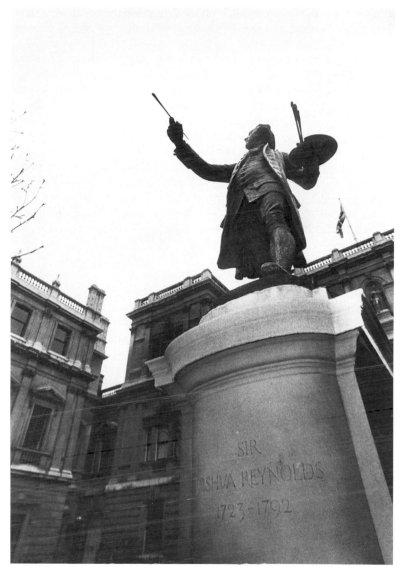

144. The Royal Academy's courtyard with Sir Joshua Reynolds on his plinth

When the Academy originally extended an invitation to men and women 'of distinguished merit', it meant precisely that. Reynolds and his colleagues quite rightly set out to stage an annual review of the very best in British art, and during the next century and a half their aims were more or less fulfilled. Burlington House became the ultimate testing-ground for anyone with true aspirations and talent, and visitors to the summer show could be sure to find a comprehensive parade of the most important, vital work produced at that time in Britain. There is no real reason why the Academy should not perform a similar service today. The range and variety of contemporary art is, of course, far wider and more divisive than anything Reynolds could have predicted. And the rapid growth of alternative outlets for outstanding individuals, through the commercial galleries, has meant that the Academy is no longer regarded as the supreme showcase of London. But the need for a regular, inclusive display of modern British art in its boldest spectrum remains, and Burlington House no longer satisfies it.

This year carries on the sorry tradition established over the past few decades by presenting a segment of modern art so narrow in its hostility to new developments, and so bankrupt in its hollow devotion to principles long since obsolete, that an absurdly irrelevant view of Britain's creative vitality results. It might not, perhaps, be quite so appalling if the exhibitors proved that they pursued their reactionary concerns with fire, energy and a devotion to fine standards of craftsmanship and imagination. But apart from a few reliable old campaigners like Ruskin Spear, who can always be trusted to produce some gutsy, high-spirited paintings, those standards are betrayed at every turn. Reynolds would be dismayed by the feebleness, both in conception and execution, of the formal portraits which seek to cling to the tradition he did so much to dignify. The worst offenders, in this field and in others, are all too often the Academicians themselves, men like A. K. Lawrence, Sir Robin Darwin, Robert Buhler, Norman Hepple, William Dring or Simon Elwes, who have the automatic right to contribute up to six pictures without fear of censure from the exhibition committee. These artists should, by rights, uphold the most rigorous qualities of excellence as an example to the whole exhibition, and they provide the soggy centre that tarnishes the credibility of everything around them.

We are therefore thrown back on the more idiosyncratic artists, whose defiant quirkiness raises them above the slipshod mediocrity so evident elsewhere. The Academy has always possessed its fair share of these odd outsiders. Stanley Spencer was the most mesmeric of them for many years, and it is always worth looking out for the melancholy, sometimes

hysterical visions of everyday doom which Carel Weight provides. William Roberts, that fanatical adherent to a stylised formula he developed for himself so long ago, likewise stands out as a consistent individualist. And Betty Swanwick, whose heavy-limbed, agitated figures fill the page with their gesticulating concern, seems determined to prolong Stanley Spencer's obsessive imagery. But they are the exceptions, and their eccentricity can easily deteriorate into the outright silliness of John Bratby, who has sent in a vulgar triptych of the Royal Family as a demonstration of his inexhaustible appetite for sensationalism at all costs. That such an atrocious piece of cooked-up nonsense can be accepted by the Academy, and hung in a very prominent position as a star item, indicates how low the summer show has sunk. And it cannot set its house in order simply by biting its lip and agreeing to hang fifth-rate examples of abstract painting or sculpture, as a sop to those who complained that it has become a defensive fortress of conservatism.

There will always, presumably, be a demand for traditional work: the sales and attendances prove it beyond all reasonable doubt. But the Academy is not the right place for such a one-sided bean-feast. Here it stands, right in the middle of London, with the most handsome suite of galleries in the country rented at a peppercorn rate of £1 a year in recognition of its services to the nation's cultural life – and what do we find? A dreary charade, supported only by those who mistrust everything that modern art symbolises, which abuses its duty to encourage all artists, whatever their beliefs or inclinations, to submit their work. We desperately need an annual forum like this, a collective and regular report on all the many-sided facets of British art today. And the Academy, through the intentions of its founders no less than its miraculous ability to charge no commission on the sale of work, has a duty to carry out such a function. But until it regains the respect of the entire art world by weeding out its own overgrown gardens, and setting up a decently objective selection procedure which will refuse to allow the Academicians to get away with their shoddy produce, the ghost of Sir Joshua Reynolds can be imagined howling with shame around the magnificent, heavily subsidised and grievously abused corridors of Burlington House.

LONDON'S FAILURE AND THE FUTURE OF THE TATE
3 January 1974

The new year started off yesterday on a sour, philistine note for art in London: turnstiles appeared at the entrances to most of our major museums, and nobody can do anything about this scandalous imposition until the whole scheme is reviewed and hopefully abandoned in twelve months' time. But while every member of the gallery-going public will be depressed by this act of governmental tyranny, it is still a good time to look forward and speculate about London's strengths and weaknesses as an art centre, its likely achievements and failures, during the year ahead.

The first priority must always be the welfare of contemporary artists, for without their continuing vitality we could deteriorate all too easily into a retrospective culture, admiring the past without any ongoing creative present to extend and reshape our awareness of what art can add to our lives. Judging from recent experience, however, the great majority of people still mistrust and shy away from modern exhibitions. Despite the fact that the artist's right to experiment has been a central source of energy in Western civilization for almost a century now, we do not extend anything like the same enthusiasm which instantly surrounds a survey of ancient Egyptian or Chinese art to a show of contemporary work. The public feels alienated from the idea of innovation, persists in suspecting that it might simply be a worthless hoax and is not prepared to test its prejudices by exposing them to a regular confrontation with new developments.

Any society so profoundly out of sympathy with the art it produces is by definition unhealthy, and this lamentable situation is mirrored in the narrowness of the outlets for young artists today. At a time when works from all periods of the past are reaching ever more insane prices in the auction houses, and investors are realizing that art of the highest quality is the safest of all hedges against inflation, the paradox is that no one wants to know about artists who have yet to establish their reputations. How many of the well-heeled dealers clustered round Bond Street are now prepared to take the risk of giving an unknown hopeful his first one-man show? The overheads are too steep, the financial rewards of an alternative and safer exhibition too tempting and the notorious unwillingness of British collectors to purchase new art too discouraging. So the predictable outcome is that even the wealthiest modern galleries, like Marlborough or Waddington, concentrate on established names alone – even though they could well afford to give at least one young artist an

airing during the year. The trouble is that they do not appear to believe that they ought to be performing this minimal service to English art: there is no proper sense of obligation, no readiness to encourage fresh talent, no impulse to forget about the enormous profits to be gained from buying and reselling blue-chip Picassos for one moment and extend a helping hand to a promising beginner.

Only outside this profitable ghetto, in areas like Marylebone, Soho, Chelsea, Notting Hill, Euston and more recently Covent Garden, are there galleries prepared to show modestly priced work which they know will not attract the jet-setting millionaire's chequebook. And even there the need to remain solvent often deters them from pursuing a truly ambitious programme, from supplying the constant progress report on what is happening now which London requires if it does not want to become a backwater celebrated only for the quality of its historical exhibitions. We are fortunate enough to have an abundance of those, at the British Museum, the Royal Academy, the Victoria and Albert Museum, the Hayward Gallery, the National Portrait Gallery and the excellent new Museum of Mankind in Burlington Gardens. But we do suffer from a terrible dearth of well-organised and informative contemporary shows, the kind of well-timed, up-to-the-minute, controversial and pressingly relevant surveys which our subsidised national institutions ought to be staging now that even the most enterprising of small private dealers simply cannot afford to perform that function satisfactorily.

This is what I find missing most from London at the moment: publicly run centres committed to the three-pronged belief that a nation's art activity fossilises without a continuously prodded awareness of current developments; that the divide between the man in the street and modern work will grow ever more unbridgeable unless such a service is offered all the time; and that any country becomes hopelessly insular if support for its native practitioners is not accompanied by a readiness to extend an open invitation to art on the broadest of international bases. The Royal Academy's uniquely central and spacious premises ought to be given over once a year to an alternative Summer Exhibition, which really could tell us how all the artists who would not dream of participating in Burlington House's antiquated and ludicrously unrepresentative annual jamboree have been developing. And it should be devoted once in every two or three years to the kind of mammoth round-up of world-wide contemporary art of which England has always been deprived. Other institutions, like the Whitechapel Art Gallery, the ICA and the Hayward Gallery, could also do much more to supplement this new dynamic with necessarily smaller and more modest exhibitions devoted to the same urgent ends.

But the real burden of this obligation rests with the Tate Gallery, which has never been able fully to carry out its role as England's major Museum of Modern Art because it has simultaneously to double up as our National Gallery of Historic British Art as well. No other comparable country is forced to put up with this woefully irrational arrangement, and it is high time that an all-out crusade was launched to rectify

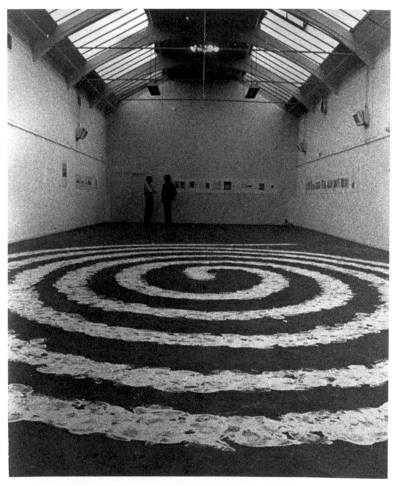

145. Richard Long (left) and Richard Cork with Long's floor piece at Whitechapel Art Gallery, London, 1971

the anomaly. At the moment, and through no fault of their own, the Tate's tiny and beleaguered staff have to pretend that they can cope with their impossible dual role, and the result is nothing less than a national disgrace. Hampered by a pathetic annual acquisition fund of £265,000, which would not now be nearly enough to purchase even one first-class painting by Stubbs on the one hand or Matisse on the other, the Tate is obliged to live from hand to mouth inside appallingly cramped premises which relegate a hefty proportion of its holdings to the obscurity of the basement. And the gallery's exhibition policy is split down the middle, attempting to carry out its schizophrenic duty to survey both the history of English art and contemporary developments at one and the same time.

Even when the new extension on the present site is completed, the Tate will only have the space to satisfy one of its requirements properly; and it will never be able to pretend that it offers anything like the facilities, the collection or the exhibitions which more sensibly endowed counterparts like New York's Museum of Modern Art have provided for decades. Suspiciously hazy plans for a new building to be commenced on the neighbouring site of Queen Alexandra's Military Hospital in 1976 offer a little hope, but they do not specify the need to slice the Tate into two separate entities, each with its own realistic number of staff, its own purchase grant and its own exhibition programme. Neither does the scheme envisage how it will combat the conservationists' rage which has already started over the proposed demolition of the Hospital.

I would like to propose, as an overriding practical goal for 1974, that this vagueness over the future of the Tate is settled once and for all. We ought to start work *now* on a new Museum of Modern Art for London, on one of the many empty sites to be found throughout the city, and decide that the present building be given over wholly to the historic side of the collection. If the Government is not prepared to supply the necessary money immediately (in spite of its willingness to finance a far less necessary National Theatre and a far more expensive National Library) then it is up to those hundreds of thousands of people who care about the continuing health of art in England to press forward themselves. Wealthy benefactors can afford to endow new colleges at Oxford or Cambridge, so why not a really superb contemporary museum for all of us to enjoy? National lotteries build Opera Houses in Sydney, and we can surely do likewise. It all depends on how passionately we believe in such an exciting project, and I for one am convinced that the will to achieve it is at this very moment only waiting to be aroused.

DAMNING THE ARTS COUNCIL
21 February 1974

Several days ago, I resigned from the Art Panel of the Arts Council in protest against a policy decision which can only be described as disgracefully injurious to the art community of England as a whole. I refer to the approval recently given by members of the Council to a British theatre exhibition, which would have the astonishing effect of ousting art from the Hayward Gallery for not just one or even two, but six entire months next year.

No one, surely, would dispute that the opening of the National Theatre, scheduled for April 1975, provides an ideal opportunity to stage a survey of our theatrical history over the past few centuries. But when the Art Panel was asked to comment on the proposal that the Hayward Gallery should forfeit the greater part of next year's programme in order to accommodate this exhibition, we unanimously condemned the idea as an absurdity. Ever since the Arts Council took over the running of the Hayward it has been understood that the gallery's space should be devoted to art, and the Art Panel quite properly stated that it would only be prepared to think about an exhibition which looked at the influence theatre has undoubtedly exerted over English painting.

In normal circumstances, such a resolution by the Art Panel would be enough to ensure that the proposal did not arise again; or that if it did, the panel would be asked to consider a redrafted submission which took its members' views fully into account. But at a panel meeting held on 4 February, we were all dumbfounded to learn that the Council had overridden our objections and, without bothering to apologise for its highhanded tactics, had allowed the original plan for the theatre exhibition to go through unscathed. The Council does, admittedly, have a constitutional right to reject the advice proffered by its expert panels, but it has never to my knowledge done so in the past. Not only does its willingness to do so now deliver an insulting slap in the face for all the Art Panel's members, who spend a considerable amount of time and energy giving their voluntary advice to the Arts Council over a vast spectrum of questions, ranging from important policy problems to the minutiae of helping young artists provide themselves with studio space. It also makes a nonsense of the Council's Art Department, in that one of their chief functions is to supply the nation with a regular series of major exhibitions at the Hayward Gallery.

By granting their consent to the British theatre survey, without pausing to suggest how on earth the Art Department should pursue its exhibition

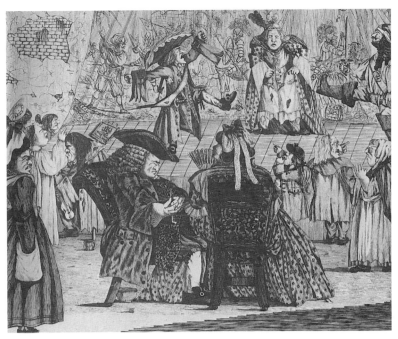

146. Catalogue cover of theatre exhibition eventually held at Hayward Gallery, London, 1975, showing R. St. G.M's *Strollers performing Hamlet before the Squire*, 1772

programme in the meantime, the Council has implied that it does not actually care what happens to the shows which ought to be held at the Hayward Gallery during that six-month period. Why did it not acknowledge that a more suitable venue could be found at the Victoria and Albert Museum, where theatrical history plays an integral part in the holdings of the permanent collection, at the Royal Academy, which can be hired out for special exhibitions like this; or, indeed, in the newly vacated galleries at Somerset House, which are to be devoted to a survey of British theatrical achievements anyway? I cannot imagine: the only obvious advantage of the Hayward Gallery lies in its position next door to the new National Theatre, and I would have thought this bonus was greatly outweighed by the prospect of cancelling the Hayward's existing, carefully planned programme without offering it any alternative housing.

The very fact that the Council did *not* view this disruption with alarm is symptomatic of a wider malaise which afflicts the establishment's attitude towards visual art in this country. Nowhere is this attitude more painfully expressed than in the relatively small portion of its budget which the Arts Council is prepared to allot to the encouragement of art in England. If opera, music or drama need money, it is always forthcoming. But art is only permitted a paltry slice of the cake: it is not well enough known that, out of a total expenditure on the arts in England of £10,371,035 for the year ended March 1973, a mere £455,891 was spent on art. Compare that with the massive total of £3,465,637 absorbed in the same year simply by the Royal Opera, Sadler's Wells Opera, the Royal Ballet, the National Theatre, and the Royal Shakespeare companies, and it will help to explain why the Council automatically assumes that painting and sculpture can be kicked out of the window to make way for more 'important' priorities like the prestigious opening of a National Theatre.

Just as the great majority of English universities still feel that art is not important or academically respectable enough to be studied like literature, the classical languages or history, so the people reared on our educational system perpetuate this absurd value-system. No less than £190,000 is to be lavished on the British theatre spectacular – a sum way beyond the dreams of anyone mounting an art exhibition at the Hayward – and even after the returns of a prolonged season at the gallery have been collected, the Council expects to pay £100,000 of this amount out of its own pocket. The money will not, mercifully, be taken from the Art Department's budget; but the fact remains that the running costs of the Hayward amount to £85,721 a year, and in 1975 the Art Department will be paying most of this to support an exhibition which has nothing whatsoever to do with art.

I have no doubt that the theatre survey, which has been devised principally by theatre lighting expert Richard Pilbrow, Kenneth Pearson of the *Sunday Times* and theatre historian Iain Mackintosh, will prove an immense popular success. It has been conceived as a dazzling showpiece, an entertainment which will wrap the Hayward's front stairs in a long white muslin tube, turn one of the main galleries into an open fairground with booths and side-shows and build an Edwardian theatre saloon bar where the public can buy drinks and meet Gaiety Girls. ('A sheer piece of frivolity', admit the organisers, 'narrow, crowded and to be avoided if not to the visitor's taste'.) But it lies entirely outside the proper function of the Hayward; and it completely castrates the Council's Art Department, who are at a total loss over where to go and

what to do from March until late September 1975. Is this *really* how art should be treated, at a time when everyone is acutely conscious of the need for more gallery space in London, particularly for all those contemporary exhibitions which this country is not seeing at the moment? I submit that the Hayward should never be abused in this peremptory manner, and that those in control of England's cultural life should realise that art must not be treated as an expendable irrelevance any longer.

WILLIAM ROBERTS: BLASTING VORTICISM
28 March 1974

It is a little unnerving for an exhibition organiser to receive, just before the opening day, a specially printed pamphlet from one of the artists he has included attacking the whole idea on which the show rests. Adverse comments are normally voiced after everyone has seen the exhibition, read the catalogue and digested its contents. But this time, William Roberts has decided to deliver a strongly worded broadside against *Vorticism and its Allies* at the Hayward Gallery without actually finding out what I attempted to establish by planning it.*

Roberts has, admittedly, some very good reasons for feeling as hostile and aggrieved as he does. The last time Vorticism was surveyed in a public gallery, at the Tate in 1956, it was tagged on to a retrospective exhibition of Wyndham Lewis's entire career. Since Lewis was granted far more space than any of the unfortunate artists grouped together in a humiliating final section entitled 'Other Vorticists', it looked as if he was a genius who invented a movement otherwise peopled entirely by minor acolytes. At the time, Roberts quite rightly published a whole series of indignant booklets refuting the distorted view which the Tate exhibition had put forward. Rightly or wrongly, he suspected a conspiracy, and with considerable verve became his own art historian in order to contest the mistaken idea that Lewis was the inspired leader of English avant-garde artists during the 1914 period. Roberts proved his point. Nobody would dare, after reading his own memoirs of the period and examining again the works of art produced at that time, to champion Lewis in such an invidious way ever again.

By 1961, he felt so happy about the success of his militant efforts that he was able to paint an elaborate and affectionate reconstruction of what

life was really like for the artists involved in the Vorticist movement. His picture, at present displayed at the end of the Hayward Gallery exhibition, shows the Vorticists enjoying a rousing dinner at their old rendezvous, the Restaurant de la Tour Eiffel in Percy Street, to celebrate the arrival of their notorious magazine *BLAST*. Lewis is placed symbolically at the centre of the table and dominates the composition, certainly; but most of the Vorticists are seated round him and the impression of a convivial, communal group of like-minded radical artists is clearly conveyed. I wholeheartedly agree with this presentation of the Vorticist movement and all my researches have demonstrated the broad accuracy of Roberts' lively painting. Lewis was without doubt a domineering personality, who delighted in thinking of himself as a man who could band together a group of faithful followers and lead them into battle against the reactionary forces of British culture. And yet the surviving paintings and sculptures show that all the Vorticists contributed to the movement in a robust and individual way, often more impressively than Lewis himself.

Now, however, Roberts has entirely contradicted the spirit in which he executed that memorial painting thirteen years ago. He has just written and published a puce-covered pamphlet declaring instead that Vorticism 'should only be used in reference to his [Lewis's] own work; and that the term Cubist should be employed to describe the abstract painting of his contemporaries of the 1914 period'. In other words, Vorticism as a movement does not exist, Roberts' own painting of the *BLAST* dinner is nothing but a misleading hoax, and I have been a fool spending so much time (not to mention the Arts Council's money) studying something which turns out to be merely a figment of Lewis's imagination.

Strong allegations indeed, and ones that deserve an answer because Roberts is now the only surviving artist who can claim to be a participant in the movement surveyed at the Hayward Gallery. His position is therefore unique, and I have tried many times to meet him so that his invaluable memories could be fully taken into account. He has chosen to ignore my requests and explains in his pamphlet that although 'I have sometimes been asked for interviews by Art critics, and students with theses to write, who wished to discuss Vorticism with me', he felt that 'these inquiries would, by their questions and investigations, only distort and enlarge unnecessarily this subject'. But could it not be argued that Roberts is *encouraging* the distortions he fears by refusing to see anyone who wants, quite understandably, to hear what an eye-witness has to say about the period? Such an attitude is in the end counter-productive, and can only multiply the misunderstandings with which Vorticism has always been bedevilled.

It is tempting to conclude that Roberts' persistent hostility towards the movement stems from a personal dislike of the tactics Lewis adopted at that time. In his new pamphlet, Roberts remembers Lewis telling him in 1915 that 'it is more difficult for an artist, working in isolation (A Painter of Abstracts, that is to say) to impress the public, than it would be, if he were a member of a Group'. Roberts takes this remark as an indication of Lewis's self-seeking desire for a publicity platform, and in one sense he may well be correct. In another sense, however, he fails to recall that vociferous movements were constantly being formed during that period as the most speedy and effective means of letting the public know about the innovatory ideas then being debated in Europe, America and Russia. Roberts is perfectly justified in stating that the artists associated with Vorticism were all inspired by Cubism. But he should also have added that they were far more directly bombarded with the principles of Futurism, then being declaimed by Marinetti in his spectacular lectures and manifestos all over London.

At first, the English vanguard were very excited by Marinetti's insistence that the new mechanised, industrial society the twentieth century was developing should be directly reflected in art. But by the summer of 1914, many of the English radicals had decided that they were tired of being associated in the public's mind with the brilliant exhibitionism of the Futurists. They wanted an alternative movement with which to propagate their own independent ideas, rejecting Cubism's love of the old studio motifs as firmly as they disagreed with Marinetti's romantic exaltation of the machine age. Lewis, who edited *BLAST* and wrote many of its hard-hitting, exclamatory pages, presented his friends' work as a group endeavour, using Ezra Pound's invention of the term 'vortex' to signify the way in which they would draw together all the most vital innovatory impulses of the time into a still and concentrated centre at the heart of the avant-garde whirlpool.

The works produced by this movement – harsh, aggressive, diagonally explosive and yet defined with a linear rigidity quite opposed to Futurism's blurred, multiple imagery – can now be seen to possess an impressive unity of aim. A unity which cannot, despite Roberts's latest plea, be described as Cubist in character. Two of the most outstanding artists involved, Bomberg and Epstein, always resisted Lewis's attempts to enrol them in the movement. But they do undoubtedly share many of its ambitions, and the exhibition tries hard to define the differing role each individual played within Lewis's art-political scheme. Roberts's contribution is very impressive and I wish he could have gone to see how his work is presented at the Hayward Gallery before damning my efforts so completely.

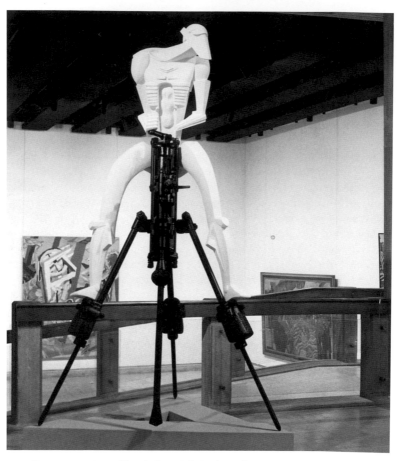

147. Reconstruction of Jacob Epstein's *Rock Drill*, 1913–15, made by Ken Cook and Ann Christopher for *Vorticism and its Allies*, Hayward Gallery, London, 1974

If he does pay it a visit, I believe he will find that Vorticism can reasonably be seen, not as Lewis's egotistical brainchild, but as an appropriate title for a spirit of energetic renewal which revolutionised the course of English painting and sculpture – before the First World War put a brutal end to all its hopes for an art directly expressive of its own time.

★ William Roberts's pamphlet, 'In Defence of English Cubists', was published by the Favil Press, Kensington.

ARCHITECTURE WITHOUT ARCHITECTS
12 September 1974

Ask the man in the street what the word architecture means to him and he will probably point to the grandest, most official building in sight: a church, a town hall or even a department store. If you ask him whether his own house could be considered under the same heading, the idea will be dismissed with a snort of contempt – architecture is considered the preserve of civic dignity and monumental landmarks, not common-or-garden terraces and bay windows across the road.

In one sense, such a misunderstanding seems naïve. Most architects have spent the past few decades changing the man in the street's everyday surroundings, tearing down his familiar habitat and transplanting him to a dehumanised tower block. But in another sense, it reflects the conditioning of a society which persists in thinking of architecture as an aesthetic activity, producing works of art rather than the total environment we all have to live in. I remember the exclusively formal way in which I was taught the subject at school, starting with the Parthenon and hurrying quickly on to Rheims, St Peter's and the Houses of Parliament. Pevsner's dictum – 'a bicycle shed is a building; Lincoln Cathedral is a piece of architecture' – was accepted without question, as was his declaration that 'the term architecture applies only to buildings designed with a view to aesthetic appeal'. And I can now see how that attitude led straight to the purist barbarism which threatens us on every side today.

It is precisely these cultural blinkers that the ICA's exhibition, *Architecture Without Architects*, seeks to remove. Bicycle sheds are not actually included in the wealth of photographic evidence Bernard Rudofsky has assembled to establish his case, but plenty of other so-called lowly objects which historians like Professor Pevsner choose to dismiss are displayed, often in panoramic dimensions. And what magnificent objects they turn out to be! A sixty-mile labyrinth of shorings in an eleventh-century Polish salt mine, quite as aspiring and dignified as the largest Gothic nave, gathers huge clusters of logs into four-square columns and extends them into a vaulted super-structure offering giddy perspectives of the seven successive layers contained in the mine. Humble granaries in the Spanish province of Galicia, balancing their often enormous lengths on pillars with circular stones for capitals, carry unmistakable overtones of ecclesiastical worship and reflect the sacred value which the corn harvest possessed for the people who built them.

Unlike Lincoln Cathedral, which represents a very self-conscious and deliberate attempt by an army of architects, painters, sculptors, stained-glass designers and many other craftsmen besides to erect a showpiece for their combined talents, the anonymous people who built the mine and the granaries were prompted by less tutored and more spontaneous impulses. It could be argued, therefore, that their vernacular structures are more miraculous than Pevsner's artefacts. If the natives of Maipua in the Gulf of New Guinea, where the achievements of Brunelleschi, Palladio or Wren have never been absorbed, are capable of rearing a bamboo framework for a clubhouse as elegant and intricate as the hull of an ocean liner, then it is impossible to withhold our admiration. The beauty of this skeletal, arching tunnel has more to do with instinct than expertise: although the necessary ingenuity may have been acquired over centuries, the soaring form that the clubhouse takes is more of a tribute to man's innate desire for something which astonishes and inspires him.

This organic relationship between humanity's needs and their architectural expression has been lost sight of in our society. The very fact that the man in the street feels architecture to be unconnected with him, isolated and apart, is a measure of the alienation which now bedevils the environment we live in. By giving architects the status of creative gods, who are allowed to take decisions about the face of our cities which would formerly have been the automatic preserve of the whole community, we have opened the doors to the growth of a professional system answerable to its own myopic rule-book rather than the public. Where, in any typical town-planning today, can be found the recognition that people themselves often enrich and add to their surroundings if they are allowed to? Disconsolate bowls full of civic shrubbery and neatly partitioned areas of pedestrianised cobblestones look pretty silly compared with the simple yet subtle way in which Mediterranean and African streets are turned into areas of cool and seductive shadow-play, through the use of trellis or net canopies and canvas awnings.

We all enjoy the experience on continental holidays of walking through villages which are so naturally attuned to the delights of casual strolling that it is enough to linger, and let the full flavour of a locality work its charm. But do we also care about the effect that our tourism may be having on the architectural integrity of those places, and does our built-in prejudice about architecture encourage us to take the memory of that flavour home and wonder why it is lacking in our own neighbourhoods? Several of the breath-taking images in this exhibition show small towns, tumbling down the Sabine mountains at Anticoli Corrado near Rome, balancing on the edge of a steep cliff above the

148. Troglodytic village in the province of Honnan, China, from *Architecture without Architects*, ICA, London, 1974

small port of Phira in a Greek archipelago, and either hollowed or hewn from an outcrop of rock in Les-Beaux-en-Provence, which are utterly harmonised with the landscape. The shape they have assumed is as much a response to the particular character of that landscape as it is to the internal requirements of the population, and they have the great virtue of knowing when to stop. All of a piece, and worlds apart from the sprawling ribbon development which has turned our towns into formless wastelands no longer aware of their identities, they provide a model for any civilization that wants to prevent further erosion taking place.

It is all, in the end, a matter of priorities. Which is more important, the architect's drawing-board ego or the ability of a given populace to express itself fully in its surroundings? The ICA survey is full of quirky and often endearing curiosities that give an area its distinct personality. Whether they are air-conditioners in Hyderabad Sind which provide its roofscape with a silhouette bristling with angular energy, pigeon towers standing like rows of pepper-pots near Isfahan to collect the droppings so highly cherished in the East, or the friendly, communal arcades running like a series of womb-like apertures all the way round the town of

Telc in Czechoslovakia, their idiosyncratic warmth lies at the other end of the scale to the depressingly neat logic of contemporary Western architecture. The lesson of this exhibition is that human beings, if left to themselves, are far more able to personalise and enhance their environment than any desiccated theorist whom society has decided is the 'expert' capable of re-ordering our lives. Order of that arbitrary kind, imposed from without, is uncomfortably close to death; and in order to prevent our imminent funeral, we ought to make sure that architects are no longer exclusively entrusted with the health of our surroundings. If we do not, the man in the street may find it so unbearable that he will have to stay indoors all day long.

IGNORING ADVENTUROUS NEW ART
2 January 1975

If 1974 was the year when England was inescapably confronted with its rapid decline as a major economic and political force in the world, the same falling-off was also noticeable in its dealings with art. Whether the one is linked with the other I do not know for certain. National prosperity and self-confidence can produce an artistic flowering as prodigious as seventeenth-century Holland, and Florence's civic decay undoubtedly hastened the demise of its painting tradition. But there are plenty of examples to prove that art can flourish in a demoralised and indeed degenerate society, so England's inflationary sickness need not be wholly equated with its deficiencies as an art community.

Some parallels can, nevertheless, be drawn. Just as the entire country is cultivating a nostalgia for the past in order to escape from its current misery, so our art exhibitions display a marked preference for historical subjects at the expense of contemporary developments. The two principal subsidised outlets for surveys of modern art in England, the Hayward Gallery and the Tate, have increasingly withdrawn themselves from any commitment to new ideas and ongoing activities. At both institutions, monumental shows devoted to Munch, Richard Dadd, Vorticism, Morris Louis, Klein and Manzoni, British Sporting Painting, Klee, and twentieth-century painting from Picasso to Lichtenstein have overshadowed the few exhibitions devoted to living artists. The Tate in particular appears to have forsaken its responsibilities towards contemporary art

altogether, and the Hayward's choice of Lucian Freud and Tapies bears out the prevailing emphasis on long-established art rather than developments of direct concern to the impetus of radical practitioners today.

I have no wish to devalue either the significance or the pleasure that retrospective exhibitions afford: everyone's awareness of a vital tradition needs to be sharpened and extended by a regular, informed re-examination of the past. But it is insufficient and dangerously backward-looking if unaccompanied by an adventurous determination to explore the germinating forces, as yet unblessed by the pedigree of history, now actively engaged in shaping the future direction of art. In this context, the Hayward's survey of *British Painting '74* proved to be more of a happy-go-lucky pat on the back for all our familiar native foibles than a coherent attempt to point out the most fruitful paths painters could be following in the years ahead.

This is not to suggest that the task of airing and debating the most pressing issues raised by art now should rest exclusively on the shoulders of national institutions. It is only proper that much of this role be played by smaller, more flexible and anti-establishment bodies, within which dissent and fresh alternatives to the existing order naturally thrive. But the track records of places like the Whitechapel Art Gallery or the ICA, which at one time fostered the unorthodox with conspicuous *élan*, have been whittled away by chronic uncertainty and financial cut-backs. Here is another parallel to the country at large, for while many of the nation's more precarious businesses declared themselves bankrupt in 1974, the Whitechapel was forced temporarily to close its doors because funds had run out. Nor was it the only victim of economic stringency. Garage, a welcome arrival to the London gallery network in that it is consistently devoted to the support of young artists, has been afflicted with the threat of imminent closure for some months and was recently granted another reprieve.

Its plight, moreover, is only an extreme manifestation of the difficulties confronting any dealer who wants to support the relatively unknown or uncommercial aspects of present-day art. Faced with the spiralling costs of a gallery's overheads, not to mention a public anxious above all to sink its money into a safe commodity and avoid taking risks, the small band of dealers who do genuinely care more about nurturing new art than about the trajectory described by their profit margins are finding it more and more difficult to realise their ambitions properly. The situation is not completely bleak: Jack Wendler's closure of his much-missed premises in North Gower Street has recently been offset by the opening of PMJ Self's spacious gallery at 10 Haunch of Venison Yard, and I am especially gratified by the Arts Council's decision to save money by axing the shameful theatre

149. Nicholas Serota

exhibition project. But these are only small shafts of light in an increasingly gloomy picture of the prospects for 1975, and the £30,000 which I gather was wasted on the Arts Council's theatre extravanganza before it was cancelled could have been so much more positively deployed backing the kind of intelligent, progressive programme which Nick Serota has succeeded in pursuing at Oxford's Museum of Modern Art.

For some disgraceful reason, London has no equivalent subsidised gallery dedicated to staging an enterprising and internationally informed survey of new art, although the advent of Art Net at West Central Street

(where lectures and symposia are often held as well) is a hopeful step in the right direction. We need more of these centres, to counteract the one-sided achievements of an institution like the Royal Academy where large crowd-pullers on themes as popular as Impressionism or Turner are invariably mounted. One way to ensure a proper balance between red and white corpuscles in the bloodstream of a vital culture is to inject constant supplies of fresh plasma, and the more vessels there are available to receive this transfusion the healthier the body of art will be.

A good example to take here is the Arts Meeting Place in Earlham Street, where a young artists' co-operative opened last year with the idea of encouraging a democratically organised and rapidly changing series of shows by unknowns who would otherwise stand little chance of displaying their work in a public London location. I can understand why some artists shy away from the amateur haphazardness of the conditions there, but that is really beside the point. The Arts Meeting Place has provided a valuable centre, a rallying-flag for the growing number of dispossessed artists who find it more and more impossible to discover hospitable galleries anywhere else. It thereby fulfils a social function over and above its artistic one, and deserves to survive as one necessary plank in the structure of London's galleries.

Other modest centres, operating for the most part on shoestring budgets, could equally well be mentioned to demonstrate how much of an enduring will exists here to make and disseminate art in the teeth of adverse economic conditions. All the courage in the world, however, will not guarantee that English art escapes from the ever-present threat of provincialism, and it is in this area that change is most urgently required. Unless these comparatively underground activities are supplemented by at least one well-financed and professionally run exhibition centre, devoted to the specific goal of providing London with fully adequate progress reports on the most potent developments in current art from Europe, America and elsewhere, the best of our intentions will flounder in ignorance and insularity. At a time when the country as a whole is tending to turn in on itself and worry about its chronic internal problems, the art community is doing likewise. That is why my greatest hope for the coming year is that, against all the odds, we will at last manage to weld our love of the past, our financial insecurity and our obsession with ourselves to an outward-looking appetite, for as much first-hand information as possible about the art dialogue conducted on the other side of the waters surrounding us.

TELEVISING ART
6 March 1975

It would have been natural for anyone to assume, in those far-off days of innocence when television first began to flicker its images across England, that the presentation and discussion of art might eventually be transformed by this new technological miracle. Millions of people who had never dreamed of visiting a gallery, let alone buying a picture or painting one themselves, could now be brought into immediate contact with the entire range of visual and plastic art. The small screen positioned in Everyman's living-room appeared by its very nature tailor-made to carry direct, accurate and enjoyable information about every facet of art activity. Unlike radio or the printed word, both of which struggle to describe experiences not easily translatable into verbal terms, television would be able to overcome those problems and concentrate on the work itself. The possibilities must have seemed limitless, for at long last a medium had arrived which promised to overcome the English public's notorious indifference to art and make it as accessible as a best-selling paperback.

Such optimism now reads, well over thirty years after the advent of the box, like pie-in-the-sky sentimentality. Television never has displayed sufficient faith or interest in art to grant it more than an incidental existence on general arts programmes such as *Monitor*, or the occasional, very self-conscious special feature which always indicates an attempt to salve the conscience of programme controllers who know they are failing to perform their cultural duty. When Kenneth Clark's *Civilization* series was first transmitted it was hailed as a triumphant breakthrough for the intelligent popularization of art on television, whereas similar projects should have been undertaken and regularly screened long before then. Its phenomenal success argued that there is a large untapped audience for broadly conceived surveys of that kind, but how many art programmes are ever given the chance to prove themselves on a peak viewing slot?

Pitifully few: the chronic fear of boring audiences with an item which does not either tickle their ribs or titillate them with sex and violence means that art is usually relegated to a quiet backwater of the television day, when few people are expected to be watching anyway. It is no accident that Humphrey Burton's *Aquarius*, which represents ITV's only regular nod in the direction of art subjects, has to put up with an obscure viewing time on Sunday afternoons which would be more suitably devoted to a children's programme. Whatever strictures can be levelled against Burton's unashamed preference for music and opera, which seri-

ously unbalanced his coverage of the other arts, *Aquarius* has been presented in a consistently breezy and entertaining format which should have broad appeal. So far, however, it has never been given a proper chance to prove how popular it might be with the general public; just as BBC1's long-running equivalent, *Omnibus*, is always relayed so late on a Sunday evening that everyone tends to be dozing away the end of the weekend while it is running.

Perhaps a firm belief that such programmes automatically induce helpless snoring dictates the unsatisfactory way art is treated when it does make its rare appearances on television. There seem to be two rigid alternative methods, both of them equally irritating: either to embalm the chosen subject as a superhuman divinity, who deserves only the most ecumenical musical accompaniment, or go to the opposite extreme and swamp the artist and his work in a deluge of irrelevant special effects. The first approach leads to the kind of hollow bathos found in last year's tribute to Henry Moore on BBC2, where the commentary Tony Church delivered in a hushed Royal Shakespearean awe broke all existing bromide records by intoning that 'perhaps in the twentieth century Moore has done what Michelangelo might have done had he lived in our own age'. And the second approach replaces this sanctimonious reverence, which succeeds only in suggesting that art be viewed as a high-minded substitute for religion, with all the fun of the fair. ITV's recent offering on Turner was a good example, insisting on dressing the poor man up as Leo McKern in a funny hat and making him lunge lecherously at a succession of ample mistresses, or else join in a pantomime house-party at Petworth. Whenever the director paused for breath long enough actually to examine a Turner canvas, the results were of course magnificent – they could hardly fail to be, given the outstanding quality of English colour television. But most of the time his film subscribed to the widespread television doctrine that art simply cannot be trusted (or does not deserve) to stand on its own merits.

Even Leslie Megahey's study of Rodin, shown on *Omnibus*, spoiled its obvious sensitivity and unusual intelligence by refusing to let the camera traverse the sculpture and leave well alone. In many respects the best way to understand the full three-dimensional identity of an object in the round is to watch it on film: sculpture is very difficult to look at when you are moving in front of it, and it is invariably rewarding to let the camera concentrate on it for you from a fixed distance. Megahey was not content with that, however, and constantly cut between Rodin's work and naked models posing artfully in the sculptor's studio. His purpose was presumably to show the sources of Rodin's inspiration; but the

A Pelican Original

WAYS OF SEEING

Based on the BBC television series with
JOHN BERGER

Seeing comes before words. The child looks and recognizes before it can speak.

But there is also another sense in which seeing comes before words. It is seeing which establishes our place in the surrounding world; we explain that world with words, but words can never undo the fact that we are surrounded by it. The relation between what we see and what we know is never settled.

The door *The wind*

The bird *The valise*

The Surrealist painter Magritte commented on this always-present gap between words and seeing in a painting called The Key of Dreams.

The way we see things is affected by what we

150. Cover of John Berger's book
Ways of Seeing, 1972

sculptures themselves include all the information we need to know about his starting-point in reality, and none of the nudes came anywhere near suggesting the energy or the ecstatic emotion which Rodin communicates at his best.

The determination by the makers of the Turner and Rodin films to embroider on their themes, to avoid a straightforward confrontation between the camera and the work, is symptomatic of the uneasiness which bedevils television's attitude towards art. Apart from a brief series like John Berger's well-received *Ways of Seeing*, none of the three channels has tried to pay art the elementary courtesy of a regular programme all to itself. BBC2 is probably most at fault here, since its charter pretends to care about the fostering of 'minority' interests. And yet, despite the fact that it thinks serious pop music, films and books deserve weekly coverage, art is nowhere to be found. Several able people who work for BBC2 are well aware of this deplorable failing, as I have good reason to know. About a year ago I discussed the injustice with them, and they then asked me to write down a private memorandum on the subject and send it to them as part of a continuing dialogue. I was pleased to do so, encouraged to see signs of an awakening desire on television's part to fulfil at least some of its obligations towards art, but have since received nothing – not even the barest acknowledgement of my letter – in return.

If this incident is at all typical of BBC2's hard-boiled attitude towards the need for a more generous discussion of art, then it is up to everybody who cares about this scandalous state of affairs to complain more militantly. So much *could* be done, in an imaginative and enlightening way, to give art the prominence it deserves on television. A regular magazine programme ought to establish itself as soon as possible, devoted to current exhibitions and topical themes, which might easily attract a wider audience than BBC2. Historical surveys tackling the entire spectrum of art from primi-

tive times to the present day should be devised, so that the public who enjoyed *Civilization* can look more closely at particular periods and personalities. Interviews with artists, many of whom are very articulate about their work and ideas, could be shown on a frequent basis. And if they were commissioned to carry out special films or projects, of the kind that are increasingly occupying the interest of experimental young artists today, the expressive potential of the television medium might well find itself greatly enlarged.

The benefits should therefore spread both ways, but television ought not to need such a selfish incentive before it shakes off its indifference and faces up to these neglected responsibilities. Its marriage with art has been postponed for too long, and it is time to atone for the delay by publishing the banns and consummating the union forthwith.

THE IMPORTANCE OF VIDEO
8 May 1975

The catalogue cover for the Serpentine Gallery's new Video Show looks like a savagely defaced copy of the *Radio Times*. The word 'Radio' has been cancelled out with a flurry of brusque black lines, and above it – proudly announcing the arrival of new priorities in communication – the word 'Video' takes its place.

Succinct and dramatic, the gesture conveys meanings on several different levels. Foremost among them is the belief that television, and the BBC in particular, ought to stop seeing itself as a visual extension of sound broadcasting. Rather than continuing to restrict its medium to rigidly controlled transmission through the established studio network, all three channels are being asked to take the possibilities of video into fuller account. Neatly packaged programmes, which rely so heavily on the techniques of stage drama and film documentary that they leave little room for improvisation or experiment, are therefore challenged in a very direct way. The contributors to *The Video Show* want television to escape from the restriction of its stereotypes and embrace a greater accessibility and freedom of manœuvre.

For the second meaning conveyed by the Serpentine's catalogue cover is that video has now become as straightforward to operate, and as capable of confronting people on their own street corners, as the graffiti

obliterating the *Radio Times* masthead. Instead of remaining within the control of a professional establishment, who often refuse to transmit videotapes from outside sources because of their 'poor' quality and 'amateur' production, television could open its doors to anyone with a message worth sending. At the moment, its audience is treated very much as a passive and inert lump paralysed in front of the all-powerful screen. But video offers these prostrate citizens the chance to participate in the making and shaping of the programmes which mesmerise them so effectively. The damage which everyone admits television has done to the life of the community could be redressed, and the public encouraged to think of video as a means of actively contributing to the nation's leisure activities. Then the box would no longer be a remote and monolithic authority well beyond reach. Approachable and above all flexible, it might eventually become the heart of our democratic system, offering an open forum to any section of the population who wanted to express itself through the video medium.

If such a revolution ever came about, it would reinforce the third meaning conveyed by the Serpentine's catalogue cover. The amended heading now reads 'Video Times', implying that video is at once the most natural and the most appropriate means of communication today. Who, therefore, is better equipped to use this medium on an imaginative, inventive level than the visual artist? The Serpentine exhibition offers abundant – if somewhat belated – evidence that many artists have already decided to adopt video as their principal vehicle. More and more art colleges are recognizing this development by setting up video departments as an alternative to painting, sculpture or even film-making, and *The Video Show* establishes that a number of clearly defined working methods have been evolved over the last few years.

To do justice to the contributions assembled here takes an inordinate amount of time, of course. Compared with a gallery full of static exhibits, which leave spectators more or less free to decide how long they want to stay there, the hundred hours of tape available at the Serpentine would seem to exclude the casual visitor altogether. But apart from the room set aside for a daily programme of up to fourteen separate items, and a 'library' where special requests can be screened, an edited compilation is also being relayed to provide a briefer, more concentrated miscellany of excerpts. They provide at least a glimpse of the wide range video work now encompasses.

Ironically enough, the more sophisticated the tapes are in terms of their technical expertise, the less impressive they turn out to be. Many of these come from America, where generous grants and studio resources

151. Richard Serra, *Boomerang*, 1972, (detail)

are available on a scale undreamed of over here. And they invariably turn out to offer a series of exquisite, fundamentally decorative special effects, flattering on the eye but in the end somewhat empty intellectually. Tapes by Ed Emshwiller and Woody and Steina Vasulka represent the best of these exercises, full of artful virtuosity and dazzling illusionism. Like marvellously proficient photographs, which rely so much on artificial manipulation that they betray the nature of the medium they employ, their sheer ingenuity ensures that the rawness and immediacy of video is left unexplored. Occasionally, it is true, the skill of these tapes bears considerable comic results: Hermine Freed's *Art Herstory* places a very twentieth-century woman inside some ingenious reconstructions of famous paintings to demonstrate the absurdity of pretending that we can ever know the artists' original intentions. But on the whole, elaborate *tours de force* of this kind appear mannered and even vulgar compared with the tapes which content themselves with a more factual, prosaic approach.

The essence of video, after all, is that it can be turned on as easily as a tap. Unlike film, it does not need a screen or a darkened room, and the most satisfactory tapes acknowledge this instantaneous, informal quality.

Although his work is often slight and perfunctory, William Wegman's off-hand slices of humour grasp this aspect of video perfectly. Understated and frankly improvised, they use a well-judged sense of throwaway wit which suits the character of video. On a more sober footing, the same directness and actuality gives force to a Richard Serra tape which confronts a female performer with an unsettling, delayed–reaction recording of her own voice. And John Baldessari's story-telling also gains from the intimate, conversational relationship he sets up with his audience.

One of video's great strengths lies in the number of different strategies it can exploit to establish this relationship. David Hall's *Progressive Recession*, a large nine-monitor installation which follows in Dan Graham's footsteps by offering a disorienting sequence of images mirroring the visitor as he walks along the row, shows one way of involving people in a live situation. And a lot of energy is currently being devoted to developing this free interaction between video and its public in community projects, where everyone is invited to experiment with it as a portable implement.

But in a sense all video-tapes, whatever their working premises, ask to be treated in a far more spontaneous and freewheeling way than this exhibition might suggest. One of the contributors, Mike Leggett, complains in the catalogue about the fact that the show still treats its visitors too much like passive consumers, rather than 'creating the conditions for people to make their own recordings, to employ video as a valid, explicit, easily assimilated tool'. It may well be that video will ultimately find its greatest justification in fulfilling this kind of social role, giving Everyman the chance and the means to become his own kind of artist. But television, and the *Radio Times* along with it, has a clear duty to help it on the way.

A NARROW VIEW OF SCULPTURE

5 June 1975

From the moment when the Arts Council first announced that William Tucker would organise the exhibition of contemporary sculpture now open at the Hayward Gallery, it was possible to predict the kind of principles he might uphold. For Tucker, a sculptor who is also a very articulate writer about the medium he employs, has no time for the many

experiments conducted over the last few years in order to challenge and extend sculpture's physical identity. As he affirms in his catalogue preface, 'sculpture is subject to gravity and revealed by light'; and so far as he is concerned, anything that departs from the central tradition of a freestanding, three-dimensional object does not deserve to be thought of as sculpture at all. That is one reason why he has called his selection *The Condition of Sculpture*: it attempts to lay down some fundamental rules of entry, and the exhibits at the Hayward belong in the main to the same, tightly unified sculptural club. Outsiders and misfits have all been blackballed, leaving the fully paid-up members plenty of elbow room in which to assert their often ponderous material bulk.

So far, so good. The survey does at least have the courage of its convictions – unlike the eclectic free-for-all that tried to examine British painting at the Hayward last year – and offers a coherent standpoint from which to be assessed. But *The Condition of Sculpture* has another meaning as well, and it is with this that I would take serious issue. If Tucker had managed to prove, through his rigorously applied set of limitations, that sculpture was vital enough to continue without even considering the alternative propositions it has recently fathered, then there would be every reason to enjoy this exhibition on its own terms. Nobody can have any defensible motive for decrying an art form which is healthy, and I would be delighted to visit a show filled with positive, imaginatively developed object sculptures.

The only trouble is, however, that far too many of the works displayed here show signs of a tradition in decline rather than in full bloom. They appear imprisoned by their beliefs, not fortified by them, and disappointingly content to embroider on well-worn themes established and explored by older sculptors a long time ago. Few of these senior practitioners have been included here, because Tucker wants to substantiate his claim that 'the number of sculptors separately and independently established in studios and workshops in London alone has never been greater than now'. But this statistical fact is no more a guarantee of worthwhile art than the proliferation of boardroom portraits and flower pieces at this year's Royal Academy exhibition – it merely proves that such things are being produced in awesome quantities. The real requisite is a convincing demonstration that younger sculptors are adding to and enriching the vocabulary of their mentors, and this Tucker cannot supply. Just about every junior British participant in the Hayward show, including Roger Bates, David Evison, Katherine Gili, Julian Hawkes, Jeff Lowe, John Maine, David Seaton and Anthony Smart, seems to have been chosen because of an unpraiseworthy ability to ape familiar precedents. A dis-

tressing number of their exhibits look like carefully reiterated details from existing works by Anthony Caro or Tucker himself, which is all very gratifying for those in search of continuity and inherited convictions, but unsatisfactory for anyone in search of work that might live up to Tucker's definition of 'free sculpture' as 'a challenge to facile and conventional views of history and aesthetics'.

Given that the number of home-grown exhibitors equals those invited over from America, Canada, Holland and Germany, it would be natural if the foreign representation was of a consistently higher standard. But the awkward fact remains that imported sculptors like André Fauteux, Robert Murray, Peter Reginato, Michael Steiner, Roger Williams and James Wolfe fail to provide a more inventive or independent way forward than their English counterparts. I cannot believe that Tucker is content with this state of affairs, constituting as it does a hefty rebuff to his stated declaration that 'new thought finds form by stretching the medium itself, not by learning an alien language, or by attempting to invent a wholly new one'. Since there is so little evidence in this exhibition that any stretching is taking place, it would have been more appropriate for Tucker to admit the existence of land art, environmental sculpture and certain so-called conceptual developments which I would argue ought to be taken into account when the present and future character of sculpture comes under debate.

It is an historical fact that many aspects of current art practice which have found no home in this exhibition sprang originally from a dissatisfaction with precisely the kind of sculpture shown here in such abundance. I do not wish for one moment to refuse sculpture the right to be either free-standing or object-orientated. It so happens that some of the works shown here – Larry Bell's elegant glass panels, Phillip King's painted version of *Open (Red-Blue) Bound*, David Nash's tensile split wood group, Ulrich Rückriem's granite plates and Jacqueline Winsor's four hemp corners – are perfectly honourable examples of that tradition. But to include Sylvia Stone's plexiglass *Manhattan Express* merely because it supports one particular kind of sculptural endeavour which Tucker sees as central to the tradition, is to be guilty of lauding orthodoxy at the expense of other, more rewarding areas of dissent.

There are signs that Tucker may be aware of the flaw in his argument: Carl Andre's clay piece, which uses the floor as a ground of relief in a manner condemned by the catalogue introduction, has been unaccountably let through the 'free-standing' net. On the whole, however, the prevailing impression is of an ostrich-like determination to behave as if sculpture had somehow stopped questioning itself around 1965, and that all the most valuable work since then has been justified in concentrating

152. William Tucker's *Tunnel* at *The Condition of Sculpture*, Hayward Gallery, London, 1975

on slavish reiteration. It is a pity, because many aspects of Tucker's writing on sculpture show an acute grasp of its essential qualities; and his own exhibit, *Tunnel*, is one of the most fully considered sculptures on view at the Hayward Gallery. Its supple ability to combine a monumental presence with a constantly unfolding series of alternative relationships ought ideally to be the achievement of a man with wider and more flexible notions about the identity of sculpture today than the constricted legislation laid down here.

ART AND MONEY

26 June 1975

Within the next few days, the Select Committee on the Wealth Tax will stop receiving evidence and set about making its recommendations to the Government. One of the most hotly contested issues it has dealt with centres on the private ownership of works of art, which many have argued should be exempt from the Wealth Tax.

As a writer who has spent much of his life viewing and responding to works displayed in public exhibitions, I am acutely aware of how dependent we all are on the availability of art. At any given time it is extremely difficult to see anything not owned by a museum or on temporary show in a commercial gallery. Such limitations mean, effectively, that the majority of art works are never freely accessible to the people for whom they were ideally made; and this only exacerbates the division which undoubtedly exists between art and its potential audience. Too many pieces in the jigsaw puzzle are missing, shut away in private houses buttressed with burglar alarms, sealed off in a bank vault, travelling between one dealer and the next on the international circuit, or else – more pathetically – stacked unwanted in lesser-known artists' studios.

The main problem is that the uniqueness of the art object turns it into a possession with a price on its head. Investment buying puts the most desirable works beyond the reach of all except the very wealthy, and discourages those with modest means from risking their funds on new art which may not appreciate in value. It has, in fact, become impossible to think about buying an original work without seriously weighing the financial implications of the enterprise: the two considerations are interwoven to a corrosive degree, ensuring that art and commerce can rarely, if ever, be separated from each other. Important loan exhibitions are increasingly hard to mount because of prohibitive insurance expenses; more and more works are purchased as a hedge against inflation and hidden from view for years; the gap between artists who are courted by the multi-million investors and those who are regarded as an uncertain return on capital outlay grows wider every moment; and society in general becomes further removed from regular, meaningful contact with the art it should be able to experience without encountering obstacles of any kind.

This is the distressing background against which pleas to exempt works of art from the proposed Wealth Tax must be placed. If the acquisition of art were suddenly to become a guaranteed haven for everybody wanting to place their money beyond the reach of the Inland Revenue, all the

153. Sir Denis Mahon at the National Gallery, London

worst excesses of our art marketing system would be multiplied over-
night. Prices would soar to still more absurd heights, an even smaller per-
centage of the population would be able to afford the work it wanted,
and English museums would find themselves barred from purchasing
the items they need in order to give the public a representative survey of
both historical and modern art. No wonder so many dealers have been
actively campaigning for an exemption clause over the last few months:
their trade is poised to bask in a spectacular boom if they win their case,
and it would become more difficult than ever before to disentangle the
pleasure of looking at an art object from the quite different pleasure of
counting the number of decimal points its cash value might contain.

Most of us who care about art, as opposed to its effect on the size of
our bank balances, would be in favour of applying the Wealth Tax across
the board were spiralling price records the only consideration. But it is
not as simple as that. Although two of the leading exemptionists, Hugh
Leggatt and Denis Mahon, are a dealer and a collector respectively, they

cannot be accused of wholly self-interested motives. Leggatt, for instance, was just as active a crusader against museum entrance charges, and Mahon has every intention of leaving his pictures to the nation if he is left unmolested by the threatened legislation.

The burden of their protest can be found in the title of their pressure group, Heritage in Danger, which seeks to highlight the prospect of a sudden drain of privately owned art from the country. They argue that the Wealth Tax would cause a mass of collectors to unload their possessions on the open market, thereby depriving England of a vast number of art works which our under-financed museums would not be able either to afford or to house. Moreover, by alienating the sympathies of most major owners, the Government would find that museums no longer received any gifts or bequests, and that a large quantity of work at present on extended loan to our museums would be withdrawn and sold abroad. It is also maintained that the collecting tradition would be gravely impaired, that the task of valuing private collections for tax purposes is impossibly complicated, and that the additional burden of a Wealth Tax might well cause many stately-home owners to give up the struggle of keeping their houses in good, cost-effective order.

These are alarming predictions, and appear to carry a good deal of force. But they can be countered. Hugh Jenkins, the Minister for the Arts, has already confirmed that anyone who places his collection on view, either at a museum or a home open to the public, will be cushioned against the full effects of the tax. If the Government made sure that this cushioning really was substantial, many art works at present unavailable to everybody except their owners would become accessible to us all. Some collectors will probably resist this idea, but only a proportion of the possessions they might sell represents an indispensable part of our so-called 'heritage'. The Government must make adequate provision, in terms of a substantial emergency fund, to enable museums to purchase these prime desiderata and exhibit them properly. It is, after all, a vital corollary of the Wealth Tax that the accruing funds be channelled towards the appreciation of art by society at large, and the Labour Party should acknowledge their obligations in this direction without delay.

When they do so, English museums stand a fair chance of being properly served by the Government for the very first time, and the manifold advantages of this new relationship will greatly outweigh any loss they might suffer from the withdrawal of loans or legacies. As for the question of valuing collections, there is much to be said for Jenkins's proposal that owners supply their own assessments, subject to the understanding that the Government reserves the option to purchase at this valuation. Many

collectors have furnished themselves with perfectly adequate insurance valuations already, and dealers have never experienced insuperable problems over valuing art works in the past.

Adjustments will doubtless be evolved to cope with the new situation, just as they can to safeguard the future of the stately homes industry. But none of the difficulties should stand in the way of the general principle at stake here, which amounts to nothing less than a concerted bid to stem the tide threatening to engulf art with the distorted and anti-social values of investment for investment's sake. If that kind of collecting dies with the Wealth Tax, it will be a tremendous gain rather than a loss. Buyers might actually start acquiring works for reasons of love, not profit. The insanity of the art market could benefit from the deflationary puncture it will probably receive when a whole group of collections comes up for sale at once, and England might begin to purchase the contemporary art it has so far always avoided in favour of safer, more predictable reputations. At their most positive, collectors can offer invaluable support to living artists, who need sustained forms of patronage if they are to be enabled to devote all their time to their work. And patrons hardly require assets of more than £100,000 (the minimum qualification for the Wealth Tax) to follow their instincts and buy art produced in their own time. They might well have to find six-figure sums if the exemptionists win the day; but I hope that the Select Committee – and the Government after it – will opt instead for a system which promises to help place art at the disposal of us all, not just the favoured few.

CRISIS OF IDENTITY IN GREEK ART
4 December 1975

The controversial exhibition which forms a part of the ICA's Greek Month has been staged at an acutely sensitive moment in the political and cultural history of Greece. As a special documentary section reminds us all too vividly, the Greeks are only just beginning to recover from seven years of repression under the colonels' dictatorship. And the militant spirit which produced the posters and other polemical cries of protest on display here is now devoting its energies to the task of restoring Greece's belief in itself, of regaining a national identity unclouded by the junta's appalling regime. It is hardly surprising, therefore, that the

decision to fill the ICA galleries with the work of eight artists who have all made their reputations and homes outside their native country has been viewed with anger and dismay.

This implicit vote of no confidence in the art produced by Greek residents would not, I imagine, have met with such resentment if it had been organised without the full force of officialdom behind it. There was nothing inherently wrong with Christos Joachimides's and Norman Rosenthal's plan to gather together a number of expatriate Greek artists and, in the words of the catalogue, 'examine the facts of a spiritual as well as an actual immigration'. But to present these artists, variously associated with Paris, New York and Rome rather than Athens, under the banner of an expensive and loudly trumpeted 'Greek Month' is to invite accusations of tactless, inappropriate paternalism. We would be quick to decry a 'British Month' exhibition in Athens devoted exclusively to art produced outside this country, and we are not as conscious as the Greeks of the need to develop a home-grown artists' community. They can hardly be blamed for viewing the ICA selection as an arrogant attempt to laud the international avant-garde at the expense of the vulnerable artists who hope, quite naturally, to restore Greek culture's battered credibility. Seen in this light, the staging of a big ambassadorial reception at the Savoy to celebrate the Greek Month appears unforgiveably inept.

The diplomatic tangle in which this exhibition has been enmeshed is doubly unfortunate, because no one would at this point in history want to support the desirability of a narrow nationalism. *Eight Artists, Eight Attitudes, Eight Greeks* is the title of the show, and the words have undeniably been placed in the right order. Insularity can be just as damaging as the characterless adoption of an idiom that has no local roots at all, and none of the ICA participants can be blamed for leaving a country where he would have found little or no support for his activities. Every since El Greco departed from Crete in the sixteenth century, so that he could measure up to Venetian art and then benefit from patronage in Spain, ambitious Greek artists have tended to regard foreign centres as a necessary stimulus. Nor are they alone in this: Rome, Paris and – more recently – New York have attracted many who feel stifled by the inadequacy of their native surroundings.

Anyone suspecting that alienation is a peculiarly Greek problem should recognise that it exists elsewhere, and ought not to attach too much significance to the theme of homelessness which Vlassis Caniaris explores in his contributions to the ICA show. Although he did execute a protest work against the colonels in the early days of the Greek junta, Caniaris has since widened his terms of reference to call attention to the

154. Vlassis Caniaris, *Gastarbeiter – Fremdarbeiter*, 1975

plight of immigrant workers, the underprivileged masses who wander
through Europe restricted to the most menial and poorly paid jobs.
Hence the group of headless figures, draped in soiled clothes and stuffed,
scarecrow-like, with rubbish inside their wire and plaster bodies, who
stand disconsolately on Caniaris's platform. The bruised suitcases set
down beside them might suggest the prospect of travelling on to a more
congenial environment, were it not for the hopscotch lines marked out
on the floor between them. They are helplessly attached to the rules of
this childish yet cruel game, which insists that each section of the hop-
scotch pitch offers equally bleak alternatives: the words 'conveyor belt',
'bad schooling', 'disorientation' and 'aliens police' are written there to
demarcate the limits of their world.

Compared with the related dummy tableaux of Kienholz, who resorts
to total theatricality and even Grand Guignol to ram home his similarly
bitter messages, Caniaris seems restrained and mute. His forte is pathos,
bordering not always successfully on the sentimental, and the paradoxi-
cal elegance with which he arranges his figures links up with the mood
of the exhibition as a whole. Sometimes, in Pavlos's plexiglass columns
full of looped paper and his whimsical room hung with illusionistic
steel-wool coats, this elegance works against itself so that the result is

merely entertaining. At other times, with Tsoclis's light-hearted interplay between painted wood and real wood jutting out beyond the boundaries of his picture frame, streamlined craft helps the trick along. But even here there is a streak of showmanship for its own sake, a kind of high-gloss polish, which also vitiates the neon installation by Antonakos and makes it appear too sweet by half. If these Greeks have benefited from international recognition, it has also encouraged them to be bland and superficially assured, practised performers who play with their abilities rather than striving for anything more profound. Chryssa's blue and white neon boxes err in the same direction, whereas her enormous so-called neon paintings fail because they are not informed by a real awareness of what the medium of oil on canvas – as opposed to flickering illuminated tubes – demands from an artist.

The great advantage of this slickness is, of course, that it makes for a very spectacular show: attendances at the ICA are healthier now than they have been for a long time, and my small son enjoyed himself hugely wherever he went. Samaras's mirrored room, all vicious spikes on the outside and endlessly reflecting within, proved so fascinating that he insisted on returning to gaze at it again and again. While even Kounellis's Art Povera sequence of coal and stone trucks, juxtaposed with a mound of fleece and poles of wool, were not sufficiently raw in their presentation to disturb the prevailing mood of glamorous euphoria.

The climax of the exhibition, in every sense, is Takis's section at the end of the main gallery, where a group of tall, vertical white slats and dark, heavy gongs produce jangling notes and deep, single sounds respectively. Each instrument, activated by a magnetic system which allows for a degree of randomness, is dramatically spotlit within an otherwise penumbral room. It looks, in fact, like a stage set for a Greek tragedy, except that the actors' roles are played not by masked humans but by sonorous noise and the sculptural presence of the instruments. Here is a fully Hellenic environment, made by an artist who remains close to his Athenian origins even though he has spent a large part of his working life away from his homeland.

Takis has managed to tap the essential strength of his Greek identity while at the same time pursuing a line of development which belongs to an international movement. He is one of the few kinetic artists who have continued to evolve since their heyday in the sixties, and he also uses his sophistication to articulate a primal sense of history. As such, he makes considerable amends for the glibness so evident in the rest of the show; and yet I cannot help feeling that a proper Greek Month exhibition should be tackling the situation inside the country itself. It may be awkward,

retarded and fumbling, and compare unfavourably with the suavity of the present offering, but it would at least be an accurate reflection of what being an artist in Greece means today.

THE ROLE OF THE ART MAGAZINE
17 June 1976

Despite the fact that art magazines have wielded an enormous influence on the development and dissemination of art during the two centuries of their existence, surprisingly few attempts have been made to survey them. As the pioneering exhibition called *The Art Press* at the Victoria and Albert Museum points out, one reason for this neglect is the sheer complexity of the material involved. In the Victoria and Albert's own national art library, the periodicals section now takes up no less than one and three-quarter miles of shelf-space: an awesome mound of reading, calculated to deter the most diligent and indefatigable of researchers. But there are other, equally strong disincentives as well. Even when the field has been narrowed down to organs concentrating more or less exclusively on visual art practice, a wide diversity of intentions still makes it difficult to define. How to generalise about an area which includes scholastic historical quarterlies on the one hand and fortnightly compilations of news and reviews on the other? The only factor which unifies these two polar extremes is a concern for art, and yet the nature of this concern takes such utterly different forms that they defy discussion in the same context.

The joint study group from the Victoria and Albert Library and the Art Libraries Society, which put together the current show, is fully alive to the contradictions. Its substantial catalogue acknowledges the multi-faceted character of art magazines by assembling seven essays that tackle aspects as disparate as 'Illustration and Design', 'Movement Magazines' and 'Dada and Surrealism'. The approach is sensible, and appropriately modest: Hans Brill emphasises, by way of defending the inevitable gaps in his review of 'The Fin De Siècle', that 'between 1850 and 1900 there must have been well over one thousand French periodical publications which took a serious interest in the visual arts'. Is this astonishing statistic a tribute to a gargantuan appetite for art during the last century, or merely the result of a foolhardy infatuation with the

Max Pechstein: Badende / Originalfarbenho-z-- hnitt

155. *Der Sturm*, no. 94, 1912, included in the Victoria & Albert Museum's *Art Press* exhibition, 1976

excitement involved in founding, editing and distributing a brand-new magazine? An adequate answer must embrace both these factors. The accelerating demand for art periodicals since the first one appeared at Augsburg in 1755 under the ponderous title *Die reisende und corre-spondirende Pallas oder Kunstzeitung*, ran hand in hand with the realization that anyone could produce a magazine with a modicum of capital, energy and blind faith.

The exhibition makes clear, however, that the memorable art periodical has always been created by something more exacting than the ability either to play to an audience or keep on producing issue after issue over an extended period of time. *The Art Journal*, for instance, was England's leading art magazine during several decades of the nineteenth century, and its impressive abundance of wood and steel engravings ensured that it compared well - in physical terms at least – with every European rival. But who remembers it today, and wants to consult its staple diet of antiquarian and topographical articles? The kindest comment it elicits from *The Art Press* catalogue is that its most useful feature for the modern student 'is the series of illustrated catalogues of decorative art objects shown at the International Exhibitions'. And these, it should be added, were issued simply as supplements to the main body of *The Art Journal* proper.

Hindsight deals savagely with such magazines, even though they earn a place in an objective historical resumé. The true test, then as now, is not their suitability for inclusion in one of the glass showcases which intersperse the present survey. Here their capacity to attract attention is artificially induced by exhibition display techniques; whereas at the end of the show a large table littered with current periodicals gives a far more realistic idea of how they are obliged to struggle for their survival among a mass of competitors. In the end, it all depends on whether they are able to make the serious reader pick them up, read them and buy them.

Many magazines try to win this battle by providing a wealth of sophisticated, lavish illustrations, and it would be silly to deny the impact visual content can exert. Some of the most stimulating items in *The Art Press* are pages from periodicals which made every effort to relay their message as much through typography and inventive design as through verbal discussion, and the innovatory enthusiasm that accompanied technical advances like the early use of colour reproductions can still be felt today. Unless a magazine devotes itself entirely to the celebration of design for its own sake, however, visual flair is not enough. The main aim of any periodical aiming at something more questioning and profound than window-dressing should rest with the standards upheld in its writing – be it criticism, investigation, analysis or information. An intense commitment to these standards is the ultimate hallmark of the worthwhile magazine, and without it the dangers of empty gossip, servile hagiography and naked art-market promotion are impossible to avoid. This, it seems to me, is the one ideal which does succeed in bringing together the many types of magazine under scrutiny here. From the most arcane historical discussion of a revalued Renaissance painter to the most

topical report about a new development in contemporary art, the level upon which the debate is conducted provides the crucial indication of a periodical's value.

In one sense, of course, the extraordinary proliferation of magazines charted by *The Art Press* is depressing. How can anyone hope to keep abreast of even a tiny percentage of the articles which have been, and are at this moment being published in so many languages throughout the world? But in another sense, this very abundance is itself a sign of health, ensuring that no one organ could ever impose its dictatorial version of the truth, unchallenged by alternative viewpoints.

There is no room for complacency, however. The bald fact remains that a vast amount of art is only experienced through the pages of magazines, which by their very nature distort the experience that the artist set out to provide in his or her original work. They also encourage the growth of art which lends itself to reproduction in this form and – because the great majority of periodicals depend for their existence on a regular supply of advertising revenue – they reinforce the all-powerful interests of the wealthiest commercial galleries. *The Art Press* scarcely comes to terms with the intimate bond between the interests of dealers and the priorities of magazines which rely on advertising. It would have been a salutary gesture if this exhibition had displayed ad pages alongside editorial content: in many cases the one could thereby be seen to have paid for the other on a blatant quid pro quo basis. By removing magazines from their normal position in the market-place to the virginal sanctuary of a museum, the organisers have failed to drive home perhaps the most relevant warning they could issue to the editors of the future.

ART AND DEPRIVATION

1 July 1976

Public reports, like private New Year's resolutions to give up smoking or stop swearing, have a nasty habit of arousing an initial round of applause and then lapsing into oblivion. It is therefore not too uncharitable to wonder if the same fate might befall Lord Redcliffe-Maud's long-awaited Gulbenkian report on *Support for the Arts in England and Wales*. A week has passed since its publication, and warm plaudits have already come

156. Lord Redcliffe-Maud

from interested politicians like Hugh Jenkins and Norman St John-Stevas. But will this official enthusiasm be backed up by widespread practical application in the months and years to come? The question needs to be asked, because so many of Redcliffe-Maud's principal recommendations have been voiced by those concerned with the future of the arts for as long as I can remember. From stressing the importance of increased public expenditure and the growth of arts education in

schools, to emphasizing the need for more business involvement and the key development of arts patronage in local government, the roll-call of proposals has an all too familiar ring about it. This is not to denigrate a report which provides a more comprehensive survey of the arts support structure than has ever been attempted before, and mounts a new argument for the devolution of patronage from the Arts Council to the Regional Arts Associations. The point I am making is that the inadequacies Redcliffe-Maud deplores and seeks to rectify have been lamented – albeit in different ways – for several decades. And there is still no sign of the wholesale awakening which everyone who cares about the role of the arts in society at large wants to witness.

The Gulbenkian report believes that it will happen, that the 'new methods of public patronage' financed by 'taxpayers and ratepayers' have already achieved 'a richer flowering of the arts of music, opera, drama, literature, painting and sculpture, and a greater increase in the enjoyment of them, than in any comparable period since the start of the industrial revolution'. These stirring words should, however, be set against the stark fact that 'enjoyment' of the arts is still the preserve of a minority, while the great mass of the population has never been to a concert (let alone an art gallery or an opera house) and has no intention of doing so. Redcliffe-Maud is prepared to admit that 'large areas of Britain constitute a Third World of under-development and deprivation in all the arts and crafts'. He realises, too, that much remains to be done. But nowhere in his report is there a frank acknowledgement of *why* this 'Third World' continues to exist.

As a liberal-minded, altruistic peer and Master of University College, Oxford, Redcliffe-Maud is anxious at all times to uphold the 'crucial' principle of keeping politics 'at arm's length' from the arts. Only thus, he believes, can creative freedom be divorced from the threat of governmental interference. While he is right to abhor the prospect of political censorship, of a government which succeeds in discouraging the growth of any arts activity which does not coincide with the ruling party's dictates, he is wrong to imply that politics has no bearing on the future of the arts in this country. The truth is that it will only be possible to dramatically increase popular interest in cultural life of all kinds when everybody is allowed proper access to it. By this I do not mean more public galleries, funds for artists, orchestras, poetry readings, theatres and local authority sponsorship, vital though all these things are. For they will never be able to revolutionise attitudes towards the arts without a radical change in our general social priorities. Redcliffe-Maud's plea for a 'fundamental development of educational practice, designed to include arts in the regular curriculum as well as literary and mathemat-

ical subjects', merely tackles the surface of the problem if education, in its widest sense, is only fully available to a privileged section of the population. This is where politics really comes in. Any teacher who has worked in a school that draws its pupils from deprived areas, where living conditions are inadequate and home backgrounds scarcely literate, freely admits the futility of imagining that these children could ever enjoy the arts on the level they deserve. Until society ceases to discriminate against such pupils, and insists that they receive the kind of education available to more fortunate sections of the population, no amount of visits from a touring National Theatre company will enable them to understand Shakespeare.

At this point it may be objected that full educational advantages for everyone are not the whole answer: many people who have been lucky enough to receive the best schooling available are not, after all, interested in the arts. My reply would be that each member of society ought to be given the chance to discover whether or not the arts have anything to offer, and nobody can possibly make that discovery if deprivation makes it difficult even to acquire basic skills like reading and writing. The five per cent of the population which Redcliffe-Maud estimates now 'regularly attends performances of serious music, opera, ballet and drama or visits art exhibitions' may never be transformed into one hundred per cent. But we will not know how many more could become arts enthusiasts while education persists in maintaining a chronic imbalance between the best public schools on the one hand and the roughest comprehensives on the other.

In this vital respect, then, there is an air of unreality about the Gulbenkian report. It recommends the fullest conceivable democratization of the arts without accepting the political implications of such a programme. In his section on Private Patronage, Redcliffe-Maud notes that 'Trade Unions in the past have not regarded interest in the arts as one of their concerns', and adds that 'we found no evidence of general change in this position, though in parts of Wales and northern England support for local festivals and colliery bands is given by branches of the National Union of Mineworkers'. He refrains from commenting on the Unions' attitude, apart from stating that 'it is at least encouraging that the Trades Union Congress last year appointed a working party on the arts.' But it would surely have been more honest of him to admit the grave shortcomings of a society which obliges its unions to devote most of their energies to struggling for higher wages. If that battle did not have to take place, the TUC could contribute much to the shaping of a genuinely populist patronage of the arts. As it is, however, the political realities of

Britain today obliged one member of the TUC's working party on the arts, Brian Blain, to declare recently that 'the idea that trades unions have this great responsibility as patrons of the arts seems to me a little bit suspect: fundamentally they are fighting organizations, and one never knows when those resources will be needed'.

It is tragic that our society casts the TUC in the role of a fighter, and ensures that union leaders confine themselves largely to questions of material gain alone. In a comparable way local authorities, confronted with the urgent need to finance new housing and other practical causes, are unlikely to provide funds for the arts on the scale which Redcliffe-Maud proposes. And in an economic climate that forces these authorities to drastically cut their expenditure, it is even more unlikely that they will step up monetary support for the arts. The Gulbenkian report states, quite unequivocally, that 'local government should become the major arts patron of the future, but should be left free by Parliament to decide how much to spend and how to organise its spending on the arts'. Can Redcliffe-Maud not see that this recommendation will remain a pipedream as long as our social inequalities consign the arts to the status of a luxury, enjoyed by few and ignored by many who have never been enabled to experience it in the fullest, most life-enhancing sense?

FILM POSTER OVERKILL
6 September 1977

Staring disconsolately at the kind of movie posters which festoon Tube platforms nowadays, I have often marvelled at how stale and archaic they appear. Almost every designer seems to be afflicted by the need to choke the picture surface with an embarrassment of trivia, rendered in a style so laborious and literal that it ends up starving the spectator's imagination. If my train is particularly late, and I am obliged to look at every poster within sight, the crass level of film advertising becomes still more insufferable. Compared with the images made for other products, which encompass a range and ingenuity few other countries can equal, movie posters conform to one remorseless norm. It usually convinces me that I have already seen more of the film in question than anyone has the right to foist on me: the sheer weight of detail, which performs the unlikely feat of being both frenetic and lifeless, offers a classic example of visual overkill. The

157. Albert George Morrow, *Edison's Life-Size Animated Pictures*, c. 1900

more it burgeons, the less confident it looks about the product it is promoting. At a time when movies themselves are filled with uncertainty about the future of the mainstream industry, their posters dramatise these misgivings by turning every single film into an Identikit smash hit.

Was the movie poster always condemned to whistling in the dark? A Welsh Arts Council touring exhibition, at the Birmingham Arts Lab's handsome new premises in Holt Street, bravely essays an historical answer. More than a hundred and eighty images have been selected from the daunting mass of available specimens to trace, in a far more substantial survey than has ever been mounted before, the development of British and American posters since the 1890s. And it must be admitted that the first item, which shows an eager audience gawping at a screen advertising Edison's Life-Size Animated Pictures, seems guilty of just as much unfounded hyperbole as its successors today. 'Reproductions Of Life In Birmingham!!! Do Not Miss This Great Treat!!!' screams the announcement, and even the most diehard of Birmingham loyalists have to snort.

But when Albert George Morrow designed this poster, at the turn of the century, both he and everyone else in Britain were so intrigued by the *technology* of the emergent motion picture that it hardly mattered whether the subject was the Midlands or Marrakesh. The very existence of this new invention was what counted; and film made its first advertised appearance – well down the list of attractions on ordinary music-hall playbills – as a medium rather than a message. 'Wonderful Cinematograph: The Photo-Electric Sensation Of The Century' sang the typography listing the attractions of Glasgow's Britannia Theatre of Varieties in 1899. The fact that incidents like 'the race for the Derby' and 'curious wrestling scenes' were to be shown on the screen was only added, like a postscript, in a much smaller face underneath. And as we see succeeding music-hall posters announce variations like 'Prof. Barron's Grand Beograph', with its 'life-size figures', it is possible to catch something at least of the genuine excitement which each 'latest improvement on the cinematograph' must have caused. Chaplin appears on one of these playbills as a live performer below the Beograph, and we can be sure that he found Prof. Barron's invention greatly to his liking.

Within a decade, refinements like the Vitagraph ensured that films were awarded the dignity of posters all to themselves. But none of their designers was remotely capable of evolving a format which would do justice to the motion picture's far-reaching implications. Although artists became aware that the challenge issued to the painting medium by photography had now been superceded, and static images of all kinds would henceforth lost their illusionistic supremacy, posters did their best to

deny film its attributes. Or rather, nobody connected with the promotion of movies thought it worth employing a designer who would have been able to signify their fluid, time-based character in poster form. Most of the Vitagraph posters look like ornate book covers, with one still photograph inserted among the elaborate floral borders.

In 1912, when *As Fate Would Have It* was issued, the Futurists were developing an art specifically committed to relaying the advent of twentieth-century dynamism: the speed, energy and complexity of disparate elements that they managed to crowd into a single painting could all have been carried over, virtually wholesale, to advertising a typical filmic experience. If Boccioni or Severini had made movie posters, the avant-garde language which the public condemned as esoteric in art galleries might have become widely understood when recast as cinema publicity. But the film industry was far too conservative to take risks with experimental artists. The revolutionary nature of this new medium seems to have cowed its early practitioners, and made them determined to reassure their audiences about the cosy familiarity of the motion picture.

Hence the rigid orthodoxy of pre-First World War posters, which look more like illustrations for *Boy's Own Paper* than harbingers of a mass-entertainment explosion. Their sheer sensationalism excites curiosity, of course, especially in the case of an image called *The Hater of Women*, where a man in a dinner jacket is spread across the lap of a matronly lady who beats him with her shoe heel from the comfort of a rocking chair. But most of them look back to a world of old-fashioned sentiment where little girls pray to 'make me good – like my daddy', and Bronco Billy stirs the heart in 'a pathetic and dramatic story of Christmas on the ranch'. The big city ambience where so many early flea-pits were situated is not reflected in these posters at all. And the nearest they get to admitting the existence of the technological age that made film itself possible, is when their plots scale the heights of supreme dottiness, with titles like *Lieut. Daring R.N. And The Photographing Pigeon*.

After the massive intervention of war, however, nothing could restrict movie posters to this kind of infantile narrowness any longer. In the place of stereotypes lifted straight from the frontispieces of pulp fiction, the 1920s gave designers licence to indulge in an eclectic orgy of borrowings. The freewheeling wit of Art Deco made it possible for posters to mix several different styles into one effervescent cocktail, where titles were torn free from their pre-war place at the bottom or top of a composition and intermingled with the zany pictorial content. In a 1934 design for *Cockeyed Cavaliers* a series of radiating concentric discs, which seem to have been lifted from the vanguard abstraction of Robert

Delaunay, is placed in the unlikely company of some naturalistic portrait heads. Innovatory ideas were now admitted if they could be watered down and made immediately comprehensible. The incisive drawing of Keaton's face in *The General*, with its triangular pupils set like sword-tips inside hexagonal eyes, is oddly reminiscent of Egon Schiele. The crucial difference being that the merciless Schiele would never have let his surgical intensity become compromised by the ingratiating cupid's bow of Keaton's upper lip – let alone by the slap-happy lettering which dances its way across the poster and dissipates whatever Austrian menace the face recalls.

Only the Marx Brothers, who after all broke most of the rules of movie making, were allowed a poster which relied for its impact on two minimal elements alone. The brothers' own faces, rendered in diagrammatic form as a row of cigars, curly hair, moustaches and so on, perch on top of giant capitals which spell MARX as they surge in a diagonal form from one corner of the design to the other. The name and their cartoon-like features are all that matter here. *Duck Soup*, the film's title, goes almost unnoticed; and apart from the director's identity, the usual paraphernalia of supporting credits is dispensed with altogether.

But on the whole, the movie industry continued to fight shy of any images that might perplex the public. The policy seemed to be: hit 'em in the eye with a face or a title they can identify without any trouble, and the stampede to the nearest Odeon is guaranteed. And as the Art Deco fizz gave way to stodgier diets in the 1940s, posters relapsed into their hidebound earlier ways. At one point during the previous decade, it had seemed as if attempts were being made to furnish the movie poster with a language of its own. The 1933 *Flying Down to Rio* is an ecstatic *tour de force*, where criss-crossing searchlights interpenetrate aeroplane wings covered with high-kicking dancers, and the green limbs of Dolores Del Rio arch across a composition which deliriously flouts all the usual properties. Its anti-perspectival, anti-gravitational irreverence does appear to be struggling towards a parallel for the multiplicity of incident and spectacle offered by the film, which capitalised on its medium's ability to defy the limitations of theatre and present 'a musical extravaganza staged in the clouds'.

But the Second World War brought with it a return to comic-book banalities, and Eric Pulford's poster for Olivier's *Henry V* looks like a jingoistic illustration for a sabre-rattling children's history book. A single image once again fills the entire surface, with Sir Laurence atop his rearing steed as he swings his sword at a black knight. The interesting attempt made ten years earlier by a routine Tom Mix cowboy poster, to place

four different images in one design and thereby imply something at least of a film's fluidity, has by now been entirely forgotten. We are back in the Vitagraph days, and a British Movietone News poster listing as its main item 'Royal Prayers for U.N.O's Success' sums up the suffocating spirit of the period.

An unexpected antidote was provided, towards the end of the war years, by Ealing Studios. According to the exhibition catalogue, S. John Woods was appointed to implement a policy of 'enlightened advertising' (whatever this curiously dated phrase may mean). He duly commissioned posters from artists like John Minton, Robert Medley, James Boswell, Edward Bawden and Barnett Freedman. The results were wayward, idiosyncratic and risibly genteel. For *Pink String and Sealing Wax*, John Piper simply reiterated one of his standard Regency terraces and stuck a photograph of Googie Withers in the foreground. Osbert Lancaster drew a design for *Laxdale Hall* so filled with delicate and fanciful detail that it simply does not register from a distance – the primary requirement of any poster. And Edward Ardizzone's proposal for Cavalcanti's *Nicholas Nickleby*, a slight little sketch which would have been more at home decorating the chapter heading of a book, was rejected by the provincial distributors on the grounds that it was 'too intellectual'. Most of the artists appear to have taken a perverse delight in not adapting their work in any significant way to meet the challenge of a movie poster. They obviously thought it beneath their dignity to devote any serious thought to the question of how best to render the film medium's structure.

But is it realistic, even with the remarkable Ealing experiment, to suppose that designers have any great autonomy of decision within the film industry? Abram Games, whose poster for *The Way Ahead* really did try to find an equivalent for the experience offered in the cinema, found his efforts rejected after printing because it was considered 'lacking in sex appeal'. The judgement was ironic in view of Games's decision to dominate his composition with an enormous phallic bayonet; and doubly so because his row of civilians marching through the hole in the bayonet's hilt, and coming out as soldiers isolated in the featureless desert beyond, neatly indicated the time-based progression of the film itself.

If Games's galling experience is anything to go by, there is pathetically little opportunity for any artist to formulate a movie poster syntax worthy of the name. Discussing the present day, the catalogue introduction stoutly denies that designers are 'hard-bitten, cynical hack artists who have been ground into the commercial dust'. But a plentiful selection of the rough sketches which contemporary designers submit for approval

proves that their best ideas are invariably rejected or amended out of recognition. Eric Pulford's initial project for a 1976 thriller starring Richard Widmark, Oliver Reed and Gayle Hunnicut restricted itself to one archetypal image: a gun clenched by a hand which contains all the stars' faces within its contours. It was powerful and succinct, standing out against a plain background and wholly attuned to the terse list of credits alongside. By the time Pulford carried out his final version, however, the stars were spread out across the design; the hand holding the gun was half-hidden in Reed's jacket and Hunnicut's hair; and the credits sprawled all over the poster's surface. It is a lamentable change, suggesting how much frustration lies behind the exuberant façade of a survey which has been given the romantic title *Selling Dreams*. The Widmark/Reed thriller was called *The Sellout*, which is a more appropriate indication of the tyranny exerted by the movie industry over its poster designers. Unless its stranglehold is loosened soon, all of us will grow completely impervious to film advertising as we wait for the Tube.

DISAPPOINTMENTS

THE FALLACY OF KINETIC ART
30 September 1970

In art, as in life, there is often an alarming disparity between theory and practice, concept and reality. Nothing is more depressing than reading the elevated statements of a painter whose work fails to measure up to his boundless ambitions: they poison one's respect, raising hopes where they should never have been allowed to grow and making a cloud of frustrated expectations obscure reasoned criticism. When artists issue grandiose manifestos they play a very dangerous game; and if the concrete products of their ideas are found wanting, they cannot reasonably complain if the audience reaction becomes vituperative rather than merely dismissive. There is something at once dignified and appropriate about Rembrandt's almost complete silence concerning his creative intentions: the paintings, it is easy to imagine him thinking, are perfectly capable of speaking for themselves, and his few recorded remarks include gruff asides to visitors who irritated him. 'The smell of the colours', he once growled at an admirer wishing to examine his work too closely, 'will bother you.'

This divergence between intention and achievement becomes especially acute when twentieth-century art is examined. Ever since the Impressionist revolution gouged out a chasm between artist and public, the avant-garde has felt a consistent need to defend itself with bombastic declarations of defiance, making alienation a positive spur to its subversive efforts rather than a tragedy to be bewailed or deplored. And simply because there have been far more verbal broadsides issued by artists than in any other previous era, the amount of pretentious nonsense has multiplied a hundredfold.

The phenomenon of a race of articulate artists had beneficial results, of course. Reading the lucid explanations set down by men as considerable as Matisse and Klee makes one regret the dearth of comparable documents by earlier masters; and even when the manifestos are more exciting than the work itself, they often succeed in inspiring a younger generation to take up and develop ideas which would have seemed weak or impossibly naïve if the paintings had survived without the written programme. How many of the seeds undoubtedly sown by the Futurist movement, for example, originated from its work rather than the exhilarating broadsides issued by the Futurists as a collective group? If too many of their paintings and sculptures now seem to be embarrassingly gauche embodiments of theories which needed a supreme genius to put them into convincing action, their ideas have nevertheless been seized

upon with alacrity by many contemporary artists.

The whole basis of kinetic art can be seen to have been born out of the Futurists' enthusiasm for the exclusively modern experience of speed, dynamism and a totally mechanised environment. Behind the heterogeneous collection of kinetic work that has just been assembled at the Hayward Gallery, one principle of unification exists: a determination to escape from the static media of easel paintings and free-standing sculpture into a world of motorised constructions. For this exhibition offers no escape from the vertiginous quality of modern life. Anyone who derives comfort from the contrast between a gallery full of calm, stationary objects and the frenetic environment surrounding him in the world outside, will find no comfort when he enters this show. On all sides, he is immediately assaulted by the blurred motion of mechanical activity,

158. Catalogue cover of Hayward Gallery's *Kinetic Art* exhibition, 1970

puzzling amalgams of light, sound and thrusting metal that only intensify the stress of urban life. They attack the sensibility of the onlooker in the most direct way imaginable, dazzling the eye with visual paradoxes and confounding the mind with scientific tricks.

A kinetic environment is closer to a fun-fair than a conventional art gallery. Visitors are invited to make their own art by throwing nails against a magnetised sheet of steel, watch their own image become twisted, distorted and inverted by a barrage of concave mirrors, and sit down on a 'Chair Stimulator' which seeks to arouse sensual pleasure with a machine instead of a human body. Just as the functional beauty of an aeroplane can only be fully appreciated by watching it over a period of several minutes as it takes off, scythes a course through the sky or screams

to a halt on the tarmac, so most of these exhibits have to be observed over a period of time as they run through a patterned performance. Kinetic art delights in spectacle, showmanship and a sense of theatre: it bullies you into a prolonged viewing, knowing full well that if the curiosity of the spectator is aroused, he will sit it out in the hope of discovering the method behind the seeming magic. The artist becomes a witch-doctor once again, hoping to impress not with the time-honoured means of aesthetic pleasure and formal harmony, but by confounding expectations and seducing with novelty. He concocts voodoo for a society weened on the logic of the computer. All the boundaries which used to separate art with a capital A from less exalted activities have been resoundingly flattened, and the critic is pushed out on his own into a world that denies the existence of any pictorial laws save those of the artist's ingenuity.

It should be an invigorating experience, one which shows the direction in which the art of the future will undoubtedly move – but it is not. After a time, the vocabulary of kinetics becomes familiar, then repetitive, and finally as cliché-ridden as any other form of academicism. The mirrors, once worried over, look like facile toys; the nail game fit only for a nursery. And the most elaborate constructions on view – like Keith Grant's huge *Idomeneo*, which stands like a robot guardian over Waterloo Bridge, daring the public to taste the wonders of the exhibition within – seem oddly simple-minded. They revolve, hiss, flash and change their appearance, to be sure; but once the extent of their operations has been understood, and the whole process begins all over again, the novelty wears thin. Their potential appears limited rather than limitless, and compared with the practical ingenuity of an industrial machine, more than a little foolish. No one could call the sight of a moon rocket erupting from the launching-pad mildly amusing, however strongly he might disapprove of the reasons for its existence. It is far too complex an invention to be laughed at. Yet the same cannot be said for kinetic art: it announces all too plainly that artists are not scientists, and teaches us that they err if they ever pretend to be.

MEDLEY'S DILEMMA
26 March 1971

Self-criticism, as any artist worthy of the name knows only too well, is a forked path that leads to creative renewal or destructive paralysis. Where one person can use it to overhaul work, discarding outworn conventions and settling at last upon an individual line of enquiry, another allows it to throw all motivating impulses into doubt. How does anyone know the best way to turn it to account? Without it, an artist soon ceases to develop and settles down in a well-worn stylistic armchair, turning out sleepy variations on previous achievements rather than extending or enriching his original precepts. That way stagnation lies; but it is equally easy to err in the opposite direction, and scrutinise yourself so closely as to end up inhibited or perplexed.

Making and explaining are two very different activities, and many artists prefer to leave analysis severely alone: Henry Moore once refused to carry on reading an interpretation of his sculpture by a Jungian psychologist 'because it explained too much about what my motives were and what things were about. I thought it might stop me from ticking over if I went on and knew it all.' Better by far to avoid standing back from personal obsessions if objectivity means that you question the validity or even the purpose of your work. Without the fundamental desire to impress a unique vision of the world upon contemporary sensibilities, no one can hope to continue operating at anything like a satisfactory pitch. Perhaps the greatest artists have always been, in some wonderfully wilful way, blind to their own peculiar limitations, madnesses and inconsistencies. Only thus are they able to preserve their uniqueness intact, and escape the form of anxious eclecticism that a more susceptible intelligence so often cultivates. It simply does not pay to react to other men's art with too much passive discernment and sensitivity; as Clement Greenberg wrote, coining one of those aphorisms that extend far beyond their ostensible context, 'a nice taste can alienate an artist from his own originality.'

Ironically enough, those most guilty of such damaging self-negation are often intensely aware of the precise cause of their shortcomings. For this very *awareness* is the stumbling-block; they cannot shut their eyes to the dazzle of alternatives and pursue a private course with single-minded conviction. Invariably, they turn out to be better teachers than artists, capable as they are of projecting their sympathies into the hopes and problems that beset every student. And this secondary talent slowly

becomes their ultimate justification, as they watch a younger generation indulge itself with a confidence they were never able to muster. Not that they abandon their own creative preoccupations: the thirst for expression remains as keen as ever, even as it is accompanied by a growing realization that they will never entirely fulfil the potential with which they were born.

One painter who seems to have been saddled with such a handicap for most of his long career is Robert Medley. Now, at the age of sixty-five, he is breaking a prolonged silence in a one-man show at the Lisson Gallery; and although the result constitutes the most satisfying and enjoyable exhibition now to be seen in London, it is still afflicted with a diffidence that prevents our pleasure from being converted into outright admiration. For Medley is a classic example of an artist who has never been entirely able to make up his mind. An early dissatisfaction with the academicism of art-school training in the twenties did not immediately lead to an espousal of radicalism, just as personal contact with Duchamp in Paris failed to dispel a lingering love of Cézanne and Bonnard. Instead, he wavered uncertainly between an affection for Bloomsbury values on the one hand and an incipient Surrealism on the other, bypassing his difficulties by immersing himself throughout the thirties in the challenge of stage-designing for friends like Auden and Isherwood. All the time, he was conscious of indecision and the lack of a central driving concern; but his acute apprehension of the dilemma served only to aggravate it and hinder him in his search for a complete persona.

The advent of war postponed any attempt to resolve the problem, but a determined and renewed assault through the *Cyclist* and *Antique Room* series of the early fifties did not succeed in allaying his intense anxieties. Medley found it impossible to reconcile the need to retain representational reality with the concomitant urge to escape from that reality into a more liberated and associative area of reference. Looking at those pictures now, it is easy to see how he held himself back, withdrawing into compromise decisions that could only thwart his wish to expose his personality more fully. Painterly skill, compositional cohesion and poetic apprehensions were displayed in abundance, but they were never vitalised by a direct, robust sense of *engagement*: Medley always seemed to be faintly distracted, as if the pressures of his questioning intellect hindered him from plunging wholeheartedly into an irrevocable commitment. It was wholly typical of his open willingness to learn from the innovations of others that he greeted the Abstract Expressionist invasion of London with approval. The American example enabled him to loosen up more, emancipate his work from descriptive considerations and trust to the

159. Robert Medley, *Three over Four*, 1970

operations of instinct and accident. But the paintings he executed in the early sixties suffer in comparison with their transatlantic counterparts because of Medley's insistence on holding to links with figuration. Once again, he simply could not bring himself to forget about alternatives and embrace the full implications of one particular avenue of thought.

In this sense, his latest pictures are far and away his finest achievement; for his recent, sudden espousal of a rigid geometrical vocabulary has helped him to iron out much of the former hesitation. Now the free wheeling calligraphy and organic forms employed in previous abstractions have vanished altogether, and in their place a coolly rational system of construction reigns supreme. The best of these large canvases have an assured finality which Medley has never before attained. Exactingly precise volumes are assembled with magisterial calm on the surface of the canvas, and permitted to swing back or forward into space whilst retaining the integrity of a flat pattern. For all their inflexibility, Medley has repeatedly infused them with sensuous colours that give out an almost Mediterranean glow: that, and the strong architectural connotations

many of them possess, suggest a new feeling for classical order and repose. So much has been improved; and yet a certain tentative dryness in the handling, combined with a curiously aloof reserve, pervades the whole exhibition. The diffidence lingers on: Medley cannot entirely break down his defences, cast aside his congenital caution and dismiss his misgivings. Self-criticism still holds sway, its very integrity a starvation, its hesitation a loss.

ROBERT MORRIS
30 April 1971

Anyone visiting the Robert Morris show at the Tate Gallery will quickly discover that the normal relationship between spectator and work of art has been dramatically reversed. Instead of looking at a series of untouchable sculptures, appraising them from a distance and waiting for them to assert an independent emotional authority, we are asked to become an integral part of the exhibition ourselves, to join in, try out, test and participate. The whole gallery area is transformed into an aesthetic gymnasium, littered with implements which call out – successively – for the energy of an athlete, the poise of an acrobat and the exuberance of a child. A huge wooden cylinder lies empty on the ground, waiting to be inhabited and moved from side to side; a long rope dangles from the ceiling, daring the intrepid to hoist themselves up on it and balance on a rolling ball; a tunnel rises up from the floor, inviting all-comers to enter and be subjected to the discomfort of a journey that finishes in an exit barely large enough to crawl through. Nothing exists here without the active intervention of the onlooker – everything cries out to be experienced in a completely physical way. The workings of the eye, usually the only means whereby art transmits its message to an audience, are reduced to a subsidiary role, and a wide range of muscles are brought into action. For Morris has devised an adventure playground where adults can cast their inhibitions aside and indulge in the kind of exertions normally considered to be the preserve of a school sport's day.

Not that races have to be run, or prizes won: on the contrary, the whole point of this venture is meditative, despite its surprises and undoubted hazards. When Morris constructs a narrow ledge along a wall and gradually whittles it away into empty space, he wants you to think

160. Installation view of Robert Morris exhibition, Tate Gallery, London, 1971

about the nightmarish sensation of being trapped at a great height: how the experience affects the movement of limbs, when exactly the mind anticipates an approaching imbalance and tells the body to jump clear. And it is pleasant, of course, to realise that an exhibition positively orders you to enjoy yourself, forget about intellectual questions and cultivate more instinctive pursuits. At the end of all these strenuous activities, the wholehearted participant feels invigorated, as if the hard mental work of gallery-going had been replaced by the unexpected diversion of a mid-day swim.

But then, just as satisfaction lulls the senses, doubts begin to creep in. What, in all truthfulness, has been expressed apart from a desire to encourage the public to become involved in a series of civilian assault

courses? If the objects Morris has assembled especially for this Tate exhibition are meant to be used rather than perused, how can they possibly be seen as anything more significant than a group of ingenious games? It is gratifying, certainly, to realise that the contents of the show escape from the pressures of the art market, can never be bought or sold, and exist solely to elicit a direct, uncomplicated response from the visitor. And it is mildly instructive, likewise, to follow Morris's planned progression from the first section, where weighty objects have to be manipulated by the spectator, through to the second and third sections, where the objects dictate human movements more and more rigidly. Yet the entire exercise remains disconcertingly superficial, a lightweight affair that leaves no lasting impression even on the person who has undergone the complete sequence of tests.

Morris has always been concerned, from the beginning of his career as a sculptor in the early 1960s, as much with the processes behind a work as with the finished product. This interest was announced with didactic clarity in one of his very first pieces, the *Box with the sound of its own making*, which consisted of a simple walnut cube containing a tape recorder playing the sound of the box being constructed. The contrast between the extreme geometrical precision of the cube and the untidy flow of noise inside showed that Morris possessed a subversive, almost Dada streak alongside his leanings towards highly simplified minimal forms. And the clash between these two seemingly irreconcilable impulses has provided him with much of his motivating force, alternating as he does between wild extremes of freedom and discipline. At one moment he is all puritanical rigour, confining himself to the schematic finality of repeated mathematical units. And then, quite suddenly, he swings away from this kind of strict definition and explores the anarchic potential of giant felt strips, allowed to sprawl down from a wall according to the laws of chance alone.

The two interests coincide sometimes, notably in the set of four cubes made entirely out of mirrored plexiglass, which successfully combine the perfection of a regulated shape with the total unruliness of the reflections held by the cubes' polished surfaces. Executed in 1965, these strange, paradoxical forms represent the best of Morris's work: arranged on the lawn outside the Tate, as part of a mini-retrospective of his earlier production, they at once impress with their four-square sobriety and confuse with their dazzling images of grass, trees and sky. But the synthesis of polar extremes demonstrated here is a rarity in Morris's development, and he has otherwise veered with disturbing frequency from one area over to the other.

Minimal sculpture – within which frame of reference half his work

seems to operate – only carries real conviction when it is exploited with fanatical consistency. The overwhelming strength of Don Judd's Whitechapel show last year lay precisely in its single-minded unity, its tenacious devotion to one purist line of enquiry. Morris's forays into the same territory, however, are far less affecting because of his refusal to be committed to a logical course. Where Judd digs deeper into his own particular fortifications, and mines his discoveries according to a dogged, steady, undeviating programme, Morris darts impatiently from concept to concept, as if frightened of being left behind with yesterday's solution. His recent affiliation with the so-called 'Peripatetic Artists Guild', which announces his readiness to provide anything a client desires – from 'explosions' to 'chemical swamps' – smacks all too suspiciously of outright eclecticism. The 'Guild' looks like a clever rationalization of his own chronic restlessness, which infects everything he attempts with a curiously detached form of blandness. Perhaps his acute intelligence acts as a barrier, sealing him off from emotional profundity; or perhaps his temperament makes him shy away from Judd's slow-moving, utterly engaged certitude.

Either way, the Tate exhibition marks a deterioration of standards, displaying all the sparks of Morris's inventiveness without any of the fire which should blaze away behind them. It is fun, to be sure, and explores the preoccupation with physical sensation that has occasionally, in the past, conspired to make him produce a fine sculpture. But it halts half-way between thinking and creating, and ends up as a grandiose, facile conceit. Good art requires far more imagination and insight than Morris has bothered to assemble here, and the playground, for all its display of bodily pyrotechnics, remains disappointingly empty.

ROBYN DENNY
22 March 1973

The most successful paintings in Robyn Denny's retrospective exhibition at the Tate Gallery appear to contain an invitation. Carefully proportioned, so that their size is in harmony with the physical scale of the person who views them, they beckon you towards the space they inhabit. And the abstract shapes placed within the canvas encourage this feeling of participation, rising repeatedly from the bottom of the picture into architectural

structures which seem to offer themselves as entrances. Once this initial welcome has been made, however, the hospitality cools. For the doorways lead nowhere: instead of taking you forward on a journey around the composition's inner depths, they block your path and remind you that they are, after all, only flat painted surfaces. The would-be explorer is rebuffed. He steps back again, wondering how the pattern in front of him could ever have been seen as a gate. It now looks solid, like a mirror-image of his own physical bulk, and seems to be referring outwards rather than inwards.

Enticement is replaced by confrontation – or rather, it *would* be if the colours Denny favours did not fight against the possibility of reaching any clear-cut, final decisions about the paintings' effect. Although their designs are mapped out with geometrical clarity, the tonal range employed by Denny veils that clarity in a puzzling, often penumbral haze. One colour bleeds into its neighbours, blurring the demarcations between them so effectively that it is hard to name them or pin them down. They merge and swim together, defying proper analysis and destroying any hopes of arriving at neat conclusions concerning Denny's aims. The ambiguity of his colours confuses all our thoughts about entrances or mirrors, and we end up realising that these pictures ultimately set out to reflect the shifting, contradictory nature of our responses. The invitation, therefore, is turned on its head: it welcomes the spectator into the picture-space, then throws him back again by emphasizing that a full appreciation of the painting depends on how much time and thought he is prepared to give.

Such a take-it-or-leave-it attitude is, of course, double-edged. If the works themselves do not hold enough basic interest we simply look, feel uninvolved and walk on. A disappointingly large amount of Denny's exhibition has this alienating effect because the pictures fail to demand prolonged attention. They can be sober to the point of incommunicative, and so retiring that they seem unwilling to strike up a dialogue. The interchange which they seek between viewer and painter cannot be established unless there is a strong desire to participate in a shared experience, and Denny's extreme reticence often rules out a vital reaction of any kind.

It is a pity, since most of his energy has been devoted to finding out how best to create an art which would present modern urban man with an equivalent to the way he deals with his everyday environment. The severe, abstract appearance of his mature work may not immediately suggest that Denny was as anxious as the Pop artists to develop a language which avoided remoteness and related directly to contemporary society. But much of his early work struggled with this very problem, and it is possible to watch him moving in the late Fifties from stone mosaics or collaged letters

161. Robyn Denny, *Life Line I*, 1963

to the idea of a 'transformable' work that could be rearranged at will by the spectator. All these different approaches were groping, erratically and sometimes incoherently, towards a way of drawing the onlooker into the picture: through the fragmented clues offered by words, through the heaped-up layers of time embedded in mosaic, dripped or smeared paint, and through actively reassembling the elements of a painting.

Without a knowledge of Denny's later work it would, admittedly, be

hard to discover a definite direction in all these disparate activities. But hindsight enables us to see how they were all preoccupied with evolving the idea of art as a game, requiring as much participation from the viewer as he would devote to the ordinary business of living. This was how Denny linked himself with the Pop artists' desire to plunder mass media images for a new, popular subject-matter rooted in modern society. He sympathised with the motives behind that wish, without accepting the need to use the actual raw material which artists like Richard Hamilton were pursuing. Chasing that kind of imagery seemed far less important to Denny than reflecting the way man was being forced to respond to the pressures and stimuli of contemporary urban life. He agreed with an essay by Daniel Lerner, which stressed how the enormous variety of situations confronting urban dwellers gave them the ability to adapt themselves constantly to new demands on their person-alities. And an exhibition called *Place* which he helped to organise in 1959 tried to put these ideas into practice, providing visitors with a planned environment of paintings planted in maze-like rows on the floor of the gallery rather than hanging straightforwardly on the walls. It was a rather literal attempt to tell the spectator that he should take part in a game which offered a whole range of viewpoints, not simply look at an assorted collection of exhibits safely removed from the area he walks in.

But the public's negative response taught Denny that his paintings must in future attempt the same task on their own, unaided by the strategies of the exhibition planner. And so he lifted his pictures back on to the wall again, relying on a largeness of scale inspired by American art to provide the spatial relationship between painting and onlooker which *Place* had sought to impose. Denny has tackled this project with great consistency ever since then. There is no mistaking his dedication or his seriousness, and he has justified his contempt for amateurism and compromise by produc-ing a body of work that adheres to its ideals with a zeal all too rare in English art. Apart from his screenprints, which dispense with the paintings' all-important understanding of scale and fail to provide any compensation to justify Denny's reason for producing them, he has never wavered. Every new development has been readily understandable within the terms estab-lished by the language of previous work: the move from dark to light tonalities, which replaced one kind of colour haze with another, equally confounding alternative; the change from vertical structures that dominate the canvas with a human presence to horizontal ledges which leave most of the canvas reliant on colour alone. These innovations do not contradict each other – they extend Denny's vocabulary by rephrasing his desire to present the spectator with the complexity of his responses.

How then to account for the low voltage which prevented me from entering into a real dialogue with anything except for one powerful group of paintings executed in 1964–65? I suspect that the very professionalism which stamps all Denny's work acts as a deterrent. The paintings are too flawless, too polished and bland: they do not seem to require the intensity of observation which would alone make them rewarding. They glide serenely past, secure in their tight, glassy perfection, impervious to our gaze and sadly incapable of arousing the commitment that Denny would like us to give them.

PHOTO–REALISM
12 April 1973

It was bound to happen. The battle between photography and painting, which has been raging ever since the advent of the camera prompted many people to predict the death of art, has come full circle at last. A whole group of mainly American artists now take their cue not from external appearances or internal imagination, but from ready-made images served up for them by the photograph. They call themselves – or rather, have been called by those whose business it is to promote neatly packaged movements in art – Photo-Realists. And their first London exhibition at the Serpentine Gallery proves how doggedly they devote themselves to reproducing the illusion of a full-colour snapshot on the surface of a painted canvas.

Their source material, culled from magazines or taken by the artists specifically for this purpose, is usually mundane. They prefer the photographs to be documentary, black-and-white records of ordinary subjects, pictures that have not already been perfected and stamped with the shaping individuality of a good photographer. That way, they feel free to mould their material, editing it down to a better composition, improvising the colours, differentiating between sharp and soft focus, heightening the significance of small details which could never have been as clear or telling in the original print. To achieve these aims at all convincingly, the artists must obviously be technically accomplished, and the best paintings on show here are skilled, often spectacular performances. They successfully mirror the feel of a photograph: its grainy or lush texture, its sometimes painful abundance of hard visual

south africa

Greyville Race Course-Durban, South Africa

162. Malcolm Morley, *Race Track*, 1970

information, its ability to reduce all motifs, however different, to the same flat, literal level. And by choosing as well a fairly neutral range of themes – shop-fronts, cars, passport-like portraits, bus windows or neon signs – they force us to realise that the real purpose of their pictures is considerably more abstract than the term Photo-Realism would suggest.

For these paintings reveal nothing about the reality of the urban life they depict. Unlike Pop Art, which chose its images from a consumer, admass world in order to celebrate a new kind of subject-matter, Photo-Realism remains dispassionate about the scenes it depicts. It is emotionally deadpan, dourly factual; and the only strong impulse at work appears to be a narrow, academic delight in the business of translating photographic values into paint. Chuck Close's gigantic heads refer, therefore, to a certain style of *Time* magazine cover illustration rather than to the relationship between sitter, photograph and artist. Richard

Estes's street scenes likewise appear most concerned with the way in which the most drab shop can be made to take on the streamlined, Hollywood glamour of a travel brochure. Reality, however paradoxical it may seem, is forgotten altogether, and we are left with an earnest desire to copy the camera that gives the show a monotonous uniformity.

It is simply not enough to rely on our enjoyment of the idea of a painter simulating photographic values. I think the Photo-Realists underestimate the camera's knack of making everything, including the most sophisticated and polished painting, look totally predictable. Instead of using that predictability in a new way, most of their pictures sink down to a visual level so ordinary and unexceptional that the only lasting response we can give is to wonder how it was done. In other words, we are back to assessing craftsmanship and technique almost as ends in themselves, and the lack of any other positive contribution from the artists gives the exhibition a very arid, mechanical air. Perhaps the lowest point of all is reached in the sculpture, where the photographic references disappear completely and we are confronted with the unbelievable dullness of John de Andrea's life-class female nude, or the absurdity of Nancy Stevenson Graves's attempt to simulate – with a wealth of different materials – the kind of stuffed animal which a taxidermist could have knocked up in a fraction of the time involved.

One painting, and one only, stands out with powerful reverberations: Malcolm Morley's painstaking facsimile of a photograph showing a South African racecourse, which has been brutally cancelled out with two crossed bars of paint. The political protest is strongly registered, but the picture gains no small part of its effect from the snub it unconsciously delivers to the whole notion of aping photographic values in painting. Art is here made subservient to the camera, whether the artists wanted to or not, and it is hardly an edifying sight.

EDWARD BURRA
24 May 1973

'The very sight of peoples faces sickens me,' Edward Burra wrote to a friend around 1945. 'Ive got no pity it realy is terrible sometimes Ime quite frightened at myself I think such awful things I get in such paroxysms of impotent venom I feel it must poison the atmosphere.' This confessional

letter, peppered with a lack of regard for conventional grammar which parallels Burra's stubbornly independent attitude towards art, makes immediate sense. There *is* a very potent whiff of poison wafting through his retrospective exhibition at the Tate Gallery: in pictures remarkable for their airless claustrophobia, it quite literally becomes the atmosphere. And whenever figures are permitted to inhabit this choked, turbulent space, they are distorted with a relish that amounts to a manic scorn for humanity.

No one is allowed to escape the scrutiny of Burra's withering observation. Whether he chooses to portray sailors in a bar, 'Negroes' gyrating across the floor of a Harlem ballroom or an elegant bridal couple pledging themselves to a Marriage à la Mode in church, the results are at once disquieting and bizarre. Half puppet and half caricature, these heavy-limbed apparitions with their gaping mouths, glazed eyes and thrusting gestures are never allowed to subside into normality. Mae West is as idiotic in her posturing as the French prostitutes pacing the pavement, and the *nouveau-riche* sisters taking tea on a Mediterranean terrace share their ghoulish vulgarity with the proletarians who guzzle in a cheap snack bar.

It would all compare in its relentless savagery with George Grosz if Burra's standpoint were not so hard to define. In the 1945 letter he sounds puzzled, even dismayed by his disgust, whereas Grosz knew exactly how to view his role as a crusading social and political satirist. Berlin, for him, was riddled with immoralities that had to be attacked. But so far as Burra was concerned, the tawdry glitter of a Toulon café could be savoured as well as pilloried. A cackling delight pervades his glimpse of a tea shop peopled with polite yet naked waitresses, and even in a full-blooded allegory of decadence and mortality such as *John Deth*, where the painted tarts, perverted vicar and bloated businessmen seem to have landed themselves in a garish, everlasting Hell, a streak of gaiety and wit prevents Burra from vying too closely with the full Expressionist horror of a forebear like Max Beckmann's *The Night*. He is fascinated by meretricious, seedy incidents which another artist might condemn: they are seen as the fragments of some irrepressible carnival rather than a dance of death. The reason why these watercolours from the late twenties or early thirties still retain their bite today is largely due to a corresponding vivacity of style, which defines each costume, grimace and extravagant fantasy with the whiplash elegance of an Art Deco designer.

Burra is, essentially, a great illustrator. His sinuous line and hard, almost metallic colour transmit the surface gloss of the Jazz Age with a precision that suggests he could have been an outstanding poster or fashion artist. In 1928 he described his ecstasy at seeing how Mae West 'stands

draped in diamonte covered reinforced concrete with a variety of parrots feathers ammerican beauty roses & bats wings at the back and ends up waving an electric ice pudding in a cup as the statue of Liberty'. This appetite for brittle, camp spectacle informs his best work, making it more like a testament to the spirit of a period than the fantasy of a man who has been notorious throughout his life as an incommunicative recluse.

Burra was, therefore, fortunate in his times. After growing up a sickly and partially educated child during the sombre First World War period, he was ready for the Charleston era, and his most intoxicating work mirrors its zany madness down to the most incidental cloche hat, false eyelash and striped suit. For all the distortion and Mannerist excess, it remains rooted in social recording of the most acute kind, and when Burra left that world behind, the temperature flags. During the 1930s, he began to flirt with Surrealism proper – as opposed to the Mirò-like glassiness of the previous period – and in a picture like *The Duenna* his unwillingness to admit any form of contemporary detail produces a generalised and not very original vagueness.

A similar waning of intensity also occurred when he switched his attention from the Vanity Fair of urban life to pastoral landscape. Deprived of the leering wickedness and waspish sophistication which made his *Minuit Chanson* watercolour so devastating four years before, a 1935 view of Plymouth Harbour suddenly looks tepid. The technique is still impressive: Burra's linear talent means that the facility with which he fleshes his contours with dense layers of wash can descend into clumsiness when oils are used. But the mania has disappeared, and without that combination of documentary acerbity and unashamed exaggeration, Burra appears diminished.

Not that imagination on its own is any better for him. The large, grandiose comments on the brutality of Civil War in Spain, which gradually overshadowed the gleeful levity of earlier works, often protest too loudly. Couched in an idiom midway between Surrealism and the Renaissance muscularity of Signorelli, Burra indulges in a scale and a passion for the grotesque that become melodramatic. These overbearing set-pieces need the tight rein which social reportage previously held on his love of theatricality. Nowhere more so than in his curious series of religious compositions, where biblical episodes are submitted to a treatment which crosses Hollywood kitsch with Hammer Horror in the crudest possible way.

It is almost a relief to move on to the last two decades of his work, and watch him settle more and more exclusively on the landscapes of Wales, Ireland and his local scenery at Rye. If Burra is 'sickened' by people, he

163. Edward Burra, *Valley and River, Northumberland*, 1972

appears unreservedly to admire the sexual swell of hillsides and straight-forwardly pretty flowers. Many of them are so attractive in the calendar sense of the word that they lose the acid bite and stylistic cheek of his earlier pictures: see how woefully he comes to grief when love turns to reverence and he executes those slick, vapid still lives around 1957! But recently, in the latest watercolours shown both at the Tate and the Lefevre Gallery, Burra has managed to recapture some of his lost verve.

Up-to-date comments on motorways and pollution run hand in hand with wild evocations of *Whirling Dervishes*. Their forcefulness, astonishing from a man nearing seventy whose health has never been robust, laces the gentler landscapes with much-needed venom. They prove that Burra only justifies his claim to stand beside Stanley Spencer as one of the great lonely eccentrics of modern English art when he marries his feeling for the macabre to his undoubted insight into contemporary life. Without that unique and easily upset union, the poison drains away, and Burra ought by now to have realised that he cannot do without it.

DUNCAN GRANT
13 March 1975

Duncan Grant, whose ninetieth birthday is being celebrated with exhibitions at the Tate Gallery and Anthony d'Offay, is as familiar a fixture in English art as the cosy household implements and well-worn furnishings which fill so many of his paintings. His very name at once suggests a homely yet aesthetic sitting-room, peopled with languid Bloomsbury associates like Virginia Woolf and decorated with tasteful, hand-painted Omega pottery. While the human values such pictures uphold are gentle and domesticated, so too are their pictorial principles. A typical Grant canvas is quietly conservative, leaning on early lessons learned from Roger Fry's championship of Post-Impressionism but unwilling to push them towards any extreme conclusion which might threaten the harmony of reassuring tradition. In this respect, Grant's progress from youthful experiment to mature caution is symptomatic of English art's refusal to accept the full implications of the twentieth-century radicalism it embraced before the First World War.

If that period of Grant's work now seems the most energetic and inventive, it is also the least known and appears to contradict his reputation for paintings as restful as an inviting armchair. There is nothing at all complacent about the quick-witted trajectory described by his development between 1902, when a modest picture of a kitchen already announces his feeling for interior repose, and the rebellious audacity of 1914. A consistent bias in favour of tranquillity and equilibrium runs through those twelve years, admittedly: even a 1909 painting of the novelist Marjorie Strachey sunk in despair beside a French translation of

Crime and Punishment is muted rather than tragic, taking its mood more from the attractive floral cushions which Grant so clearly enjoyed rendering in the foreground. But the rapid assimilation of different styles is still bewildering, and bears witness to a clash of loyalties between Piero, Chardin and the Pre-Raphaelites on the one hand and Cézanne, Gauguin and above all Matisse on the other. Sometimes this conflict is successfully resolved, and Grant manages to execute a picture like *The Tub* which translates Matisse's simplified linear rhythms and Picasso's African distortion into a tender Bloomsbury idiom. Elsewhere, however, Grant lingers half-way between tradition and innovation, and a 1911 canvas called *Football* shows how loath he often was to abandon solid modelling and exchange his lingering devotion to realism for a wholly stylised alternative. It looks unfinished and embarrassed by its search for new forms of expression, and Grant may well have stopped work on the painting when he realised how impossible it was to reconcile its opposing aims.

By 1914, when he was nearly thirty and drawing strength from a close creative partnership with Vanessa Bell, many of these problems were temporarily solved. Free for the moment from misgivings about the anarchy of radical ideas, he embarked on an extraordinary scheme to combine the resources of music, movement, collage and total abstraction in one ambitious multi-media experiment. Inspired perhaps by Fry's theories about pure visual music, and definitely by newspaper reports on Scriabin's plan to accompany a composition called *Prometheus* with colour projections, Grant glued a series of painted paper cut-outs to a thin strip of canvas more than eighteen feet long. The paper rectangles, each painted in one of six different colours, are arranged on the canvas in seventeen clusters which often link up with one another and form a continuous frieze of dancing shapes. The distance separating the abstraction of this work from his earlier treatment of a *Dancers* theme, where five statuesque females join hands in a dignified circle of Gauguin-like limbs and classical draperies, is enormous. Grant's instinctive preference for a calm, stately tempo permeates both works, and yet the artist who painted *Dancers* around 1910 could never have dreamed that only four years later the human figure might be dispensed with altogether.

Moreover, a static and silent painted surface was by this time no longer enough: Grant also planned to set the canvas in motion around two motorised spools positioned at either end, restrict viewing to one section at a time through a small aperture, and enhance its rhythms with a slow movement from Bach. The Tate Gallery, which recently restored this remarkable work and filmed it to the accompaniment of the First Brandenburg Concerto, has therefore resurrected a landmark in modern

164. Duncan Grant, *Abstract Kinetic Collage Painting with Sound*, 1914 (detail)

art's intermittent desire to ally the painting tradition with devices drawn from a variety of other disciplines. Seen in action at the exhibition, this narrow screen of delicately unfolding segments achieves a union of colour, form, sound and motion which still seems pregnant with possibilities for the cross-fertilizing of different media even today.

All the same, Grant's refusal to pursue the avenues opened up by this high point of Bloomsbury radicalism does make us aware of its hesitancy as well as its daring. He never added movement and music to the collaged canvas, and his failure to do so suggests that he was not entirely happy about the project. The abstract austerity of his cut rectangles may have worried him, too, because some of their minimal strength has been dissipated by a fussy surround of watercolour stippling, which creates odd shadows and breaks out into distracting whirls all over the background. Unlike Matisse's later cut-paper compositions, which Grant here anticipates so strikingly, the collage is not given a chance to assert its own clean authority; and towards the left edge of the canvas Grant ceases to use collage, painting directly on to the background instead.

Despite its extremist ambitions, then, the work is compromised by the seeds of an uncertainty that soon afterwards caused Grant to return to more orthodox procedures. Just as he later added a representational white jug to another abstract composition of 1914, turning it from a vertical stripe painting into a polite still life, so he reverted to a surprisingly tame form of naturalism in his later career. The Sussex landscapes, interiors and portraits which dominate his art from now on remain faithful to the previous emphasis on placid harmony and decorative charm, it is true. Yet their unwillingness to continue searching for new means of expression counts against them. Grant's increasing attachment to tradition is not in itself disappointing, of course: even the kinetic collage was related to the possibilities suggested by Chinese scroll painting. But he has come to lean on comfortable formulae which evade

the challenging question he once asked himself about how best to revitalise tradition, not accept it with sighs of relief.

Up until 1914, Grant was able to supply a fertile and stimulating series of replies to that question. They never fully answered it, but each reply was more provocative and versatile than the last. His lack of a didactic programme actually helped him take exhilarating risks without the burdensome responsibility of following them all through, and their ample supply of visual adrenalin is still immediately apparent. The trouble with this kind of darting opportunism, however, is that it leaves an artist with very little to fall back on after the adrenalin begins to falter. Grant's most important mentor, Matisse, realised that hard intellectual decisions must be made if a painter is not to ossify in middle age, and his achievement was to ensure that renewal came about at key intervals all the way through his life. Grant, by contrast, seems to have come to the conclusion that it is enough to rely on an uncomplicated enjoyment of pretty fabrics, apples in a bowl, trees leaning over the pond at Charleston, and hayricks incandescent with sunlight.

He may be true to his own retiring hedonism by doing so, and faithfully reflect his view that art is an extension of everyday life as natural as eating and breathing. But I cannot help feeling that he has done less than justice to his abilities since those heady days of 1914. If his transparent love for the appearance of things earns continuing affection, he has not sustained the spirit of inquiry which once charged that love with enormous pictorial vigour.

L. S. LOWRY
9 September 1976

It has almost become a cliché to claim that L. S. Lowry persuades us to see Manchester, and by extension any archetypal northern industrial city, through his eyes. The pipe-legged pedestrians, smoking factory chimneys and gaunt façades have all grown, through a process as thoroughgoing as osmosis, indistinguishable from the reality they are supposed to depict. This identification of painting with source material is partly due to the ubiquitousness of Lowry's work: so many cheap reproductions of his pictures are hung in so many homes that they have come to be accepted as the Authorised Version of life in the north. And Lowry did his best to

165. Lowry at Work

further such a belief by reiterating, in canvas after canvas, the same equa-
tion of people and architecture, as if to imply that there was no other
way of portraying the subject he settled on with such remorseless regu-
larity. Like Cézanne in Provence, or Canaletto in Venice, he quite liter-
ally pre-empts any other artist's chance of proposing an alternative inter-
pretation of his chosen locale.

The large Lowry retrospective at the Royal Academy is full of these
identikit cityscapes, and the appeal they exert is more powerful than the
most concerted propaganda campaign. Handled with a blunt gaucherie
close enough to Sunday painting to convince spectators that they could do
as well, given a little practice, and redolent of a man who wanted to com-
municate in the most straightforward manner imaginable, the 334 items in
this exhibition mount an impressive plea for popular, totally accessible art.
Lowry's devotion to a plain-speaking idiom throws the hermetic charac-
ter of modernist painting into sharp relief, just as his concentration on
urban, working-class settings makes most other twentieth-century British
artists look like escapists who would never dare to stray beyond a genteel
preoccupation with still life, landscape or pure abstraction. And, in order to
drive home this image of a spokesman for the people, the catalogue repro-
duces a photograph captioned *Lowry at Work* showing him in a rain-soaked
playground, dressed in a dowdy mackintosh, sketching a mother and child

on a slide against a backdrop of glistening roof-tops. The man in the street, researching at first hand the gritty mundanity of a neighbourhood he was determined never to renounce.

Like all the other charismatic photographs which the exhibition so liberally displays, however, *Lowry at Work* is by no means a reliable record. Avuncular, portly, and always posed with a kindly twinkle in his eye, Lowry was enough of a ham to ensure that the cameramen who entered his home and followed him along the road never really penetrated the defences guarding his private self. For the truth is that he was essentially a hermit, a withdrawn and isolated man whose lifelong celibacy manifested a desire to keep his involvement with humanity at arm's length. So secretive was he that no one realised until recently that he had worked in a nine-to-five office job for almost fifty years, and that the majority of his paintings were executed at night. His ability to produce such a large body of work testifies, therefore, to an austere and anti-social existence, whereby his free time was largely given over to painting at home in the silent small hours, accompanied only by an electric light bulb, a collection of swooning Rossetti sirens, and the tick of his antique clocks.

An enclosed and 'unreal' existence if ever there was one, and sufficiently at odds with the supposedly populist stance of his art to cast doubts on the entire Lowry myth. The presence of some early life-class drawings in this exhibition prove that he could, if he so desired, have developed into a proficient realist artist dedicated to the accurate description of ordinary Mancunian life. But a curious 1922 pencil study called *The Rent Collector*, which ought in theory to document his own rent-collecting experiences as an employee of the Pall Mall Property Company, is already at pains to remove autobiographical references altogether. In their place, Lowry sketches a scene close to caricature, and expunges all trace of the doubtless painful encounters he must have had with poverty-stricken tenants in favour of a deadpan, comic-book humour.

Six years before, in an untypical pastel called *Mill Gate*, he had allowed himself to acknowledge the brutal degradation of industrial working life: the hunched figures queuing in a funereal procession outside the factory railings are drawn in a raw, cheerless style which expresses his direct and despairing response to the scene he had witnessed. It is, however, an exceptional moment in Lowry's work, making clear that the so-called 'primitive' idiom he subsequently evolved was by no means the language of a parochial artist who could express himself in no other way. *The Rent Collector* proves that between 1916 and 1922 he took a deliberate, not to say highly sophisticated, decision to distance his art from the kind of undiluted misery exposed in *Mill Gate*. Both the collector and the tenants are

now no more than puppets, incapable of the human emotions so ago-nizingly uncovered in his earlier factory queue. And throughout the 1920s, Lowry can be seen removing his work still further from the plight of the Depression, mass unemployment and the General Strike.

The citizens who scurry through his paintings are notable for their sense of isolation, certainly, and they receive scant comfort from the unseeing windows of the buildings which dominate and control their manic movement. But the overall context is that of a toy-town, a pic-turesque stage where Lowry can dramatise his own private loneliness and draw reassurance from the childlike dream-world his imagination inhab-ited. He later attempted to explain his preference for urban subject-mat-ter by relating how one day 'I was with a man in the city and he said "Look, it is there!" and suddenly I *saw* the beauty of the streets and the crowds.' The anecdote is revealing, not only as an example of Lowry's need to hide his real self behind a cloak of fable, but also for his use of the word 'beauty'. The grand industrial panoramas of his maturity were, fundamentally, a source of consolation to a painter who could not bear the true, unsettling face of his surroundings, and opted instead for a reas-suring fantasy.

His grasp of his favourite *mise-en-scène* was by this time so assured that he could invest lamp-posts, flights of stone steps, churches, palisaded trees and – supremely – the crowd, with a quirky significance which carries considerable conviction. Lowry's strength as an artist lies in his ability to construct an artificial tableau rooted at the same time in an intense love for the geometry of back-to-back terraces, the attenuated silhouettes of chimneys, the blackened and immovable bulk of squat warehouses. His understanding of the stylised convention he developed is, in his best can-vases, so complete that a suspension of disbelief can be engineered among his spectators.

The most positive aspect of Lowry's prolonged love-affair with slum-land is that he mounts a plea for the kind of generic townscape which we now recognise, after decades of wholesale redevelopment, as an envi-ronment worth rehabilitating rather than destroying. People interact with the architecture in his pictures with a fluid, instinctive ease entirely lost in the desert of tower-blocks and pedestrian precincts so heartlessly ushered in by post-war building. But the most negative side of Lowry's work is its concomitant nostalgia. Locked in a 1920s time-capsule, which bears little relation to the present-day nightmare of soulless concrete to be found as much in Manchester as its equivalents elsewhere, his art pro-vides a springboard for sentimentality. That is why so many Lowry paint-ings are owned by wealthy northern industrialists: they find infinite solace

in the daintiness of a painter who conveys grass-roots knowledge of his vicinity and yet removes all the blemishes we would prefer to forget.

Admittedly, Lowry's occasional excursions into the depiction of human figures alone are genuinely disquieting. Cripples suddenly sprawl in grotesque profusion across the centre of his pictures, while close-up portraits of men with staring, bloodshot eyes and full, hermaphroditic lips reveal the disturbed bedrock of his psyche. We are, however, only allowed glimpses of this otherwise undisclosed nightmare. Most of the time Lowry suppresses it, and reasserts an Elysian fabrication of the north as he wanted it to be, swathed in a mist of uniform whiteness which signifies his yearning for a virginal, untainted and above all hygienic city. Anyone who confuses this compelling exercise in wish-fulfilment with the reality it distorts is guilty of accepting the most dangerous and soft-centred delusion art can offer.

DISSIDENT SOVIET ART
27 January 1977

In view of the Soviet Union's notorious and reprehensible campaign of censorship against any artist who refuses to accept Socialist Realism as an unassailable creed, the large survey of Unofficial Art from the Soviet Union at the ICA should be warmly welcomed. Almost all the participants have never exhibited in this country before, and their inability to gain the smallest measure of acceptance in their native country means that London is providing them with a rare opportunity to contact the gallery-going public. Since it is impossible for a Western observer to imagine the difficulties they encounter in Moscow or Leningrad, the least I can do is salute their courageous attempt to assert beliefs which clearly cost them all hope of support and recognition at home.

I am afraid my positive response stops here, however, because the work on show fails to amount to anything more substantial than a hotch-potch of third-rate exercises in idioms long since evolved – with far greater authority – in the avant-garde West. It may seem churlish to castigate artists who are helplessly cut off from a proper international dialogue for not rising above the level of provincial Sunday painting. After all, if the authorities ensure that the USSR has no easy access to contemporary art from

Europe, America and elsewhere, then they should be held fully responsible for keeping their 'unofficial' artists stagnating in an ill-informed backwater. But it would be equally wrong-headed to gloss over this exhibition's shortcomings and merely administer an encouraging slap on the back. Michael Scammell, in his preface to the catalogue, claims that the artists 'would not want to be shielded from the rigours of an appreciation and criticism based on the same standards as applied elsewhere'. And I would agree that one of the principal advantages of a London showing lies in the opportunity it gives Western reviewers to discuss the problems faced by dissident Russian artists with as much frankness as possible.

My own misgivings about this exhibition are centred not so much on its unavoidable element of pastiche, which often makes it look like an exhumation of mannerisms fashionable in Paris during the 1950s, as on its rampant individualism. Each contributor seems to take an inordinate amount of pride in cultivating his or her own style, as if the worst crime would be to resemble a contemporary, and there is no sense anywhere of a communal agreement about the function of art save for the licence it grants these artists to differ one from another. The result is a wholesale assertion of the isolated romantic, the private and obsessive visionary cultivating imaginative insights and then bestowing them on spectators who are made to feel like Moses confronted by the Burning Bush. Yuri Zharkikh's painting of *The Artist* typifies this approach in its dramatization of an infinitely sensitive prophet-figure, surrounded by a mystical nimbus and withdrawn from the world.

However understandable such a stance may be as an extreme reaction against the dogma of Socialist Realism, it cannot be called a healthy pointer towards the future of this 'Unofficial' alternative. Sir Roland Penrose's catalogue introduction declares that 'in the diversity of style that emerges among the unofficial artists there is a refreshing sense of individual freedom'. But liberty, if it remains unallied to any definable purpose other than a celebration of the right to do as you wish, can be almost as tyrannous as suppression itself. The tragedy of Soviet censorship is that it appears to have polarised Russian art into two undesirable extremes: either the party chairman and heroic tractor-driver are depicted marching forward together into a future filled with banal propaganda, or all discernible references to life in the USSR today are replaced by a self indulgent riot of geometrical abstracts, tachiste expressionism, artful collages and eccentric surrealism. The whole weary bag of modernist tricks, which is now as redundant in the West as the notion of an avant-garde, has been emptied out over the walls of this exhibition in the belief that it can emancipate art from Kremlin bromides.

It is incapable of doing so because, in an all too understandable determination to avoid the territory occupied by Socialist Realism, it makes the mistake of retreating into an interior dream-world where sanctuary can at least be guaranteed. The only way to combat the rigidity of Socialist Realism in the Soviet Union is to tackle it on its own terms, and develop an art so pertinent and robust in terms of interpreting modern Russian life that the established state artists are exposed in all their whitewashed insincerity. But unlike Sir Roland Penrose, who considers that 'the common outstanding virtue of this otherwise heterogeneous collection of paintings and drawings is the sense of urgency that informs almost every one of them', I can find no energetic response to the artists' environment, urgent or otherwise.

It would be natural to assume that the oppression suffered by the men and women who produced this work would express itself in the form of vigorous protest. But apart from the tortuously symbolic prison-cell drawings by Alexander Kalugin and Boris Sveshnikov, Alexander Rubin's painting of Lenin's portrait hanging down over a city in ruins, and Valentina Kropivnitskaya's sentimental pencil study of two sad-eyed mythological creatures sitting pensively on a roof-top as flood-water drowns the church behind them, no hint of polemic ruffles the spirit of well-mannered experimentation in this exhibition.

Now and again, a drawing like Alexander Makhov's nightmarish *Execution I* implies some kind of dissent by allegorizing persecution as a savage crucifixion peopled with Expressionist grotesques. And the sturdy Ernst Neizvestny, whom John Berger's writings have made probably the most familiar artist on show here, is permanently caught up in a rhetorical – not to say portentous – drama enacted by writhing Rodinesque nudes. On the whole, however, the general withdrawal from any desire to depict the outward face of contemporary Russia has been accompanied by a quietism which often has overtones of nostalgia for Christianity and the rich, encrusted surface of the icon tradition. Even when the religiosity and the proliferation of agonised still lives full of writhing branches, stones and skulls clears for a moment, and we find Lev Nussberg proposing gigantic sculptural constructions which look back to Tatlin and Lissitsky, it soon becomes apparent that these cityscape projects are doomed to remain drawing-board fantasies. The nearest approach to a realist alternative is to be found in the work of Oscar Rabin, a forthright and instantly recognizable painter whose squat forms, always enclosed in thick black contours, are reminiscent of Josef Herman's neanderthal Welsh miners. But although one of his pictures goes so far as to include a couple of collectivised trucks, and another

166. Oscar Rabin, *Still-life with Fish and Pravda*, 1968

places a cat eating a dead fish on the deserted street of a skyscrapered American city, Rabin's main emphasis rests on picturesque Russian villages which industrialization seems to have passed by.

Both the styles and the yearnings of these so-called rebels are fusty, caught in a limbo of disagreement with their country's policy and unable to formulate a more convincing direction for Soviet artists to pursue. As chance would have it, Darcy Lange's videotapes are on view upstairs in the ICA's New Gallery to prove that some young Western artists are producing far more grass-roots work than their Russian equivalents. Lange's documentary studies of factory labour in Bradford, teaching in Birmingham, sheep-shearing in Ruatoria and much else besides, represent a straightforward attempt to hold up for our inspection the process of work as it really is: a grinding repetitive ritual, an animated conversational event, a demonstration of manual skill and in the steel smelting works a dramatic encounter with extremes of light and heat. These videotapes are a long way beyond the vanguardist meanderings of the work downstairs, and all the better for their independence of constricting state directives as well.

A SPURIOUS SIMPLICITY
8 October 1979

I have always mistrusted the term 'naïve art.' It appeals to the patroniz-ing notion that artists are somehow at their best when untutored, eccen-tric and even feeble-minded. The British, whose instinctive suspicion of the visual arts has long been notorious, find the naïvety myth especially attractive. It enables them to belittle artists without appearing philistine. One of the dictionary definitions of naïve is 'amusingly simple', and it is easy to imagine such a condescending comment being made whenever a Rousseau or a Lowry comes into view.

As it happens, both these painters had a very sophisticated under-standing of how their intentions could be effectively carried out in pictorial terms. So do some of the contributors to an event loudly trum-peted as Britain's First International Naïve Art Exhibition, a determined and lavish dealer's attempt to turn naïvety into a best-selling asset. The large, glaringly spotlit rooms of Hamiltons gallery, which tries to recre-ate a bizarre Spanish-colonial atmosphere in the middle of Mayfair, have been given over to an assortment of supposedly guileless paintings from all over the world. Quite how many nations are represented here remains oddly unclear: according to the catalogue, thirty-seven listed countries 'have agreed to take part', and twenty-five others 'have also been approached who may yet agree to take part'. (Naïve artists obviously find it hard to make up their minds.)

There's also a certain amount of confusion about whether the expect-ed works in fact arrived. In a disarming printed note which could be described as a masterpiece of naïve grammar, visitors are informed that, 'owing to the late arrival of many of the pictures, it has been impossible to ensure that the right paintings were sent to Hamiltons by the artists until it was too late to rectify mistakes which the artists themselves have made'. (Naïve artists apparently cannot be trusted to post off the *really* naïve examples of their work).

All this last-minute shilly-shallying is, I suppose, meant to prove that the exhibitors actually are as dim-witted as they're cracked up to be. Sheldon Williams, who organised the show and seems to spend his time jetting around the world on the look-out for sundry international naïvety, is at pains to establish his artists' proper credentials. In a fulsome introduction to the show, he claims that, 'just because their works are unsullied by the niceties of professional expertise, the cunning of an academic training, and schooled profundity, they are entirely the product of their own creative

167. Catalogue title page of Britain's First
International Exhibition of Naive Art, 1979

selves . . . They are painters of pure vision.' This claptrap sums up the
woolly thinking behind most apologia for 'naïve art'. Williams seems to
imagine that expertise, training and profundity all sully an artist's work. The
truth is, of course, that good art invariably thrives on a considered aware-
ness of what other artists do, and anyone who discounts skill is in danger
of elevating sloppiness into an automatic virtue. But the worst fallacy pro-
moted by connoisseurs of instant naïvety is the idea that the artists they
champion are sublimely unaffected by outside influences. This is prepos-
terous. Mass-reproduced images, whether department-store prints, paper-
back art-book illustrations or commercial hoardings, are by now so wide-
spread as to be almost inescapable. And even the most isolated native artist
on a remote island is nowadays likely to be a knowing producer of work
aimed at the tourist market for 'noble savage' souvenirs. In a telling phrase,
Hamiltons' press release claims that the show 'is like a cultural package tour
of the globe' – although they should have added that only the wealthiest
traveller could afford some of the prices. Eva Lallement's *Les Fiancés
Bretons*, for instance, costs a far from naïve £3,383.

Plenty of other exhibits wear their knowledge of revered artists so openly that they demolish Williams' protestations about 'pure vision', whatever that means. Maria Kloss has a painting of draughts-players whose tubular limbs and massive, machine-age furniture owe so much to Léger that the entire exercise descends to the level of pastiche. John Bensted owns up to his mentor more honestly, and produces in *The Rousseau Banquet* a picture riddled with diligently researched references to the dinner Picasso held in the Douanier's honour. But Belén Saro even dares, in *Homage to Goya I*, to travesty one of his hero's most powerful works by placing bunches of flowers in the hands of the victims being gunned down in *The Third of May*. We are a long way here from artists whose work is 'entirely the product of their own creative selves'.

The floral bouquets, which recur in two other equally intolerable Saro homages to Goya, point to the all-pervasive example of Chagall. His later work, so cloying and winsome, has exerted a disastrous influence on twentieth-century art, and 'naïve' work in particular relies heavily on his saccharine charm. There's such a surfeit of wide-eyed pseudo-innocence in this exhibition that an exception like James Lloyd comes as an enormous relief. He can paint a girl hugging a dog, or three children tenderly discovering a birds' nest in a wood, without indulging in sentimentality. Why should 'naïve' so often mean mawkish? John Allin turns out to be one of the few participants who doesn't see life as a bland, remorselessly smiling charade. His boys swinging from a lamp-post are as tough as their council-estate surroundings, and he knows how lengthening afternoon shadows in the street can measure out the full extent of urban desolation. Even when Allin paints a man whistling for his dog in the middle of an open space, the figure is marooned so completely within the bleak expanse of grass that he embodies the loneliness of modern city life.

There is nothing 'naïve' about either Allin's insights or the unassuming precision with which he paints them. He deserves far better than a catch-all context like this exhibition, which demeans the worthwhile artists it contains by placing them indiscriminately among painters who pretend to a spurious simplicity they do not, and should never want to, possess. Labels like 'naïve' say more about commerce than art, and bury the individual imagination inside a dealer's promotional rhetoric.

FINALE

EXTENDING THE TATE
July 1979

A decade has passed since I wrote, in a spirit of impatience, an article attacking 'The State of the Tate'. My criticisms then were aimed at the lamentable condition of an institution which had no space to hang the majority of its holdings; paid disappointingly little attention to the particular display requirements of the few works it did place on view; and dithered over its preposterous dual role as custodian of both British and modern foreign art. I was aware that back in 1954, when the Tate was separated from the National Gallery by an Act of Parliament which finally allowed it to be administered by its own independent Trustees and Director, the government had agreed to use the empty north-west corner of the site for a major extension. But by the time my polemic was published fifteen years later, no construction work had begun. The new building, which promised to provide 50 per cent more hanging space for the modern collection and thereby enable the Tate to rectify some of its more glaring deficiencies, was as far away as ever.

Now, at last, the addition has been completed. And the Tate will never be the same again. But has the change brought about a significant improvement? I fear not. A gigantic hangar-like slab, the first extension made to the gallery for forty years, provides the exterior with yet another of those featureless frontages found throughout countries where the idiom of Anonymous International Modern holds sway. Decked out in Portland stone like the rest of the Tate's façade, it has taken care to choose material from the quarry's shelly bed so that its surface texture marries with the smooth stone of the old building. The upshot, according to one of the proliferating press notices, is part of an overall design 'concept that happily related well to the appearance and structure of the existing building'. But no optimistic publicity can hide the disparity which separates the Victorian Tate, a palace festooned with symbols of Britannic greatness, from the minimal austerity of the extension walls. Their bare expanses, punctuated by vertical slits presumably added because even the architects could not stomach the prospect of an uninterrupted façade, signify the blankness in the thinking behind them.

Emptied of the imperialist pride and self-aggrandisement which drove Henry Tate to finance the original building, the new exterior expresses nothing but a functional urge to provide More Space. If Sidney Smith's embellishments reflect Britain's ebullience during the final years of the last century, the structure designed by the hydra-headed firm of

168. Exterior view of the extension, Tate Gallery, London, 1979

Llewelyn-Davies Weeks Forestier-Walker & Bor provides a mirror-image of the recession-torn 1970s. The Victorians were at least impelled by the desire to build a temple, celebrating their enthusiasm for the whole idea of a National Gallery of British Art. We, by contrast, can only offer a reductive box indistinguishable from banks, factories and office-blocks which multinational companies commission from architectural practices.

Accordingly, the lustrous revolving doors which offer entry to the new extension from the earlier sections of the Modern Collection seem to have strayed from the cool, impersonal setting of hotel foyers, airport lounges and government departments. The 'Property Service Agency of the Department of the Environment' shares official credit for the architecture with Llewelyn-Davies . . . & Bor, and I imagine that the DoE's monolithic skyscraper headquarters in nearby Marsham Street is full of similar doors, turning soundlessly as they respond to the discreet touch of a thousand gliding civil servants. But the people who do manage to overcome this psychological barrier and penetrate the galleries beyond will find that the ambience confirms the deadening influence of bureacracy. With few exceptions all the rooms have been painted a uniform pale grey,

and on their walls a total of 477 paintings and prints are hung like postage stamps crammed on to the pages of an album by an anxious collector. Add to that a further 151 sculptures, and the feeling of congestion is complete.

The very real pleasure to be got from finding so many works of art displayed, almost for the first time, is therefore countered by the realization that they have been treated with the same dispassionate efficiency which dictates the housing of battery hens. Occasionally, a clearing is reached in the jungle and one favoured artist – Moore, Rothko, Long – is given a room to himself. Such respites are brief. Scarcely has the work of one individual begun to establish a particular voice than we are pitched inside another gallery filled with arrays of objects never intended by the makers to be treated as ingredients in some composite stew. Giving a worthwhile art-work the attention it deserves is difficult in the best circumstances: the act of contemplating is a prey to distraction at all times, and when the onlooker is besieged by an embarrassment of contenders for attention, all attempts to view become intolerably frustrated. The awareness that while one exhibit is being scrutinised half-a-dozen others are also swimming into vision, and that beyond this cluster wall after wall of equally choked imagery is waiting to be inspected, soon kills off all spontaneous appetite. Enjoyment gives way to glum duty, a ticking-off of artists' names, titles, accession dates, donors' identities and other curatorial paraphernalia. In the end, the capacity to respond on any level is defeated, and the numbed visitor begins to wonder why the work artists produce should be reduced to such an institutional norm.

The answer is, quite baldly, that the present power hierarchy at the Tate wants it that way. The Norm – forgive the pun – is the brainchild of Sir Norman. Before he assumed the directorship in 1964 the collection always appeared to be a relatively haphazard affair: an agglomeration consisting mainly of Tate's founding gift (late-Victorian set-pieces by artists with impeccable academic credentials); the Chantrey bequest (more academicians from The Best at Burlington House); the enormous Turner legacy (disgracefully flouted); the Lane bequest (Impressionists which the Irish protested belonged to them); and whatever successive directors could scrape together from the purchasing funds at their disposal. The result was deceptive. If the Tate's character was shaped in a deliberate manner by the rearguard at the Royal Academy – and therefore by the most reactionary forces in British society – it wreathed these prejudices in a smoke-screen of endearing amateurism. Like exclusive London clubs, where antediluvian furnishings disguise their members' continuing ability to control establishment opinion, the Tate contrived to exclude all the

169. General view of Tate Gallery extension, London, 1979

most experimental, subversive forces of modern art without *appearing* to do so. Although explosive avant-garde movements were never allowed to disrupt the somnolent calm of the Millbank Mausoleum, their absence looked like an accident or a shortage of money, rather than censorship.

But when Norman Reid took over the balance of power was reversed in modernism's favour. Rothenstein, his predecessor, had stubbornly stockpiled holdings of outstanding figurative artists like Spencer, Burra or Bacon, and left the paramount achievement of, say, Cubism almost unacknowledged. Reid, without drawing unseemly attention, rehung the Modern Collection in a more rigorous and methodical way, stressing the importance of vanguard movements according to the accredited model laid down by the Museum of Modern Art in New York. His own preferences leaned towards non-figurative art of the most bleached and discreet kind – Ben Nicholson, now represented by an enormous number of works, is clearly one of his favourite artists. And he has admitted that, since the Director's 'taste and predilections shape the collection . . . it may be that during the last 15 years my particular love of abstract art has placed the main growth there.' The positive side of Reid's reign, then, is that he finally forced the Tate to come of age and admit the full extent of the radical transformation art has undergone during the twentieth century. He deserves considerable respect for releasing the stranglehold which the Royal Academy once exerted over our national understanding of modern art, and nobody apart from recalcitrant conservatives would ever want to turn the clock back towards the desperate days when Picasso and Matisse were reviled for their decadence. In comparison with the past, Reid's directorship has been a triumph of enlightenment.

Even so, his tenure's negative side can be located just as readily. For art-historical orthodoxy, which insists more and more on equating twentieth-century art with a series of neatly tabulated modernist labels, now dictates the form Reid has made the Modern Collection assume. As the informed visitor walks through its galleries, armed with the new 'Room by Room' guide, an arid pattern of codification becomes apparent. The magisterial dominance of 'isms' begins with Impressionism and Post-Impressionism and proceeds blithely onwards through Fauvism, Expressionism, Cubism, something called 'Later Cubism', Dada and Surrealism, Neo-Constructivism, and, of course, Abstract Expressionism. All the renegade flotsam which refuses to be hauled in by the net which Reid trawls so ruthlessly either finds itself ignored or is scooped up in odd handfuls, and given indigestible titles like 'Aspects of British Visionary Art and Styles Developed from Cubism' which provide painful proof of the underlying bureaucratic mind.

Once the extension is reached, the gap between instant movements and everything outside becomes laughable. The progression from Post-Painterly Abstraction to Optical and Kinetic Art, closely followed by a quasi-biblical lineage implying that Pop Art begat Minimal Art which begat Conceptual Art, is undermined by rooms where the tabulation breaks down altogether. The section headings break into violent curatorial hiccups, and the final room of all – a dumping ground for 'Stuff That Doesn't Fit In Anywhere Else But We Really Ought To Show' – has actually been given the despairing name 'Further Aspects of Painting and Sculpture, *c.*1958–1976.'

I was careful to describe the person undergoing this tour as an *informed* visitor, because nothing will convince me that most uninformed members of the public will either consult the 'Room by Room' guide or stay the course. The likelihood is that, having entered the extension and found how the monotony of the architecture reinforces the regimentation of the hanging, they will come to a halt. Even before the official opening, two young architectural students with a special interest in museum design previewed the new building and came to the conclusion that its anonymity was a serious fault. 'The architects seem to have decided that a "neutral" building would be more successful for the display of art than one with "strong architectural character",' they wrote in a disenchanted letter to *The Guardian*. 'However, the result, in our eyes, demonstrates that this is not the case: its neutrality is somehow obtrusive, even detrimental. Is it not conceivable that the architecture of an art gallery might contribute positively to the spectators' appreciation of the artefacts it houses, that an inspiring environment might catalyse a deeper reaction to them?'

The question is worth posing. This 'deeper reaction', the ultimate *raison d'être* of art, cannot be nurtured in an environment dedicated to the premise that the work artists make must be parcelled up into rigidly designated packages and then buried in an overcrowded depository. But that is how the Tate's extension operates. After a while the absence of any discernible *sense of place* in this maze of interchangeable rooms becomes disorienting. Non-specialist visitors, who after all constitute the majority of the Tate's public, are bound in the end to feel that they no longer know where they are, what they are supposed to be looking at, and why they should submit themselves to such an ordeal. Without the guide-book, the only help which the staff supplies – apart from the mandatory caption beside each item – is the number of the room. Not even a label volunteering the information that either an 'ism' or a 'further aspect' is here surveyed. No indication that we are in St Ives or Berlin, the Depression or the Second World War. This is the no-man's-land of museumology at

its most professional, where works of art are lifted clean out of the contexts they originally inhabited in the world and marooned inside hermetically-sealed containers. The manifold interconnections between art and life are sundered, leaving behind a sanitised version of the truth which casts the museum in the role of self-appointed purifier.

In the Tate's extension this cleansing operation is most evident at ceiling level, where the yawning space is divided into twenty-one separate modules. The roof of each is a technological marvel containing independent air-conditioning and controls for both natural and artificial lighting. Linear grills positioned round the module's perimeter introduce and extract air, guaranteeing a permanent temperature range and maintaining relative humidity. The modules themselves are covered by double-layer pyramidal rooflights, complete with sets of aluminium louvres, which silently adjust themselves to keep natural light within the prescribed conservation limits and to reduce the amount of solar heat reaching the gallery beneath. The controls of the lower layer of louvres are activated by a photoelectric cell in each bay, and the levels of illumination can be pre-set to deal with what the Tate disapprovingly describes as 'excessive variation in illumination levels from natural sources'.

In other words, the whole atmospheric envelope through which visitors move is constantly being maintained at a clinical level which eradicates the vagaries of normal living. However much the Tate insists that the louvres 'must avoid responding too quickly to slight changes and will preserve variations in light level that are characteristic of natural light' the general effect is eerily artificial. Too dim to recall the daylight outside the gallery, and devoid of temperature shifts so typical of the British climate, the rooms are detached from any level of reality other than a blandly scientific one. The large squares in the centre of each ceiling module loom down like monitoring devices on the works of art. Their presence is all the more obtrusive because of the rooms' grey inability to draw attention away from the roof areas. Starved of information about the exhibits they are supposed to be viewing, visitors find themselves searching for solace in the pyrotechnics poised above their heads. And the quiet, efficient machinery lodged there confirms their worst suspicions: the will to conserve a collection has been given a far higher priority than the will to communicate with the public. This multi-million-pound box of tricks looks after the art works but ignores their onlookers. Preservation is here lavishly deployed almost for its own sake.

Such an astonishing dearth of guidance argues a disdain for the needs of a lay audience, which typifies everything that is wrong with the Tate's attitude towards modern art. How on earth are people supposed to

initiate themselves into the mysteries of modernism if the keepers of our national collection have no compunction in withholding aid where it is required most? It is an élitist standpoint, which implies that the Tate is not seriously concerned with addressing its holdings to anyone beyond a minority of converts. The rest of the public are left to flounder from section to section, exhibit to exhibit, wondering why it all seems so impenetrably shut off from their understanding; and anyone wanting the Tate to extend itself towards the widest strata of society can only be dismayed by this failure.

They could scarcely be blamed from deciding, if they get as far as room 46 ('European Art c.1945–c.1960'), that Francis Gruber expressed their dilemma very directly when he painted a large canvas called *Job* in 1944. This gaunt picture of a bare, emaciated man, slumped in resignation among Parisian tenements, was intended to symbolise the citizens of France who, like Job, had undergone suffering during the Nazi occupation. Yet it could as readily sum up the bemusement of visitors feeling browbeaten by an institution which gives few signs that it cares about sharing its contents with them. I would like to think that they will voice their complaints, and thereby provoke the Tate into mending its ways. But the intimidating atmosphere of a museum, combined with innate British stoicism, makes any protest unlikely. Most people will doubtless settle for a swift departure, in the same way that Gruber's *Job* opts for staring down at a paper message on the ground which reads: 'Now once more my lament is a revolt, and yet my hand holds back my sighs.'

In the Tate's partial defence, it should be made plain that throughout this inaugural display felicity of presentation is consciously sacrificed to the airing of exhibits like *Job* which have never been seen within living memory. I doubt, for instance, whether Guttuso's monumental *The Discussion*, surely one of his most vigorous works and a welcome corrective to the vulgarity of his recent paintings, has been shown at all since its purchase in 1961. Plenty of older acquisitions have likewise been brought up from obscurity, and at this preliminary stage there is some excuse for concentrating solely on giving such things the right to be seen after so long a banishment. Besides, before too much time elapses the current arrangement will change, partly to make room for the temporary exhibitions programme, partly because Norman Reid retires this year.

But however many objects are eventually humped back to the basement, one urgent problem confronts any museum official trying to make sense of a huge gallery like the Tate. How can its possessions be arranged so that they become something more than an inert mass of visual evidence, stretching away into a daunting perspective of rooms which testify

primarily to a zeal for amassing endless codified data? What is the best way of going beyond the Tate's own narrowly statistical explanation of how the opening enables it 'to present the largest display of its collections that has ever been possible or will be possible for many years to come'? Surely most visitors need an approach at once less functional and more determined to generate a passionate engagement with the full imaginative meaning of an artist's work?

INDEX

Page references in *italics* indicate illustrations. Works are listed under artist and subject.

CREDITS

The publisher has made every effort to contact the relevant copyright holder for the images reproduced. If, for any reason, the correct permission has been inadvertently missed, please contact the publisher who will correct the error in any reprint.

COPYRIGHT LINES